CONSUELO JIMENEZ UNDERWOOD

CONSUELO JIMENEZ UNDERWOOD

ART, WEAVING, VISION

LAURA E. PÉREZ AND ANN MARIE LEIMER / EDITORS

Duke University Press · Durham and London · 2022

Library of Congress Cataloging-in-Publication Data
Names: Pérez, Laura Elisa, editor. | Leimer, Ann, editor.
Title: Consuelo Jimenez Underwood : art, weaving, vision / edited by
Laura E. Pérez and Ann Marie Leimer.
Description: Durham : Duke University Press, 2022. | Includes bibliographi-
cal references and index.
Identifiers: LCCN 2021037912 (print) | LCCN 2021037913 (ebook) |
ISBN 9781478015697 (hardcover) | ISBN 9781478018322 (paperback) |
ISBN 9781478022930 (ebook)
Subjects: LCSH: Jimenez Underwood, Consuelo. | Wall hangings—United
States. | Weaving—United States. | Hand weaving—United States. | Women
weavers—United States. | Textile design—United States. | BISAC: ART /
Individual Artists / Essays | ART / Women Artists
Classification: LCC NK8998.J56 C667 2022 (print) | LCC NK8998.J56 (ebook) |
DDC 746.3—dc23/eng/20220204
LC record available at https://lccn.loc.gov/2021037912
LC ebook record available at https://lccn.loc.gov/2021037913

Cover art: Consuelo Jimenez Underwood, *Flowers, Borders, and Threads,
Oh My!*, 2013. Mixed-media wall installation, 17 ft. × 45 ft. × 10 in. Photograph
by James Dewrance.

PUBLICATION OF THIS BOOK HAS BEEN AIDED BY A GRANT FROM THE WYETH
FOUNDATION FOR AMERICAN ART PUBLICATION FUND OF CAA.

DUKE UNIVERSITY PRESS GRATEFULLY ACKNOWLEDGES MIDWESTERN STATE
UNIVERSITY AND THE ANDREW W. MELLON FOUNDATION FOR A DEAN'S FAC-
ULTY EXCELLENCE PROGRAM AT THE COLLEGE OF LETTERS AND SCIENCE PROJ-
ECT GRANT, AWARDED THROUGH THE UNIVERSITY OF CALIFORNIA, BERKELEY,
WHICH PROVIDED FUNDS TOWARD THE PUBLICATION OF THIS BOOK.

May this book help midwife greater appreciation for our interdependence with all other people and other life forms.

LAURA E. PÉREZ

For my mother, Rachel L. Leimer, who taught me to love and honor all things thread.

ANN MARIE LEIMER

CONTENTS

**SPINNING—
MAKING THREAD**

**WEAVING—
HAND WORK**

LIST OF ILLUSTRATIONS

LUIS VALDEZ

The Art of Necessity

What are the roots of art, particularly great art that is intrinsic to life itself? What are the differences between arts and crafts, between artists and artisans, and between what or who defines their difference? What are the distinguishing characteristics of the household arts and why are those works not formally considered to be fine art—or even art? The artistic work of Consuelo Jimenez Underwood both addresses and transcends these questions with a visceral and intellectual power that belies the humble roots of her working materials. She materializes, with primordial effect, the voices of her ancestors from the loom of life, death, and rebirth.

Weaving with barbed wire, she makes an "Undocumented Tortilla Basket" the receptacle of hunger and empty promises. The child of a weaver, she has inherited the tactile sensibilities of her forebears as the creative roots that connect her to their humanity. But her work reflects the vast parameters of her twenty-first-century vision of the Americas. The hard pain of immigration looms heavily on the warp and weft of her creations. The very shape of the Mexican border, la frontera con los Estados Unidos, becomes an emblematic line that appears again and again as a symbiotic scar linking the past with the painful present. This image appears and reappears against the hemispheric backdrop of the two Americas, both north and south, suspended on the fragile threads of works seemingly in progress, invoking the fragility of our continental history while condemning the imperialistic land grabs that define our border realities.

As a transformative artist, Consuelo Jimenez Underwood re-
claims and gives profound new meaning to what other less en-
lightened times once called "women's work." With the full pano-
ply of her compassion she reinterprets the meaning of "Tortillas,
Chiles and Other Border Things." Her series of burial shrouds,
once part of the domestic purview of women at home, becomes a
political roll call acknowledging the life and death of heroes such
as Emiliano Zapata and Woody Guthrie. By the same token, her
re-creation of rebozos embraces the sun, moon, and stars, invok-
ing the tenderness and power of Mother Nature herself. Her art
cumulatively builds to a deep and vast vision of human existence
conscious of her time and place close to the Mexican border. Yet
she meaningfully transcends those limits by going deep and broad
into her world of everyday objects until the border she envisions
extends across the entire world.

Ultimately, the beauty of her work must be seen in the imme-
diacy of her installations in order to be fully appreciated; it must
be experienced in the powerful presence of their three dimensions.
Even so, images of her superlative handmade canon are irresistibly
moving and rise to a categorical celebration of her artistic imagi-
nation, wit, and compassion. Born of the border regions, her work
transcends the oppression, sexism, and racist ignorance of her time
to emerge fully empowered in her rebirth as a world-class artist.

ACKNOWLEDGMENTS

We warmly thank all of the contributors to this anthology who worked patiently, cheerfully, and faithfully with us through numerous and time-consuming rounds of editing. Special thanks are of course due to the artist herself, Consuelo Jimenez Underwood, with whom we worked closely, and to Alyssa Erickson, who was invaluable as Jimenez Underwood's administrative right hand and whom we brought on board to help us organize the manuscript and images. It was a joy to work with the authors of our anthology, Consuelo, and Alyssa, and a blessing to work together as co-editors. We also thank the other artists whose work appears in our anthology for kindly providing permission to reproduce their images: Christi Belcourt, Yreina D. Cervántez, Delilah Montoya, Celia Herrera Rodríguez, and Georgina Santos, and we thank the Mingei International Museum in San Diego; Movimiento de Arte y Cultura Latino Americana (MACLA) in San Jose, California; the Oakland Museum of California; and the San José Museum of Art. Special thanks are also due to the external readers whose thoughtful and detailed feedback made this volume a stronger one. We also thank the College Art Association for a 2020 Wyeth Foundation for American Art Publication Grant, Midwestern State University for an Office of Sponsored Programs and Research Intramural Grant, and the University of California, Berkeley, and the Mellon Foundation for a Faculty Mellon Project Grant, all of which enabled color publication of the images and beautiful design. Warm thanks to everyone at Duke University Press, including Ken Wissoker, Josh Tranen, and the art and design team, to Julie Allred of BW&A Books, to copyeditor Andrea M. Klingler of Silverwood Editorial, and to Julián Sánchez González, who prepared the index. The friendship and support of the Chicanx Latinx arts scholar community, many of whom are in this volume, but also including Guisela Latorre and Adriana Zavala, made this book a pleasure to discuss.

I thank family and friends, especially Maya Elisa Pérez Strohmeier and John P. Strohmeier, for their companionship, love, and support on our interwoven journey; my mother, María Elisa Pérez Tinajero, and my sister, Silvia Manetti; my brothers Jaime and Hugo and their families; Graciela Lechón and family; Berni Smyth; PJ DiPietro; and Brian Weiders. For their camaraderie and support throughout the years of preparation of this volume, I warmly thank the Latinx Research Center community, especially Angela Marino, Abraham Ramírez, Daniel Marquez, Lissett Bastidas, Ray Telles, Frida Torres, Jesus Barraza, Patricia Baquedano-Lopez, María Cecilia Titizano La Fuente, Angela Aguilar, Javier Lopez, Gabriela Padilla, Charles Briggs, and Clara Mantini-Briggs, and the faculty advisory board, especially Kris Gutiérrez, Cristina Mora, and Kurt Organista. I also thank my tirelessly dedicated and excellent colleagues in the Chicanx Latinx Studies Program: Jesus Barraza, Federico Castillo, Carmen Martínez Calderón, Pablo González, Ramón Grosfoguel, Lupe Gallegos, and Laura Jimenez-Olvera. To the colegxs who are also friends, who walk together supporting each other as we open ways in thinking about the decolonial, spirituality, art, and Chicanx and Latinx feminisms, I thank Irene Lara, Lara Medina, Karen Mary Davalos, Connie Cortez, Yreina D. Cervántez, Celia Herrera Rodríguez, Amalia Mesa-Bains, María Esther Fernández, Mariana Ortega, Guisela Latorre, Adriana Zavala, and my blessing of a coeditor, Ann Marie Leimer, for your work, your friendship, your integrity. I also thank Tomás Ybarra-Frausto, a teacher who generously opened caminos and modeled the walking of them in open-hearted, creative, and future-creating ways.

LAURA E. PÉREZ

I recognize my home institution, Midwestern State University (MSU Texas), for providing an initial Office of Sponsored Programs and Research Intramural Grant (OSPR) that enabled necessary research and travel and a second OSPR Intramural Grant that provided publication funds; MSU's Fain College of Fine Arts Dean Dr. Martin Camacho for support that brought this work to a national audience at several conferences; MSU student assistants Jaeda Flores, Selena Mae Mize, and Holly Anne Schuman for providing research assistance; Letetia Rodriguez, Director of Operations at MACLA for supplying important exhibition documents; and Dr. Fermin Herrera for assisting with the correct use of the Nahuatl language. The loving support, enthusiastic encouragement, and unending patience of Jesús Manuel Mena Garza deserves particular recognition. I recognize and thank Holly Barnet-Sanchez for being the art historian who first introduced me to the use of Mesoamerican imagery by contemporary Chicanx artists in a presentation on the work of Ester Hernández at MACLA in the late 1990s, which strengthened my resolve to pursue graduate studies. I thank my teachers and mentors Manuel Aguilar-Moreno, Jacqueline Barnitz, Richard R. Flores, Julia Guernsey, Nikolai Grube, Amelia Malagamba-Ansótegui, David Montejano, Brian M. Stross, David Stuart, and Louis A. Waldman, and my colleagues and treasured friends Karen Mary Davalos, Cristin Cash, Connie Cortez, Kori Kanayama, Lars Klein, Lillian Larsen, Josie Méndez-Negrete, Clara Román-Odio, and Nohemy Solórzano-Thompson. Most especially, I thank my coeditor, Laura E. Pérez, whose kindness, generosity, and brilliant presence in the world has made this mutual project a grand adventure.

ANN MARIE LEIMER

INTRODUCTION

I first became aware of Consuelo Jimenez Underwood through her altarlike installation *Alba* (1997) (figure 23), a strikingly poetic artwork that featured a wire-mesh cone that climbed thirty feet toward the ceiling of San Francisco's Mexican Museum. Its base was at the center of a six-foot crescent moon traced on the gallery floor with small white stones. Ears of corn and other objects lay in a small heap at that center. The piece seemed to render visible the correspondences activated in spiritual offerings, casting those connections in the language of the net, a weaving of threads and air, of the material and the immaterial—in short, of heaven and earth.

The title ("Dawn") captured the liminal through the crepuscular, when night and day are simultaneously present. Grounding the moon as the base of the piece lent it to further musings about the relationship of the moon to planetary life, to the Earth, to the human, and pointed to what is above and beyond the moon, in the cosmos. The verticality of the wire netting proffered a rendition of the proverbial spiritual ladder. This encounter still fills me with wonder, and I remember even now the feeling it evoked in me. I could see the artist's hand in the making and feel her own reverence before what she invoked and to which she paid homage.

This was more than twenty years ago, in 1997. Some time later I began corresponding with the artist. I visited her Cupertino, California, home and her studio in Gualala to interview her and enjoyed hours studying slides of her work, newspaper reviews, and a few curatorial exhibition catalogs. I wrote about some of her work of that period, including *Sacred Jump* (1994) (figure 14), *Virgen de los Caminos* (1994) (figure 15), and the *Land Grab Series* (1996) (figures 17–22), in a book on Chicana feminist art and spirituality.[1]

In the decade that followed, I came to know Consuelo, her family, and her work better as she began preparing for her 2009 retirement from teaching and as she started to develop, more or less simultaneously, several new series that she anticipated would occupy the coming decade, 2009–2019, as indeed it did. We continued to work closely.

In 2009, an exhibition I cocurated opened, for which she had created the installation *Undocumented Tortilla Happening* (figure 50). We traveled together to Albuquerque a few days before the opening of *Chicana Badgirls: Las hociconas*, where I was enlisted to help her hang the translucent "flying" *Undocumented Flower Tortilla* (2008) (figures 44 and 45) and where she installed the powerful *Undocumented Tortilla Basket* (2008) (figure 47) I'd seen in various stages of construction.

I recall seeing on many occasions the multiplying *Flag* series and the bloodred thread and metallic wire she would use in *Rebozos for Our Mothers* (2010–13), sharing space on looms and tables in the converted low turkey barn that served as her weekend home and studio (figure 64). The "flags" were numerous and ranged from impossibly intricate 1.5- to 3-inch textiles (*Guns and Stripes* [figure 42], *Double the Fun* [figure 58], and *I Pledge Allegiance I* and *II* [figure 62]), to the 72 × 99 inch *Home of the Brave* (2013), a mixed-media wall hanging safety-pinned to a larger traditional Guatemalan textile that peeks out beneath it like a growing girl's slip (figure 61). The series experimented with the design, symbolism, and color of the US and Mexican flags, boldly exploring their symbolism with flowers or guns, for example, in place of stars. Her energy, commitment, and creative spark were contagious and immense. She was on fire. Her laughter is a memory of that time because it is a core part of who she is—joyful, playful, but also ironic, satiric, bemused by the contradictions sometimes hidden in plain view of racist, classist, sexist privilege.

Consuelo's often poetic, experimental work, the product of an artist who "masters" weaving, is also the medium of some of the most serious work of our decade, from which she indefatigably lays bare the less pleasant landscape of our time and place. California's entrenched anti-Mexicanism, crafted across more than 150 years following the US-Mexico War of 1846–48—and beneath this the anti-Indigenous and anti–African American racism that rationalized Eurocentric colonial settler occupation of the indigenous Americas, warfare against Mexico and Spain and annexation of their territories, and slavery—are not off the hook in Consuelo's work, nor, most importantly, is their legacy today, found in the inhumane and dehumanizing racial profiling of, criminalization of, violence against, and ongoing social, economic, political, and cultural marginalization of people of color and our cultures.

Indeed, early on, metallic wire and barbed wire, signatures of her oeuvre, gird, sever, cross, tear, and hide within the folds of beautiful woven

pieces and other multimedia objects that irresistibly attract us, holding our hand while we stay to see that something serious is afoot, while through our hearts we enter a space of connection to the plight that Consuelo has made visible through her compassionate, urgent work.

We walk away from her work potentially in transformation, thinking about the suffering of others, wondering about our own responsibility and power, activating our common humanity to work against the extinction of kindred life-forms on this planet, in favor of the poor of color, homegrown and immigrant, in our country.

Against this era of historically disproportionate enrichment and pauperization, against the hardening of the heart that does not see homelessness, poverty, immigration due to war, and economic crisis as our problems, against the ethical and moral confusion of patriarchal bias, of Eurocentric racism, of classism, and of a human-centrism that has already destroyed a great deal of our planetary commons, Consuelo Jimenez Underwood grows her strangely beautiful hybrids. Crossing painting, silkscreen, installation, and murals with spinning, weaving, sewing, and embroidery, she creates things that seem impossible, like a tree that envelops the barbed wire that once fenced it and flowers that push their way up through pavement.

Consuelo's *Consumer Flag* (2010), woven from recycled plastic bags, hung in a gallery-wide installation, from which rained streamers made of that and other waste, when she first exhibited it at the Gualala Arts Center (figure 51). Indeed, some of that "waste"—including precious metallic gold thread—are materials left over from previous moments of industrial production, like weaving itself, which is an ancient yet ostensibly outdated "craft" that the artist reuses, that is, uses again in our era.

It might be said that Consuelo's work has become even more capacious in her most recent series of "wall installations," *Borderlines*. In these ephemeral offerings, mapping the United States and Mexico, or the world, the artist crisscrosses them, as Amalia Mesa-Bains phrases a core technique in the artist's work, with local histories and local places, in some cases incorporating local communities to cocreate with her.[2]

In 2013, María Esther Fernández curated a one-woman exhibition of Consuelo's work at the Triton Museum in Santa Clara, California. It was something of a retrospective in that it brought together older work with pieces from her newer series. At that exhibition, *Consuelo Jimenez Underwood: Welcome to Flower-Landia*, I saw two of Consuelo's newest works completed: *Welcome to Border-landia!*, a 17 × 25 foot "wall

installation" that was 6 inches deep with spikes, wires, prayer wands, and enormous cloth flowers "appliqued" to the painted wall (figure 68); and the even more immense and impactful white *Flowers, Borders, and Threads, Oh My!*, dissected by a dark red borderline across a 45-foot-long and 17-foot-wide three-dimensional "border installation" of the planet (figure 59). Fernández's and my essays from that exhibition catalog are included in this anthology.

After years of talking about how good it would be to write extensively about Consuelo's artwork and publish images of it in book form, it finally happened after that exhibition. In late 2014 I sent invitations to various people, some of whom Consuelo had named (she had worked with them over the years and felt they understood her work), some of whom were scholars I had heard or read who have written about her work or other artists; we eventually also included a poet, whose wonderful poem joins the assembly gathered here. Others wanted to coedit or write but their prior commitments did not permit this.

Ann Marie Leimer, who had been missing all along, joined me as coeditor midway through our project. She brought her artisan's precision, unerring judgment, and beautiful calm spirit to the labor of editing the content and form of the contributions, making two rounds of editing an enjoyable if sometimes arduous, painstaking task. Finally, Luis Valdez, the distinguished playwright and Chicano theater pioneer who, like Consuelo, knew what it was to labor in agricultural fields as a child, agreed to make room, between the opening of his new play and playwriting, to preface this collection in honor of Consuelo Jimenez Underwood.

The beauty of an anthology is that it shows that it does take a village. The sixteen authors assembled here bring to our understanding the broad arc of Consuelo Jimenez Underwood's life's work thus far. To study her work, as these writers do, allowing us to accompany them, is to journey with her, to see her interests and commitments broaden or deepen—through her themes, images, and techniques—to shed light on the lowly, the humble, the most victimized of racist colonialism: the Indigenous, Indigenous peoples, and the natural world indigenous to the American continent, north and south, and to the planet as a whole. It is to see her recuperate the safety pin and fabric scraps in this same homage to the humble and to the humus, the earth, our Mother.

In the end, Consuelo's allegiance is not to a nation, or even to a people, but to our environmentally imperiled planet. The Indigenous

philosophies or worldviews that she draws on—those of her own family: of Huichol, of her husband's ancestral Yaqui that through marriage is also her own, of the Mesoamerican core of common Indigenous beliefs reflected in Maya and Nahua spiritual and philosophical beliefs—become as religions and philosophies hope to be, useful perspectives from which to heal the human-made social infirmities that allow sexism, racism, classism, and the like. These Indigenous philosophies decenter an irresponsible, narrow human awareness into a more responsible, modest, accurate understanding of ourselves as a mere, if crucial, part of an interdependent planet. Her oeuvre as a whole suggests we matter, but not more, nor less, than other life-forms. Our authors here help us to follow her in this pilgrimage toward the wisdom that characterizes her art, her love of thread and weaving, her vision.

LAURA E. PÉREZ

———

I first learned about the art of Consuelo Jimenez Underwood in May 2010 when I received an announcement for the group exhibition *Xicana: Spiritual Reflections/Reflexiones Espirituales*, which was advertised as the initial show in an exhibition series titled *Bay Area Chicana* sponsored by the Castellano Family Foundation. I had lived in the Bay Area for fifteen years before attending graduate school in Texas, and I welcomed any opportunity to return "home," especially because my interest in Chicanx art had been fostered at San Francisco's Galería de la Raza and the Mission Cultural Center for Latino Arts and San Jose's Movimiento de Arte y Cultura Latino Americana (MACLA), and through frequent exposure to the plethora of murals throughout San Francisco's Mission District. Because my research interests often focused on the intersection of Chicana art and spirituality, I resolved to see the show as soon as the semester concluded. One day in early June, I boarded a plane to San Jose, took a cab from the airport to the Triton Museum in Santa Clara, interviewed the show's curator, María Esther Fernández, extensively photo-documented the artworks for the rest of the day, and flew back to Southern California that evening. The extraordinary work I encountered that day, specifically *Undocumented Border Flowers* (2010) (figure 53), has inspired many research presentations; the chapter "Cruel Beauty, Precarious Breath: Visualizing the US-Mexico Border,"

first published in *New Frontiers in Latin American Borderlands* (2012) and subsequently reprinted in *Border Crossings: A Bedford Spotlight Reader* (2016); and the essay "*Vidrio y hilo*: Two Stories of the Border," recently published in the online *Journal of Latino/Latin American Studies*.

When I entered the central exhibition room at the Triton, I encountered *Undocumented Border Flowers*, which consumed an entire wall of the museum and composed the second work in Jimenez Underwood's ongoing *Borderlines* series. I was immediately struck by the combination of installation, mural, sculpture, and painted and sewn textiles, and felt a sense of commemoration and incantatory petition similar to a home altar. Having studied and exhibited sculpture in the Bay Area before graduate school, I was completely taken with the three-dimensional qualities of her installation, the found and fabricated objects that composed the "power wands" or place markers that indicated twin border cities such as Calexico, California, and Mexicali, Baja California; the ten gorgeous larger-than-life-size flowers representing specific border states; and the tiny, three-dimensional votive image of the Virgen de Guadalupe that Jimenez Underwood inserted amidst red barbed wire pierced by gold and silver nails that marked the El Paso–Ciudad Juárez border. I had once laboriously woven various colors of ribbon into the diagonal openings of a punishing and inflexible wire mesh to fashion a garment honoring an individual. But this! This was weaving, sewing, and paying tribute to all sentient beings on a grand and unimaginable scale!

Two woven wall-hangings, MA'ALA (2010) and *American Buy* (2010), were installed immediately to the left of *Undocumented Border Flowers*. Although I had some familiarity with fabric and fiber, I had never seen anything like this. The sheer physical beauty of MA'ALA, now *Rebozos for Our Mothers: Mother Mundane*, with its shiny, bloodred metallic thread and woven wire, its sole section of flower-printed fabric strips intertwined at the very top, and its areas of openwork that revealed the vertical (warp) threads, stuns to this day. *American Buy* (now called *Consumer Flag*) visually referenced the US flag, and a reading of its materials made an immediate and pointed critique of rampant American consumerism and our often complete disregard of the environmental impact of today's throwaway culture (figures 51, 52). Jimenez Underwood wove shopping bags from Target, tortilla packaging from Trader Joe's, and delivery bags that encased the *New York Times*, along with fiber, woven copper wire, and other threads into a singular statement that

indicts our negligent behavior, which propels continual climate change and progressive, perhaps irreversible, environmental degradation.

I became a coeditor of this anthology in March 2017, at the invitation of Laura E. Pérez. The following spring I traveled to the Bay Area, where I first met Jimenez Underwood and experienced the artist at work on her loom, weaving what would later become *4U+Me* (2018), one of a trio of works celebrating Woody Guthrie titled *Woody, My Dad and Me* (2018) (figure 80), which she would initially exhibit at 108 Contemporary in Tulsa, Oklahoma, as part of the exhibition *Consuelo Jimenez Underwood: Thread Songs from the Borderlands*. During that visit she showed me a range of works—from the earliest surviving examples of her embroidery on her family's clothing, to her first intentionally wearable rebozo, which measures more than eight feet long and graces the wall above her living room window, to her first delicate tapestries (graduate school assignments) with their infinitesimal warp and weft threads and which contained select sections in which the artist used silver metallic thread to produce distinct patterns, a harbinger of greater things to come.

Father, Son and the Holy Rebozo (2017) (figure 74) and *Ingles Only* (2001) (figure 28) both resided on nearby living room walls. The father-and-son reference in the title indicates the Holy Trinity of Father, Son, and Holy Spirit in the Catholic tradition, in which divinity is conceived as male. Jimenez Underwood's wicked sense of humor fuels her iconographic synthesis of these figures into specific hats worn by men. She represents the "Father" with a cowboy hat, its exterior shape formed by a repeated chain stitch overlaid upon a woven ground that contains an additional raised depiction of the border intertwined with barbed wire. The artist follows the Christian hierarchy by placing the cowboy hat in the upper register and a baseball cap, its form again outlined with a chain stitch and placed on top of a raised woven border, in the middle register to stand for the "Son." The Holy Spirit, because "He" is ghostly, appears without form in the lower register, indicated with a section of open work weaving using shiny metallic and thicker cotton thread in various muted greens, blues, and lavenders. The artist interrogates and questions the construction of masculinity, the association of maleness with divinity, and the erasure of women and femaleness from positions of power and authority in the imagination of organized religions. *Ingles Only* rebukes attempts to declare English as the "official" language of the state of California, a position that became law in 1986 with the passage of Proposition 63 but was eventually overturned in 2016. Jimenez

Underwood uses a brown canvas field, perhaps to suggest both earth and skin, to support a maplike representation of California. Gold metallic threads pierce the canvas in evenly measured running stitches, producing a delicate, shiny grid over the entire work that reminds us of imposed boundaries, land taken from rightful owners and later divided, and the impacts of colonialism. The artist used white paint to depict multiple images of animals such as salmon, ravens, and otters, and signifiers such as a bow and arrows, baskets, and feathers; these, taken as a whole, constitute the state's shape. At the top of the work, two rows of words embroidered in white thread, "UtoAztecan, Athabascan, Penutian," and "Yukian, Hokan, Algonkin, Lutuamian," indicate Native language families literally and figuratively imprisoned by three rows of white painted barbed wire that perforate the cotton fabric, lay over and in front of the text, and hold the languages hostage. In a final reference to the Indigenous peoples of California, the artist surrounds the work on three sides with regularly placed strings of beads and shells that serve as fringe.

After this initial immersion in Jimenez Underwood's work at her home studio, I experienced her solo show *Consuelo Jimenez Underwood: Thread Songs from the Borderlands*, which displayed several new works, some of which were produced with this exhibition in mind. At Tulsa, she worked with women from the local community to create *American Border Charge: Power Wands and a Basket* (2018), one of the most recent site-specific iterations of her *Borderlines* series (figure 79). She incorporated many new elements: green and orange deer tracks, pink raccoon tracks, blue tracks that resemble those of a fox or a wolf, large-scale painted sunflowers, several specific pathways across the border whose outlines suggest rivers, and the insertion of an existing barbed wire basket, which took her a year to make, in the center of the work.

Jimenez Underwood never fails to surprise the viewer. I was particularly taken with *Home of the Brave* because of the sheer complexity of its making, as the artist used a finely woven piece of fabric as a backing for the entire work (figure 61). The backing, with its small-scale and intricate designs, is visible only along the bottom of the piece and then overlaid with three distinct sections that appear to be woven separately and then joined together. The open work at the bottom of the three sections are sequentially red, white, and blue and are porous enough for the viewer to see the backing underneath. Above the open work, each section quickly becomes woven with fibers of various thickness, while

a hoop made of barbed wire rests in the white center panel complete with three fabric scraps printed with the caution sign. A depiction of the border crosses the entirety of the piece, while gold and silver safety pins populate the work along with small paper or fabric flowers.

The way Jimenez Underwood uses fiber is revelatory—thread becomes not just a tool for suturing together disparate parts, but one for drawing in space and time. It becomes line, becomes texture, becomes energy pulsating with life. In her hands, thread has a life of its own! It critiques and cajoles; it provokes and prognosticates; it rages and repairs. In the artist's statement that accompanied the *Xicana: Spiritual Reflections/Reflexiones Espirituales* exhibition, Jimenez Underwood expressed a hope that her work would "induce" her audience to recognize "the threads that bind us." My coeditor, our authors, and I have woven together an anthology that demonstrates the profound contribution that the work of Consuelo Jimenez Underwood makes to the histories of art and to our world. Let us, like the artist, initiate the process of healing and transformation our planet so dearly needs and "begin with the thread(s)" that connect us steadfastly and irrefutably to each other.

ANN MARIE LEIMER

––––––––

The authors in this anthology demonstrate the multiple contributions that the work of Consuelo Jimenez Underwood makes to various fields of study, such as art history, cultural studies, ethnic studies, gender studies, history, religious studies, visual cultural studies, and women of color feminisms. Deploying analyses rooted in feminist "intersectional" or "simultaneity of oppressions" approaches examining the complex imbrications of racialization, gender, class, and histories of imperialism,[3] the anthology's contributors are attentive to the specificity of the artist's historical and cultural moment, the conditions of Jimenez Underwood's childhood, and her career through the present. They are mindful of what it meant for the artist to be raised on the border as the child of a Mexican American mother and an undocumented immigrant Mexican Huichol father, of her family's labor and her own childhood labor in the agricultural fields of California, and of her tremendous compassion for those who are cruelly targeted today by anti-immigrant sentiment and her concern for the environmental fate of our planet.

From this engagement with her and our time and place, Consuelo Jimenez Underwood makes a particularly unique and socially urgent contribution to the histories of art and visual culture. Many artists have produced bodies of work that elicit a sense of awe because of their technical mastery, intrigue us with their conceptual depth and breadth, move us deeply with the sheer power of their aesthetic beauty, and prompt us to action by giving us a deeper understanding of the toxic effects of dominant power structures through the construction of compelling and incisive social critiques. Rarely, however, do we encounter work that accomplishes all these tasks while also exploding the established boundaries of art media and blurring disciplinary boundaries of visual art forms such as installation, performance, sculpture, fiber, murals, public art, and community engaged, socially conscious art. In many ways, Consuelo Jimenez Underwood defies strict art historical classification precisely because she repeatedly uses a complex confluence of media and multiple art forms in her work.

Many Chicanx and US Latinx artists have explored the human cost of the US-Mexico border, whereas the effects on the animal and plant life at these constructed borders, which Jimenez Underwood consistently portrays in her work, have received less attention. Rupert García's stark ¡Cesen Deportación! (1973), Malaquias Montoya's gripping Undocumented (1981), and Jacalyn López-García's longing-filled California Dreaming (1997) form a trio of serigraphic representations of border issues from three separate decades; all of these two-dimensional works use barbed wire, one of Jimenez Underwood's signature elements, as a central compositional device.[4] Considering three-dimensional depictions, installations, and performances that present various views on the border, Richard A. Lou's ironic and searing The Border Door (1988) gives a playful, sardonic, conceptual spin on passage through a literal door between borders,[5] whereas Delilah Montoya photographically captures the impact migrant and asylum seekers have on the terrain they travel through in her Sed: Trail of Thirst (2004) installation and video, along with the more recent iterations of her installation Detention Nation (2014–), in Houston, Lubbock, and Albuquerque, where she uses the photographic printing process of cyanotype to create a sense of ghostliness that illustrates the invisibility of disappeared women and others at the border and reveals the conditions and stories of those held inside detention centers. In 1990 the multinational women's collective Las Comadres produced a series of installations featuring room inte-

riors for a show at San Diego's Centro Cultural de la Raza titled "La Vecindad/*The Neighborhood*," and they staged a performance of *Border Boda* (*Border Wedding*) as part of the exhibition. The artists furnished one of these rooms, *La Sala de Lectura* (the Reading Room), with a book-covered reading table, stools, reading lamps, and the Virgen de Guadalupe's mandorla painted on the corner where two walls met. The collective repeatedly painted the caution sign, so frequently used by Jimenez Underwood, on both walls in Spanish and English, but with one notable difference—the fleeing family under the English text *Caution* is whole and alive, whereas the three-member family under the Spanish text *Cuidado* have now become *calacas*, skeletons.[6]

Within the histories of Chicanx art, Jimenez Underwood's art production shares perhaps the closest connection to the work of Margarita Cabrera in terms of media, process, politics, and use of the sculptural form and the treatment of fiber and thread. The ongoing *Borderline* series Jimenez Underwood initiated in 2009 consists of site-specific installations that merge aspects of murals and sculpture, raise questions regarding the political and environmental impact of the US-Mexico border, and have increasingly involved community members in their production. Similarly, Cabrera produces sculptural objects in concert with immigrant communities using embroidery, various sewing processes, and traditional Mexican craft forms and practices, such as those of the Otomí people.[7] In an ongoing project titled *Space in Between*, or *Espacio entre dos culturas*, in 2010 members of Houston's immigrant community participated in a sewing and embroidery workshop led by Cabrera, in which they produced three-dimensional representations of various desert plants such as *yucca* and *nopal*, plants encountered while migrating from Mexico to the United States. The workshop participants used thread, copper wire, and pieces of border patrol uniforms to fashion these plants; embroidered personal narratives of their migration stories on nopal paddles and other plant structures; and placed them inside Mexican ceramic vessels. The artist has taken the project to other communities in the United States, such as Fresno, California, and Charlotte, North Carolina, where in 2012 the immigrant community produced "soft sculptures" with "site-specific" narratives illustrating that community's stories of border crossings.[8]

Within the framework of twentieth-century artwork by US women of color, Faith Ringgold, whose hanging Buddhist tanka-inspired *Feminist* series (1972), *The French Collection Part I* (1991), with a pieced fabric

border, and the *Flag Story Quilt* (1985) show similar engagement with materials and media feminized in Western cultures, such as fabric, thread, quilting, and embroidery. Ringgold's US flag–based work, such as *People's Flag Show* (1971), also forms part of a similarly motivated critique of the lack of democracy for people of color.[9] Emma Amos's use of African fabric borders on her paintings from the early 1990s, such as *Tightrope* (1994) and *Worksuit* (1994), like Jimenez Underwood's work, interrogate the divide between Western "fine art" history and "third" world "craft"; like Yreina D. Cervántez in pieces such as the *Nepantla* triptych (1995), they also map the difficulties of painting as a feminist woman of color trained within patriarchal Eurocentric art history, and enact visual strategies to expand these into more universal, or "pluriversal," practices.[10] Nora Naranjo-Morse, an artist from the Santa Clara Pueblo who created the installation *A Pueblo Woman's Clothesline* (1994), and Jolene Rickard, an artist from the Tuscarora Turtle Clan who conceived the installation *Cracked Shell* (1994), both hybridize non-Western Indigenous and Western aesthetics to highlight the toxic effects of imperialism and settler colonialism on the environment. In *Cracked Shell*, "a warning and an honoring," Rickard "locates the scars on the land that ooze toxins" from the chemical industrial waste of the 1940s into the Niagara Falls and River (New York) that affected the territories of the Tuscarora Nation.[11]

Miriam Schapiro's extensive and pioneering work with acrylic and fabric on canvas, which began during the early 1970s and continued throughout the 1980s (e.g., *Lady Gengi's Maze* [1972] and the *Collaboration*, the *Vesture*, the *Kimono*, and the *Fan* series), also allows for meaningful comparison of feminist critiques of patriarchal art historical genre boundaries through use of fabric and paint that Jimenez Underwood, like Schapiro, also employs, particularly when, in Schapiro's work, the fabric obliterates the stretched canvas.[12] Jimenez Underwood, however, does not work with prefabricated or stretched canvas as Schapiro does, but rather recalls—and, we might argue, displaces—canvas-like effects through printing or painting on her own very fine weavings or through incorporating four-sided wooden-framed looms (e.g., the *Land Grabs* series). With weaving as one of the techniques she masters as a multimedia artist, Jimenez Underwood might be said to take Schapiro one step further: creating the kinds of "printed fabrics" that Schapiro incorporates into the "femmage" of her feminist paintings. Indeed, Jimenez Underwood's extensive use of weaving allows us to begin to grasp how

conscious image- or mark-making, and thereby meaning-making, are at work in traditional, non-Western weaving, as they are in medieval tapestries and modern painting, whether abstract or figurative.

This anthology is organized into three sections. As in weaving, we first had to select the thread in a creative but preparatory production stage. In our anthology, a small group of essays serves an analogous function in part I, "Spinning—Making Thread." A preface by renowned Chicano writer and filmmaker Luis Valdez opens the section; it is followed by essays by Carol Sauvion and Christine Laffer. In part II, "Weaving—Hand Work," essays developed for exhibition catalogs and for art historical and interdisciplinary visual cultural studies scholarship look closely at Jimenez Underwood's work. The bulk of the anthology's essays are here, written by Constance Cortez, Amalia Mesa-Bains, Laura E. Pérez, María Esther Fernández, Emily Zaiden, Clara Román-Odio, Ann Marie Leimer, Karen Mary Davalos, Cristina Serna, Carmen Febles, and Jenell Navarro. Part III, "Off the Loom—Into the World," examines Jimenez Underwood's effects as a teacher in her own and others' classrooms and through her public lectures. It includes essays by Robert Milnes and Marcos Pizarro, and a poem by prize-winning poet Verónica Reyes, which closes the anthology.

Our anthology begins with filmmaker and Craft in America Executive Director Carol Sauvion's reflections on the making of her documentary titled "Threads" for the first episode in the fourth season of *Craft in America*, a prize-winning PBS television series. Chapter 1, "The Hands of Consuelo Jimenez Underwood: A Filmmaker's Reflections," provides a personal and charming filmic narrative that recounts meeting the artist during an initial exploratory visit to her Gualala, California, home and studio and subsequently deciding to include her in the now-aired and online documentary series.

In chapter 2, "Charged Objects: The Multivalent Fiber Art of Consuelo Jimenez Underwood," textile artist and teacher Christine Laffer—also a former student of the artist—gives a history of textiles as craft and art and explores the contexts that shaped the development of fiber as a media for art within the histories of art and within academic environments. Situating the artist within the lineage of Arts and Crafts,

Bauhaus modernist industrial and fabric design, and feminist art of the 1960s and '70s, the author traces the contributions and enduring legacies of several figures in the field, such as post–World War II émigré Anni Albers, teacher of Jimenez Underwood's mentor, Joan Austin. Laffer observes that the material qualities and affective associations of the thread and materials the artist works with are central to her pieces.

In chapter 3, "History/Whose-Story? Postcoloniality and Contemporary Chicana Art," we reprint Chicana art historian Constance Cortez's important 2007 essay on the artist, which was first published in the journal *Chicana/Latina Studies*. Cortez examines the postcolonial critical framework developed in literary and cultural studies from the perspective of the Mexican American experience of territorial and cultural imperialism (from which Jimenez Underwood's work largely departs) alongside the Indigenous (Huichol, Yaqui, and Mesoamerican Nahua and Maya). She introduces the use of theories especially relevant to Chicana art, such as the "borderlands" and "la conciencia de la mestiza" theory of queer Chicana writer Gloria E. Anzaldúa, Chela Sandoval's "oppositional consciousness," and Emma Pérez's "decolonial imaginary" and "third space feminism," to approach the artist's work. Cortez thereby invokes an early lineage of decolonial thought among US women of color. Land and social memory thus figure in historically resonant and culturally specific ways. Cortez analyzes what she terms "unseen dangers" present in *Virgen de la Frontera* (1991) that articulate an anxiety-filled "psychological landscape" (figure 9). She also reads the use of a single stamped or silk-screened image of the Virgin of Guadalupe as a "talisman," a figure of protection for the solitary migrant that moves through the textile's landscape, setting the stage for later scholars to consider the significance and multivalent meanings performed by Virgin imagery in Jimenez Underwood's work. A comparative analysis of the work of Jimenez Underwood alongside that of Chicana artists Celia Herrera Rodríguez and Delilah Montoya rounds out the essay, illuminating the work of all three.

In chapter 4, "A Tear in the Curtain: Hilos y Cultura in the Art of Consuelo Jimenez Underwood," we reprint an important essay by artist, curator, and Chicana art theorist Amalia Mesa-Bains, which was originally written for the artist's one-woman show at MACLA in San Jose, California, in 2006. In this essay, Mesa-Bains introduces the reader to a then-new series produced by Jimenez Underwood, *Tortillas, Chiles and Other Border Things* (2006), in which the artist uses ancient food from

the Américas, the tools that make them, and the implements that serve them as "metaphors" for larger social and political issues that directly address the impact of the "destructive Tortilla Wall," described at that time as "the new 20-mile border pieced from the remains of the Gulf War steel" (figure 40). The author reflects on the movement begun by historic Chicana Movement feminist artists like Ester Hernández and Santa Barraza, who emerged in the late 1960s and '70s to reclaim and integrate "the Chicana Indigenous voice," and invokes the concept of memory, arguing "This redemptive memory heals the wounds of the past . . . [and] can be seen as a political strategy that reclaims history and prepares us for the current battles." Mesa-Bains writes that Jimenez Underwood blends the ancient and the contemporary through "the spirit of her hilo," and that "by using the ancient forms of weaving and placing her vision on the border, . . . her artistic terrain is marked by the sign of Mother Nature as a metaphor of gender, identity, and memory." The author concludes by observing that Jimenez Underwood's work maps the "spiritual geography . . . of ceremonies, the abundance of agriculture and feasting, and the place of everyday life."

In chapter 5, "Prayers for the Planet: Reweaving the Natural and the Social—Consuelo Jimenez Underwood's *Welcome to Flower-Landia*," anthology coeditor and visual cultural studies scholar Laura E. Pérez provides a broad overview of the artist's work through the 2013 exhibition *Welcome to Flower-Landia*, for which the essay was written, in order to contextualize that retrospective. Pérez pays particular attention to early installations such as *Alba* (figure 23) and *Diaspora* (figure 30), and to details about the earliest, the smallest, and the most recent works in the *Flag* series, including the two created for the exhibition, *Home of the Brave* (figure 61) and *One Nation Underground* (figure 63). She also examines the initial "Five Mothers" *Rebozos* series (figure 64), also created for that exhibition, and the pieces from the then-new *Borderlines* series: *Flowers, Borders, and Threads, Oh My!* (figure 59) and *Welcome to Border-landia!* (figure 68). Continuing the analysis of "decolonizing, culturally hybrid spiritualities and aesthetics" that she introduced in *Chicana Art: The Politics of Spiritual and Aesthetic Altarities*,[13] Pérez observes the growing shift in the focus of the artist's work—from the US-Mexico geopolitical border to the globe, and from humans to other creatures in a continuously evolving thread of environmental consciousness of interdependence of all life-forms. In this essay, originally commissioned for the on-demand catalog of the *Welcome to Flower-Landia* exhibition,

Pérez suggests the artist's practice of art increasingly functions as an intentional act of prayer, wherein prayer is understood as effective performance of directed will.

In chapter 6, María Esther Fernández revises an essay developed for the exhibition *Consuelo Jimenez Underwood: Welcome to Flower-Landia*, a solo show she curated at the Triton Museum in Santa Clara, California, in reaction to the overwhelming public response to the 2010 work *Undocumented Border Flowers* (figure 53), which was exhibited as part of *Xicana: Spiritual Reflections/Reflexiones Espirituales*. Fernández explains that her curatorial strategy was based on numerous interviews that allowed her to identify as key to the artist and her work the borderlands experience, which rendered the artist "neither from Mexico nor the United States" and that marked her with the experience of the Calexico-Mexicali border as "both fantastic and horrifying." The exhibition aimed to "re-create that journey, to relieve the tension of a highly volatile border region as embodied by a young girl, and to re-imagine it [the border] as a place where the spirit can roam free." Conceived in two parts, that exhibition included works "depicting varying aspects of Jimenez Underwood's journey, paralleling her fear, joy, survival, and transcendence."

In chapter 7, Emily Zaiden, the director and curator of the Craft in America Center, revises the 2017 essay "Between the Lines: Documenting Consuelo Jimenez Underwood's Fiber Pathways" that she developed as part of the exhibition *Mano-Made: New Expression in Craft by Latino Artists—Consuelo Jimenez Underwood*. This exhibition debuted as part of the four-month-long series "Pacific Standard Time: LA/LA," a collaborative initiative dedicated to Latino and Latin American art in Southern California. Zaiden writes that "lines are the root of [Jimenez Underwood's] creative practice—physically, representationally, conceptually, and metaphorically," from the accumulation of threads on the loom, to sewing, painting, and the marks left by the removal of painter's tape in her *Borderline* series. This use of lines extends to her concern with lineage and is rooted in her "concern with the borderlines that exist between cultures and places, past and present, the spiritual and the mundane." Zaiden's essay finely explores the importance of the "line" in Jimenez Underwood's work, from thread, warp, and weft to borderline, timelines of her life, the hand-drawn line, and the *Borderlines* series (2009–) and subsequent work. Zaiden introduces discussion of the artist's early *Heroes, Burial Shrouds* series (1989–1994) (figures 4–8 and 12)

and some of her most recent work: *Quatlique-landia* (2017) (figure 77); *Mother Rain Rebozo* (2017) (figure 76), which Navarro further analyzes in chapter 13; and *Father, Son and the Holy Rebozo* (2017) (figure 74). Her discussion of the 2014 *Undocumented Tortilla Happening* installation introduces important contextual information about the reality of deportation that the artist's family experienced and that shaped such pieces, particularly the barbed wire *Undocumented Tortilla Basket* (2009) (figure 47). Important details regarding flowers and border/prayer wands in the *Borderlines* series are also introduced. As do the authors of many of the other essays, Zaiden captures important insights from the artist herself in quotations from her own interviews and other sources.

In chapter 8, "Flags, the Sacred, and a Different America in Consuelo Jimenez Underwood's Fiber Art," literary and cultural studies scholar Clara Román-Odio introduces the *Flag* series, and the central idea of a politicized "sacred" that centers the artist's work, in the context of resistance to the imperialist and neocolonial conditions many Mexican Americans/Chicanas such as the artist experience and about which Jimenez Underwood creates much of her work. Román-Odio carefully introduces readers to Chela Sandoval's relevant Chicana/US women of color feminist and queer thought and, like Cortez and Mesa-Bains, centers the importance of Mexican American experiences of geographical and cultural displacement, and their resistance to racism and other forms of oppression. She argues for the "sacred as a method of transformation" of dominant cultural politics and policies. The global, the transnational, and the transcultural are invoked as the result of European and US histories of imperialism. The resulting "asymmetries of power" are shown to contextualize the artist's "appropriation" of maps and flags. Cross-cultural identity, the Anzalduán concept of "nepantla," consumerism, the in/visibility of undocumented labor and extreme deprivation, the ghostly, "border thinking" (Mignolo), and "spiritual mestizaje" (Delgadillo) are some of the rich concepts developed here and serve to anticipate further treatment in the essays that follow.[14]

In chapter 9, "Garments for the Goddess of the Américas: The *American Dress* Triptych," coeditor of the anthology and art historian Ann Marie Leimer builds from the notion of "topographies" (described by Cortez in chapter 3 and further focused on by Karen Mary Davalos in chapter 10) and "the lens of the spiritual" to analyze the construction of each triptych piece. Leimer carefully examines the hand-sewn grids on fabric, button embellishments, embroidery, and quilting in the three

wall hangings of *American Dress*. *Virgen de Chocoatl* (1999) (figure 26), *Virgen de Tepin (Chili)* (1999) (figure 27), and *Undocumented Nopal. 2525 AD* (2019) (figure 81). Referencing codices and Mesoamerican art scholarship, Leimer provides an in-depth art historical account of the significance of the Coatlicue goddess figure that appears in so many of Jimenez Underwood's works. This discussion serves well other essays (such as chapter 12 by Carmen Febles) that discuss Virgin of Guadalupe and Coatlicue imagery while introducing the idea that the presence of such figures in the artist's work serve as "observant and compassionate witnesses" to the "'horrible' subjects—border violence, the effects of colonization, environmental deterioration, racism" she addresses "but that she must treat . . . in a beautiful manner." Leimer also discusses clothing as ritual garment and analyzes the nature of the fragment in the triptych and the precolonial sacred significance of the foods referred to in the titles, chilis, chocolate, and cactus paddles.

Anthropologist and visual cultural studies scholar Karen Mary Davalos studies Jimenez Underwood's cartography as the product of a "decolonial imaginary," following historian Emma Pérez's formulation of the concept, in chapter 10, "Space, Place, and Belonging in *Borderlines*: Countermapping in the Art of Consuelo Jimenez Underwood." In the artist's mapping work of the *Borderlines* series in particular, Davalos identifies a "counter-hegemonic visualization of space," challenging the history of mapmaking and its role "in engendering, producing, and securing colonial domination." In her alternative mapmaking, Jimenez Underwood creates "earthly contours, national and state boundaries," waterscapes, and humanmade as well as natural borders that convey different meaning and visualizes Indigenous resistance and struggle, "sublime beauty and grace," inclusive history, and a sense of belonging that does not depend upon the geopolitical uses and abuses of space. Davalos also examines the decolonial imagery at work in the installation *Diaspora* (figure 30) and the series *Land Grabs: 500 Years* (1996) (figure 17).

In chapter 11, visual cultural studies scholar Cristina Serna engages a comparative and transnational analysis of Jimenez Underwood's work and that of Mexican fiber and multimedia artist Georgina Santos. "Decolonizing Aesthetics in Mexican and Xicana Fiber Art: The Art of Consuelo Jimenez Underwood and Georgina Santos" approaches the artists' work through the concept of "decolonial aesthetics,"[15] demonstrating the ways in which the gendered, racialized, and class politics of

textile work function, from the vantage point of Indigenous weavers, as texts of resistance, as "decolonial acts of knowledge" that record and preserve ancestral knowledge. The chapter provides a broad yet well-documented discussion of textile art and analyses of early Jimenez Underwood *rebozos*, *Rebozos de la Frontera: Dia/Noche* (2001) (figure 29), and of the installation *Diaspora* (figure 30).

Chapter 12, "Reading Our Mothers: Decolonization and Cultural Identity in Consuelo Jimenez Underwood's *Rebozos for Our Mothers*," written by Carmen Febles, is the author's first foray into visual art. Febles begins by reflecting on the learning process involved in writing about Jimenez Underwood's work and the move from wanting to apply various theories to it, to instead learning from the artist's own and in general Febles's growing self-awareness of having been trained in a Western humanistic tradition that cannot by itself assist in understanding the artist's project. As such, the essay gathers numerous illuminating quotes by the artist. Febles is particularly concerned with the artist's "ecological sensibility" and how this arises from "a decolonial Indigenous cosmovision."[16] The nonbinary worldview, the recuperation of the "feminine," the conscious deployment of "the humble," the practice of "infiltration" into museums, the decolonial function of Virgen de Guadalupe imagery, why the artist ended the *Heroes, Burial Shroud* series (figures 4–8, 12), and in particular, the ongoing *Rebozos for Our Mothers* series (figure 64)—all of these Febles examines in this essay. Observing that tribute is a staple in the artist's work, Febles ends her essay with an examination of the triptych *Woody, My Dad and Me* (2018), three woven rebozo hangings in homage to Woody Guthrie, her deceased father, and, interestingly, to herself (figure 80).

In chapter 13, "Weaving Water: Toward an Indigenous Method of Self- and Community Care," Native American cultural studies scholar Jenell Navarro deepens discussion of the long history of the rebozo, in its various names across the American continent before colonial invasion and its multiple uses, complementing the discussions by Serna and Febles. She also takes a decolonial framework, bridging northern- and southern-focused "Native American" studies. Centering her work on the meaning of water as a living and life-giving "relative" on a planet in ecological crisis, Navarro focuses on two rebozos: *Rebozos for Our Mothers: Mother Ocean (Water)* (2011) and *Mother Rain Rebozo* (2017) (figures 55 and 76). In the chapter, Navarro also studies the water-centered artworks of Chicana Indigenous artist Yreina D. Cervántez and Métis

artist Christi Belcourt as part of hemispheric "Indigenous epistemologies" and "storytelling," which are "operationalized" against settler colonial erasure and repression of traditional Indigenous ways of knowing across the Americas. Navarro takes seriously the idea of the living nature of the materials the artists use and the theme of water, which all three artists honor as the source of life, a "mother" to the planet. Within this context, the rebozo's traditional protective and ritual functions, among others, are particularly relevant in choice of media, given the contamination of water throughout the planet. Navarro elaborates on the Indigenous aesthetics of all three artists, centered in "spirit first" methodology and art-making purpose; in Jimenez Underwood's work, it derives from the Chicana artist's Huichol lineage through her paternal grandmother and the Yaqui through marriage. Navarro reads the work of all three artists as advancing art forms that "honor Indigenous ancestors and our living elders," that view water as one of our relations, and that embody "Indigenous epistemologies that are vast, complex, sacred and—most importantly—dangerous to settler colonial logics of domination in the Americas."

Chapter 14, "Consuelo Jimenez Underwood: Artist, Educator, and Advocate," provides a personal account of meeting the artist and observing her development as a teacher and an artist from Robert Milnes, the artist's colleague and former chair of their department at San José State University; he traces her impact on various students who are now practicing artists or art teachers. An educator and longtime personal friend and colleague of Jimenez Underwood, and also an artist himself, Milnes uses the frame of education, the processes of acquiring and of disseminating it, to shape his chapter. He provides an overview of Consuelo Jimenez Underwood's development, first as a student and then as a teacher of art, tracing her initial forays into community college classrooms, the completion of her undergraduate degree, and her pursuit of graduate study, when she encountered the ancient Peruvian textiles that would profoundly shape her view of, and her approach to, weaving. Milnes introduces us to the mentors who paved the way for her success as a faculty member at San José State University, and he interviews and profiles several of her students who have become artists themselves, including Jonathan Brilliant, with whom Jimenez Underwood collaborated and participated, along with fellow San José State University faculty Robin Lasser, in the 2005 In:Site Festival. Milnes uses education

as a trope to demonstrate how Jimenez Underwood's presentations, in conjunction with her recent exhibitions, compose another critically important form of teaching and public discourse. Ultimately, Milnes demonstrates the artist's legacy, the impact of her teaching on students and colleagues alike, for whom her mentoring has often provided life-changing and "life-defining moments."

Chapter 15, "Being Chicanx Studies: Lessons for Racial Justice from the Work and Life of Consuelo Jimenez Underwood," by Marcos Pizarro, a professor of education and Chicano studies at, and a colleague of the artist before her retirement from, San José State University, provides testimony of the artist's transformative effect on him and his students. Reflecting on the integrity of her person during her everyday interactions and in her observed family life, and on the politics of her moving artwork, Pizarro finds in the artist a model for deciphering a more sensitive and supportive pedagogy by which to teach Mexican American students from low-income communities and with immigrant experiences in more hopeful and empowering ways.

Our volume closes with chapter 16, Verónica Reyes's "Blue Río Tapestries." This long narrative poem by the author of the prize-winning collection *Chopper! Chopper! Poetry from Bordered Lives* (2013) was written as a beautiful testimonial in response to a university lecture by Jimenez Underwood and reflects on many of the artist's specific works. The poem is divided into three sections: a prologue, the first section titled "The Weaver," and the second section named "Blue Thread." The poet imagines the artist at work at her loom, moving between studios in San Jose, Cupertino, and Gualala, California, and traces the journey of creating woven artworks with delicate metallic threads, celebrating the birthing of the five rebozos that make up the *Rebozos for Our Mothers* series (2010–2013) (figure 64). The poet code-switches, moving seamlessly between Spanish and English, and plays visually with the sound and the motions used during the physical act of weaving. She structures the poem to make these rhythms of weaving visible on the page through innovative graphic use of punctuation and spacing. Reyes's words become incantatory, a visual cadence that entrances the reader and serves as a rich poetic and visual invocation with which to conclude the anthology's journey through the artist's work to date.

Please note that we have italicized words in Spanish upon first usage in the anthology, but not thereafter, with the exception of the Preface,

where we followed Luis Valdez's own preference to not italicize at all. Nahuatl words are not accented, following Mesoamerican Studies conventions. With respect to capitalization of titles in Spanish, we have followed the artists' own preferences, so some titles will appear capitalized following English usage, while others will follow that of Spanish with the use of lower case. Names of contributors and others will also therefore only sometimes appear accented following individual preference.

SPINNING — MAKING THREAD

I.

CAROL SAUVION

The Hands of Consuelo Jimenez Underwood

A Filmmaker's Reflections

I first saw the name *Consuelo Jimenez Underwood* on a label at the Renwick Gallery, the Smithsonian's national craft gallery in Washington, DC. Hanging next to the label was a quilt, a wonderful thing. It was a soft, cream-colored silken textile, loosely couched and comforting, with a spectacular image of the Virgen de Guadalupe presented as a skeleton, embroidered full size, with beautiful flowers surrounding the Virgen. Titled *Virgen de los Caminos* (1994), there was something miraculous about the image and I remembered that quilt (figure 15).

When we at Craft in America began to imagine a "Threads" episode for our series that would feature fiber, quilts, weaving, and work with needle and thread, Consuelo Jimenez Underwood's quilt came to mind. I called my friend Kenneth R. Trapp, who had served as the curator-in-charge at the Renwick Gallery and had brought the *Virgen de Guadalupe* quilt into the collection. Ken remembered Consuelo vividly, which is the only way anyone could possibly remember her: "I think Consuelo Jimenez Underwood's work is magical. The *Virgen de Guadalupe* textile touched me deeply. It is both topical and a beautifully designed and executed piece."[1]

After I researched her work, I decided that I had to meet Consuelo. I consider any crafted object to have some political content, but Consuelo Jimenez Underwood was using her work for

her message, not necessarily for its original function. So, a weaving becomes a "messenger." Using her particular "threads," she is weaving together a story about American history, how the world is now and how it needs to change. And her hands are always busy. If you happen to be with Consuelo when she is working, your hands will be busy too.

I contacted Consuelo Jimenez Underwood in the fall of 2011 and asked whether I could meet her. She invited me to visit her at her home in Gualala, California, a small town on the Pacific coast several hours north of San Francisco. Wind-blown fields of wild grasses, golden hills, and spectacular views of the Pacific Ocean are the visual stimulants one sees while driving the road to Gualala, and I cannot help but think that this landscape and geography must have a mystical effect on Consuelo.

I arrived at Consuelo Jimenez Underwood's home after following her husband Marcos's instructions on how to get up the last bit of the road from Highway 1 to their place. Quiet. Nature. Pure air. These were the stimulants as I walked toward the front door. The house was beautiful; a low, porched building with an open floor plan one hundred feet long and twenty-five feet wide; cool and dim, with exposed beams and a fireplace in the middle of the room. There was a bed to the right as I entered, with a spread like the *Virgen* quilt. A wall of windows to my left gave a breathtaking view of the landscape. Marcos told me that centuries ago Indigenous people had meetings in the meadow that is in front of this house, and I could imagine them there. The end of the long room led to a kitchen with a wood-burning stove and a warmth that welcomed me. But just before the kitchen, on the left, looking over a full California landscape, was a work table, which turned out to be one of many "work spaces" for Consuelo. I had no idea that one day I would be sitting at that table, twisting barbed wire for a frontera wall installation, but I did feel activity in the air between Consuelo's table and Marcos's desk, both positioned in front of overflowing bookcases flanking the entry to the kitchen.

Consuelo, Marcos, and their granddaughter, Xochil, greeted me and suddenly it was all about the weaving. I noticed a small loom in the house, but before I could ask about the thin yardage it held, we were on our way out the door and along the winding drive to the studio, my notebook in hand. We passed an altar next to the road and I glimpsed a redwood grove as we entered Consuelo's studio, a large, bright space with many projects and finished pieces on view. There was an altar to her father that honored his life and his Huichol heritage, a flag project

on the large table, pieces for a *Borderline* installation, gigantic tortillas in a sculpture in the middle of the room, and *Mendocino Rebozo* (2004) (figure 31), from the series *Rebozos de la Frontera*, hanging in the corner—a snapshot of the issues and materials that are included in this artist's unique expression.

After an hour of discussion and explanation, I left knowing that we had to present Consuelo Jimenez Underwood and her art in the *Craft in America* series. What should her segment include? It must start with her personal story, which would lead us to other topics such as human rights, heroes, the border, and our precious Mother Earth.

Consuelo Jimenez Underwood works with her hands. Handwork seems a modest means to change the world, but Consuelo's hands are capable. How did Consuelo learn her hand skills and transform them into an art practice? How does her work hold the power of social change? Why does it begin with, and always return to, her craft? What is the complex story that must be told in the film we make together? To answer these questions, we must know Consuelo's history and become aware of her methodology.

It began when she was a small child. Little children learn by watching. At age five, Consuelo, the eleventh of twelve children born into a family of farmworkers in Sacramento, California, often spent hours watching her father, Ismael Aguirre Jimenez, weave on a primitive frame loom. Familial and social pressures often made his weaving activities secretive, but not to Consuelo. As he wove, Ismael would sing and tell her tales of wonder and a spiritual landscape defined by intelligent forces of natural flora and fauna. The textiles he wove had traditional, colorful, and strong designs in the style he learned from his mother, a Huichol Indian, in Mexico when he was a young man. He used his bright woven textiles to sew dresses for Consuelo. He may also have sown the seeds of her future.

Consuelo's mother, Francisca Cruz Jimenez, a fourth-generation American of Mexican descent, loved to dress by combining contemporary styles with Indigenous traditional accessories, often wearing a brightly colored rebozo. She also influenced Consuelo's love of craft, teaching her to crochet and embroider at a very young age. In Consuelo's words:

> Embroidery was the easiest way to draw for me. It was one of my first loves. As kids we didn't have crayons and pencils and pens and all that.

> My Mom had embroidery threads. And once in a while she would allow
> me to embroider. And when she saw that I knew what I was doing she
> let me embroider onto the tortilla cloths or kitchen cloths. And it was
> like drawing. It was so neat: the colors of the embroidery threads, the
> malleability, the magic of a white surface and then having a flower ap-
> pear. And then—and then I had to go to school and that all stopped.[2]

But it did not really stop. Consuelo had discovered the magic of thread
and color and the pleasant physicality of expression with handwork. So
began her life in the fiber arts.

What future does a farmworker's child have? In her case, determi-
nation, intelligence, and creativity gave a young Consuelo the tools she
needed to escape a very difficult existence. But first she planned her
life—no small feat for a nine-year-old. Her childhood consisted of in-
termittent schooling that was often interrupted by fieldwork. In grade
school, Consuelo did not start the year until October, when all the
picking was over. She had to leave school in March to help in the fields.
It's difficult to believe that child labor was the norm in California fields
into the 1960s. One has to wonder whether it still exists.

Consuelo excelled in school despite her frequent absences. Accord-
ing to the ten-year plan she devised for herself, she would attend college
and have a career. She mapped out her life year by year and realized that
at age eighteen she would be free to follow the path she planned.

Life intervened temporarily when Consuelo fell in love with and
married Marcos Underwood, whom she met at her high school in
Calexico, California. The young couple decided that Marcos should
complete his education first, and then Consuelo would attend college
according to her plan.

Consuelo spent her early adult life raising her son and daughter
while Marcos earned a PhD and began his career as an engineer. During
that time, she expressed herself through her embroidery, which was her
art form for several years. Using images from Mexican prehistory and
mythology, she created elaborate embroideries, mostly on clothing. She
showed me these embroideries and explained, "Embroidery was such a
beautiful way to draw, and it just seemed to be much more meaningful
than a mark on a paper. And so I would get old Mayan hieroglyphics
and transform them with my embroidery. Each one would be differ-
ent, kind of Mayan-ish, but I made up the pose, stylized it a little bit.
I wanted the sun, the power of the sun to be the most dominant here.

And it was really interesting. I felt so ancient when I did this because the Huichol embroider clothes."

For these embroideries Consuelo used the chain stitch, a fluid stitch very different from the cross-stitch that is used for Huichol embroidery. The masterful needlework and sophisticated designs on these hand-embroidered clothes must be considered an integral part of her oeuvre (see, for example, figure 2). In their symbology they carry a great deal of information about spirituality, Indigenous prehistory, and Consuelo's creativity. Their quality highlights her hand skills. By contrast, the garments, which were her canvas, were very contemporary—the style of clothing in the late 1960s/early '70s, part of the fashion that represented the era of the counterculture.

Consuelo taught herself to weave during the early 1970s and began with the tapestry format. The weavings are small in dimension but masterful in technique, color, and subject matter, exquisite examples of the storytelling that can go into a tapestry, where the weft is manipulated by hand and pictures can be created. One such example is the eagle logo that she wove into her United Farm Workers tapestry, *C. C. Huelga* (1974) (figure 1). Another example is her first flag, woven with the United Farm Workers thunderbird and Mexican eagles.

Also at that time, Consuelo took a class at a junior college, began to weave on a loom, and was surprised by her success. She recounts, "I remember weaving on the loom, but do not remember knowing how I did it! I was the best in class; the weavings just came off the loom and I remember wondering . . . 'How in the world did I do this?'" Perhaps, as a young child watching her father weave, the process was impressed in her mind. Her hand skills, developed over time, gave her an understanding of the technique. To teach oneself a complicated craft such as weaving is difficult. Her inherited and inherent love of making things and her determination prevailed as she began to express herself at the loom.

College was a different experience from what Consuelo had imagined. When it was finally time to apply, she had not decided what to study. Marcos urged her to study whatever would bring her satisfaction, and she realized that it was art. She enrolled at San Diego State University, which in the 1970s was a great place to study art, craft, and design in all materials. It was a time of labels: Studio Art, Studio Craft, Decorative Arts. The myriad names caused confusion for many enrolling art students, but not for Consuelo. She had found her medium, and the threads gave her power.

Joan Austin was Consuelo's first weaving teacher and proved to be a great mentor for a young artist passionate about thread. Austin had studied at Cranbrook Academy of Art in Bloomfield Hills, Michigan, a graduate center for the study of craft practices and materials. The program at Cranbrook benefitted from the emigration of some of Europe's most revered artists/teachers, and Joan Austin received a rigorous, complete education in all aspects of weaving.

Consuelo's work under Austin was centered on the mastery of processes:

> By the time I got to San Diego with Joan in the late seventies, I knew the rudiments, plus the desire and interest from my Dad, so Joan tightened it up. She helped me control and know well the form, craft, and process of the textiles: dyeing, printing, and most important, WEAVING! She taught me the floor loom WELL, for I already knew the frame, a head start in her class. I learned the double weave with her. I knew it was difficult, pattern weaving as well, plus I remembered this time how to do it, even with closed eyes!

Of Joan Austin's influence on her, Consuelo explains: "She probably did not want to overwhelm me with content as well. I was her full assistant and a mom, and a full-time student. She helped me cross the cultural and art 'border line' by taking me with her everywhere, to museums, art friends, her home, etc. I began to feel comfortable with myself on the 'other' side. She gave me the support necessary for me to do so. More importantly, I think she consciously guided me through that process. I was still coming out of my shell. I was pretty much still very reclusive."

Consuelo took Joan Austin's course, but she was, in fact, torn between pursuing painting or weaving. In weaving, anything she did was almost intuitive in that she did not always know how she accomplished the A+, whereas drawing was not as natural a learning experience: "I was torn between the two until one day I ditched the painting class to go to the cafeteria to work on my tapestry. The painting teacher walked in. We locked eyes and I knew he was thinking, 'You're supposed to be in my class and you're weaving on a loom.'"

At that time, in the 1970s, at San Diego State and many universities, Applied Design and Fine Arts were perceived as different levels of expression, but Consuelo's inner voice spoke up: "I'm gonna do it with thread." Congruently, she was in a class about the history of Mexico and

she recalls, "The instructor was telling me, 'All these beautiful gorgeous textiles: they're not art.' Get over it! It's folk art. And I had already said, 'It's too much; 500 of years of this is too much. I'm not gonna put it down. I will forever make my threads my art.' And I never looked back."

Consuelo combined her natural ability with her hands, her work ethic (learned early), and the discipline she had achieved through years of mastering the needle arts to accomplish a great deal in college. Upon graduation she decided to further her education in the fiber arts and was accepted into the graduate program at San José State University in San Jose, California. As she explained many times, "At San José, it was a totally different ball game. They could care less about form. It was the idea. It was the concept. That's what was important. And I thought, 'This is gonna be cool. Most people just get one or the other; I'm gonna get both. Ah! Great! Go Consuelo. Pick that row, you know.' At San José I was challenged, needing/wanting to understand and command context/content. All I did was weave and try to figure out how to transform weaving into an art expression."

In graduate school Consuelo realized that she knew how to spin, how to cut, and how to put things together. She could make her own thread out of anything. That freedom, of what a thread is or can be, was part of what she wanted to do as an artist. What was her message and what were the materials that could give her work the content she was after? She made her own threads with scissors and a metal cutter. Barbed wire, soft silk, recycled plastic bags, bias tape, brown cotton, and bandannas were among her choices. She included safety pins and images printed on textile in her repertoire: "I love the safety pin because it's a very, very humble object in our society, but yet it has this power to connect. And it's often overlooked. I always felt that the most important things are overlooked in our society and culture. So, I'm here to bring them to the forefront. Wildflowers, safety pins, color, little pieces of leftover fabric or paper, and the corn . . ."

After graduate school Consuelo taught at San José State University for more than twenty years, creating work at the same time but never able to devote herself entirely to her practice. The twenty years she spent teaching informed a new generation about the power of thread and the intimacy of handwork, the expressiveness of the techniques, and the uncharted path on which they take us. After she retired from teaching, her work became stronger year by year.

Filming with Consuelo was a rigorous experience. Her work and life

are one; her thoughts are multileveled, almost stream of consciousness. The young girl is still inside her, directing her and keeping her goals in order. Process intertwines with philosophy, and always the hands are working. Decisions are being made. Her work is holistic, focused, determined, and aspirational. My crew and I were working with an artist who is on a mission and proud of it, who honors her heritage and her craft and uses her skills to deliver her message.

As we do when we film with an artist, we took our cues from Consuelo, learned what she wanted us to know, and documented the projects that are important to her. What objects has Consuelo chosen to imbed with her messages? The rebozo, the burial shroud, the border, the giant tortilla—and others that her fertile mind have not yet imagined.

Rebozo de la Frontera was the first rebozo art textile Consuelo created:

I've always loved the rebozo. It reminded me of the Indigenous aspect of my people. Ever since I learned how to weave in San Diego I wanted to weave one but I never saw a way to enter that world as art. I only saw it as a functional cloth that contained a lot of context of politics and history and culture. I can't weave it because to weave a rebozo takes so much time. But then I started thinking and as an artist: "Let's make a rebozo for that Indigenous woman who crosses the border and has no time to weave."

What does she do? What do I do? I don't have time to sew either. I use safety pins to hem up my skirt when I need to sew it. Safety pins— oh, oh, that's the contemporary way to sew, safety pins! I can make a rebozo with safety pins. Hmm. Wait a minute. If I were to wear a rebozo here, I immediately go up higher on the radar because everybody knows the rebozo is Indigenous, Mexican Indigenous. So how do I put that in here? Millions of little caution signs is my code way of saying if you're Indigenous like me you're always going be under the scrutiny of the border patrol. So I decided to combine these ideas of no time, always on somebody's radar, and functional versus nonfunctional, decorative versus just pure a cloth. I put everything together and I made a rebozo.

I made this [*Rebozo de la Frontera*] in the early '90s and I even wore it to an opening at the Museum of Arts and Design in New York. And so it's wearable but it's obviously a wall piece. On a rebozo the most important part, they say, is the fringe. And so on this one I tried to put some kind of a pattern on the beads, on the safety pins. It talks about

the contemporary state of affairs for the rebozo now in this day and century. As a girl, when I would go to Mexico, I would say 40 to 50 percent of the women had this on. Now when I go I only see it worn daily in the Indigenous nation of the Yaqui tribe in Sonora. Every woman there has a rebozo still. Once they become Mexican they don't wear the rebozo. But if you're Indian in Mexico you wear a rebozo. To me it's a marker that stands for woman, culture, and the struggle to survive.

An important series for Consuelo was the *Heroes, Burial Shroud Series* (1989–1994), which she wove to pay homage to her heroes. The hand-woven trapezoidal weavings honor Joan of Arc, Martin Luther King Jr., Emiliano Zapata, John Chapman (Johnny Appleseed), Woody Guthrie, and Cesar Chavez, who dedicated their lives to their beliefs and changed the world for the better (figures 4–8 and 12). The *Burial Shroud* weavings contain symbols—some universal and some invented by Consuelo—to illuminate the important work her heroes accomplished. Kenneth R. Trapp, then curator at the Oakland Museum, purchased the entire collection. In his words, "The *Burial Shroud* series was one of a few works of art I added to the Oakland Museum's collection. They commemorate well-known Americans who fought for the rights of others. They are gossamer-like, a metaphor about death and dying."

The border is perhaps the single most important issue Consuelo takes on in her work. The border installations she has created over the past five years have a dual message. Besides commenting on the negative political message the border wall represents, Consuelo is concerned about the environmental effects constructing a wall will have on our children and grandchildren and on the flora and fauna that live in the area. She uses barbed wire, flowers, and recycled materials to symbolize the effect the wall will have on the environment. As she prepared the installation for the 2013 exhibition *Welcome to Flower-Landia* at the Triton Museum in Santa Clara, California (figure 69), she considered the symbols and the design of *Welcome to Border-landia!* (figure 68): "This ultimately will be hanging over my cactus leaves on the wall; it'll be a wall piece, again, a very large-scale wall piece, and I have several barbed wires already prepared to receive the blessings."

Creating large installations requires months of work and dedicated volunteers who help Consuelo realize her vision. Such was the case with the Triton Museum installation, where Consuelo worked directly with her helpers and was involved in the smallest details of every component.

In 2016 she spent a week working with the staff at the National Textile Museum in Washington, DC, creating the borderline installation *Undocumented Border X-ings. Xewa (Flower) Time* (figure 73). As always, she was involved in every aspect of the wall, her thirty-foot barbed wire border threading through the giant flowers and magic blessing wands that "throw blessings on our country, on our nation, on our land."

Filming with Consuelo Jimenez Underwood was an experience unlike any we've had. The last scene we shot at her home in Cupertino, in front of the loom with *Rebozos for Our Mothers: Mother Ocean (Water)* (2011), ended with me twisting the barbed wire that would represent the seven oceans in the weaving (figure 55).

Being with Consuelo Jimenez Underwood is a life-changing experience. I felt the urgency of her message and the power she has to achieve her goals. I marveled at her energy, creativity, and indomitable spirit. And of course at the work she does so beautifully with her hands.

CHRISTINE LAFFER

Charged Objects

The Multivalent Fiber Art of
Consuelo Jimenez Underwood

Matter and meaning are not separate elements. They are
inextricably fused together, and no event, no matter how
energetic, can tear them asunder.

KAREN BARAD, *MEETING THE UNIVERSE HALFWAY*

Throughout the past sixty years or more, artists have looked dif-
ferently at fiber materials and seen their potential as a means for
making art. Particularly when breakthroughs breached the bound-
aries between industry and art after World War II, artists began to
engage with the expressive qualities of craft materials and meth-
ods. This legacy, along with an era of broad social changes, con-
tributed to a surge of excitement and experimentation in the field
of fiber art in the 1960s and '70s in the United States. Consuelo
Jimenez Underwood can be understood as part of that lineage of
fiber art even as she pushed beyond many of the ideas she encoun-
tered during her development of a language of visual and tactile
expression charged with meanings that are inseparable from their
fiber elements.

Jimenez Underwood has lived and made her art at a nexus of
social conflicts. She has vivid memories of a family that gave her

fragmentary and contradictory views of life's textiles. When she moved to Los Angeles with her husband in the late '60s, when Cesar Chavez was calling for boycotts and picket lines at supermarkets, she saw how he caused change in the lives of people like herself. With his understanding of what it was like to work in the fields, he convinced farmworkers to form a union that could successfully counter the power of the growers.[1] And when she reached the point where she decided to major in art, she brought her concerns for Mexican American, Mexican immigrant, and other farmworkers to her university work. After receiving her degrees, she went on to hold a tenure-track position at San José State University (SJSU) and taught a diverse student population. In her teaching and her artwork, she let her lived experiences provide insights that she sought to make vividly real through the material of thread, even though she didn't believe that many of her peers understood the use of threads or fiber as art. In a 1995 interview, she recalled "that textile connection has always been real for me. One of my first 'I-am' experiences was with crocheting a cotton thread. So it's always been right there, anything with thread and cloth, mostly thread. And so knowing that, if my body and my sense and my aesthetics are totally zeroed in on this element, do you think that just because the culture is telling me not to do it—I'm not going to do it? So that's a physical bonding, that's something that I am, I don't think that I could shake it."[2] Jimenez Underwood speaks of how making an object involves an intimate physical knowledge that lives in the maker. This kind of knowledge gives a real sense of identification with and immersion in the materials used. Her challenges as an Indigenous-identifying Chicana involved both early experience with thread and embroidery during childhood and as a young wife, but she, like so many others, had to regain a connection to her ancestral arts in museum holdings of Indigenous weavings, such as those from Peru, and archaeology publications in the San Diego State University (SDSU) library.

From roughly the 1940s through the 1990s, universities offered classes in weaving, and those professors often presented various aspects of textile history.[3] Although the discipline of art history could have included craft media, the restricted categorization of art as either painting or sculpture had consistently excluded other ways of making.[4] This situation began to change as artists incorporated collage, photography, assemblage, and found objects during the early twentieth century. Art

historians, however, continued to exclude textile objects that they perceived to have anonymous makers, even if those objects had become part of a trove in a museum's collection. Textile objects and their makers did not fit into Vasari's scheme of master artists, their apprentices or patrons, and their creation of masterpieces, nor did they fit into his ranked categories.[5] Instead, the histories and processes of textile arts (e.g., the tools and techniques of material preparation, weaving, netting) were kept locally through traditions handed down by families, kin groups, and religious communities in regional areas and villages. Thus the acquisition of textile knowledge, for many Indigenous peoples of the Americas, and people in other parts of the world, has always relied on verbal and tutorial transmission. As these traditional knowledge systems began to break apart, particularly under the brutal pressures of colonialism and industrialization, an accompanying lack of written records could make their recovery challenging for a contemporary maker.

To give an example, Debbie Sparrow, of the Musqueam Indian Band in Vancouver, British Columbia, described her difficult path to learning the Salish weaving of her people in 1985. Through a program offered by the Vancouver Aboriginal Centre—an experience that she shared with her sister, Robyn—and assisted by a book that documented historical pieces, written by Paula Gustafson,[6] Sparrow eventually began to understand herself and her culture through weaving:

> So we started to learn how to do just the plain weaving itself and just a little bit of tabby, and putting these two things together. All the women were very excited and we started to sense the identification of the Salish weaving; we started to relate to it, to think very seriously about the women who made the original blanket, the original tapestry. We wanted to be a part of that and connect to them. We thought that would happen by reviving this, that we would only connect to them and no one else in the process. . . . As we made one, and then another, and another, and became more confident in what we were doing, we were spinning also with time, backwards in time to try to understand our own people, and what they were doing in the 17th century and what they were doing prior to the time that Europeans came here.[7]

Their experience parallels that of Jimenez Underwood, who had made an early connection to weaving through watching her father. He would warp up a simple wooden frame loom propped against a

table. At times people poked fun at him when he wove, and he'd put it away. Other times he would weave in the garage as they waited for the threat of immigration officers to pass. His fingers would move quickly, surely, the same as they did when he trimmed the nopales of their sharp thorns. Some twenty years later, in the early 1970s, when Jimenez Underwood decided to take a weaving class at El Camino College in Los Angeles, she made herself a simple frame loom. She wove a series of interconnected diamonds and triangles in red and brown, remembering the farmworkers' posters and that eagle with its spread wings (figure 1). Later she said that in this beginning point, "I discovered a way of expression sanctioned by the ancient elders."[8]

Although her father never taught her his skills, she found herself drawn to art and weaving and wanted to know more than the community college offered. Like others around her, once she decided to pursue a bachelor's degree, she had to make a choice between two program goals: either art or something more practical. For Jimenez Underwood, the answer had to be art: "¡Sí, se puede!"[9]

Industrialization, Arts and Crafts, and Fiber Art Lineages

As Jimenez Underwood discovered that colleges and universities offered classes in weaving as part of their art programs in the mid-1980s and stepped into her undergraduate and graduate studies, she encountered the confluence of a set of educational ideals, social reform efforts, and local circumstances. To understand this legacy of artists and their ideas, it is important to trace some strands in that lineage which shaped her teachers, and which she, in turn, would further shape.

One of the more widespread influences came from Europe where the Arts and Crafts Movement formed out of anti-industrial sentiments of the mid-1800s. This movement eventually aligned with socially liberal and morally inclined bourgeois ideas in England during the 1870s.[10] By the 1890s it had spread to Europe and the United States. As part of this social change, groups of artists and artisans formed arts and crafts societies, gave lectures, taught classes, and mounted exhibitions.[11]

Some of their reforms centered on returning a sense of pride to workers who could make things with their own hands—as opposed to mechanized industry—allowing them to reclaim control over their work by applying themselves directly to their materials, as craftsmen

had done in the past. A journal called *The Craftsman*, started in 1901 by Gustav Stickley, a furniture maker in upstate New York, included "designs and plans for bungalow-type 'Craftsman homes' and lessons in making Craftsman furniture." Stickley placed emphasis on "simplicity, individuality and dignity of effort," advocating a return "to the old frankness of expression, the primitive emphasis upon structure."[12] Influenced by Morris, he and other proponents believed that this would restore a sense of individual value through the power of making and living with handmade objects. The Arts and Crafts Movement—whether in the United States, Britain, or Europe—fostered a preference, in both makers and purchasers, for natural and organic forms in architecture, wood furnishings, textiles, ceramics, metalwork, and glass.[13]

Between the two world wars, a shift in education took place at the Staatliches Bauhaus, founded by architect Walter Gropius in Weimar, Germany (1919–25), then moving to Dessau (1925–33), that differed from the many regional adaptations of Arts and Crafts. As a new generation began to accept the success of industry during the 1920s and saw the benefits of quicker production methods, they seized on a new abstract aesthetic for handmade utilitarian items that could be manufactured. This evolved throughout the life of the Bauhaus "as the workshops' identities and products shifted under the weight of economic pressures and the school's changing artistic and political allegiances."[14] Gropius began with plans for a Morris-like unification of art and craft that, in just a few years, became a site of early modernism, with an abstract, scientific vocabulary of design.[15] Using an architectural approach, a designer would develop ideas on paper, providing details, specifications, and models for a company to follow. The end product would improve and everyone would benefit from good design in a simple, direct form without excess embellishment in everyday commercial products.[16] As the politics in Germany grew increasingly oppressive under the effects of Nazism during the early 1930s, however, the idealism that fueled their program resulted in forced closure of the school. Unemployed teachers left the country, and several emigrated to the United States. They became highly influential architects, artists, and designers, among them Josef and Anni Albers, Ludwig Mies van der Rohe, Marcel Breuer, and László Moholy-Nagy.

For future fiber artists, Anni Albers would be the most notable of these immigrants. She accepted a position to teach at Black Mountain College in North Carolina. An experimental college initially formed as

a cooperative venture in 1933, its programs encouraged teachers and students to explore novel, even futuristic, approaches to art making, similar to those at the Bauhaus.[17] Albers taught weaving with a traditional foundation and then directed each student to explore both artistic experimentation and useful design solutions. Although she attempted to fuse craft, art, and design methods on the loom, she believed that important distinctions existed between craft's historic traditions, an artist's self-expression, and design's focus on innovation. In her book *On Designing*, first published in 1959 but mostly written between 1939 and 1947, she found faults in the role of designer.[18] She wrote that "designing has become more and more an intellectual performance, the organization of the constituent parts into a coalition. . . . It deals no longer directly with the medium but vicariously: graphically and verbally." In contrast, craft traditions brought intimate material knowledge that the designer lacked: "To restore to the designer the experience of *direct* experience of a medium, is, I think, the task today. Here is, as I see it, a justification for crafts today. For it means taking, for instance, the working material into the hand, learning by working it of its obedience and its resistance, its potency and its weakness. . . . The good designer is the anonymous designer."[19]

After underscoring the necessity of personal material knowledge, Albers went on to cut a separation between art and craft. She saw art as having a singular purpose, one that responded to a constant human need that could not be filled in any other way: "It is the forming of a vision into material reality. . . . Art directs itself to our lasting fundamental spiritual, emotional, and sensuous needs: to the spirit by embodying an idea, prophecies, criticism; to the emotions through rhythm, harmony, dynamics; to the senses through the medium of color, sound, texture. The aim of art is to gratify our lasting needs and it absorbs and passes beyond the imprints that temporal influences may have on them. It transcends the merely personal in our desires."[20]

Albers accepted a division between art and craft, one along the lines Vasari had described in the sixteenth century, but for different reasons.[21] She linked the path from craft to art through free exploration: "The more we move to free exploration, the greater vision is demanded and the greater our insight will be. . . . Art objects are objects of both reality and vision."[22] The importance of her textile works was acknowledged in 1949 with her solo show at the Museum of Modern Art in New York City, the first exhibition of its kind. Her views laid a solid ground-

work for the early phase of fiber's transition into an art medium as the next generation of makers began to emerge.

Although Albers acted as a trailblazer and showed the validity of weaving as an art form, her finely restrained aesthetics fit the East Coast modernists. For the West Coast, the work of Trude Guermonprez spoke in a more personal vernacular to the next generation of fiber artists. Invited by Albers to teach weaving at Black Mountain, Guermonprez arrived from the Netherlands in 1947. She had studied at the School of Fine and Applied Arts in Halle, Germany, often referred to as the "little Bauhaus," and thus she held views similar to those of Albers on the importance of both skill and expression.[23] Guermonprez found the emphasis on experimentation at Black Mountain College invigorating and began testing dyes brushed directly on her warp threads. Then, in 1949, responding to a request from Marguerite Wildenhain, a Bauhaus-trained potter and ceramic artist, Guermonprez headed to northern California to live and teach at Pond Farm, "a working community of craft masters, each with separate studios in which to carry on their work."[24] In her new location, Guermonprez continued the warp-painted experiments she had begun at Black Mountain, altering brush-dyed images by manipulating wefts of varying materials.

After a brief period at Pond Farm, she moved to San Francisco and agreed to teach summer weaving classes at California College of Arts and Crafts (renamed California College of the Arts in 2003). In 1954 she accepted their offer of a full-time faculty appointment. By the mid-1960s and early 1970s she had had six solo shows of her fiber art, which included pieces such as *Our Mountains* (1971). Photos of these works appeared in popular publications like *Craft Horizons* and *Fiberarts*.[25] These images struck a chord in younger weavers. The inherent immediacy and quickness of her dye techniques held a lot of appeal; Jimenez Underwood would begin to elaborate some of these techniques during her MFA studies at SJSU. Examples of the freedom she discovered in directly altering warp and weft elements show up in early pieces such as *Virgen of the Headlights* (1987), in which she spray-painted bamboo strips with silhouettes of white and gray and then wove them into her cloth. She shifted to applying by hand small silkscreen motifs of different colors onto the finished weaving of *Night Lights* (1991). She chose masking tape as an easy-to-use resist in *Deer Crossing* (1997), which, when peeled off, revealed white outlines of four state flowers embedded in her woven highway (figure 24).

The Shift from Designer-Craftsman to Artist
and Jimenez Underwood at SDSU

Both Albers and Guermonprez continued for most of their careers to separate their practices between industrial production and self-expression in art pieces made with threads.[26] The post–World War II economic boom triggered a widespread interest in modern textiles (along with furniture, architecture, and ceramics). From the 1950s to early 1970s, particularly in the rapidly growing urban areas of California, groups formed to exhibit their works around this new vision of the "designer-craftsman."[27] Their fresh approach to making objects of unusual sculptural forms in free-hanging threads, experimental abstractions, and outrageous jewelry displayed in exhibitions such as *California Design*, a show initiated by the Pasadena Art Museum (now the Norton Simon Museum) in 1954, attracted a large audience. Ironically, within a decade, the social fascination with innovative design as the herald of a free, modern, and beautiful lifestyle began to include industrial materials such as concrete, fiberglass, acrylic, and vinyl, which allowed designers to move away from crafting with hands-on knowledge of their materials, as in Albers's critique quoted earlier. At the same time, craft makers began to think of themselves as artists—dynamic creators making expressive art pieces that left behind any interest in design for domestic use or industrial manufacturing.

Part of the impetus that pushed enthusiasm for *California Design* exhibitions in southern California affected universities. Most of the expanding state campuses had a studio classroom for weaving: SDSU, California State Long Beach (Long Beach), SJSU, and San Francisco State University, to name just a few. Even community colleges in areas near these universities set up classrooms for weaving and hired teachers. Jimenez Underwood had taken her first weaving class at El Camino College before she decided to enter SDSU as an art major in 1979. She started as a painter but found herself adding to a painting's surface other elements such as thin wires that crisscrossed nails in a wood panel. One day at SDSU she passed by a room of students weaving and stopped to see what they were doing. She immediately signed up for the class the next semester. She also took an art history seminar titled "The Arts of Mexico," which gave her a new challenge: "I wanted to see the textiles. So they focused on textiles for, like, three weeks, and I was blown away.

And I remember asking something about, 'Is this art? Can this be considered art?' 'Oh, no. No. This is folk art. It's very different from art.' I remember a little cloud going over my head going, Grr. I said, This is what my father was against. . . . It's been 500 years of this thinking. I'm going to make it art."[28]

¡Si, se puede!

Jimenez Underwood Studies with Joan Austin and the Cranbrook Lineage

At SDSU, Joan Austin taught all the weaving classes from the time she was hired in 1970 until her death in 2003. Austin had a voracious interest in all things made with manipulable linear elements—from intricate weaving to traditional baskets to constructions that used multiple techniques. She had mastered the possibilities of a wide range of natural materials from split reeds to partially spun wool fleece to commercially manufactured fine threads.[29]

Austin was the daughter of a fisherman who worked off the coast of Long Beach; her mature work combined textile traditions into a variety of vessels and screens marked by traces of organic growth patterns suggestive of sea life. Many of these she made with translucent effects using monofilament, paper, shimmering surfaces of plastic film and Mylar, and loose, hairlike silk threads. See, for example, *Ocean Lights* (1985) (figure 82). Her woven vessels appear insubstantial and skeletal, as though they might have been abandoned on the shore. In other works, movements emerge in a flat yet translucent space, threads floating freely toward the light above, as in *Waves of Grace* (1978) (figure 83).

For her undergraduate degree Austin went to Long Beach, where she studied textiles with Mary Jane Leland, herself a graduate in 1951 of Cranbrook Academy of Art's MFA textile program under Marianne Strengell.[30] Leland's knowledge of textiles and her teaching, both at LA City College and then at Long Beach, fueled the interests of her students, including Austin. Austin then also went to Cranbrook to get an MFA degree with a dual focus on textiles and printmaking, which she completed in 1969.

Until 1970, the program at Cranbrook had similarities to the Bauhaus, although Marianne Strengell had lived and studied in Finland,

with no connection to the German school. Yet her teaching style echoed that of Albers and Guermonprez, as she urged students to develop their own sense of color and explore and experiment with unusual materials without referring to textbooks or other sources. Further, she insisted that they develop finished pieces for functional casements and upholstery without telling them what to do.[31] This approach to fiber materials and techniques allowed many students to evolve in several directions at once, developing ideas with both fine threads and thick, large-scale elements. Ted Hallman, who went on to become a well-known fiber artist, spoke of his experience pushing boundaries: "I had some plastic yarn that was stuff that Marianne had gotten from one of her dealers or something that she hadn't used, that was sort of like in a leftover pile there, and I made a warp of this yarn. It was really fiberglass yarn that was coated with . . . I believe it was an acrylic plastic. So I made this web and I designed a pattern to make little pockets, so as I wove this thing, I would make these little pockets and then stick these pieces of copper sulphate in and just finished it off."[32]

When Austin arrived at Cranbrook in the autumn of 1967, Strengell was no longer teaching. Robert Kidd, one of her graduates, headed the program and continued with the same method of free experimentation mixed with main assignments on utilitarian textiles. Sometime between 1966 and 1970, the program ran into issues when students demanded change—possibly because of the emphasis on "utilitarian." According to Gerhardt Knodel, who interviewed for the position as head of textiles in the summer of 1970, "Cranbrook had just had a revolution and half the faculty was dismissed or left the school. Primarily, it was over the issue of whether the institution was up with the times. Most of the agitation was created by Californians who were in school there."[33]

Returning to San Diego in 1969, Austin was hired by SDSU in 1970 to take over their weaving program, and she may well have experienced and participated in the "revolution" Knodel described at Cranbrook. She demonstrated an exuberant energy by exhibiting a large abstract piece in 1971 at the *California Design 11* show organized by the Pasadena Art Museum. Her piece, *Wall Tapestry*, overflowed with natural fibers of raw wool, mohair, and loops of unspun linen that in their excess referenced the drips and splatters of expressionist paint, clearly displaying nonutilitarian qualities of art.[34]

As fiber artists began, however, to claim a vernacular material language that paralleled forms in painting and sculpture, such as expres-

sionism and process art, the mechanisms that set up ranked categories in the art world continued to discriminate against craft out of necessity. As Elissa Auther has documented in her book, *String, Felt, Thread*, critics, artists, and historians have steadily manipulated a ranking system wherein art depends on craft's inferior status.[35] Auther notes that Albers herself had, in an article that appeared in *The Weaver* in 1940, used some of these ideas to separate textile art from craft by devaluing weavings made from "recipes" and "traditional formulas." Further, Auther identified anxiety about the art/craft divide in Louise Bourgeois's criticism of the seminal 1969 *Wall Hangings* show at the Museum of Modern Art in New York City as including works that "rarely liberate themselves from decoration."[36]

Many teachers of fiber art sought to bring more depth in material expertise into their classrooms, and they made efforts to emphasize the innovations of diverse cultures. Others attempted to challenge and enrich students' insights and bring them into currents of critical debate. Austin preferred to study the knowledge of specific traditions around the world, many of them overlooked by teachers in the United States.[37] When possible, she traveled to learn directly from textile collections in Greece, Korea, and parts of Europe. In 1974 and 1978 she studied ikat dyeing, paper making, and bamboo basketry with heritage craftsmen of Japan, and in 1990 she spent time in Oaxaca, Mexico, learning the natural dyeing and weaving techniques of the local Indigenous cultures. She continued delving into museums within the United States, seeking historic textiles and baskets to better comprehend their structures and meanings. Austin instructed her students to learn from museum collections of weavings.

While studying with Austin between 1980 and 1985, Jimenez Underwood experimented with materials and content and ways to defy the art/craft divide. She developed technical skills and mastered the use of color, letting the beauty of the threads convey her intense love of California lands, and she explored color field weaving. Finishing her bachelor's degree in 1981, she entered the master of art program at SDSU in 1983. Jimenez Underwood became Austin's second graduate student and was immediately hired as her graduate assistant.

Textiles as Charged Objects in Feminist Art and Jimenez Underwood's Use of Multivalent Materials

The early years of feminism in the 1960s and 1970s not only broadened the types of choices young women could make for themselves as to career paths and lifestyles. It also affected the perceived power of choosing to deliberately include references to the "feminine" through materials and practices relegated to women throughout the past several hundred years.[38] As fiber art gained visibility in the late 1960s, feminist politics aligned and aesthetic boundaries broke in the preference for unorthodox, female-gendered materials. Painter Miriam Schapiro's femmages, for example, combined abstract forms with commercial fabric that women normally used to make clothes, quilts, and other domestic items. As a provocateur, Schapiro brought a politically charged surface to works that she made on canvas in acrylic, fabrics, and hand-embroidered textiles from the household domain, such as *Anatomy of a Kimono* (1976).[39]

With both experimentation and feminism fueling the fires of fiber art, Jimenez Underwood could see the gendering and racialization of material meanings, sometimes deployed overtly by a particular color or image, and sometimes through references to historic methods and structures.[40] Moving farther along the path carved by artists like Schapiro, Jimenez Underwood investigated the physical properties and cultural associations of textiles and threads.

When, for example, she wove dense bands of tapestry alternated with open lengths of gauzy cloth, she discovered that the softer weave could drape in ways that suggest human forms, as in her early piece *Los Muertos* (1984) (figure 3). The tapestry bands seem to stand vertically as poles holding up the white cloth draped between them. They take on a pose that is strikingly human: both arms up, torsos covered in plain tunics that fall to their knees. Four of them are set side by side, arms overlapped, each bracing the other in the line. Yet in another way they look like stretchers stacked against a wall, each waiting to carry a body, their surfaces clean and empty.

Cloth speaks by having within it an indicator that points toward a use, an implied potential purpose that includes the inseparable charge of its material. Linen, for example, prized for its cool lightness and absorbency when spun fine, makes body wrappings such as nightgowns, sheets, and shrouds. Copper wire, by contrast, conducts electricity,

wraps around a core to make a magnet, reflects a bright metallic light, and oxidizes to a warm, earthy brown. Combining copper and barbed wire woven into an open grid in *Night Flower* (1993), Jimenez Underwood layers this metal veil over an assembled textile (figure 11). Distributed by the matrix of sturdy copper wire, sharp steel barbs press the cloth and threaten to rip it the same way it would rip our own skin.

Veils bar our touch and keep people out and thus they protect the textile behind them. In this piece, however, the ground cloth seems hardly to have value. It consists of a rough burlap that still carries its long, red border stripe of mass manufacture and bears half-hidden letters stenciled in blue ink: "—duct of —ombia," some upside down numbers and letters, "Trade," and "Supre—." These marks disclose that the cloth was used for shipping, but Jimenez Underwood adds another layer of images—a repeated plant silhouette silk-screened white-on-black as if from an x-ray. Printed in flat rectangles that form another rough grid, this irregular checkerboard remains indifferent to the order imposed by the veil. A strip of black fabric tumbles out, bleached by the same stencil of the plant silhouette and refusing the veil's protection.

A discomfort pervades *Night Flower* between its two layers, which do not resolve their apparent conflict. The barrier-veil presents a threat to touch but does not limit or prevent visual access. Jimenez Underwood has set up two fields of charges, one metal and the other fabric, that cannot be severed from the materials themselves, but their meanings must be pieced together bit by bit. The puzzle in this piece remains the identity of the plant silhouette. It takes a different kind of knowledge to discern the stenciled coca plant, once known for its medicinal and sacred qualities by Indigenous peoples of the Americas, now regarded in the United States as an illegal drug that undermines the order of society. The barbs-to-skin/metal-to-cloth contact thus hangs suspended between two different peoples, lands, and ways of life.

Two years later, Jimenez Underwood wove an unusual sequel to her *Shroud* series with *Buffalo Shroud, Almost 1,000 Left* (1995) (figure 16). Woven in an open-weave grid based on a historical fragment from the Chimú area along the northern coast of Peru (dated between AD 1000 and 1476), she brought a further past into the present. This borrowing, an homage to the forgotten ancestral Indigenous weaving masters of Peru, formed the cloth that displayed marks of a more recent harsh history. She interwove warp and weft threads to form a grid of tiny two-inch squares, each silkscreened with a bison hoofprint in a different

shade of golden brown. Jimenez Underwood had woven a bridge between North and South America, between distant ancestors, and she honored the beauty of what they made while also mourning the loss of Native American livelihood by printing tracks of the bison herds that had existed for thousands of years before Europeans shot them nearly to extinction.

From a point of hands-on awareness of embroidery thread, initially based in childhood, to the influence and freedom of feminist art practices, Jimenez Underwood turned to experiences centered on people of color, including those of her early years as an agricultural laborer with her family. Turning her experiences into the pathways of threads, her ideas developed within the practice itself. She placed the material meanings of textiles in contemporary art, historic artifacts, and her own life close to each other, as in *Night Flower* and *Buffalo Shroud*, to address large social wrongs occurring along the US-Mexico border. She kept searching for fibers that could express ways poor families unjustly suffered when they were prohibited from traversing the lands where their ancestors had freely moved, their lives expendable in a racially callous culture that is particularly cruel to negatively racialized immigrants. She knew the highways they ran across, the clothes they wore, and the freedom from poverty they tried to find.

Using the image of a running family—potentially her own mother, father, and herself as a child—taken from signage made for southern California highways, Jimenez Underwood placed this border warning at the top of *Deer Crossing* (1997) (figure 24). The word *caution* hovers over them in yellow—both a warning sign and a sun rising above the horizon. She outlined the letters in shirt buttons as though found at the edge of those roads from the scattered remnants of fatal accidents. The long, narrow lane of highway weaves up from the ground and continues as high as it can go—up the gallery wall—carrying large outlines of flowers. Blue dye brush-painted on resist-masked white warp, the state flowers of the four border states stretch along the road. Jimenez Underwood has made two white veils, one of delicate silk strands and the outer one of painted barbed wire. These veils together have a different effect than the copper barrier-veil of *Night Flower*. White paint reduces the immediacy of the sharp metal barbs, and without copper to "electrify" them, they attract notice only at close range. On approach, they emerge as if the air had unrolled itself in a haunting layer of white bleached bones and gauze to cover the road.

Questioning what does or does not cross US borders, how people cross, and why, Jimenez Underwood has returned again and again to the strangeness of the importance given to imaginary lines drawn on a map. The gridded veils that drape over her works often act as barriers; warnings against border trespasses; a denial of Indigenous rights through state political suppression, as in *Resistencia Yaqui* (1992); and sometimes protection from view of what lies behind, as in her early piece with images of the Virgen de Guadalupe, *Night Lights* (1991). The political fabric made of map lines has covered the mountains and fields of free movement with ownership bound up in the colors of a country's flag.

Jimenez Underwood wants her viewers to remember that the land itself has no nation. Making a series of pieces that combine two national flags, she has rewoven them and stitched in simple strips of fabric or plastic to create a new flag of an undivided land. *Home of the Brave* (2013) takes the basic plan of three vertical fields from the Mexican flag and allocates one to each of two nations (figure 61). The United States has a square field of blue above horizontal red-and-white stripes on the left, and Mexico has its red above green on the right. Between them sits an open white field marked by a simple circle of twisted wire and cloth. The new flag is covered with gold- and silver-colored safety pins that try to hold it together, and it is scattered here and there with small flowers. Across all three areas marches the current US-Mexico borderline, with small "caution" talismans pinned to the border towns, places where people are intimately familiar with formal and informal crossings. No veil prohibits physical access to this flag of assembled parts. Instead, a cloth lies behind the surface, just visible at the bottom hem— a hidden fabric of incredible strength woven by Indigenous peoples of Guatemala.[41] This fabric comes from the hands of Indigenous people who hold all the lands together.

Jimenez Underwood brought her fearless challenge of weaving to her art in ways that required no special skills to understand. Whether making huge fabric flowers and using strands of bright threads to crisscross the US-Mexico line of separation for her *Borderlines* mural projects (e.g., *LA Borderline* [2014; figure 70]), or weaving fine threads into shaped shrouds for her *Heroes, Burial Shrouds* series commemorating the people who guided her from the fields to university, she lets the materials be themselves to make their story compelling.[42] And as the long trail of material knowledge from World War II to the twenty-first century passed along a chain of personal contacts—often brief, inspiring, and

reliant on printed material—she added her biography, beliefs, and skills to the works of other fiber artists to keep their collective efforts alive.

The different ways that Jimenez Underwood engages with her materials—whether remnants of torn clothing, copper wire, barbed wire, plastic strips, metallic filaments, brush-dyed warps, silkscreened motifs, or safety pins—add their associations to her social concerns and activate the multivalence that charges each kind of fiber. These meanings cannot be separated from the material, nor can they be separated from their culture, even if they travel far from their origin. None of these elements exist independently of the people who made them, nor do those people exist independently of the land they live in. She continuously brings old knowledge together with new images in the present, in art galleries, to show people that they can speak of their own experiences in a personal and shared history.

WEAVING—
HAND WORK

CONSTANCE CORTEZ

History/Whose-Story?

Postcoloniality and Contemporary
Chicana Art

When looking at imagery produced by Chicana artists, the question arises as to whether or not we can understand and discuss this artwork under the nomenclature of "postcolonialism." An initial examination of the term would seem to throw its applicability to Chicana/o art into question. For scholars who seek to define *postcoloniality*, the rapidity with which the term has taken on more and more of a semantic load has led to debates over both chronological and contextual applications.[1] Theorists Bill Ashcroft, Gareth Griffiths, and Helen Tiffin broadly define *postcolonialism* and then go on to note the speed with which the term went from specific usage to general applicability: "Post Colonialism deals with the effects of colonization on cultures and societies. As originally used by historians after the Second World War . . . 'postcolonial' had a clearly chronological meaning, designating the post-independence period. However, from the late 1970s the term has been used by literary critics to discuss the various cultural effects of colonization . . . [and] has subsequently been used to signify the political, linguistic, and cultural experience of societies that were former European colonies."[2]

While the term's early usage privileges newly independent nations, it is clear that the consequences of colonization continue to inform cultural definitions and self-awareness. In terms of post-

colonial studies, this trend has broadened scholarly definitions and chronological parameters even further. Emphasizing the ever-increasing breadth of the discourse, Ashcroft, Griffiths, and Tiffin go on to state that "post-colonialism as it has been employed in the most recent accounts has been primarily concerned to examine the processes and effects of, and reactions to, European colonialism from the sixteenth century up to and including the neo-colonialism of the present day."[3]

While the nature and chronology of postcolonial discourse is broad, so are its mechanisms—that is, the ways in which people respond to the post- or neocolonial presence. This is due, in part, to the diversity of colonial experiences. This marked heterogeneity has led to a veritable laundry list of ways in which writers have voiced the postcolonial experience. According to Stephen Slemon: "[postcolonialism] has been used as a way of ordering a critique of totalizing forms of Western historicism; as a portmanteau term for a retooled notion of 'class,' as a subset of both modernism and post-structuralism . . . ; as a name for a condition of nativist longing in post-independence national groupings; as a cultural marker of non-residency for a Third World intellectual cadre; as the inevitable underside of a fractured and ambivalent discourse of colonialist power; as an oppositional form of 'reading practice.'"[4]

Questions of Postcoloniality

Given the definitional parameters and mechanisms of postcolonialism, the position of Chicanas/os within this discourse could seem highly problematic. While typically treatises dealing with postcoloniality address the political and cultural fallout inherent in newly formed independent nations, Chicanas/os as a people have no "nation" in the conventional sense. For better or worse, they recognize the fact that they are part of a larger nation. Nonetheless, many Chicanas/os, especially in the Southwest, view themselves as living in "occupied America."[5] Adding to this sense of difference is the manner in which Chicanas/os maintain their connections to the first peoples of this continent; intrinsic to the very definition of Chicana/o is a recognition of their status as a New World hybrid. Despite the deliberate invocation of indigeneity, the truth of the matter is that a great part of identity is based on a colonial history of biological and cultural miscegenation.

The question then becomes one of how to negotiate traditional no-

tions of postcoloniality with a very real sense of alterity that is dynamic and bicultural in its nature—that is, to recognize as valid of positionality in which identity is contingent upon changing internal and external cultural discourses and reassessments. Within the Chicana/o community, theorists and cultural critics have addressed modes of activism that allow for a variety of positions that can be experienced singularly or simultaneously. They have also described the interstitial space in which this activism occurs. In this regard, Slemon's "oppositional form of 'reading practice'" benefits greatly from Chela Sandoval's differential mode, and allows the subject to self-consciously "read the current situation of power . . . choosing and adopting the ideological stand best suited to push against its configurations."[6] Gloria Anzaldúa has also expressed the methodology of oppositional consciousness under the rubric of *la conciencia de la mestiza*.[7] This term references the possibility of action born of numerous sites in which subject identity may lie. It occurs in a dynamic space where negotiated identity is created over and over again by "a continual motion that keeps breaking down the unitary aspect of each paradigm."[8] Emma Pérez labels this "third space" of historical recovery as the "decolonial imaginary" and states that it is "where agency is enacted through third space feminism."[9]

Visual responses to this alterity are particularly apparent in artworks generated by Chicanas since the 1970s. Many artists employ the mechanisms of postcolonial discourse and oppositional consciousness to combat notions of canonical histories and art history as well as their European-based constructs. Given the apparent permanence of their position as part of a larger US construct, some artists have chosen to challenge the center/periphery paradigm that often privileges the dominant system of power and representation over subaltern systems. These works reaffirm particular sites of Chicana/o cultural memory, thereby challenging external hegemonic postures that attempt to erase histories validating alternative visions of the past. In doing so, the artists create bridges for understanding the multivocality present in the United States.

This essay will address the work of three Chicana artists who envision their work as postcolonial responses to the dominant constructions of history. Painter, performance, and installation artist Celia Herrera Rodríguez (University of California, Berkeley) addresses the blurred boundaries of indigeneity. Her work references an imaginary wherein past Indigenous and European interactions collide with the

spiritual and implicate the present and future. Fiber artist Consuelo Jimenez Underwood (San José State University, retired 2009) examines contested topographies in her work. The US-Mexico border is presented as a site where ideological battles are waged. This conflict is the product of two distinct definitions of *land*: one that views it as a historic site of unrestricted passage, another that understands it as a reified manifest destiny. The third artist to be discussed here, Delilah Montoya (University of Houston), uses photography and video to subvert colonial iconography and folklore. In doing so, she underlines ongoing class and gender struggles in her home state of New Mexico. Through their art, these three women explore and critique notions of truth and social memory. They also respond to challenges brought about by the continuation of colonial, political, and social practices, which include inequities based on race and gender. As will be shown, their artwork exemplifies "la conciencia de la mestiza" in its fully operational mode.

Celia Herrera Rodríguez: Reinscribed Pasts, Re-visioned Presents

Celia Herrera Rodríguez is one generation and one country removed from her northwest Mexican Tepehuano roots. However, for the artist, the main obstacle blocking access to a fuller understanding of indigeneity can be traced back to the Spanish Conquest and subsequent colonization of the culture during the eighteenth century. Much of her work explores both apparent and hidden ramifications of the cultural encounter between the European and Indigenous peoples. It is acknowledgment of this and subsequent moments that enable the reclamation of both the preconquest and the colonial past, as well as the recognition of her current position as heir to multiple histories.

In *Red Roots/Black Roots (Tree of Life)* (1999), Herrera Rodríguez recounts the impact of the colonial presence on her family (figure 88). The work was displayed at three venues and is both an installation and a stage for a performance.[10] Like an onion, the work's subsequent layers lead to an inner core that represents the historic moment when Europeans attempted to supplant the native religions with Christianity and when Europeans' bloodlines were mixed with those of the Indigenous peoples. The work takes the form of an eight-foot-square chamber that rests upon a slightly elevated tiled base. While the top of the chamber

is open, painted screens enclose the walls. A tree of life, the focus of the work, is visible through the transparent walls. It consists of the tree, a bundled object supported by its topmost branches of the tree, and the Christian cross, which is positioned at its base. These three elements act as a metonymic device, invoking both personal memory as well as a larger historical context.

The screened walls are our introduction to the work. Here, generations of Herrera Rodríguez's Tepehuano ancestors, the form of children, gaze toward the room's center, bearing silent witness to their own history. Clothing and bodily feature have been captured in an abbreviated, almost sketched, manner, their presence barely perceptible. This ghostlike quality is enhanced by the use of white paint as well as by the surface on which the artist paints. Because the figures are rendered on only one side of the screen, as the viewer moves from one side of the installation to the next, entire groups of individuals seemingly disappear and reappear, making it impossible to see all the figures at once. Clearly, these ghosts from the past reference the marginalization of the Tepehuanos into a state of visibility, one nearly subsumed by the forces of colonization. Here, as in the case of most colonial situations, access to history is controlled by the conquerors. So while the figures gaze upon their tree and their history, they can only do so from a single perspective. Frozen as they are within the confines of the mesh, they cannot engage nor can they manipulate their own past.

The multicolored tile work in front of the figures in *Red Roots/Black Roots* serves as both an impediment to history as well as a seductive invitation to the same history. Herrera Rodríguez has chosen to use 9 inch × 9 inch tiles that date to the middle of the twentieth century. While these tiles invoke the domestic warmth of midcentury kitchens, rooms tiled in such a fashion would have been accessible only to a rising post–World War II middle class. For the Tepehuanos, access to such privileged spaces would have been made possible only in the context of their roles as domestic workers. The triadic use of red, white, and blue tiles speaks of the migration to the United States brought about by the disruption of traditional systems of subsistence. The green tiles forming another triad of red, white, and green—the colors of the Mexican flag—remind the viewer, and perhaps the figures in the piece itself, that while people may move from place to place, sites of origin remain an immutable part of identity. Across the tiles, handwritten names inventory some of the artist's ancestors and operate as indices referencing the past

existence of individuals. However, the record is incomplete. These are slave names, that is, names given to the Indigenous people by the Spaniards after conquest. Their Indigenous names, along with their true identities, have been masked by the colonial presence and by the passage of time. In an ironic reversal, the viewer has to reassume conceptually the role of a domestic worker and tread across the ersatz bodies of ancestors—here represented by the inscribed names—in order to gain access to the tree of life and, by extension, the institution of history.

The focus of the work, the tree, provides a polyvalent framework that encapsulates past and present. The tepee-like shape of the willow construction was utilized by the artist because of its association with Native American spirituality. Larger, similarly shaped constructions were created by Native Americans as focal points for Ghost Dance ceremonies held during the late nineteenth century.[11] These events constituted last-ditch public reaffirmations of unity and prayers on the parts of Native Americans. Through their ceremonies, they sought to restore the past, revitalize their slain ancestors, and eliminate the source of their consternation, the White Man. In the Ghost Dance, a pine or willow tree was placed in the center of a plaza and individuals would dance around it. It was believed that the branches, extending toward the heavens, served as conduits along which prayers could travel to unseen spiritual forces. In this way, personal and communal prayers would be heard by supernaturals, who would respond to the pleas of a people bordering on extinction. Herrera Rodríguez makes another reference to Native culture by placing a bundle amid the tree's topmost branches. Here, the artist invokes the custom of tree burial formerly practiced by the Plains groups such as the Oglala Sioux. Again, proximity to a supernaturally charged heavenly realm was the incentive for the elevated placement of the body.

In Herrera Rodríguez's work, Indigenous historic references have been interrupted by the inclusion of the cross, indicating the European presence. The black cord wrapped around the tree cross-references the black-clad Jesuits, purveyors of Christianity in Tepehuano communities. While the bundle represents past generations and, by extension, their offspring, successful unification with traditional supernaturals has been interrupted. The red lifeline, connecting cross to bundle, tethers the spirit of past ancestors to the earth.

The installation was given life as an altar via Herrera Rodríguez's 1999 performance titled *Cositas Quebradas (broken little things)* (figure 89).

In this work, the artist physically positions herself outside of the space and history but views with clarity her own past. Her performance—part ceremony, part prayer, part entreaty—focuses on the suppression of Indigenous identity via assimilationist strategies such as the imposition of slave names and the masking of her family's indigeneity by her own parents. In the fifth and final part of her performance, the artist invites audience members to sit on a small textile, a space demarcating what she says is left of her nation. After the distribution of the food into receptacles, she attempts to invoke an understanding of the plight of her people by sharing the experience of loss, even if it is only through the actual shattering of material objects born of distant lands. For the artist, the reacquisition and re-membering of Indigenous identity is achieved not only through the work but also through ceremony. Her gift to her ancestors offers a kind of immortality through visual and narrative historic references and through the acknowledgment of their importance to the artist herself.

While *Red Roots/Black Roots (Tree of Life)* is decidedly aimed toward the past and an overall examination of the impact of colonialism, the artist's most recent series of watercolors are decidedly forward-looking in their direction. In the painting *Ojo de Sabiduría* (2004), Herrera Rodríguez again uses a bundled figure but this time, one that is not bound by the historic referents of colonialism (figure 90). The main figure is situated on a life-giving red background that indicates a supernatural realm. Depth of field is implied via the deft use of transparent layers of watercolor. In the center of the painting, the main figure arcs in movement, simultaneously dancing with and giving life to fantastic creatures.

Pictorial elements found in Herrera Rodríguez's previous work that reference Church iconography have undergone catachresis and are reinscribed with new meaning, proclaiming a newfound Indigenous agency and meaning. For instance, the mandorla, the luminous cloud that surrounds the Virgin of Guadalupe, is no longer gold and perfectly symmetrical. In Herrera Rodríguez's depiction, the central figure is encircled by a red mandorla marked by irregular, almost explosive, edges. This mandorla can be conceived of as an exclamation mark connoting sudden self-awareness on the part of the figure. The halo, normally associated with Christian icons, has also been modified. It surrounds the head of the figure and now includes triangular elements associated with the Aztec symbol for the sun. As if to underline this source, Herrera

Rodríguez has dotted the edges of her sun disc with twenty flowering plants, a reference to the life-giving qualities of the sun and to the Mesoamerican calendar, which was made up of twenty days. Finally, the cross that forms the bundle's head is far removed from Christ and notions of death. Again, Herrera Rodríguez has borrowed from Indigenous iconography. This cross is used by both the Tepehuanos and their neighbors, the Huichol. This is a sikuli, a cross that connotes the five directions.[12] At the juncture of the cross's arm is a faint ojo de Dios, an Eye of God. In Huichol usage, the sikuli is a kind of talisman to protect their children and is constructed over time. The object is given at the time of birth, and an arm is added on each birthday for the next four years. The five points represent not only five directions (north, south, east, west, center) but also the elements of air, earth, fire, and water, with the eye representing the union of all four elements. In each instance, the central element is associated with supernatural vision and the ability of supernatural beings to see and hear the prayers of the sikuli's owner.

The artist also freely manipulates iconography that is unambiguous in its pre-Columbian origin. These elements uniformly point toward concepts of transformation. For instance, the serpents emanating from three arms of the cross making up the figure's head possess the attributes of Quetzalcoatl, the feathered serpent found in many Indigenous mythologies. The creature traditionally mediated both earthly and heavenly realms, and here the artist broadens its domain by painting its body blue, a reference to water. The second element, the butterfly adorning the cloth shrouding the figure, is also transformative in its nature. In this instance, the insect clearly indicates the bundled figure's metamorphosis. The figure will soon break the bonds of its cocoon to realize a new incarnation as an even more powerful being. The third Indigenously derived element employed by the artist is that of a yei, or a holy being.[13] These long-waisted, often bigendered beings are part of southwestern religious cosmology and are represented in Navajo dry painting. They are holy beings who address issues of personal and communal healing and restore hozho, spiritual balance. Here, Herrera Rodríguez shows only the lower portion of a yellow yei located just below the figure's midpoint. The head of the creature is partially hidden as it dives under one of the swaths of cloth, apparently on its journey to impart balance to the transforming body of the bundled being.

Although many of Herrera Rodríguez's earlier artworks can be un-

derstood as multilayered tributes to historical moments, her recent works, as exemplified by *Red Roots/Black Roots* and *Ojo de Sabiduría*, represent a synthesis of histories and a validation of a re-visioned present. This can be understood as an act of decolonization. She has transformed the visual vocabulary of the colonial system that shackled Tepehuano spirituality while giving equal voice to these same Indigenous roots. By acknowledging and reconciling the two pasts—the Indigenous and the colonial—she amends the present and is able to look toward the future. As viewers, we are left to contemplate the applicability of her Spring of Knowledge to our own lives and to ponder at the potential results of such transformations.

Consuelo Jimenez Underwood: Cartographic Explorations

> . . . 1,950 mile-long open wound
> dividing a pueblo, a culture,
> running down the length of my body,
> staking fence rods in my flesh,
> splits me splits me
> *me raja me raja*
>
> This is my home
> this thin edge of
> barbwire
>
> But the skin of the earth is seamless.
> The sea cannot be fenced,
> *el mar* does not stop at borders.
> To show the white man what she thought of his
> arrogance,
> *Yemayá* blew that wire fence down.
>
> This land was Mexican once,
> was Indian always
> and is.
>
> And will be again . . .

GLORIA ANZALDÚA, *BORDERLANDS/LA FRONTERA* (1999)

The above passage from Anzaldúa seems an appropriate introduction to the work of Consuelo Jimenez Underwood. As in Anzaldúa's work, Jimenez Underwood charts the geographic, historic, and spiritual realm marked by the "1,950[-]mile-long open wound," the US-Mexico border. She employs both barbed wire and silk in her art, weaving topographies that re-create conflicts and contradictions born of historic circumstances. In her works, the border becomes a conceptual field in which she lays bare questions regarding colonialism as well as the nature of an externally imposed border, a tangible symbol of the ongoing colonial presence.

Movement through and beyond the border is a leitmotif in her fiber art and is reflective of childhood experiences. Born in the Southwest of a Chicana mother and Huichol father, Underwood was part of a large migrant farming family. Because of this, her youth was determined by the seasonal demands of agribusiness in California. The experience of moving from place to place led to an early awareness of the relationship between life and land. At the same time, discrepancies between the value of the land, as ancient provider of food and spiritual sustenance, versus the inhumane manner in which those who cultivated the land were treated also left an indelible mark on her psyche. Her life amid these contradictions provided the artist with a stage on which she could visually contest these realities with an Indigenous rescription of territory.

In *Virgen de la Frontera*, from 1991, Underwood pays homage to her migrant childhood and the seasonal night passages from one side of the US-Mexico border to the other. Issues of liminality and specificity are literally interwoven across the field of this textile (figure 9). The darkness of the piece imparts a sense of apprehension about the unknown territory, and the silken threads of varying colors speak of the unevenness and harshness of the geological terrain crossed by migrants. But the passage here is not just a physical one; it is a passage that is also experienced at a cognitive level, where that which is experienced does battle with that which is unseen and unknown. This is a psychological landscape filled with anxiety about the journey and the journey's end.

The physical markers of the present danger associated with the US-Mexico border are woven into the fabric of *Virgen de la Frontera* in two ways. The first of these is in the form of the irregularly spaced barbed wire inserted among the weft threads. These metal threads reference

the actual lines of barbed and razor wire that form man-made barriers impeding migrant crossings. Danger at the journey's end is stated via the golden diagonal lines darting across the field of Jimenez Underwood's piece. These are the headlights of the INS, or la migra. Rather than represent the border patrol in their fully realized corporeal form, Jimenez Underwood only hints at their very real presence via these lights, their impalpable manifestation. Hence the sudden appearance of lines shooting across the darkened desert floor constitutes both illusions and allusions. The lines are the ethereal references to faceless individuals who have the power of life-altering decisions over migrants.

Responses to questions of unseen dangers woven into the fabric's narrative are given in the form of images stamped randomly across the textile. Dark calaveras, skulls, of ancestors dot the landscape. These are polyvalent in their meaning. They reference ancient ancestors who lived and died in the desert without ever knowing the reality of the line that would be inscribed upon the land. At the same time, they speak of the tenacity of more recent unsuccessful migrants who were willing to sacrifice their lives in the pursuit of better conditions for their children. They are the same skulls that are celebrated on home altars during el Día de los Muertos. These calaveras own the land demarcated by the textile and bear witness to successive groups of travelers who attempt night journeys across the border.

Finally, what remains is the single stamped icon of the Virgin of Guadalupe, referenced in the work's title. Located in the third register of the textile, this golden figure functions as a talisman protecting the single migrant traversing this field. The power of Guadalupe derives not only from her identity as a Christian icon, but also from her well-known association with the pre-Columbian mother goddess, Tonantzin.[14] She thus represents the fecundity of the earth as well as a maternal protectress. As pointed out by Anzaldúa, Guadalupe/Tonantzin's inherent bicultural identity makes her "the symbol of ethnic identity and of the tolerance for ambiguity that Chicanos-Mexicanos, people of mixed race, people who have Indian blood, people who cross cultures, by necessity possess."[15] It should be remembered, however, that the Virgin is the product of a colonial incursion. As such, she has been the object of controversial reinscription by contemporary artists such as Yolanda M. López, Ester Hernández, and, most recently, Alma López. In Jimenez Underwood's work, she is a reference to the double-edged faith that

sustains travelers. While the faith has its basis in the tenets of traditional Catholicism, the Virgin as earth deity holds the promise of a better life. Guadalupe floats above the desert floor, above the lights, and presumably will float beyond the lines of la migra and their barbed wire.

Deer Crossing, a ten-foot-long silk weaving from 1997, also addresses border crossings (figure 24). Unlike *Virgen de la Frontera*, the references to topographies are much more explicit. For instance, the blue that constitutes the lower part of the narrow swath of woven silk alludes to *el Rio Bravo* (the Rio Grande, as it is known in the United States). The delineated white silk-screened designs within the blue field represent the state flowers of the four US states bordering Mexico: the golden poppy (California), the cactus blossom of the saguaro (Arizona), a bluebonnet (Texas), and a yucca flower (New Mexico). The artist has deliberately abstracted the representations of the plants to resemble designs found in ancient Anasazi petroglyphs or Chumash rock paintings. In doing so, she reminds the viewer that the plants, the river, and the people who have historically inhabited this land are older than any modern border. Nonetheless, we are also reminded of the preset reality and that even the flowers are now restricted by a fence that defines the edges of US territory. Here, the border is represented by barbed wire, woven and painted white.

Also part of our modern reality is the bright yellow "caution" symbol located above the blue zone. Such signs are commonly posted along California freeways near San Diego and warn motorists of border-crossing immigrants. Holding hands, a mother, father, and child are shown fleeing across a highway and are presented in a style that is reminiscent of deer-crossing signs. The artist has rightly noted that this kind of representation has the effect of dehumanizing human beings and creating a field of reference that facilitates the transformation of undocumented immigrants into "illegal aliens."[16] One could push this interpretation even further and suggest that an open season has been declared on migrants. However, the image may be read on an additional ambiguous level. While references to deer-crossing signs are apparent, deer themselves carry polyvalent meanings for the people with whom Jimenez Underwood self-identifies. Deer are universally hunters' quarry, but among the Huichol and Yaqui, they are also totemic animals and spirit helpers. The artist's representation of the family could therefore point to the presence of contradictory simultaneous meanings—one of danger and the other of Indigenous affiliation and

totemic power. The implication here is the possibility of an ongoing struggle for contested space that extends to the home turf of the opposition's semiological domain.

Consuelo Jimenez Underwood's artwork explores the cultural fluidity of borders in the face of man-made impediments. She makes good use of the multiple traditions available to her. Using a medium as old as the Americas themselves, the textile becomes a map through which we visually travel the tale. Embedded prose of barbed wire and silk relate histories of Indigenous and non-Indigenous conflict and express implications of power relations between people who work the land and those who own it. Perhaps an even larger issue that goes to the heart of her work is that of the nature of the border itself. On one level, the geopolitical borders that we traverse are inherently fictive creations. Their artificiality is made evident by the ever-changing historical criteria that colonial powers have used to erect these borders. On another level, these borders are very real, and crossing them can entail serious consequences. In the end, Jimenez Underwood provides viewers with a personal cartographic journey through which they can view with clarity the impact of real and imagined lines of demarcation on the life of those who have traveled the tale.

Delilah Montoya: Our Saints among Us . . .

In 1998, New Mexico celebrated the four-hundredth anniversary of its so-called founding by the Spaniards.[17] The years between Juan de Oñate y Salazar's arrival in 1598 and the present era have been marked by a constant reaffirmation of colonial Hispanic identity as the official standard by which to understand New Mexico history and culture. Politically and culturally speaking, this Iberian-identified Hispanic identity has been privileged over Mexican American/Chicana/o identity.[18] In the realm of politics, the resulting antagonisms between upper-class Hispanic criollos and poorer agrarian and working-class populations have been an ongoing source of tension and division on both sides.[19] In terms of culture, art production has been driven by the market and by fixed notions of Hispanic authenticity. Traditional art forms such as devotional imagery not only promote privileged Hispanic identity but are also subject to rules of production. For instance, santeros, or saint makers, who fashion devotional imagery in two- and three-dimensional

forms, have an established guild that maintains strict codes regarding formal representation and canonical interpretation of art. Those who waiver from or challenge the guild's rules can expect expulsion from the group. Additionally, since authenticity is associated with guild products, outcasts can also expect to be edged out of the art market that sustains them.[20] It appears that there is no room in the New Mexico art scene for those who question the constructed myth of identity or who challenge monolithic visions of cultural purity. Artists who reference devotional imagery outside of the sanctioned ideological framework find themselves going up against a negative bias born out of a colonial elite structure that is more than four hundred years old.

It is in the light of ongoing colonial traditions that we must consider the work of photographer and video artist Delilah Montoya. Using her camera, she records, critiques, and re-members the cultural, sexual, and political ramifications of the constructed mythologies that are part of a colonial New Mexican identity. In many works, she lays claim to her own identity as a *Nuevo Mexicana* vis-à-vis canonical representations of devotional imagery. At the same time, her critique of New Mexico's sanctioned mythology is never far behind, and it usually comes in the form of contextual changes to the canon. Thus altered, the art calls into question both the standard modes of representation and the exclusive ownership of iconic forms that elite New Mexican groups seemingly possess.

A case in point is Montoya's fourteen-foot photomural *La Guadalupana*, from 1998 (figure 86). Here, the artist reexamines codified sacred traditions while critiquing class structures. As noted by Victor Sorell, the function of photograph and altar are the same in this case, as both can be recognized as "a tribute to the past as well as a reification of memory."[21] Montoya's overall format is in keeping with traditional altars. Forty-nine separate photo panels make up a retablo, or two-dimensional sacred image. Offerings are placed on the floor before the image. However, the similarities to colonial-inspired altars end here, for the central iconic space offers an unlikely subject—a handcuffed pinto, or convict, shown from the behind. Tattooed across his back is the patroness of the Americas, the Virgin of Guadalupe.

Montoya has deliberately divided the mural into two photographic zones: the central core, in which she utilizes black-and-white photography, and the border, in which she employs color photography. The artist's choice of black and white in the central field brings to mind

documentary photography and speaks to the bleak reality of mug shots and captivity. Seemingly, the only hope to be found in this dismal institutional setting is in the image of the Virgin, whose yellow mandorla has been hand-colored by the artist. While Guadalupe's presence as a protective, sacred figure references traditional Catholicism, her image is also employed in a manner never intended by the Church. Inside the context of a prison, her placement on the back of a convict acts as a talisman, warding off potential rape by other Catholic inmates, who would have to gaze upon the Virgin while carrying out the act and thus subject themselves to the wrath of God. As unusual as the placement of the Virgin is, so are the offerings found on the pinto's arms. Echoing the shape of the Virgin's mandorla, his arms are covered with images derived from popular culture—among these, maracas, a so-called Poncho figure, Yosemite Sam, and a hypersexualized señorita. These offerings bespeak the integration of popular culture into the sacred sphere and are celebratory statements of rasquachismo, a Chicana/o bicultural aesthetic sensibility reflective of "a view from *los de abajo*."[22]

The colored photographs framing the central icon make references to family snapshots and the intimacy of personal memories. The icon of the Virgin is repeated on the backs and arms of a variety of males, as represented in the photographic fragments surrounding the central figure. The variety of contexts for the Virgin and the outdoor setting indicate to the viewer that the photos have been taken in a space where choices can be made without institutional repercussions or personal considerations regarding safety. Memories of blue skies and New Mexico's landscape are visible over the subjects' shoulders, as are women, who are shown caressing the male subject in some of the photo fragments. These still shots are narratives of desire—they operate in a manner similar to memory, where dreams and reality merge into idealized, fragmented vignettes.

La Guadalupana is deliberately provocative and challenges the viewer to question traditional notions of where God is found—and where redemption happens, for that matter. Further, it is a deliberate assault on canonical notions of representations associated with colonial Church doctrine in a society that privileges authenticity and a continuation of colonial elite hierarchy. *La Guadalupana* shatters traditional mythology while acknowledging an iconographic hybridity of meaning in the religious practices enacted by different social classes; the Virgin, as protectress, is not the exclusive domain of the upper classes. Nonetheless, the

image does follow, albeit in a nontraditional way, Christian doctrine. This inmate is the new prodigal son—unnamed, and in dire straits to be sure—but not untouched or forgotten by God. He reminds us that distinctions between saints and sinners are rarely clear or unambiguous.

In a more recent piece, *San Sebastiana: Angel de la Muerte* (2004), Montoya combines her photographic skills with digital technology to produce a work via two venues: a continuous DVD and an online, interactive video (figure 87).[23] The cult of the folkloric icon Doña Sebastiana emerged during New Mexico's colonial period. The saint's primary role is to accompany the dead into the hereafter, and for this reason, santeros have traditionally represented Doña Sebastiana in the form of a skeleton seated in a cagelike wooden cart.[24] The cart references the carretas de la muerte, that is, the death carts that were "loaded with heavy rocks and drawn by hooded [penitentes] to a site representing Calvary" as public acts of self-mortification.[25] In her sculpted manifestations, Sebastiana represents the public acknowledgment of the presence and burden of death.

In Montoya's updated version, Sebastiana is very much animated and shown "off-duty" in the context of her private life.[26] In an often poignant yet humorous manner, the artist relates her version of events just prior to Sebastiana's agreement to take on the job of New World allegory for death. In the interactive video's introductory narrative, Montoya provides the viewer with a historical context through which to understand Sebastiana and her New World hybridity:

> One cannot help but remember the complementary Western icon— Saint Sebastian, who during the early Christian era was martyred. This saint's depiction is of an euphoric looking Roman strapped to a column who is shot through the head, the trunk as well as the legs with arrows. Mm, once he crossed the ocean, did this saint receive a gender transfer? It is well known that in pre-colonial America "death" is represented as a female skeleton. If Sebastiana was to survive as a death figure in hybrid America, the gender could only be understood as female. Yet, if the truth was to be known Sebastiana never wanted to be "Death" [;] really all she wanted was love, if not love at least to be respected. In the following interactive video, God must convince her that she is right for the job. Her character is revealed as barter with him for sainthood. It is her humanity that God desires at the deathbed. Sebastiana loves gossip and believes Time should be halted

to allow a revealing story to conclude. Ultimately this gives way to her self-righteous nature as she uses a satirical wit to comment on the "chisme/gossip" of human folly.

After entering the site, the viewer is asked to contemplate and assess the differences between two versions of the same script—one in which we view Sebastiana as she views herself, that is, as a fully fleshed, beautiful, and mature diva, and the other in which we view her from the vantage point of the looking glass as a calaca, or skeleton. Sebastiana then takes her position by literally approaching her vanity, her dressing table. Phone to ear, she is in the process of estar chismeando, or gossiping about a woman in the barrio who has become pregnant out of wedlock. Though it may seem off the point, the inclusion of this scandalous footnote has two functions: it bestows an air of flawed humanity to Sebastiana, and it also allows the artist indirectly to validate her own family's "unofficial" history.[27] Montoya's grandfather was the illegitimate son of Charles Illfeld, an Anglo landowner. Her great-grandmother was forty-seven years old when she gave birth to the artist's grandfather. After Charles Illfeld died, his two legitimate heirs did not wish to share the money with their illegitimate brother and therefore "closed up" the will. Although Montoya's grandfather died at ninety, he was never able to benefit from his father's vast wealth, nor were his twelve children, of whom only five survived. At the time of Montoya's grandfather's death, the will had been closed for forty or fifty years, and the legitimate sons of Illfeld willed the money to the University of New Mexico. In the context of the video, Doña Sebastiana represents both the pride and folly of such situations as well as the inherent unfairness of life.

As the story progresses, we are shown that Sebastiana's vanity, her narcissism, leads to her downfall. Her vanity is indicated by the ever-present mediation of the mirror. In Sebastiana's diva manifestation, we understand her through her reflection. She flirts with herself and with an imagined suitor while posing and speaking in a seductive manner. When God makes his appearance and asks her to be the angel of death, she answers his queries, again via her reflection. The discussion she has with God differs from the playful conversations with herself—as it is impossible to hide one's true self from God: she is frank and tries to avoid committing herself to the job that the Almighty has in store for her. He tries seducing her with flattery, noting her success in earlier roles such as the tax collector. Not buying his line, she retorts: "Tax

collector! I hated that job. . . . At least as a *puta* [whore], people ran to me and not from me!" It is only after he offers to make her a saint that she agrees to take on the position of angel of death. For her, this new position signifies a raise in her current status. Nonetheless, Sebastiana, true to her optimistic (and opportunistic) nature, muses at the video's close, "I wonder, how close would I be to an archangel?"

Ever the mestiza, Sebastiana walks between two worlds. As the namesake of a Saint Sebastian, she is as helpless to stave off the arrows of fate as he, and, in the end, she acquiesces to the will of God. However, unlike her silently suffering male counterpart, Montoya's Sebastiana has something to say about the process. Clearly outgunned, she tries to look toward the future possibilities that may lie within the job description inscribed by the Almighty. Sebastiana's ability to visualize her agency within these confines is intrinsic to the definition of oppositional consciousness. History aside, we are left to wonder if she ever did make archangel.

In both *La Guadalupana* and *San Sebastiana*, Montoya responds to the colonial hegemonic control of cultural icons. Embedded in her inquiry are questions of how devotional images function within a modern context and within nonelite class structures. The alternative interpretations offered by the artist are reflective of hybrid realities. These realities are given agency by unconventional reinscriptions of the canonical rules that govern representation and behavior: the Virgin does indeed belong on the back of a pinto, and Doña Sebastiana is, after all, psychically and emotionally fleshed despite skeletal voiceless archetypes promoted by santeros.

Conclusion

The three artists whose works have been examined in this chapter critique the colonial presence by setting up an oppositional reading of Western historicism. History and memory are not always recorded by those in power. However, this is not to say that the artists' visual discourses lack complexity, for their artworks go beyond a mere contestation of imposed history. While Herrera Rodríguez and Jimenez Underwood position themselves within their Indigenous traditions and use the visual mechanism of precontact and colonial iconographic motifs, such positioning constitutes something greater than merely romanti-

cized nativist longing. There is a recognition of their own hybridity, as both are keenly aware of the impact of biculturalism on their work: after all, the artists are also the inheritors of Western cultural and academic traditions. Likewise, Montoya's use of photography and video, media often associated with the West, underlines her debt to non-Indigenous technology. In the end, however, it is the ease with which the artists employ visual code-switching and their willingness to exploit culturally polyvalent referents that gives claim to their mestiza consciousness. As in all things postcolonial, there is a kind of etymological slide and glide inherent in definitions of Chicana art. To be Chicana/o is to be informed by many colonial pasts that simultaneously suggest multiple readings of the present. As such, Chicana artists and their work are able to validate alternative cultural experiences that are essential to our understanding of the larger American experience.

AMALIA MESA-BAINS

A Tear in the Curtain

Hilos y Cultura in the Art
of Consuelo Jimenez Underwood

She seems to be kneeling, spreading out her giant diaphanous tortilla in the ocean. The metal bars of the Border Wall loom behind her, cutting through the land and sea. A man watches through the bars from the other side, el otro lado, as she offers the tortilla to the earth, la madre tierra. Amid the lapping waves she kneels, her wet skirt billowing as the tortilla begins to float out on the surface of the water, sent on its way with what wish, what message? A lonely figure silhouetted against the ocean tide, she stands, arms akimbo, and watches as the sacred, ancient food is received by the powerful forces of nature that pull it away. She has done her walk. What remains of this beautiful moment of offering and perhaps sacrifice is the destructive Tortilla Wall, as it is called—the new twenty-mile border pieced from the remains of Gulf War steel. Constructed with triple layers in some places, the concrete pillars divide the land and divide the ancient soil of the Americas (figures 35–37).

At this moment Consuelo Jimenez Underwood blesses her new work in a gesture of healing, an antidote to the steel razor that cuts across the water and the land. Her offering is more instinctive than shamanistic. Yet we are reminded of the global traditions of flower offerings to mother water, to goddesses like Yemaya.

This beautiful vision of ancient offering is the beginning of a

new series, *Tortillas, Chiles and Other Border Things* for Consuelo Jimenez Underwood, consummate weaver and fiber artist. Responding to the provocation of the ever-increasing anti-immigrant xenophobia in the era after 9/11, Jimenez Underwood has focused her incisive artistic wit on the complex and often contradictory relations of the United States and Mexico. Her artistry is a subtle and bittersweet reminder of the US passion for and consumption of Mexican food and the paradox of growing border abuses and virulent vigilantes.

Beginning with the ancient tortilla, she uses weaving, fiber, constructed objects, and other techniques to remind us of the nutritional, mystical, and spiritual life sources in our culture. She moves beyond her earlier weaving with a dramatic elegance in work that calls to mind the multiple layers of social gesture present in the meaning of food, consumption, and culture.

In an era of acceleration and racialized advertising of Mexican fast food that has even characterized Mexican culture and food through a chihuahua, one might ponder the political context of these media campaigns and the concurrent popularity of such food. The latest market research has begun to reveal that tortillas outsell white bread. An unavoidable and tragic irony exists in legislation that attempts to scapegoat the Mexican as a drain on the US economy who must be stopped by a massive steel wall, and in attacks on education, bilingualism, affirmative action, and public health services, all while America pursues the bountiful burrito. As Mexican and Indigenous Mexican laborers plant and harvest, prepare and serve the food of the Americas, they continue to live in substandard conditions. We cannot fail to see the acute historical role Mexicans have played in the agricultural life of this country, from field to table. Jimenez Underwood's own upbringing performing the fieldwork of agriculture reflects a personal context for this art. Indigenous ancestry and spiritual practice bring her weaving into a graceful vision, cutting through her anger as she approaches the work with both humor and elegiac power.

Her new works maintain a constancy of materiality in their form and of spirituality in their content. Her revitalization of Chicana weaving is an hilo (thread) that connects ancient Mesoamerican traditions of weaving with contemporary forms and cultural language. Her fiber work brings a compelling approach to the Indigenous ceremonial source during a period of crisis in the politics and treatment of Indigenous

people in the Americas during the aftermath of the Zapatista uprising. These issues continue to gain importance, as the undocumented laborers entering the United States are increasingly Indigenous groups such as Mixtecos and others from Chiapas and Oaxaca.

Family, Labor, and the Hands

Consuelo Jimenez Underwood's weaving has its source in the experiences of her family, particularly her father, an undocumented worker who would often weave hidden in the garage during times of unemployment. She spent many hours with her father as he wove, and she describes these times as the happiest of her childhood amid twelve siblings. Jimenez Underwood credits her hand speed, agility, and capacity for the work of weaving to her farmworker background. The family worked the winter picking in Imperial Valley and the summer picking in Vacaville, and the hardships of this ranch life often meant starting school late and leaving early. In this agricultural life, close to the abundance of the earth, her earliest food memories begin with the first chile picked and the *picoso* sensibility that is a continuing source of identity.

Textiles, Text, and Threads

Jimenez Underwood has a special place in Chicana art as an important figure in recuperating the oldest of women's traditions in the Americas—the tradition of weaving. Much has been written of the origins of weaving in the Old World. Fiber structures predate recorded history, and many believe weaving originated in Egypt. Isis is depicted with a shuttle in her hand, and the Greek goddess Athena is said to have taught the art to humans. Young girls are still told of the myth of Arachne, the young woman who challenged Athena to a weaving contest only to be punished for her vanity and conceit by being transformed into a spider, eternally spinning webs. Even Scandinavians still tell their children that the stars in Orion were the staff of Frigga, who spun the clouds for Odin.[1]

But in the Americas weaving had a prized place in the daily and mythic life of Indigenous women. Xochiquetzal, the first woman, was often represented carrying a child and was associated with rain and

fertility. She is sometimes seated at a loom. Even at the end of their lives, women who were sacrificed were burned with their weaving tools and wearing paper dresses. The life of a Mesoamerican Indian woman, from birth to death, was concerned with weaving beautiful, well-made textiles. One of their obligations was to teach their daughters to weave and spin on a back-strap loom, as depicted in the images in the *Codex Mendoza* of 1542.[2]

Indigenous garments were simply made from straight lengths of cloth taken from the loom without being cut. The cloth, often brocade or tapestry, was woven with designs and often highly decorated with figured gauze, warp-and-weft-faced stripes, embroidery, stamps, and hand-painting. The quechquemitl and huipil were the most common and most traditional garments worn.

Toward the end of the fifteenth century, the textile industry in Mexico was one of the most highly developed and richest in the Americas. According to the *Codex Mendocino* and tribute rolls, during the fourteenth century the groups that were subjugated by the Aztec empire paid annual tribute to it with more than a million pieces of cloth. This revealing figure shows that cotton cultivation and weaving had reached a very high level of development, probably the highest of all pre-Hispanic history.[3]

Jimenez Underwood's work brings back these ancient skills of patience, physical labor, dexterity, rhythm, and technique that were so crucial to the work of our ancestors. She often refers to these ancestors as the viejas, those whose spirits inspire her and give strength to her work. In this tradition of complexity of surface, she has used many stamped embellishments on her weavings of organic materials. In her earlier works she used velvet, oilcloth, gauze, bark, twigs, copper wire, beading, and plastic. Her strategies have been to layer the weaving and textiles to create the metaphor of memory through faded images disappearing and reappearing as memories are forgotten and recalled at the same moment. Her technical capacity only strengthens her textiles' delicacy as she uses screening, stitching, and shredding to engage our visceral experience with the material and the meaning. Barbed wire, copper grids, and flower patterns have been consistent traces in her work, and the Indigenous has been a reference in the powerful graphic iconography of Tonantzin/Guadalupe as the central figure in a number of previous works.

The spirit of Tonantzin/Guadalupe has occupied an ascendancy

given to no other figure. She has become both an icon and a text read as a beginning for Chicana spiritual regeneration. As critic Victor Zamudio-Taylor writes:

> *Tonantzin/Guadalupe* has functioned historically as an emblem of struggle and identity. *Tonantzin* at her Hill at *Tepeyac*, would intercede for the people so that the Rain God would bestow his life-giving liquids. After the conquest, *Tepeyac* served as a focal site that continued to nurture Mesoamerican identity. Today *Tepeyac* continues to be a ceremonial center of pilgrimage, from where *Tonantzin* cures the sick and aids the poor. Her blazon *corona*, stars and roses have helped Indians and *mestizos* resist and rebel against extreme forms of suffering. From the rebellions against taxation in Colonial Mexico to the Independence from Spain and social change in the Mexican Revolution to the struggles for economic and social justice of the Southwest, *Tonantzin/Guadalupe* has been approached for sustenance and solace. Through the Chicano Movement in the affirmation of *Aztlan*, the mythic homeland, and the farm worker's march to Delano, she became a pilgrim too.[4]

It is in this tradition of politicizing spirituality that Jimenez Underwood has created her most seminal works. In the similar fashion, Coatlicue has also represented a vision of the ancient resistance in stamped and painted garments. The resurgence of spiritual iconography has been one element in the fiber work of Consuelo Jimenez Underwood. Her contrast of modern industrial materials and old traditions has given her weaving a contemporary charge. Often caught in the tension between art and craft, weaving has, in the hands of Jimenez Underwood, taken on a more complex formal property as she applies a wide range of materials to critical concerns in the hemisphere. Her works remind us of the roots of the term *textile* from the Latin verb *textere*. For the Romans it meant to weave, to braid, or to construct, and for Jimenez Underwood, these actions have been recurrent strategies in her weavings. She has used twisted and braided materials including leather, wool, silk, cotton, hair, plastic, gold thread, raffia, leaf, metal thread, mirrors, coins, sequins, beads, feathers, and other ephemera. The perishable nature of weaving often calls to mind the momentary and fugitive nature of these works, thereby enhancing their aura.

New Work—Tortillas, Chiles, and Molcajetes

In her new works, Jimenez Underwood has undertaken a scale that confronts issues in a powerful set of structured forms. Both sculptural and textual, the works bring the metaphors of food, labor, and social consumption to the fore in a transparent set of layers. The tortilla reminds us of the ancient origins of this food. Her large-scale tortilla with its thickened hojas (leaves) and fabric is held in a diaphanous tortilla cloth imprinted with the Yaqui language and text on its surface (as seen in figure 39, for example). Her mythic tortilla recalls the memories of the fabled Aztec cuisine, which included the staples of Mesoamerica that are now shared with the world. Foods such as tomatoes, beans, vanilla, chiles, maize, avocados, eggplants, potatoes, cashews, peanuts, and chocolate were treasures of the New World. The tortilla, now an integral food in American society, was and remains a main element of the basic diet of the Indigenous and mestizo people of Mexico. Maize, which grows in about a dozen rich colors, has played a role in the history of Mexico. It was believed that the great god Quetzalcoatl, who brought civilization from the Huaxteca region, created this vegetable. Legend has it that Quetzalcoatl turned himself into a black ant and accompanied a red ant to bring corn, the food of the gods, to the people. Quetzalcoatl carried the corn to Tamoanchan, a mythical Mayan place of creation, where the gods chewed up the corn and put it into the mouths of humans. The symbolic place of corn can even be found in creation myths of the *Popol Vuh*, one of the sacred writings of the Maya. All the creations of man from clay, wood, and reeds failed, and only the white and yellow corncobs pleased the Creator, according to the sacred book: "They made their flesh of the yellow and white ears of corn. Then, they husked and ground the yellow and white ears, and Ixmucane made nine drinks, these elements belonging to substances destined to give life, force and energy to the people. The *tzite* corn was the flesh of man and this is how our forefathers and our mothers were created and formed."[5]

The multitude of dishes that arise from corn include at least two hundred varieties of the tamal and life-sustaining drinks like atole, corn gruel. This basic food was at the heart of a pattern of culture that would continue for three thousand years.

In this cultural continuity, the tortilla stands alone as a central

sustenance and, in the term coined by Tomás Ybarra-Frausto, it serves as a visual symbol or "nutrient source" for a founding Chicana generation of artists.[6] Jimenez Underwood describes part of her "tortilla"-making process: "The first attempts included painting the dyed corn husks with rabbit skin glue to stiffen them, stitching them to sturdy linen, and finally quilting silk organza in between two layers of corn husks to create 'maize leaves' that were then sewn together to create large scale dimensional tortillas. . . . Then I decided to reconstruct a metaphoric 'tortilla cloth' that would not only hold and keep warm the tortillas, but also the lost memories of our ancestral past."[7]

Her *Tortilla Wall* panels (*Border Spirit*) convey the passing of time, journey, and sacrifice, and for some, ultimately, the meaning of death (figures 38–40). The scale of the three panels seizes the viewer with its melancholy beauty and its momentary recollection. What has been rendered by the US government as a boundary between peoples and a protection against imagined fears during a time of hysterical surveillance becomes, in Jimenez Underwood's art, a translucent place of memories and recuerdos. The progression from transparent to opaque organza and the palette of sacred colors—black, red, and white—is a progression of loss and redemption. The panels begin a slow transformation as the flower's falling petals and crosses encased in metallic thread give way to spaces of absence in outline, in the shapes of silver- and gold-embroidered tortillas. All the dead, all that crossed, and all that labored are rendered in the currencies of each country, United States in gold/oro and Mexico in silver/plata.

The molcajetes, constructed of mesh wire, are dominant in size and scale, bringing to mind the skin of a rattlesnake as it sheds (figure 40). Jimenez Underwood has created the skin of the molcajete. In these pieces, we experience the daily utensils for a gigantic mythic household, where the domestic life of goddesses takes place in the routine everyday grinding of chiles. The mesh shaping is like the seductive undergarments and corsets on a body, a repository, where traces of the body and the hands remain. Her chiles occupy that space of desire and sexuality, where the picoso is the source of our strength and the source of America's hidden fears. Jimenez Underwood has brought her senses, her taste, and her nourishment to us while reminding us of a society that wants our food, our hands to labor, our craft and culture, but cannot quite digest us. This is her grito and her pleito.

Summary

In her own unique form, Consuelo Jimenez Underwood has completed the Chicana Indigenous voice begun by artists such as Ester Hernández and Santa Barraza. She has found in this form a blending of the ancient and the contemporary through the spirit of her hilo. Her life as an artist/weaver is like a river with an undercurrent, quiet, strong, and continuous. Her new work is an extension of the Indigenous American voice, sacred and contestatory. To understand this artwork that is inspired by revered sources, we must return to the concept of memory. The relationship of memory to history is the connection between the past and the present, the old and the new. Jimenez Underwood's new work reaffirms that the Chicana community has no absence of memory; rather, it has a memory of absence constructed from the losses endured in the destructive experience of colonialism and its aftermath. This redemptive memory heals the wounds of the past, but once again we must face new wounds and new struggles. Her work can be seen as a political strategy that reclaims history and prepares us for current battles. In a sense, her art is inspired by the remembrances of the dead through acts of healing that reflect a fierce spirituality.

By using the ancient forms of weaving and placing her vision on the border, she focuses her art to balance Mother Earth. Her artistic terrain is marked by the sign of Mother Nature as a metaphor of gender, identity, and memory. She calls up a spiritual geography in these new works that are the site of ceremonies, the abundance of agriculture and feasting, and the place of everyday life. Our souls are mended by tearing down the tortilla curtain.

5

LAURA E. PÉREZ

Prayers for the Planet

Reweaving the Natural and the Social—
Consuelo Jimenez Underwood's
Welcome to Flower-Landia

Consuelo Jimenez Underwood's rich thirty-year career is characterized by a passionate call to what lies beyond the conventional, whether in terms of artistic media or, more importantly, of the cultural imaginary that limits our perception of the normal and even of the possible. This is no flight from reality, but rather a foray from which to remedy the social and environmental wounds of our time and place. The urgency and the promise of this call to more clearly perceive the social worlds we have fabricated and to more deeply feel our relation to Nature is perhaps nowhere more evident than in Jimenez Underwood's fall 2013 exhibition *Welcome to Flower-Landia* (figure 69), although it marks her oeuvre as a whole.

Jimenez Underwood leapt beyond the gendered and racialized demarcation between craft and fine art early on, creating work that mixed weaving, painting, print, embroidery, found objects, and multimedia installation. No small feat. To her art world contemporaries and teachers, the medium of weaving seemed to be part of Europe's art historical past, and in the present it was more suitable as a feminine, Native American, or Third World craft. Regardless of skill in execution, loom work and needlework seemed practical or decorative, not the matter of serious art, of ambitious aesthetic, philosophical, and social considerations.

We now begin to know from traditional Indigenous weavers of this continent that weaving is both a historical archive of cultural knowledge and a record of the heightened awareness of its practitioners— literally a social text. Jimenez Underwood is positioned at the crossroads between this ancient art form and those of the westernized present. First introduced to the loom in her childhood by her father, a man of Huichol ancestry, during her graduate art school days she discovered in the loom, thread, textile, and needle particularly effective media by which to focus on seemingly removed, marginal aspects of reality.

In the 1990s, renewed anti-immigrant, anti-Mexican, and post-9/11 antiterrorist sentiment gave rise to the construction of a multibillion-dollar concrete and steel wall, with high-tech surveillance equipment positioned at checkpoints along the United States' 1,933-mile-long southern border. Thus far, only some seven hundred miles of wall have been completed, largely because of the massive expense of what has turned out to be highly ineffective means of barring undocumented immigration. Instead, it has driven border crossers to more remote mountainous and desert crossings, resulting in many more deaths— numbering in the thousands—through exposure to extreme temperatures and access to little water and food.[1]

Through her loom- and needle-based mixed media, Jimenez Underwood has consistently drawn parallels between near-extinct, over-hunted wildlife such as the buffalo and the salmon, and the dehumanizing and dangerous pursuit of undocumented immigrants. In the artist's work, xenophobic nationalism is of a piece with alienation from, and callous disregard for, the environment as an ecosystem. Corporate-driven consumer culture of insatiable acquisition is not only using up the planet and laborers through excessive extraction and insufficient replenishment of the same, it has dulled our physical senses, our awareness, our instinct for survival. It is consuming us all.

Jimenez Underwood's work, apace with the funereal roll call of extinctions, alarming weather pattern changes due to global warming, the rise of the incidence of cancers linked to synthetic chemicals that gratuitously lace the processed foods lining grocery store shelves, and the spread of air, water, and soil pollution to all corners of the earth returns us to an acute awareness of the short- and long-term necessity to care for the natural world that feeds, clothes, and heals us. And if we are moved to care about our environment because we ourselves are literally

a part of the environment, then perhaps we can care about the dehumanizing treatment of our southern border's human migrants.

Welcome to Flower-Landia is an invitation to glimpse beyond the norms and the givens that have brought us to the precipice of irreversible ecological damage and human insensitivity to a life-giving perspective, a more expansive, ambitious, and yet completely natural intelligence grounded in the natural world and the preservation of the beautiful and the good within it—and within us.

One of the most powerful and now signature elements of Jimenez Underwood's mixed-media work is the use of barbed wire. Over time, the artist has repurposed this and other wire—some of it precious copper, silver, and even gold—and recycled it from industrial waste into the ink of her handwoven and stitched mixed-media texts. In early pieces, writs of our time, she wove grids by hand that functioned like fences or nets over paintings, textiles, or both. One of her earliest flag-based mixed-media pieces, *Frontera Flag #1, Revolution* (4 feet × 6 feet × 3 inches; 1993) featured the overlapping and rotated flags of the United States and Mexico (figure 10). In one corner, as if beneath and beyond these flags, she stamped images of the Virgin of Guadalupe, Coatlicue, and Mictecacihuatl—the last two, the Mesoamerican goddesses of creation and the underworld, respectively. Painted, woven, and stitched, the piece was girded with a wire grid and crisscrossed by sharp barbed wire.

In *Deer Crossing* (1997), painted white barbed wire was laid over the length of a woven and dyed ghostly strip (9 feet × 15 inches) of the four border state flowers, topped by the yellow highway caution image of a family crossing (figure 24). The piece anticipates the rendition in this exhibition of the four border flowers in *Four Xewam* (i.e., "flowers" in Yaqui) (2013) (figure 60). Although each flower is visibly crossed with barbed wire, they nonetheless pulse with vibrant, joyful golden orange, bright grass green, lapis lazuli, papaya pink, and warm vanilla white. The top of this tapestry seethes with multicolored energetic forms. In the set of four palm-size (3½ inches × 3 inches) *Sun Set/Rise CA* (2011) linen and cotton weavings, the scarlike seams of barbed wire have disappeared altogether, and instead, the life-giving star of our planet is pictured as a California poppy, its fissures only those that shape its petals (figure 56).

The use of rich color strikingly characterized her earlier work, such as two sumptuous pieces from 1999: *American Dress. Virgen de Chocoatl* and *American Dress. Virgen de Tepin (Chili)* (59 inches × 39 inches) (fig-

ures 26 and 27). Dark burgundy silk robes were stitched with metallic threads in a grid pattern, "representing the colonial mindset"; the folds of the first bear barbed wire.[2] Handwoven grids were reshaped in *Alba*, a 30 foot × 6 foot × 6 foot installation from 1997, into a conical stairway to heaven, honoring the spring ritual of spiritual ascent to the moon of the Yaqui, a culturally autonomous Indigenous people from both sides of the US-Mexico border, to whom the artist is related through marriage (figure 23).

Weaving itself is transformed in this and other sculptural work, as it is in the artist's *Rebozos de la Frontera: Dia/Noche* (2001) where barbed wire served to suspend each of two shawls constructed not as the durable, strong fabric a loom produces, but instead something held together by ordinary safety pins (figure 29).[3] At first glance, these beautiful pieces suggest glamour and wealth, but closer inspection indicates that the garments are patched together from bits of fabric stamped with the highway caution signage showing a family crossing, which for the artist recall the remains of those who met their deaths migrating in search of silver and gold, the colors of the flimsy pins binding each shawl.[4]

In the 8 foot × 12 foot × 12 foot installation at the San José Museum of Art, *Diaspora* (2003), the artist installed a two-dimensional rendition of the globe on a platform raised slightly off the floor (figure 30). Set against different blue fabrics, a landmass of pale pink fabric was configured through or bordered by flower appliqués and strewn with flower petals and corn kernels. A red barbed wire grid covered the entire planet. Across a fourth of this flattened sphere, the artist positioned a mist-like white gauze fabric. Hovering above all of these elements were three hoops, each increasingly smaller than the preceding one, rising up and away toward the ceiling. Made of barbed wire, these hoops were carefully covered in multicolored, rubber-coated wire.

The circular as a sign of the planet, of unity, and of integrity and the spatial dimension of *Diaspora* were further worked in 2005 and 2006 in *Tortilla Meets Tortilla Wall* and *Tortillas, Chiles and Other Border Things*— food-centered sculptures of tortillas, peppers, and cooking implements made from corn husks, fabric, reeds, and barbed and other wire.[5] Responding to the multibillion-dollar high-tech, heavily militarized fence that extended into the ocean at the San Diego–Tijuana border, in the 2005 performance of *Tortilla Meets Tortilla Wall*, under the watch of Border Patrol agents, Jimenez Underwood set free a corn-husk tortilla as large as herself into the ocean to see whether it would cross the

border (figures 35–37). The following year she made a six-foot reed basket and a petal-lined organza cloth to cover more of the human-sized corn husk pieces in *Tortilla Basket with Tortillas and Cloth* (figure 39). She then went on to make two six-foot-wide barbed wire, chicken wire, and plain wire *molcajetes*, evoking the traditional mortar and pestle made of polished lava stone still ubiquitous in Mexican kitchens. She also added proportionally oversized hot peppers made of barbed wire.

This *Tortilla* series marked the persistence of ancient Indigenous foods and their preparation, much as Jimenez Underwood had called attention to the remarkable, tenacious survival of American animals and plants in *Buffalo Shroud, Almost 1,000 Left* (1995) (figure 16); several mixed-media pieces featuring salmon (known for their return against the current to their ancestral spawning grounds); *Deer Crossing* (1997) (figure 24); and *Xewa Sisters* (1997), in which she embroidered the flowers of American squash rather than roses over the Virgin of Guadalupe (figure 25). The life-size scale of her more recent traditional food-based work, constructed with countless full-sized corn husks, suggests an identity between these foods and migrants, who, though hounded as illegal, are like the flora and fauna of the continent. As Jimenez Underwood suggested in earlier work, undocumented Indigenous mestiza/o workers are like salmon, returning to their homelands against all odds—natural and human-made. In this sense, the artist's increasingly humorous work opposed immigration law and xenophobic nationalism with the proven might of the humble yet persistent and increasingly cross-cultural tortilla—and its makers.

A 2009 installation, *Undocumented Tortilla Happening* (figure 50), featured three *Undocumented Flower Tortillas* of white silk organza entrapped within a painted red chicken wire enclosure (see figures 44 and 45). Installed on an oilcloth-covered table, an *Undocumented Tortilla Cloth* and a silver barbed wire *Undocumented Tortilla Basket* sat poised to receive three runaway tortillas suspended from the ceiling as if magically flying (figures 46 and 47). The translucent organza fabrication of the oversized tortillas, their whimsical adornment with flower petals, and the white-on-white stitching of Virgin de Guadalupe imagery suggest that spiritual and cultural nourishment are simultaneously at play as basic foodstuffs.[6]

In this same recent period, Jimenez Underwood began her *Flags* series, many of which she showed in 2010 at the Gualala Arts Center in California, in an installation that "rained"—from red banners across

the ceiling of the gallery—hangings made of flowers; images of maize; recycled plastic bags from Target, the *New York Times*, and Trader Joe's; small patches of the family border crossing signage she had used in her safety-pin shawls; beads; and other recycled bits. Several of the small flags she mounted on the wall functioned as prototypes of the *Welcome to Flower-Landia* exhibition's two large flags, *Home of the Brave* (2013) and *One Nation Underground* (2013) (figures 61 and 63, respectively).

A composite flag made of portions of the US and Mexican flags and an intermediary space between or beyond them had already appeared in some of her earliest work, as I have mentioned. In the 2010 exhibition, an intermediary white zone featured images of a hoe, a laboring worker, and a Libby's can, or a small circle. Other flags appeared to be slices from presumably full-sized flags and replaced stars with guns (*Guns and Stripes* [2008] [figure 42]) or with abstract geometric renderings of flowers (*Roses and Stripes* [2008] [figure 43] and *Flag with Flowers* [2009] [figure 49]). The triangular *Border Flowers Flag* (56 inches × 23 inches; 2008), made of dyed and embroidered fabric, featured flowers throughout and returned to the four border state flowers used in earlier works in place of the stars (figure 41).

Home of the Brave (72 inches × 99 inches) and *One Nation Underground* (56 inches × 90 inches) both return to the three-part composite structure of the Mexican and US flags and a white intermediary space. The first flag has a very raw texture and construction, using large safety pins to quilt (that is, bind) the flag's façade to the bottom layer, a traditional Guatemalan textile hanging several inches below the hemline. The second flag also uses the three-part composite structure but superimposes the two national flags, producing an effect of double vision. The visual-conceptual confusion of the piece is further intensified by an additional embroidered layer of the four oversized border flowers over the entire flag and a snaking diagonal borderline of blue barbed wire.

I Pledge Allegiance I and *I Pledge Allegiance II*, also completed in 2013 and scaled to palm size (3 inches × 1.5 inches), zoom in to the microscopic and zoom out astronomically (figure 62). Across fields of blue, even more abstract or elemental renditions of the star-filled canton of the US flag now appear as floating units of quantum and cosmic energy. The artist's tapestries now thematize a materiality that is inclusive of the animating physical energy that weaves visible materiality and the less visible auric.

This binding life force is, in much of Jimenez Underwood's work,

counterposed to the fencing of barbed border fences and mental or ideological closed-mindedness. This, for example, was visible in one of her earliest pieces featuring the four border flowers. The fiber and mixed-media wall installation of 2009, *Border X-ings* (8 feet × 6 feet × 3 inches) featured magnified silhouettes of the California poppy, the Arizona saguaro, the New Mexico yucca, and the Texas bluebonnet covering the focal border area (figure 48). Shown with *Diaspora*, discussed above, red barbed wire also lay like a grid over the entire piece.

"Power wands" made of beads, miniature images of the *Frontera Flag #1, Revolution* (figure 10), and the names of the checkpoints at the ten border towns on either side of the new border wall that was under construction at the time suggested that the works were performative, actively, consciously engaged in practices of "prayer," that is, of focused, intentional, directed, and energetically concentrated awareness.

The artist's immense 20 foot × 60 foot wall installation *Undocumented Border Flowers* (2010, Triton Museum) (figure 53) and the even larger fiber-based installation *Undocumented Border Flowers: Dia* (figure 57), at the Conley Art Gallery at California State University in 2011, both placed the human-made national borderline center stage within giant maps of the US-Mexico borderlands. The 2010 installation featured red barbed wire around large nails at the ten checkpoints, a kind of gash, tearing open the unified field of blue pigment on either side of it. The 2011 brown-red borderlands map also visualized the border as a sharp cut in the cloth. In both pieces, however, the entangled mess of barbed and other wire also appeared to be fraying. And in both cases, huge images of poppies, bluebonnets, saguaros, and yucca floated above, beyond, and below the proportionately shrunken line representing the nearly two-thousand-mile border. "Power wands" also appear in both; each wand bears the names of ten twin border city checkpoints.

Flowers, Borders, and Threads, Oh My!, the 17 × 45 foot installation in *Welcome to Flower-Landia*, features a very different palette based in soft whites and represents the two-dimensional silhouette of the planet entirely covered in three-dimensional border flowers (figure 59). The thick, messy barbed wire borderline, though also a knotted entanglement, perhaps is on its own way to extinction, even as it crosses the globe. The focus is no longer only the specific binational tensions of the US-Mexico border, but more fully a planetary and environmental crisis of perspective.

The matter is simultaneously frightening, a kind of Dickensian

ghostly image of Christmas Past, and yet perhaps it is also a vision of hope, of the earth thickly repopulated by plant life, visible in their spiritual structure as a unified, barely material field of energy. The abundance of flowers in this piece, and its unabashed embrace of flowers in their lovely materiality, surely signals, as few things can, the intrinsic, seemingly gratuitous, and yet essential and healing beauty and power of the earth. This ephemeral beauty of nature is evoked in *Tenured Petals*, ten pieces, measuring 36 inches long × 30 inches wide, scattered across the 45-foot length of *Flowers, Borders, and Threads, Oh My!* on pedestals of various heights that correspond to global "border checkpoints" (figure 67).

Scale and reversal are likewise central to *Welcome to Border-landia!* (2013). Five metal cactus paddles, one of which is "embroidered" with the image of the American continent, are crossed by barbed wire but also with rays of light shining from highly reflective metallic wire (figure 68). Here, too, prayer ties, power wands, or blessings (as the artist has variously called them) hang in space around this ancestral, highly nutritive and healing food plant that along with maize is an essential part of the continent and its oldest inhabitants. Awareness and gratitude for the sustenance the earth provides and the shelter it gives humans characterize the traditional guiding philosophy of this continent, a nature-based worldview grounded in the care and maintenance of respectful relationship to the environment and other beings. This view is a pragmatic "spirituality"—more to the point, an ethos—of everyday social, cultural practices aimed at maintaining the reciprocity basic to the well-being of an energetically, and therefore materially, interconnected reality.

I turn now to Jimenez Underwood's newer *Rebozos* series (2010–13) (figure 64). Though five rebozos were hung in the exhibition, when complete, the artist explained to me, she projected four per season in honor of the following "mothers": "Mendocino," the beautiful northern coast of California where the artist lives part time; Malinche/Mundane Mother, Earth Mother, Mother Ocean, Moon Mother, and the Virgin of Guadalupe (figures 31, 52, 54, 55, 65, and 66). All of these pieces move, it seems to me, even more fully into the realm of art as an intentional act of spiritual awareness, an awareness that contributes to harmonization of the energetic life force that undergirds visible, ordinary perception and the order that escapes material and conceptual grids, enclosures, and traps.

Shown in the *Flower-Landia* exhibition together for the first time, the shawl series was initiated in 2010. These exquisite rebozos, made of fine metal wire warp (the vertical threads) and other natural and synthetic fibers, turn the mind's eye away from centuries of imperialist carving of the continents, globally unequal power relations between peoples of different "nations," and disregard for the planet and its natural "resources" to the lasting power, strength, wealth, beauty, and endurance suggested by the metals from which they are fabricated. They also suggest that these qualities are feminine ones, notwithstanding patriarchy, and even more to the point, of those living with awareness of Nature as our sheltering rebozo and nurturing "mother."

The rebozos speak to what protects and abides—the ground, the warp and weft of human and other life on the planet, the Earth's animating forces themselves—and to the mundane, everyday woman, the backbone of life on the planet, whether as gender-assigned or self-identifying caregiver. The beauty and strength of these rebozos, woven with precious metal threads, powerfully render homage to everyday women, to the so-called Malinche, the fabled "first" Indigenous mother of the "new" colonized, mixed peoples after invasion of Mesoamerica. Tellingly, in modern-day parlance, a *malinchista* is a *vende-patrias*, one who betrays the nation or community. Here, the mundane woman Malinche is honored as an Every Woman, a protector of life and therefore of Nature, who works to realign the human-made social to the natural order. She therefore is a certain danger to patriarchal and neocolonial nationalist orders from which have sprung the selfsame logic that rapes nature and women, that wrings dry the planet's and humanity's life forces in the name of the individual pursuit of wealth and power.

Welcome to Flower-Landia works to shift viewers' awareness to natural reality, the ultimate test case against the denials of multinational corporate spokesmen and the evaporating front line of scientists aligned with them who insist that unnecessary (and ineffective) pesticides, animal growth hormones, synthetic pharmaceuticals, genetically altered seeds, chemical toxic waste, nonbiodegradable garbage, excessive animal sewage runoff into water tables, global warming, and so on pose no significant danger to humans or the environment.

The artist returns to our awareness a perspective that is beyond political ideologies of modern human craft, whether of the Right or the Left, to the undeniable fact that we are literally made of the same stuff as the planet. Beyond feminism and patriarchy, like nearly extinct an-

imals and plants, we, too, are of this planet, natural to it, part of it. Therefore, quite literally what happens to "nature" happens to "us." We are far beyond being able to continue using the planet as a garbage bin, beyond thinking that Earth is so vast that no matter what we trash, it won't show or really matter.

Welcome to Flower-Landia, a gallery installation of giant fabric- and metal wire–centered murals, flags, and rebozos, aligns itself with the planet and, via scale, repeatedly calls our attention back to a Nature that has been paradoxically and perilously minimized, not least within our own rib cages.

In some spiritual traditions, prayer is above all else intention. It is the directing of attention, of energy, toward a particular outcome, often toward loving union with whatever name and idea we have of the Creator(s), the creative energy that constitutes. But whether religious or secular willpower, prayer is an invisible yet energetically real act of alignment. It is a kind of weaving of our intent toward a particular outcome, whether this be replenishment of our own flagging forces, the regular maintenance of our well-being and that of others, or the powerful plea for change to remedy situations of crisis. Prayer is an act of harmonization, the sewing up of tears in the fabric of being, the reweaving of new patterns for better futures, a protective rebozo.

Weaving is an ancient, cross-cultural spiritual and practical art form. For the ancient Greeks, the art of weaving served as a metaphor of both Nature's creation and of healthy human social relations, including those of good government. Power was thus acknowledged, according to ancient Greek texts, through practices of "investment," of dressing statues of the gods or of human rulers in ceremoniously presented, intricately embroidered woven robes and cloths.[7] The so-called Huichol, who call themselves the Wixárika, and the Colombian Kogi are among today's traditional peoples for whom weaving remains a sacred activity, one undertaken mindfully through physical and spiritual preparation, sacrifice, and offerings.[8] At heart, it is simultaneously a practical art and a path of spiritual growth or wisdom—one akin, I take it, to icon painting in Orthodox Christian traditions.

I can't help but to feel and think that across time and space, to create with the intention of the greater good is "prayer" by whatever name, if by this we mean a profoundly ethical act of care and a harnessing of power, acting with an awareness that all acts, including those of art, can be acts of power rather than mere metaphors. Having

discovered Consuelo Jimenez Underwood's work in the mid-1990s, and having loved it since, I can say she continues to culturally hybridize art forms that meaningfully bring together the arts, media, and aesthetic and spiritual philosophies of different cultures, thus contributing toward truly more universal art histories and, beyond those, human knowledges.

With aspirations of spirituality and social purpose in art still dismissed as naive, wishful, delusional, or merely politically motivated—rather than "real," ostensibly ideologically disinterested art—Consuelo Jimenez Underwood's work, in which she makes use of whatever materials and media serve her purpose, continues to enact social awareness as art's inevitable intellectual, historically grounding reason for being. It continues to affirm the reality of "the spiritual," the energetic, as a practical matter. And it continues to act like an acupuncture needle, unblocking flows of awareness necessary to well-being.

In this show, she has moved the practice of art more fully into the zone of power-filled, intentional prayer, directed toward remedy of the effects of a toxic century of massive pollution and equally massive human injustice, violence, and cruelty that the legacy of the unbridled pursuit of wealth, land, and power has transformed into the highest aspirations of humanity. Consuelo Jimenez Underwood's work jumps off the loom and canvas to invite us to reweave ourselves into the fabric of a more real reality, that of Nature, of which we are each vital strands of living, intelligent energy. We can recycle the waste of this era, which we have inherited and learned to reproduce, into new social fabrics in harmony with ecological well-being. In this beautiful show, Jimenez Underwood's work suggests that we can reweave *ourselves* with fibers of deeper perception, greater care, and much needed creativity for the greater good.

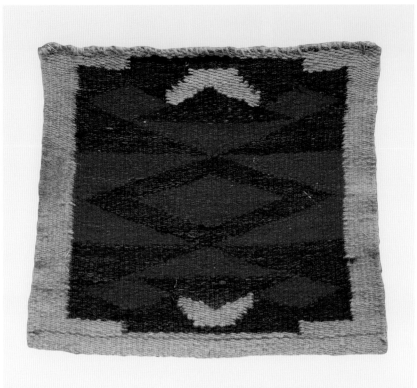

FIGURE I

Consuelo Jimenez Underwood, *C. C. Huelga*, 1974. Woven cotton and wool, 13 in. × 15 in. Photograph by Ron Bolander. Collection of the artist.

FIGURE 2

Consuelo Jimenez Underwood, *TB's Q Shirt (Quetzalcoatl)*, late 1970s. Cotton embroidery on man's shirt. Photograph by Ron Bolander. Collection of the artist.

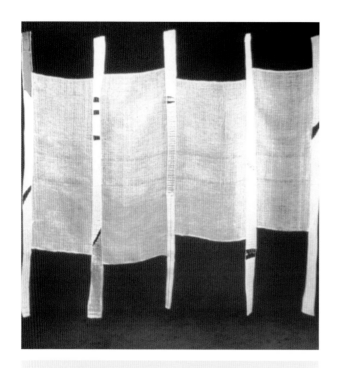

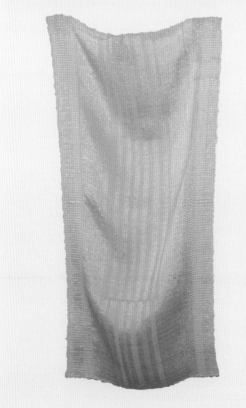

FIGURE 3
Consuelo Jimenez Underwood,
Los Muertos, 1984. Woven linen
and plastic, 60 in. × 80 in.
Photograph by Ron Bolander.
Collection of the artist.

FIGURE 4
Consuelo Jimenez Underwood,
*Heroes, Burial Shroud Series:
Joan of Arc, 1431*, 1989. Woven
linen, cotton, rayon, plastic,
57 in. × 21 in. × 3 in. Collection
of the Oakland Museum of
California. Gift of the estate of
Marjorie Eaton by exchange.

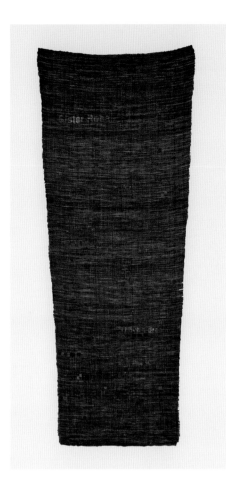
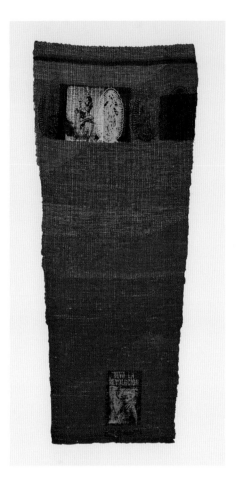

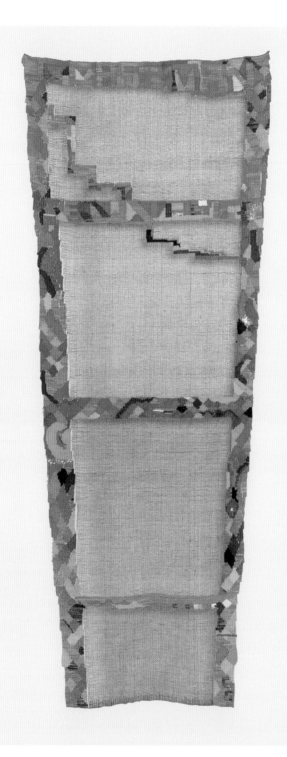

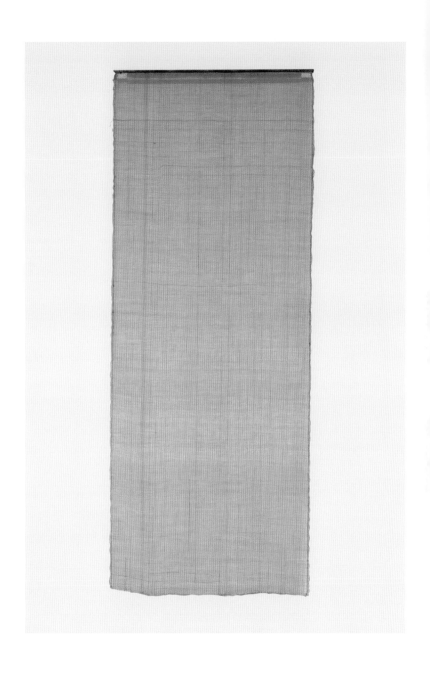

FIGURE 7

Consuelo Jimenez Underwood, *Heroes, Burial Shroud Series: John Chapman, 1845*, 1990. Woven linen, silk, rayon, 72 in. × 27 in. Collection of the Oakland Museum of California. Gift of the estate of Marjorie Eaton by exchange.

FIGURE 8

Consuelo Jimenez Underwood, *Heroes, Burial Shroud Series: Woody Guthrie, 1967*, 1990. Woven linen, cotton, 66 in. × 26 in. Collection of the Oakland Museum of California. Gift of the estate of Marjorie Eaton by exchange.

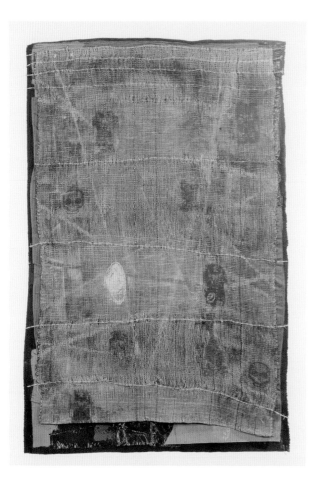

FIGURE 9
Consuelo Jimenez Underwood,
Virgen de la Frontera, 1991.
Dyed and silkscreened linen
and synthetic threads, barbed
wire, 7 ft. × 5 ft. Photograph
by Curt Fukuda. Collection of
the artist.

FIGURE 10
Consuelo Jimenez Underwood,
Frontera Flag #1, Revolution,
1993. Fiber, fabric, wire,
threads, 4 ft. × 6 ft. × 3 in.
Photograph by Curt Fukuda.
Collection of the Museum of
Art and Design, New York,
New York.

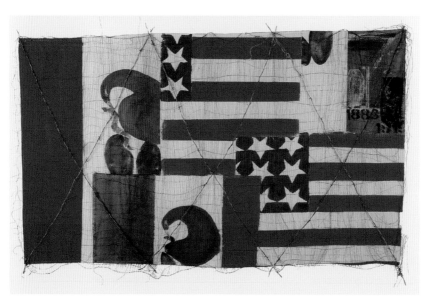

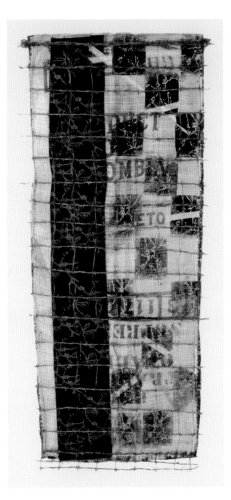
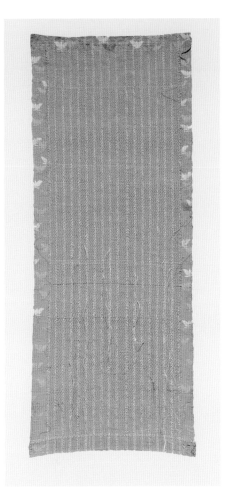

FIGURE II

Consuelo Jimenez Underwood, *Night Flower*, 1993. Woven, silkscreened, assembled, linen, wire, and barbed wire, 60 in. × 28 in. Photograph by James Dewrance. Collection of the artist.

FIGURE I2

Consuelo Jimenez Underwood, *Heroes, Burial Shroud Series: Cesar Chavez, 1993*, 1994. Woven cotton, coicoichatl (brown cotton), 66 in. × 26 in. Collection of the Oakland Museum of California. Gift of the estate of Marjorie Eaton by exchange.

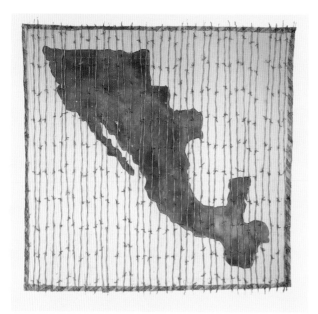

FIGURE 13

Consuelo Jimenez Underwood, *Mi Oro, Tu Amor*, 1994. Cotton, barbed wire, gold wire, paint, corn, 48 in. × 51 in. Photograph by Curt Fukuda. Collection of the artist.

FIGURE 14

Consuelo Jimenez Underwood, *Sacred Jump*, 1994. Woven, silkscreened, embroidered, silk threads, barbed wire, and gold wire, 83 in. × 38 in. Photograph by Curt Fukuda. Collection of the artist.

FIGURE 15

Consuelo Jimenez Underwood, *Virgen de los Caminos*, 1994. Cotton, silk, metallic thread, 5 ft. × 3 ft. Photograph by Curt Fukuda. Collection of the Smithsonian American Art Museum, Museum purchase.

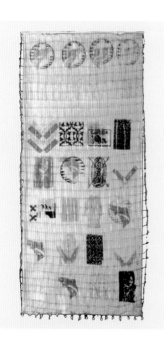

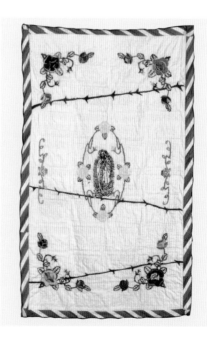

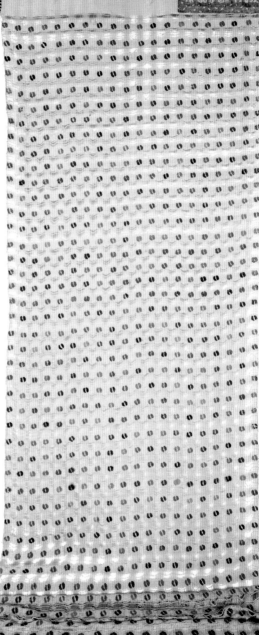

1865 - 1878
60,000,000
In God We Trust

FIGURE 16

Consuelo Jimenez Underwood, *Buffalo Shroud, Almost 1,000 Left*, 1995. Woven silk and cotton, silkscreened and embroidered, 8 ft. × 36 in. × 12 in. Photograph by James Dewrance. Collection of the artist.

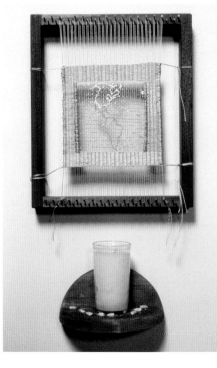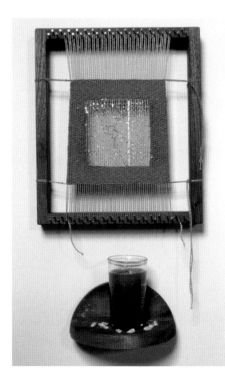

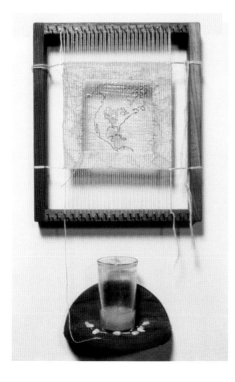

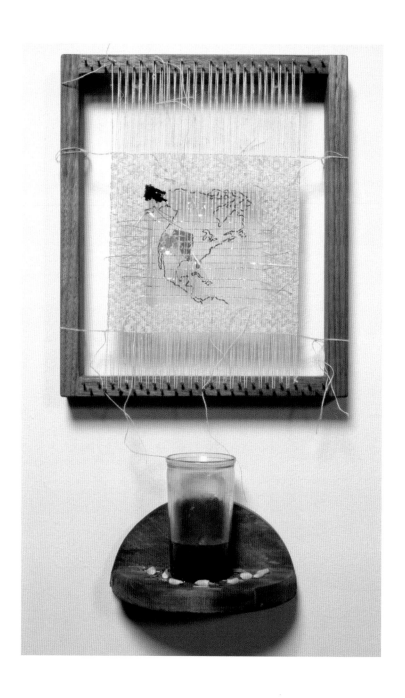

FIGURE 21

Consuelo Jimenez Underwood, *Land Grabs:
Mexican Acquisition* (green candle), 1996. Wood,
linen, cotton, silk, rayon, plastic, glass, wax, corn,
gold, 30 in. × 12 in. × 5 in. Photograph by James
Dewrance. Collection of the artist.

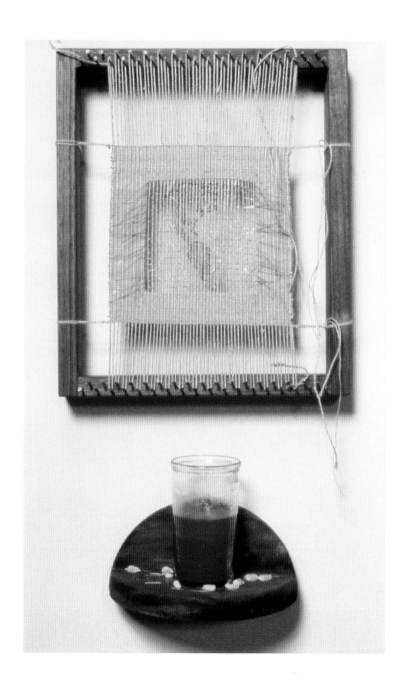

FIGURE 22

Consuelo Jimenez Underwood, *Land Grabs:
UK/France Invasion* (red candle), 1996. Wood,
linen, cotton, silk, rayon, plastic, glass, wax, corn,
gold, 30 in. × 12 in. × 5 in. Photograph by James
Dewrance. Collection of the artist.

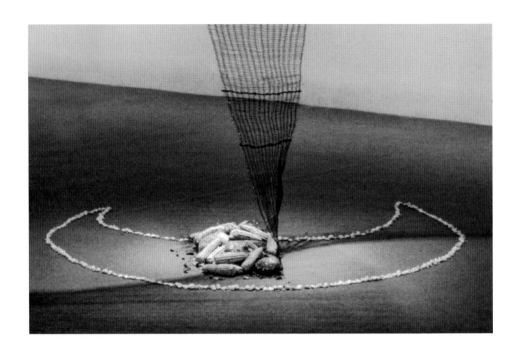

FIGURE 23

Consuelo Jimenez Underwood, *Alba*,
1997. Mixed-media installation,
50 ft. × 6 ft. × 6 ft. Photograph by
Marcos Underwood II.

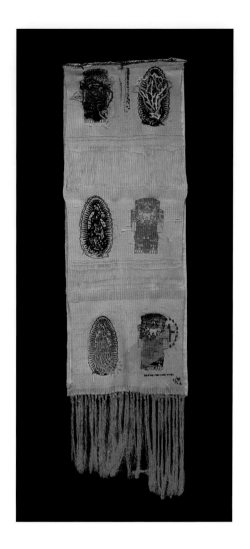

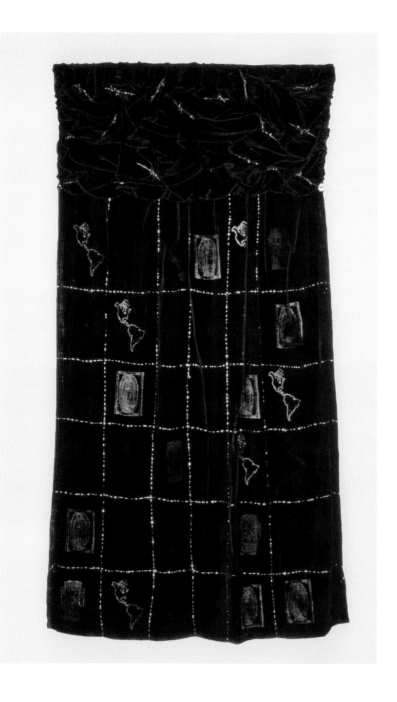

FIGURE 26

Consuelo Jimenez Underwood, *American Dress. Virgen de Chocoatl*, 1999. Silkscreened, embroidered silk, barbed wire, 59 in. × 39 in. Photograph by Ron Bolander. Private collection.

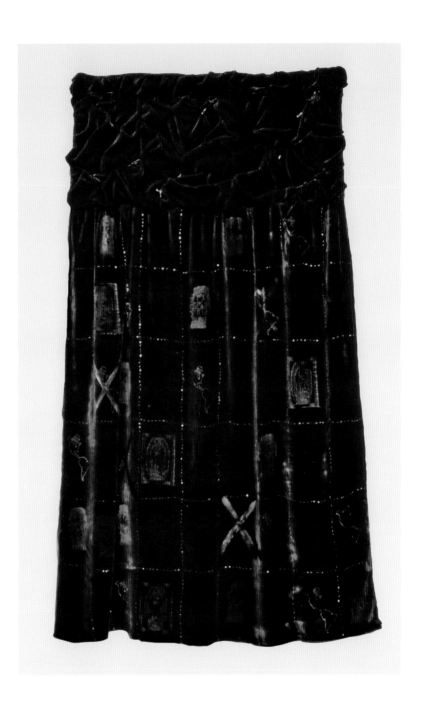

FIGURE 27

Consuelo Jimenez Underwood, *American Dress.*
Virgen de Tepin (Chili), 1999. Silkscreened, embroi-
dered silk, barbed wire, 59 in. × 39 in. Photograph
by Ron Bolander. Collection of the artist.

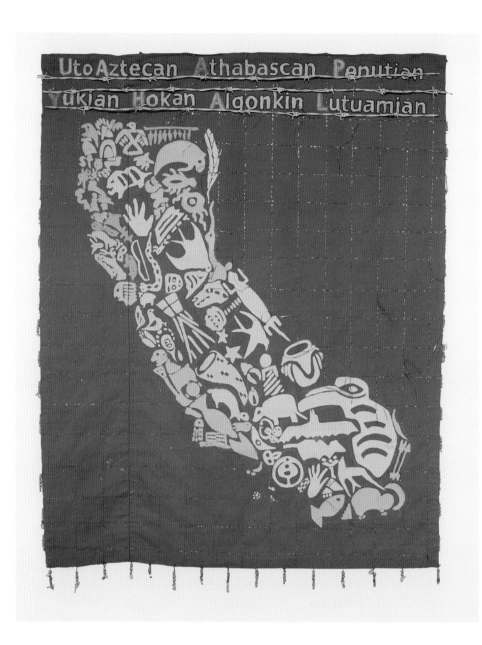

FIGURE 28

Consuelo Jimenez Underwood, *Ingles Only*, 2001.
Fiber, embroidered, painted cotton, barbed wire,
50 in. × 48 in. Photograph by Ron Bolander.
Collection of the artist.

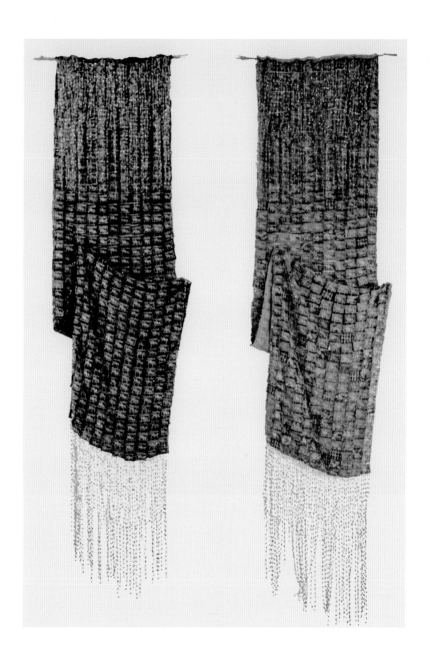

FIGURE 29

Consuelo Jimenez Underwood, *Rebozos de la Frontera:
Dia/Noche*, 2001. Fabric, safety pins, barbed wire, 9 ft. ×
45 in. Photograph by Ron Bolander. Collection of the
Mexican Museum, San Francisco, California.

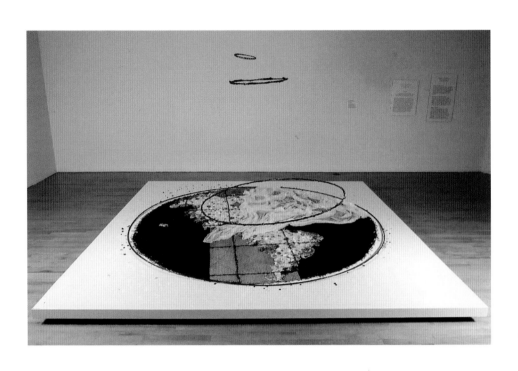

FIGURE 30

Consuelo Jimenez Underwood,
Diaspora, 2003. Mixed-media
installation. Cloth, steel,
barbed wire, buttons, safety
pins, 6 ft. × 12 ft. × 12 ft.
Photograph by Ron Bolander.

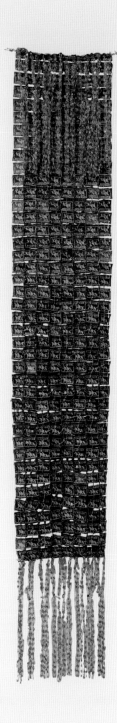

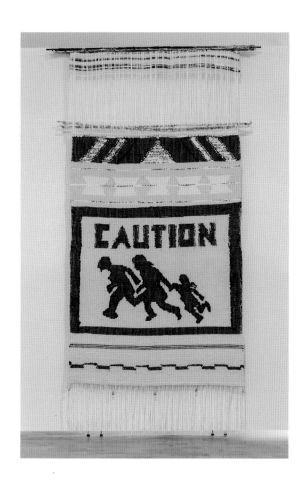

FIGURE 31

Consuelo Jimenez Underwood, *Mendocino Rebozo*, 2004. Mixed media: fabric, safety pins, glass beads, 68 in. × 17 in. Photograph by Ruben Diaz. Collection of the artist.

FIGURE 32

Consuelo Jimenez Underwood, *Run, Jane Run!*, 2004. Woven cotton, linen, fabric, barbed wire, and caution tape, 10 ft. × 6 ft. Photograph by Ruben Diaz. Collection of the Smithsonian American Art Musuem, Museum purchase made possible by the Alturas Foundation.

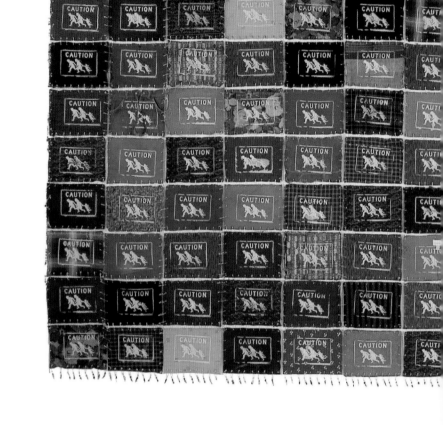

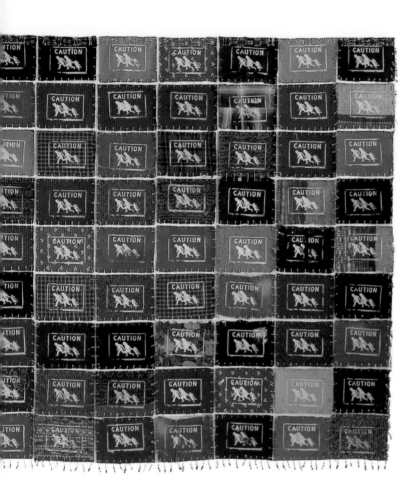

FIGURE 33

Consuelo Jimenez Underwood, *C. Jane Run*, 2005.
Silkscreened and pinned fabric, 10 ft. × 17 ft. Pho-
tograph by Ron Bolander. Collection of the artist.

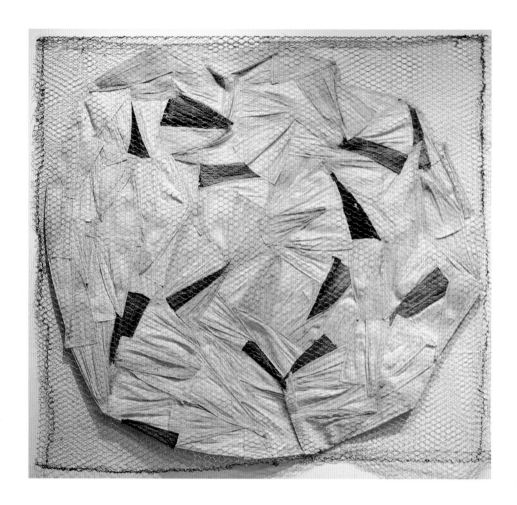

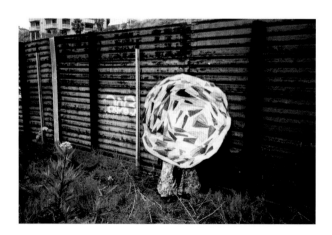

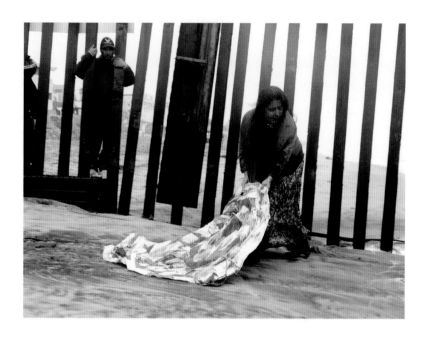

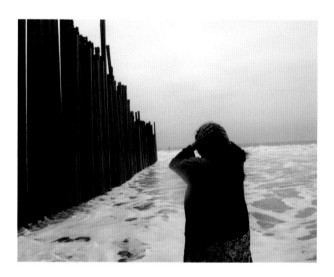

FIGURE 36

Consuelo Jimenez Underwood, *Tortilla Meets Tortilla Wall*, detail 2, 2005. Site-specific performance. InSite_05, Border State Park, San Diego/Tijuana border, California. Photograph by Robin Lasser.

FIGURE 37

Consuelo Jimenez Underwood, *Tortilla Meets Tortilla Wall*, detail 3, 2005. Site-specific performance. InSite_05, Border State Park, San Diego/Tijuana border, California. Photograph by Robin Lasser.

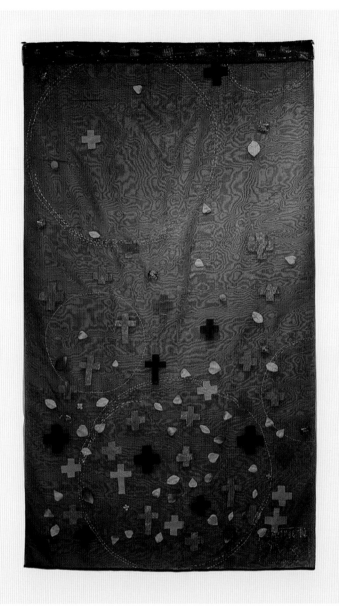

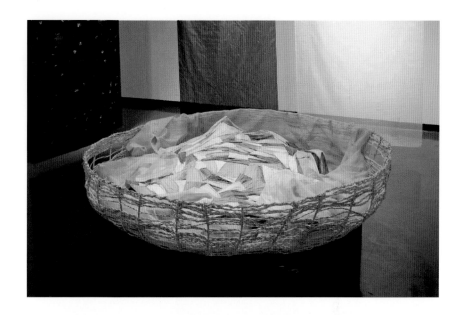

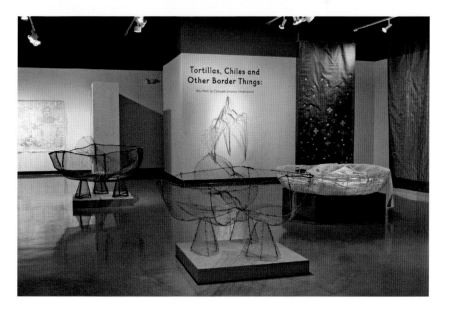

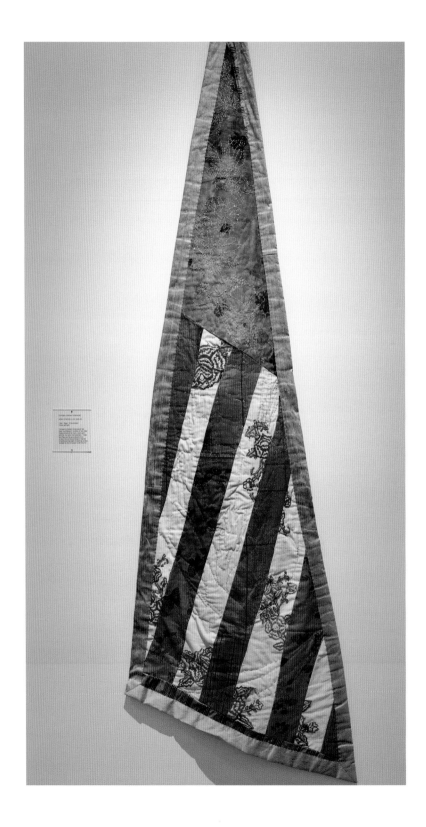

FIGURE 42

Consuelo Jimenez Underwood,
Guns and Stripes, 2008. Dyed
linen, cotton, and synthetic
threads, 18.5 in. × 8 in. Photo-
graph by Bill Apton. Collection
of the artist.

FIGURE 43

Consuelo Jimenez Underwood,
Roses and Stripes, 2008. Dyed
linen, cotton, and synthetic
threads, 14.5 in. × 8 in. Photo-
graph by Bill Apton. Collection
of the artist.

FIGURE 4I (OPPOSITE)

Consuelo Jimenez Underwood,
Border Flowers Flag, 2008. Dyed
cotton, silk fabrics, embroidery
threads, 56 in. × 23 in. Photo-
graph by Bill Apton. Collection
of the artist.

Consuelo Jimenez Underwood, *Undocumented Flower Tortilla. Caution*, 2008. Fiber, 27 in. × 27 in. Photograph by Ron Bolander. Collection of the artist.

Consuelo Jimenez Underwood, *Undocumented Flower Tortilla. Lupe*, 2008. Fiber, 27 in. × 27 in. Photograph by Ron Bolander. Collection of the artist.

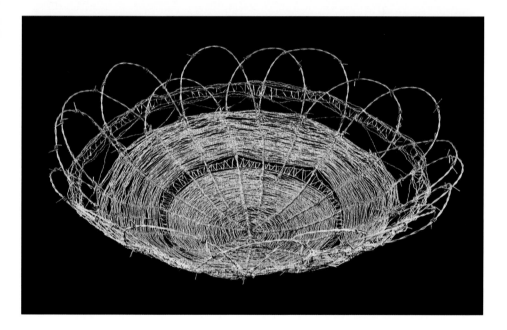

MARÍA ESTHER FERNÁNDEZ

Consuelo Jimenez Underwood

Welcome to Flower-Landia

Triton Museum of Art, Fall 2013

Consuelo Jimenez Underwood is from neither Mexico nor the United States. She is of the borderlands. Her earliest memories are of crossing back and forth through the border city of Calexico in California from Mexicali, Mexico, to work in the fields of Vacaville and Sacramento.[1] Experiencing the border as a child was both fantastic and horrifying. It was the backdrop for her childhood, enigmatic and ever present. As a child, Jimenez Underwood learned that the border was a force to be reckoned with. The fear that she experienced viscerally at a young age stirred in her a fight for survival, to preserve her spirit. Her Huichol heritage gave her the strength and purpose to infiltrate, play the game, and survive. Trained as a child to cross borders both real and psychological, Jimenez Underwood walks between opposing issues. Living in the middle as an infiltrator, she has learned to navigate contested territories: as a field-worker in the fields, as a student in school, and as an artist using Indigenous weaving traditions as fine art. Weaving became her deliberate language rooted in the aesthetic and political conditions along the border. This exhibition is an attempt to recreate that journey, to relieve the tension of a highly volatile border region as embodied by a young girl, and to reimagine it as a place

where the spirit can roam free. This exhibition is conceived in two parts, early mixed-media wall hangings and recent woven tapestries, rebozos (shawls), and installations depicting varying aspects of Jimenez Underwood's journey, paralleling her fear, joy, survival, and transcendence.

Border-Landia

As a child, Jimenez Underwood struggled to understand the grown-up interplay at the border, where many undocumented transactions occur and where people are disposable and culture is commodified. She began questioning persecution along the border and the ramifications of it for her family. Her father was a Mexican national without papers. Even her own citizenship provided no solace for her as a child crossing with her undocumented father. Rather than retreat, Jimenez Underwood was unwilling to lose her soul, so she looked inward to preserve her spirit. A child's spirit, not yet consumed by trauma, inhabits a place of joy, which, coupled with the Indigenous belief that the spirit resides in the land, is how she harnessed her strength to survive. This was the key to Jimenez Underwood's survival: an understanding that the ills of the border are engendered by adults lacking a worldview that acknowledges the spirit. Joy continues to inform her artistic practice. Her early body of work incorporates minimal weaving, which reflects the artist's lived experience as a young scholar with little time to devote to her weaving practice. This work differs aesthetically from the more recent works in the exhibition, created after she retired from San José State University. Mixed-media pieces that incorporate found materials such as plastic, wire, and safety pins pervade her earlier pieces. In these works, Jimenez Underwood's focus is on material as opposed to the weaving process.

Jimenez Underwood refers to these found materials as "mundane elements" in that they represent the gritty tension of the lived condition along the border. In many of her works, these elements do not lose their original form. In contrast, Jimenez Underwood refers to "spirit work" as the transformation of an object in the creation of a new one through weaving. Natural fiber and material such as leather, cotton, and silk are transformed into cohesive woven pieces that transcend the individual elements that form them. Minimal woven fiber is present in her earlier works as a nod to the spirit. Jimenez Underwood's artistic practice is informed by the Toltec understanding of consciousness,

the tonal and nahual.[2] The tonal is an awakened state that is associated with the structure of the physical world, which the artist equates to the mundane. By contrast, the nahual incorporates all things of the spirit world. Jimenez Underwood reinterprets this philosophical approach within her artistic practice. She conceives of her earlier work as the tonal, which uses mundane elements from the earthly and human world along the border.

Jimenez Underwood's concept of *Border-landia* exists between the disparate views of the border as a seedy underbelly of crime and violence, a hedonistic playground for tourists to prey on culture in an exploitative economic exchange, and Jimenez Underwood's internal view of the border as a place of intrigue, excitement, joy, and survival. *Border-landia* is fraught with tension as it inhabits a place of fear within her, but in doing so it elicits her survival instinct to preserve the spirit through joy and celebration. The wall installation *Welcome to Border-landia!* (2013), is a glimpse into her reimagining of the border as a bright, shiny, colorful space, as reflected in the placement of large bright-green nopales, cactus, constructed of wire on the wall (figure 68). Silver- and gold-painted nails are placed at ten points along the border where the wall is being constructed, representing the peso (Mexican currency) and the American dollar. In Mexican Spanish vernacular, the peso is commonly referred to as plata, silver, and the American dollar as oro, gold. The border towns are labeled with images of Mexican products that can be purchased on either side of the border, commenting on the contradiction between allowing the free exchange of commerce in order to satiate the American thirst for Mexican food and labor, and the construction of an imposing border wall intended to keep Mexico's people out. The border is conveniently porous and insurmountable.

Not only does Jimenez Underwood expose the hypocrisy in the US government's "protect our borders" hyperbole, she also takes direct aim at the hypocrisy in Mexican nationalism. Indigenous peoples of Mexico are equally exploited on both sides of the border, although aspects of their culture are prominent in national Mexican folklore. Jimenez Underwood is equally scathing in her critique of border transnationalism; flags from both countries are featured and reimagined in her work. It is not surprising that these flags are among the first symbols Jimenez Underwood manipulated early in her artistic career. In her first weaving, *C. C. Huelga* (1974), Underwood masterfully marries aesthetics and content (figure 1). We see the deliberate use of weaving as the method

of communication, and of Indigenous angular designs as language, with the message inspired by the farmworker politic as evidenced by the thunderbird at the top and bottom of the weaving. Although not in the exhibition, this piece is a pivotal and prophetic one in her trajectory, as it is a precursor of work to come. In subsequent iterations of her flags, we see a shift to mixed media with the introduction of plastic and wire. The careful choice of material not only creates interestingly beautiful weavings but forces viewers to reflect on the pervasive consumerism prevalent in American culture. Jimenez Underwood has used food wrappers, plastic bags, newspaper delivery bags, copper wire, and other found objects in creating the flags, as seen in an earlier piece, *Consumer Flag* (2010) (figure 51).

The newer flags in this exhibition are a return to traditional weaving, as with *C. C. Huelga*, although still mixed media with the predominant use of silk, cotton threads, and leather. Noticeably absent are the mundane found objects of her earlier pieces. Jimenez Underwood uses flags from both the United States and Mexico and makes them one in a visual reference to their interchangeability in the subjugation of native peoples. Either brand of nationalism is detrimental to native peoples and to the land. In *One Nation Underground* (2013), the flags are sewn together, one over the other, creating a singular flag; barbed wire constructed from leather depicts the physical border (figure 63). The Mexican flag's central emblem of the eagle with a serpent in its talons perched on a nopal, a cactus, is visible in the center of the flag. In lieu of the US flag's stars, the California poppy, Texas blue bonnet, Arizona yucca, and New Mexico saguaro—all border flowers—appear ghostlike on the flag, highlighting their endangered status.

In *Home of the Brave* (2013), Underwood again marries both the US and the Mexican flags, but some of their traditional elements are missing (figure 61). This piece pays homage to the survival of the Indigenous border crosser. At the center of the flag is a hoop in lieu of any national emblem or coat of arms. The hoop is an abstraction of the Mexican emblem of the eagle and the serpent. The eagle and serpent perched atop a nopal ultimately represent the land and are intentionally stylized to look like a hoop, emblematic of the strength and survival of Indigenous peoples. In addition, the flag is layered over colorful Indigenous textile. Silk flowers are sewn throughout the flag. They differ from the ghostly flowers sewn in *One Nation Underground*; they appear alive in full earthly form and suggest the quiet beauty and resiliency of Indigenous com-

munities present at the border. Barbed wire reworked as the borderline is sewn across the flag; the ten points at which the border wall is being constructed are defined by safety pins, glass beads, and fabric printed with the caution sign. These materials allude to all things earthly and human regarding the border: immigration and consumerism. This imagery is repeated throughout Jimenez Underwood's work when depicting the physical border.

The iconic and controversial caution sign, erected along the border along Interstate 5 near San Ysidro beginning in 1990, features the silhouettes of an immigrant family running. Designed by graphic artist John Hood, this image features prominently in Jimenez Underwood's work not only in acknowledgment of the perilous conditions along the border for immigrant families, but also as a personal statement for the artist, who identifies with the young girl depicted. The titles of the pieces *Run, Jane Run!* (2004) (figure 32) and *C. Jane Run* (2005) (figure 33) intentionally reference the popular Dick and Jane reading series from the 1930s to the 1970s, underscoring the grittiness at the border as witnessed through the eyes of a child. In these pieces, Jimenez Underwood again makes deliberate aesthetic choices in using fiber, plastic, safety pins, and glass beads to represent the real and mundane human elements of the physical border.

Jimenez Underwood plays with scale in all her work, using miniatures to engage the viewer on a more personal level while allowing larger pieces and installations to be more confrontational and overwhelming. The miniatures *Double the Fun* (2013) have a colorful border that represents Jimenez Underwood's assertion that, through her Indigenous identity, her spirit remains intact (figure 58). The stars in the canton, or upper left corner, of the US flag, representing the states, are missing. Instead she plays with the traditional colors of the American flag and imbues the canton with black, red, yellow, white, and green, the five sacred colors in Native American tradition, in a direct challenge to the nation-state and its borders. These pieces transition seamlessly into the next body of work. Although they are still flags, they are devoid of national emblems and mixed media referencing the physical border. They are an aesthetic return to more traditional weaving, signaling Jimenez Underwood's transcendence from highlighting the ills of the border to directly engaging the spirit.

Just as Jimenez Underwood has manipulated the flag to critique the US and Mexican governments and their policies, she has similarly

used the rebozo to address the human condition of crossing the border. Historically, the first iterations of the rebozo are depicted in pre-Columbian codices as being used by Indigenous peoples to carry bundles. The Spanish reintroduced the decoratively woven rebozo used by women at church. The word *rebozo* derives from the Spanish word *rebozar*, which means to cover up. It has become a national Mexican symbol and expression of history, art, and culture. Indigenous women use the rebozo to hold their children or around their waists to support their backs while engaging in physical labor in the fields. In the United States, the rebozo and other native dress such as the huipil have been worn by women as a political act of cultural resistance and affirmation.

Early in her career, Jimenez Underwood set a goal to weave a rebozo for the Virgen de Guadalupe. While she was in school or working in the art department at San José State University, she found limited time to weave. Her desire to weave this rebozo never subsided, so she would appease it by creating "quicker pieces" such as the *Mendocino Rebozo* (2004), using safety pins to "sew" fabric pieces with the caution symbol printed on them (figure 31). Unlike the decorative handwoven patterns predominantly featured on traditional woven rebozos, the silhouette of the immigrant family running is used as the decorative element. Its repetitive use in silver and gold creates a ghostly effect. This rebozo is for all women crossing the border who cannot weave anymore. They perilously cross the border to work, camouflaged and invisible to society, keeping our surroundings orderly and clean. The *Mendocino Rebozo* is constructed so that half is in silver and the other half is in gold, referencing the currency of both Mexico and the United States, which alludes to the exchange of people and currency as well as the disparity in what labor we value. The fabric pieces with the caution symbol are intentionally placed in opposite directions on either side of the rebozo in order to outline further the shift from Mexico to the United States.

Flower-Landia

Crossing the border suggests leaving one place for another. Although there is much conflict and turmoil in the border region, the spirit of the people and the land are still present and enduring. This message is perhaps the most important one of Jimenez Underwood's work. This consciousness reconstructs the border as a place of survival and transcen-

dence where the spirit fully inhabits the land. *Flower-Landia* existed in Jimenez Underwood's mind as a child, a way to survive the day to day. Now, as an adult, she brings this vision to life by creating transcendent pieces and situating her practice within the realm of spirit work. In this body of work, we see the deliberate use of thread; there is less use of mixed media and a more focused return to the weaving of natural fibers and material. Jimenez Underwood moves from creating overt political pieces that play with imagery referencing US and Mexican border politics to weaving more spiritual pieces that are no less political but that align with her understanding of the land. In these works we see a connection to the ethereal through the use of materials and thematic content rooted in Indigenous practice with a global perspective. Jimenez Underwood asserts that hilo, thread, is the authentic voice of the Indigenous woman. So this is how she speaks. She defines joy as "playing with threads in the weavings whose value is only in how you look at the world. There is no economy dictating the value and setting the rules of the exchange, it is pure."[3] These works reflect this time in Jimenez Underwood's career, which she defines as a moment of clarity, or nahual, allowing for more spiritual reflection within her artistic practice.

Flowers began to take a more prominent visual presence in Jimenez Underwood's work after the birth of her granddaughter, Xochil, in 1994. *Xochitl* is the Nahuatl word for flower. The flowers occupy that space in contention between what is earthly and spiritual. *Whether dead or alive in their earthly form, the spirit is always with the flowers.* At times they appear to abandon their earthly forms and inhabit the spirit world. The wall installation *Flowers, Borders, and Threads, Oh My!* (2013) is a crossing over into the spirit world (figure 59). The installation features the world map in the background, referencing border struggles all around the world. The painted borderline in brown hues depicts the US-Mexico border, intentionally contextualizing this piece in Jimenez Underwood's homeland. She refers to the border as an herida, or wound, in many of her previous works, yet here it is scabbed over. Her engagement with the border in this installation shifts to consider a global political and environmental perspective. The flowers found along the US-Mexico border are seen here in white and are placed across the entire global map, representing the earthly being in spirit form in a direct reference to the detrimental impact of the construction of physical borders on the environment. A veil of glitter sparkles to reflect the shine of an apparition. The spirit is still alive in the land.

The most personal piece is *Tenured Petals* (2013), a self-portrait featuring ten petals placed on a plinth (figure 67). Ten is a magical number for Jimenez Underwood. When she turned ten, she felt a sense of accomplishment at reaching a decade, and she used this mark of time as a framework for planning her life and subsequently for developing a system of measurement in her weaving practice. This piece also references her struggle in her academic career, having achieved tenure at San José State University while retaining her identity as a weaver after facing intense pressure to succumb to a more traditional fine art practice. The petals are placed below the wall installation *Flowers, Borders, and Threads, Oh My!* as if having fallen from the flowers before they crossed over into the spirit world. The petals were hand-dyed by using a natural dye made with yellow onion skins in order to differentiate them from the ethereal white flowers of the wall installation, underscoring their earthly form.[4]

The series *Sun Set/Rise CA #1-4* (2011) (figure 56) and the tapestries *Four Xewam* (2013) (figure 60) embody the joy at the core of Jimenez Underwood's artistic practice and were created solely on a loom. These brightly colored floral pieces are playful, yet they have visible references to the border, with the borderline running through them. The barbed wire representing the border in these pieces is constructed using leather. Rather than sewing the barbed wire on top of the weavings, as in her flag series, Jimenez Underwood weaves the barbed wire into the tapestry as if it had been consumed by the spirit. The deliberately colorful bordered edges on some of the tapestries are references to childhood that, for the artist, bring joy to the individual pieces. In these works Jimenez Underwood again exclusively uses natural fibers and material in her weaving in an attempt to inhabit the realm of the spirit. There is less use of metal and plastic, what Jimenez Underwood refers to as earthly, human, and mundane elements. Woven fabrics, leather, and thread pervade the work.

Jimenez Underwood's *Rebozos for Our Mothers* series (2010–2013) features five rebozos of varying sizes (figure 64). Each is woven for one of the spiritual mothers: Mundane Mother (Malintzin/Malinche), Virgen de Guadalupe (Tonantzin), Earth Mother, Moon Mother, and Water Mother and Rain/Serpent Mother, which are two rebozos paying homage to water.[5] In weaving rebozos Jimenez Underwood anchors the spiritual mothers to everyday women. Having transcended the mundane aspects of earthly life and therefore clothing of any form, through as-

signment of a rebozo the mothers become of this earth. The vertical orientation of the work is not a misinterpretation or misuse of the rebozo; it is a reorientation in order to tell a story of rebirth within the divine. The shift from mixed media to thread is further evidenced in this series. All the rebozos in this series share similar characteristics. For example, most contain both woven and found fabric to varying degrees. In addition, each rebozo uses fine metal wire in the warp, or vertical threads, to create a strong structural base. Jimenez Underwood selected threads in vibrant colors with flecks of silver, gold, or both to suggest the ethereal. Each piece has related imagery such as flowers and crescent and full moons stitched throughout. Jimenez Underwood's rebozos not only reflect an aesthetic shift in the use of media; they signal her transcendence to a spiritual plane. The first rebozo woven in this series, *Mother Mundane* (2010), is made up of mostly wire, giving the form a rigidity and strength symbolic of our carnal mother, Doña Marina/Malinche/Malintzin (figure 52).[6] Malintzin is a controversial historical figure from the time of the Spanish invasion and is often portrayed in myths as a traitor to her race for having served as an interpreter to Hernan Cortés. Chicana scholarship, however, has contributed to a feminist recasting of Malintzin as a slave who rose to political prominence.[7] Whatever the interpretation, she is considered the mythical mother of the mestiza. Jimenez Underwood explains that she felt a pull to weave this rebozo before moving on to the other mothers. This tension to complete the rebozo for Mother Mundane is reminiscent of the Toltec philosophy that one must wrestle with the mundane, or tonal, to achieve nahual, or spiritual transcendence.

Jimenez Underwood made deliberate aesthetic choices early in her career, driven by a political critique that had traces and hints of the spirit. Her perspective, rooted in her Indigenous traditions, has been that of a survivor; however, her motivation has been to expose the ills along the border and their effects on the spirit. The overtly political mixed-media pieces set a foundation upon which Jimenez Underwood attempts to correct historical inaccuracies, shed light on current inequities, and heal the spirit. This exhibition maps a trajectory of Jimenez Underwood's life's work, both personal and political.[8] During childhood, joy was survival; during adulthood, it is the path forward. Jimenez Underwood explains that this work is a movement forward, a completion of a message that is a higher calling, transcending the horror she experienced as a child and fully residing in a place of joy.

EMILY ZAIDEN

Between the Lines

Documenting Consuelo Jimenez
Underwood's Fiber Pathways

Rarely does an artist's chosen media and artwork embody her in-
dividual essence as universally as in the case of Consuelo Jimenez
Underwood. Lines are the root of her creative practice—physically,
representationally, conceptually, and metaphorically. The basic
unit of her artistic process begins and ends with the line, whether
a piece is constructed by weaving or sewing in thread or barbed
wire, or through paint, pastel, caution tape, and even the removal
of painter's tape. As a child, she first became fascinated with art by
drawing with lines of embroidery thread. In weaving, each piece is
structured on a foundation of lines, and it can only grow through
the addition of threads added line by line. This generative process
via lines reflects her central concern with the borderlines that exist
between cultures and places, past and present, and the spiritual
and the mundane. Lineage is another key guiding principle in her
overall outlook. By no small coincidence, she charted a deliberately
linear path for herself to becoming a mother, teacher, and artist.

Jimenez Underwood's earliest memories are tied to cloth. As a
child, she dreamed of weaving rebozos (shawls) like those she saw
wrapped around the arms and over the heads of Indigenous women
at the Mexicali-Calexico border, where her family lived. Their col-
orful, patterned textiles were what drew her attention amid the
frenzy of people, unfolding drama, and constant action. Many of

the women wearing these shawls were beggars. Their handmade rebo-zos were old and ragged but to her they were beautiful and dignified—symbols of their Indigenous identity. She knew this was also her iden-tity, in part. She saw the fringy, frayed ends of their skirts and imagined the places they had seen.

As a young girl, Jimenez Underwood learned to embroider from her mother, and she loved watching her father weave on a frame loom. She was an avid reader especially of nonfiction, thanks in part to a book mobile that came to the fields where she worked alongside her parents, who were migrant workers. They lived in both Calexico and Mexicali; her mother owned houses in both places, and they would shuttle back and forth between the two cities and wherever they could find work.

When she was fourteen, at a dance she met a boy who would be-come her husband, and they married four years later at the age of eigh-teen. The couple left the Imperial Valley and had two children. With a family of her own to care for, she decided to formulate a ten-year plan for the next decade of her life. Once her children were almost teenag-ers and her husband had finished his doctorate, it was Jimenez Under-wood's turn to go back to school. She opted for art over religious studies because she knew she could challenge religious patriarchies through her work as an artist.

She enrolled at San Diego State University and learned to weave while studying painting. Finally, she saw her chance to make a rebozo of her own. Torn between painting and fiber, while sitting at a loom in the studio one day she determined that paint was not what spoke to her as much as the canvas itself. Despite her consideration of the hierarchies between craft and art at that time, fiber was her calling. She dove into the field—learning everything she could about spinning, thread mak-ing, natural dyes, and a variety of techniques.

At San Diego State University, with guidance from the respected head of the textile program, Joan Austin, she attained a master's in art. Austin came to the school from Cranbrook Academy of Art and was steeped in the Bauhaus approach to textiles. With a strict emphasis on technique, form, and respect for materials, she taught Jimenez Under-wood process, traditions, and how to skillfully execute tight, perfect weavings. Austin took Jimenez Underwood under her wing, leading her all over San Diego to immerse her in the art world. Her critical piece of advice was that Jimenez Underwood find her distinct voice.

Jimenez Underwood decided that her weavings were going to be

tough—not just aesthetically beautiful things. With skills and a solid grounding for her artistic practice, she went on for her MFA to San José State University. While there, she was forced to shift gears as content became paramount to form. She learned how to express herself as an artist and how to use materials to help her in her expression. Articulating the meaning behind the work came naturally.

As the lone fiber student in the program, she was surrounded by painters and mixed-media artists who questioned her focused passion for the traditional medium. She saw it as a realm that could become her own. They questioned her obsession with weaving, and her response was, "Would you have told Van Gogh you're getting too obsessed with painting, try weaving?"

Shortly after finishing her MFA, she was hired to helm the fiber/textile program at the school in 1989. In accordance with the decade-long plan she had plotted for her life when she had been a young girl in the farm fields, she landed a tenure-track position at San José State University, where she continued to teach for the following twenty years. Everyone who entered the fiber studios under her watch would leave empowered with "thread knowledge" to be able to expand the potential of fiber as an artistic media.

Jimenez Underwood started making burial shrouds dedicated to her heroes in the late 1980s—initiated with one for Joan of Arc (1989), whose story had given her hope when she read it as a nine-year-old (figure 4). These woven wraps were related in form and function to the rebozos she had always admired. She wove commemorations of individuals who were willing to die for their beliefs and whose strength and courage deserved to be honored and protected for posterity. Ten years after weaving the hero shrouds, she created her first true rebozo, inspired by the idea of an Indigenous woman who must use safety pins to complete the piece because she has no time to sew. She reinvigorated this ancient woven textile tradition as a format for expressing modern concerns and conflicts. Today, she creates two rebozos per year through her labor-intensive process.

In her tongue-in-cheek *Father, Son and Holy Rebozo* (2017), she depicts what she considers to be the "Holy Trinity of border region headgear": the sombrero or cowboy hat, the baseball cap, and the rebozo, which is positioned below the other two (figure 74). Jimenez Underwood notes how the two hats serve as symbols of masculinity and are worn on both sides of the US-Mexico border without distinction. The

authoritative sombrero at the top, in the northernmost position, is intended to represent the father. The baseball cap below, a newer form of headwear, is south of the cowboy hat, and it represents the son. Jimenez Underwood overlaid the line of the US-Mexico border in copper and silver wire with metallic threads on top of each of the two segments to suggest the question: Who wears what, and where? Both hats are now interchangeable and ubiquitous, regardless of the nationality or citizenship of the wearer. The absurdity of making these distinctions has undoubtedly larger implications, and Jimenez Underwood explores this theme throughout her work.

In this piece, three manifestations of gender and cultural identity are placed in juxtaposition. In addition to noting how contemporary clothing and popular culture migrate freely over borders, the piece touches on the issue of how women fit into the trinity of society, politics, and religion. As a child learning about Christianity, Jimenez Underwood questioned the exclusion of women from the Trinity. Fringe in the lower third portion of this piece represents how women are beneath everything and often pushed to the bottom. Simultaneously, the piece is indicative of how, as Chicana art theorist Laura E. Pérez describes, Jimenez Underwood has consistently undermined "contemporary gendered and racialized distinctions between art and craft that demote weaving to a 'feminine' or 'third world' artistically undeveloped 'craft.'"[1]

Triality pervades Jimenez Underwood's work as a reflection of her beliefs and her ancestry. Her approach to her work involves equally the hand, mind, and spirit. Identifying as a Californian Chicana of Mexican and Huichol descent, she has always drifted between the margins of three cultures. Through her father, she inherited her connections to Indigenous and Mexican culture, and her mother was a bridge to her Mexican American identity; Jimenez Underwood absorbed these histories while growing up straddling the border.

Jimenez Underwood came to understand the border as a young child of a bracero. Some of her earliest memories as a three-year-old involved smuggling her father across the border under her feet in the family car once the bracero program was terminated. The trauma of witnessing officials violently taking him away when he was discovered was something that never left her. He played a game of cat and mouse with the government for years until he finally received a green card.

The triality of nations is further manifested in *Quatlique-landia* (2017), as the ghostly image of Aztec goddess Coatlicue seeps through

this stitched and embroidered US flag, which was formed over a nylon Mexican flag (figure 77). Jimenez Underwood has worked on merging the flags of the United States and Mexico formally, structurally, and thematically in her work since the early 1990s. Through the zig-zagging mayhem of colored and metallic threads, Coatlicue's ugly, powerful face and skirt of serpents imbue the striped US flag with her spirit. She will not be erased nor limited by arbitrary political boundaries. Her pregnant, protruding belly holds both the eagle and the snake of the Mexican flag.

Jimenez Underwood's art exemplifies what textile scholar Beverly Gordon describes as the "holistic consideration of the symbolic and literal importance of cloth in human life."[2] She has created other rebozos to signify a reconnection with the spirits of the land and the elements—envisioning them as offerings to spirits that cannot be seen but can only be felt. After weaving a series of rebozos dedicated to Mother Earth, she decided in 2016 that a rain rebozo was long overdue. *Mother Rain Rebozo* (2017)—woven in linen, metallic, silk, and wool thread—was initiated as a rain dance or prayer to encourage an end to the California drought (figure 76). This masterful piece subtly captures the shimmer of falling raindrops over arid earth. When she started the weaving and the rains finally came, her artistic meditation was actualized.

The resist-dyed ikat warp anchors a herringbone pattern of gradations of blue. At the bottom of the piece, the defining fringe of a typical rebozo is alluded to as a woven implication. Jimenez Underwood conceived of the piece as a woven portrait of the rain serpent mother. An indicative demonstration of how Jimenez Underwood plays with the balance between tightness and looseness in her work, she left the ends free and unbounded by the limitations of perfection. Incorporating threads of varying thicknesses, she evokes the elusive and fluid quality of water with specks of color from the finest of threads. "We can't even see [water] sometimes. It's a mist as it falls until it collects on the windshield. When it's in space, you can't see it, like these threads. But after they build up, you see it."[3]

Once the rains finally began, Jimenez Underwood created a piece to capture the wonder of color that appears when rain falls. *Inside the Rain Rebozo* (2017) is woven and embroidered on a warp of fine blue wire with the spectrum of color that appears as the sun hits each unique rain drop (figure 75). The top of the piece is what Jimenez Underwood calls "the cloud kitchen where rain begins." The eyes, nose, and fangs of the

mythical rain serpent peek through. Individual drops of rain fall toward the rolling California landscape at the bottom. Strips of a printed commercial fabric separate the fine wire threads of the fringe and serve as reminders of the mundane acts that fill our days and lives. This simple fabric reflects Jimenez Underwood's fundamental belief that art can bring the mystical into the mundane: "I love bringing the lowest into the highest realm."

The driving notion that our society is no longer living in spirit, and that we are consumed strictly by the mundane, compels Jimenez Underwood to create works like these to remind people that there is something much bigger than and outside of ourselves. Jimenez Underwood acknowledges the challenges in reaching people with this realm of subject matter in this day and age. Nonetheless, she encourages us to question how much of the everyday we can put aside to look instead at larger issues.

Wire, as used in this piece and in most of her work, has been a signature element in Jimenez Underwood's art since her graduate studies days at San José State University. The untapped potential of the material carried her work into a new level. The nature and properties of wire as a strong, quotidian, and industrial material offered both physical and conceptual depth. She admired its solid presence as a striking, reflective, and unexpected contrast to more traditional thread materials. It instilled aspects of her own character into the work. Her ability to create fiber forms that contain a blend of enticing softness and inner strength has set her work apart: "The difference in wire weaving is that it's like one of those kids that you tell it to go there and it goes over here. Whereas with the silk, it will do what you want it to do and the cotton, it's very predictable. The wire, you've got to keep your eye on it because it does not want to go with the program. It kind of has its own mind, so I can deal with that. I was one of those kids . . . I tend to use [materials] to my advantage."

Her frequent and pioneering incorporation of barbed wire takes her material innovation even further. To Jimenez Underwood, barbed wire is a weapon of natural devastation because of its long-standing history of being used to impose barriers on open lands: "The barbed wire is one of those inventions of the colonists here in America . . . to keep the buffalo out, the cattle in. . . . But it was used to divide up land and we use it now for fences. As a child, when we had to cross that border with my dad, the border was a cyclone fence with barbed wire around it.

I always felt that was such a horrible, ugly mark to have between these two towns."

In her lacey, barbed wire basket from *Undocumented Tortilla Happening* (2009), she intricately formed a traditional yet oversized basket for tortillas from this visceral material (figure 50). The basket was the anchoring element within an installation that provided commentary on the state of immigration policy (figure 47). It was shaped with the memory of her father being caught and detained repeatedly during immigration raids as she was growing up and the impact of living in constant fear, poverty, and instability. She notes in her scene-setting narrative for the piece: "Imagine the wee hours of the night, in a kitchen, in a home, where tortillas have Spirit! There is a loud noise, OPEN UP!! YIKES!! IT'S ICE!!! The *Undocumented Tortilla Basket* remains calm and stoic. The tortillas are super startled, flying right off the tabletop! It's the *migra*!!"

The tortilla has been the basis of the diet in cultures across the Americas for centuries. Jimenez Underwood interprets its circular shape as symbolizing a halo of spirituality, which is echoed in the shape of the basket. Combining barbed wire with regular wire, she built the walls of the basket in a pattern that mirrors typical industrial fencing.

Around the same time that she was constructing the walls of an enlarged basket, she decided to create the first in what would become an ongoing series of large-scale wall installations that depict the border wall. In contrast to her intimate rebozos, Jimenez Underwood made the decision to "go big" with the border wall installations, a message that is intended to overwhelm and overtake the viewer with beauty and urgency. "There is an alarm system going off in the borderlands and everywhere else in the world. Borders are changing the earth's physical environment in a negative direction. I feel no one can hear it. Maybe if I can show it, reveal it, travel the issue around. . ."

Jimenez Underwood easily traces the line of the US-Mexico border freehand at this point in her career, having depicted that politically charged boundary for years in various formats throughout her work. After being raised in the shadow of its looming presence, she knows the invisible line that crosses North America by heart. This line is the beginning and impetus of her *Borderlines*, which were initiated with a piece entitled *Border X-ings* that she made for a group show in 2009 at the Euphrat Museum of Art in Cupertino, California (figure 48). At that time, US Customs and Border Protection reported that more than 580 miles of barriers existed between the United States and Mexico. Today, there

are roughly 700 miles of erected barriers along the nearly 2,000-mile distance between the two countries, and that number is slated to change potentially with the current political administration.

With parallel origins in mural traditions and graffiti, each wall evolves from a thin pencil line that Jimenez Underwood draws and covers in tape before adding a scrawling, frenetic intermeshing of paint and pastel. These walls are the result of Jimenez Underwood's approach to artistic mark making. The border itself is, in her eyes, one of the strongest acts of mark making that our society has generated.

Each border wall installation emerges through a progressive layering of painted, drawn, and tethered lines. At the core of the image, the border cavity itself is formed through subtraction. Toward the end of the installation process, Jimenez Underwood removes the initial strips of tape to echo the void that the actual wall imprints on the land and the dead zone that surrounds its immediate vicinity. Jimenez Underwood's central line remains bare amid a convulsion of wiry scribbles and radiant streaks of color symbolizing people traveling to and from each side of the border.

These enveloping installations spark discussion about the contested boundaries that define place and identity. Beyond addressing the social impact of the border, giant cut and embellished fabric "spirit" flowers float across the landscape. These are the materialization of Jimenez Underwood's notion of "undocumented flowers," which are reminders of the beauty and autonomy of nature, which knows no boundaries. Her lyrical reading of these flowers is a response to the ecological impact of the border on all living creatures.

Flowers fell into Jimenez Underwood's vocabulary once her granddaughter was born and was named Xochil, which means flower in Nahuatl. At that point, she suddenly looked differently at the native flowers and weeds that grow along this threatened zone. She started representing in her work the four "cousin" border state flowers—yucca, Texas bluebonnet, saguaro, and the poppy—to indicate how the natural world is impacted by this divisive process. By depicting these flowers, she instills new meaning into the phrase *native species*. They are now key elements that appear throughout her installations. "These wild flowers have become state flowers, but they don't have documentation. Even worse, by that wall, the life force that's in the land that sustains them is being decimated. There's no life; there's nothing growing up to three to five miles on each side of that wall. So, we're not just invading their

territory. These are Indigenous flowers of America, but we're also decimating their homeland."

Jimenez Underwood's installation *Undocumented Border Tracks* (2017) reflects her core wish for protecting the fundamental ties between landscapes, cultures, and animals as well (figure 78). In addition to the scattered flowers, Jimenez Underwood incorporates stenciled paw prints and hoofprints of various animals that make it to the border, only to end there. Environmentalists have expressed increased concern about butterfly migration corridors and the future of species of regional wildcats—the ocelot, the jaguarundi, and the jaguar—among other animals. Studies and reports have asserted that the existing fence already endangered species and harmed fragile ecosystems.

The palette for each incarnation of these walls links the installation to the location where it is shown. Jimenez Underwood was inspired by the colors of Los Angeles with *Undocumented Border Tracks*. Emanating out of the whiteness of the border are the colors of her memories of living in a city on the edge of the Pacific Ocean that glows at night with neon streams of headlights and street signs. The blue ocean waves, the beaches of Malibu, and the purple surrounding mountains provide the initial perimeter, which bleed into the smoggy haze of the sprawling megalopolis. Darkness encroaches on the outer edges of the border wall—alluding to the stories of crossing through at night.

This is the tenth in her *Borderlines* series. She has created a new format for site-specific mural-based work by incorporating various fiber and found materials that bring dimensionality to the piece. Integrating safety pins, plastic beaded necklaces, torn strips of fabric, and extra-large nails, she references the dreams and dangers that the border signifies: "I love the safety pin, because it's a very humble object in our society, but yet it has this power to connect. I always felt that the most important things are overlooked in our society and culture. I'm here to bring them to the forefront."

Dramatic steel nails the size of stakes represent where the main border crossings were located in 2009 when she started the installations. Since then, many additional crossings have emerged. Labels for each of the border cities dangle from safety pin chains on these exaggerated nails. These tags are the same ones she has used since she installed her first wall. The machine-stitched lettering is printed on photographs of identical products found on shelves in grocery stores located on both sides of the border. Nails north of the border are painted gold whereas

the nails below the border are silver, symbolizing the historic US gold standard and the prolific production of silver in Mexico. A web of caution tape, metallic threads, and leather barbed wire links the nails to one another. These spikes are a reference to crucifixion, as Jimenez Underwood views the border fence as being nailed onto Mother Earth with the same brutality.

Jimenez Underwood's dedication to nature via her art reflects a yearning for spiritual connection and also her personal bittersweet history, having spent her childhood years on farms, working the land alongside her family. She would arrive at school late and leave early to help her parents. Those circumstances made her decide as a nine-year-old that she was going to get out of the fields and live her life differently once she was old enough. At such a young age, she had already started thinking about getting from point A to point B, which in some ways was a reflection of how she got through picking fruit and doing other manual labor. It was a process of physically moving from one line to the next within a certain time limitation. This clear goal of linear progress, both in her life and in the creation of each work, characterizes her to the core. She built herself a lifeline out of the challenges.

Having found her own pathway in art, experiences from her early life gave her self-knowledge and empathy to motivate emerging art students for decades. She retired from San José State University in 2009 to focus strictly on her art creation, yet she remains a teacher by identity and soul. For *Undocumented Border Tracks*, she invited students from Fairfax Magnet Center for Visual Arts and William Jefferson Clinton Middle School to participate in workshops to generate power wands and install ghost flowers that are interspersed across the wall. Jimenez Underwood guided the students to approach their additions to the wall as expressions of their own aspirations, pride, and heritage.

The students' flowers and wands serve to bless the land and to bring to it optimism and regeneration, as these young people carry the promise of the future in their own hands. High school students were taught to honor the strength of their individual branches and to make wands imbued with the power of the mind and heart. Each wand, made from a collected tree branch, has found elements that dangle from safety pins and wire as personal amulets. Additionally, transparent images of loved ones who traversed borders were included in order to inspire these young artists as they move forward.

Jimenez Underwood encouraged the middle school students to find

their inner beauty and individuality as they shaped their colorless flowers with beads, safety pins, and thread. Her goal was to anchor these young people in positivity and activity so that they can become lifelines toward change. Her intent is for these walls to motivate our community to stand up for the invisible and the voiceless, the flora and fauna. To that end, children are the tenuous hope that survives, despite the odds.

Jimenez Underwood's *Undocumented Border Tracks* is simultaneously an altar that commemorates freedom and the lives of all kinds of creatures that have been lost as a result of this physical and political barrier. The history of the border wall is brief when compared with the amount of time that the natural environment existed before this human-made intervention. In a relatively small span of years, such staggering damage has been caused. All that remains is a short moment of time in which to prevent further destruction from taking place on this land. Her wall is a temporal offering. It is constructed and, in the end, removed. The larger-than-life piece is ephemeral, but Jimenez Underwood will undoubtedly reconceive of it for other venues in new places and it will continue as she charts her way along her line. "The last one is always my favorite and the idea that's not made yet is the coolest."

CLARA ROMÁN-ODIO

Flags, the Sacred, and a Different America in Consuelo Jimenez Underwood's Fiber Art

Methodology of the Oppressed, the Nation, and the Global Market

In Chela Sandoval's Chicana political theory, the notion of "oppositional consciousness" is part of the "methodology of the oppressed," a process by which marginalized and oppressed peoples resist dominant ideologies. This consciousness is deployed via five technologies of resistance that work individually or in concert: (1) "semiotics," or the interpretation of signs and symbols; (2) "deconstruction," or the dismantling of a material form in order to extract its dominant meaning; (3) "meta-ideologizing," or the appropriation and transformation of dominant ideological forms; (4) "democratics," or a moral commitment to equality; and (5) "differential movement," a reappropriation of social and ideological boundaries in order to maneuver within dominant powers and thereby effect change. These technologies of resistance are used in order to transform cultural practices that restrict the agency of the oppressed.[1] Consuelo Jimenez Underwood's fiber art exemplifies Sandoval's theory of oppositional consciousness and finds resonance in the work of a group of artists, including Faith Ringgold,

Mónica Landeros, Orly Cogan, and Diane Gamboa, who engage in "needle arts" (weaving, embroidery, crochet, knitting, and quilting) with the aim of producing radical social and political commentary. As Ann Marie Leimer explains, "Significantly, they have created a broad spectrum of work of a primarily political nature. This work uses precisely those materials considered most 'female' to question limiting gender roles, to produce new forms of knowledge, and to generate new sites of education, struggle, and survival. What begins in the domestic space of the kitchen or bedroom, and the sacred space of the home altar, moves into the gallery and museum under the creative hands and incisive critical minds of Chicana artists."[2]

Jimenez Underwood in particular tells an imaginary story of how the world came to be fragmented when it is meant to be whole—and how we might put it back together again. Her sign readings, deconstructions, and ideological reappropriations make visible those subjects who have been erased or devalued by mainstream US American culture. She also maps colonial legacies and explores the sacred as a method of transformation.[3] This chapter examines Jimenez Underwood's oppositional consciousness as expressed in her exhibits between 2008 and 2014, which focused on flags, maps, and tortillas. As sites of struggle and spiritual survival, these works enable us to rethink history and cultural identity by challenging the notion of national territories and the divisive human boundaries born of colonialism. Hence, in response to Gayatri Spivak's question "Can the Subaltern Speak?," Jimenez Underwood's politics of weaving answers that the subaltern not only can but should—and will—speak.[4]

As a child who crossed the US-Mexico border many times with her Mexican American mother and undocumented father, Jimenez Underwood re-creates visual elements of the border to dismantle notions of nationalism and to contest political and ethnic divisions. She reappropriates maps and flags to destabilize myths of origins and descent, as well as ideas of a common history and common territorial associations. For instance, in her 2010 installation *Undocumented Border Flowers*, the artist forcefully represents colonial presence by depicting national boundaries, the clash of colonization, and cultural encounters along the border (figure 53). In particular, the mural presents the ten pairs of sister cities that lie next to each other on opposite sides of the border, with textiles, wires, and nails capturing three-dimensionally the intricate, painful connections that tensely join those cities' disparate

realities. As Constance Cortez explains, the artist sets up an opposi-tional reading of Western historicism: "Jimenez Underwood charts the geographic, historic, and spiritual realm marked by the '1,950 mile-long open wound,' the U.S.-Mexico border. She employs both barbed wire and silk in her art, weaving topographies that recreate conflicts and contradictions born of historic circumstances. In her works, the border becomes a conceptual field in which she lays bare questions regarding colonialism as well as the nature of an externally imposed border, a tan-gible symbol of the ongoing colonial presence."[5]

Indeed, the artist reads, deconstructs, and reappropriates border symbols to chronicle with hallucinatory imagery the colonial legacies of the Americas: brutal domination of the land and Indigenous cul-tures, marginalization of the vanquished, tarnished environment and poverty, cultural and spiritual *mestizaje*, and maximum exploitation of human capital and natural resources to find gold to benefit those in power.

In her *Flag* series, Jimenez Underwood generates new knowledge and nuanced identities that cannot be essentialized or overgeneralized. For instance, in *Frontera Flag #1, Revolution* (1993), the artist combines a version of the American flag with a version of the Mexican flag to make visible the borderlands' cross-cultural identity (figure 10). The fabric is crossed with wire, and text informs that "Once borders are crossed, notions of nations are re-evaluated and reset."[6] This flag refers to a geo-graphic locale (the US-Mexico border) and the specific history of Amer-ican citizens of Mexican descent, but also to a cross-cultural category and the spiritual result of residing in that location: the state of nep-antla, the space in the middle—not this, not that, but a bit of both.[7] National identity is conceived not as an essential category but rather as an ongoing activity and a complex composition that melds disparate selves. Thus, in *Frontera Flag #1, Revolution* Jimenez Underwood resig-nifies the borderland as a cross-cultural territory grounded in its own unstable reality. Such a notion of national identity is revolutionary in that it challenges the holistic category of "nation" that fails to take into account the pluralities and locations of marginalized populations.

In another flag reappropriation, *Consumer Flag* (2010), Jimenez Un-derwood uses the flag symbol to show the heart of the US nation at the turn of the century—a heart determined by massive consumption of food, clothing, and press (figure 51). Weaving together copper wire, tortilla bags from Trader Joe's, and plastic bags from the *New York Times*

and Target, the artist comments on the habits of the nation. The *New York Times* is often taken as the beacon of truth regarding the world and the United States. "But is it, really?" asks the artist.[8] US citizens have one of the highest rates of consumption in the world, and these bags attest to it. By reading, deconstructing, and resignifying the US flag, Jimenez Underwood resists nationalism as a dominant ideology and forces the viewer to reflect on the nation's bad habits, which thrive not on democratic principles but on the global market.

In *Home of the Brave* (2013), the artist explores the theme of social justice in relation to colonized people (figure 61). The flag is divided into three panels: to the left are the colors of the United States, to the right are the colors of Native Americans, and at the center—white, the color of nepantla—represents the land in the middle. A circle of wire on the white panel contains three iterations of the "CAUTION" sign precariously hanging from safety pins. Across the flag, the artist delineates with barbed wire the 1,950-mile-long US-Mexico borderland using barbed wire. By dividing the panels evenly, Jimenez Underwood opens new spaces for reflection about asymmetries of power at the borderland. In this flag the borderland is represented as wide as the United States and Native American lands, as though by making it so the artist could level out power differentials. The circle in the center panel focuses our attention on the caution sign, which was used along the border freeways in the late 1980s by the San Diego Department of Transportation to warn drivers of the deadly risk posed by border crossers.[9] The original sign depicts a silhouette of a mother, a father, and a little girl running on a stark yellow background, an image that is close to the artist's heart. She recalls:

> We had two homes, one in Calexico, the other in Mexicali. We lived in both congruently, [and] thus we would cross the border two or three times a day. Because my father was undocumented, the political nature of his existence was compromised. The paranoia of deportation was incredible. Many times my father would be accosted by the officials while we were working in the fields, and would be taken away to Mexico. As a result, even I, as a little girl, would be involved in smuggling him across, back to California. It was these experiences that made me aware of the political history of our land.[10]

In *Home of the Brave* Jimenez Underwood reappropriates the caution sign both to denounce discriminatory perceptions of border crossers as

dangerous and to transform such perceptions by honoring the homes of the brave through alternative representations of their flags—as wide territories where the artist seeks to level out power differentials.

By transforming the US flag from an emblem of the nation to a representation of shifting territories and national habits, Jimenez Underwood engages the spectator through Sandoval's meta-ideologizing, that is, by appropriating and transforming nationalism, a dominant ideology. As Sandoval explains, the "methodology of the oppressed" emerged from women of color writers who recorded everyday life in their communities to challenge dominant ideologies via five technologies of resistance—semiotics, deconstruction, meta-ideologizing, democratics, and differential movement.[11] Jimenez Underwood avails herself of these technologies and reads the US flag as a dominant ideological apparatus that excludes any population that is not Anglo and white. She deconstructs this ideology by breaking down the original flag to include other protagonists: Mexican citizens who lived on the land before the 1848 Mexican-American War, border crossers, and Indigenous Native Americans. By appropriating and transforming the signifier, the artist meta-ideologizes and points to how ideology shapes our conception of the nation. Moreover, Jimenez Underwood's visual transformation of the flag can be considered an oppositional social action, for it intervenes on behalf of the oppressed, complying with the social justice imperative (a moral commitment to equality) in the democratics technology. Ultimately, Jimenez Underwood's flag series exemplifies Sandoval's technologies of resistance in the methodology of the oppressed, for these compositions invite the spectator to operate both within and outside of national/racial/ethnic/class ideologies and transform power relations through a reappropriation of boundaries.

On the Limits of the Sacred in Contexts of Extreme Deprivation

> What are the limits of the sacred in contexts of extreme deprivation? In Mexico and in Latin America, the universe of myths, rituals, and centers of worship, of socially uncontrolled emotions and annual pilgrimages to the most inconceivable of sacred places, of marvelous tales, charismatic heroes and stories of saints whose names are not even included in the calendar of days, are all reproduced as dense cultural formations.
>
> CARLOS MONSIVÁIS, *MEXICAN POSTCARDS*

As Monsiváis notes in the epigraph above, in contexts of extreme deprivation, such as in Mexico and Latin America, the sacred crosses into culture as "dense cultural formations." Yet as Luis D. León reasons, not only human suffering but also pleasure and ecstasy push the limits of the sacred: "At the border, the limit separating the sacred realms of pleasure and ecstasy and the profane realm of suffering and pain, the sacred is recorded, idiomatically, idiosyncratically and poetically, and densely (re)emerges in cultural practices so that misery and agony too become sacred."[12] Jimenez Underwood's fiber art poetically captures an experience of the US-Mexico borderlands where the sacred meets the profane. Barbed wire, plastic-coated wire, and nails paradoxically intertwine with images of hallucinating beauty and in so doing, the visceral suffering of border crossers evokes the sacred. Who are these border crossers and why do they need artistic representation?

More than 60 million Latinos/as/x lived in the United States in 2019, comprising more than 18 percent of the total US population.[13] California alone had 15 million, followed by Texas with 11.5 million and Florida with 5.7 million.[14] Clearly, these data don't include the number of undocumented workers who enter the United States invisibly, as ghosts, to work in a political economy that requires their labor for its maintenance but refuses to acknowledge them as citizens contributing to the wealth of the nation. As Luis D. León explains, "Borderlands dwellers must shed their bodies. Their bodies must be dissipated, they must exist in opacity, their materiality denied them in order to conform to Western capitalism."[15] In the 2005–8 *Undocumented Border* series, Jimenez Underwood materializes and honors these Mexican American bodies living in invisibility by exploring what Monsiváis named "the limits of the sacred."

The dominant motifs of this series are the simple tortilla and the basket, both symbols of Indigenous peoples particularly renowned for their basket-weaving techniques and the long-standing eating habits they shared. As baskets are used to hold food, to trade goods, or for religious ceremonies, basket weaving is one of the most prevalent crafts in the history of any civilization. Baskets are usually made of natural materials such as wood, grass, or animal remains. But in *Undocumented Tortilla Basket* (2008), an empty basket made of barbed wire, aluminum, and steel wire evokes the unnatural experience of the US-Mexico borderland: a territory plunged in pain and disavowal (figure 47). Similarly, in *Undocumented Tortilla Cloth* (2008), the artist transforms the

piece of fabric normally used to cover warm tortillas into a stiff red object made of barbed wire and steel mesh (figure 46). How can art materialize bodies living in invisibility? Jimenez Underwood does it here by outlining absent bodies while highlighting their pain through materials that poke, stab, and make us bleed.

In *Undocumented Flower Tortilla. Caution* (2008) the artist uses red-painted barbed wire to hold a flour tortilla made of silk and synthetic flower petals (figure 44). These elements comment on the cultural and political layers of the borderland. Maize tortillas predated the arrival of Europeans to the Americas. Flour tortillas were an innovation created after wheat had been brought to the "New World" from Spain, when this region was a colony of the Spanish Empire. In Jimenez Underwood's composition, the undocumented flour tortilla (representing the border crosser) is caught in the red barbed wire of colonial legacies. The ghostly body materializes here through an idiomatic representation, as in the dialect of the borderland people, the difference between corn and flour is clear. It represents a long history of imperial expansion and oppression, which exchanged corn for flour. Like in colonial times, nowadays undocumented bodies are caught in the barbed wire of powerful economic systems and are forced to labor harshly for the wealth of the empire. As Laura E. Pérez explains, "The fact is that Mexican and other Latin American immigrants are an integral part of our economy, from planting, harvesting, packaging, cooking, and serving our food, to helping care for our children, homes, buildings, and cities, to making and selling our clothing, and so on through every labor sector, including the most prestigious. Disparaging, marginalizing, and yet greatly benefitting from the exploited labor of working-class immigrants is cruel, hypocritical, and unethical."[16]

Beyond invisibility, border crossers suffer other disturbing hardships including sheer despair and fear. In the installation *Undocumented Tortilla Happening* (2009), Jimenez Underwood captures this emotional experience using a traditional kitchen table, around which families usually gather in warmth to break bread (figure 50). The inviting traditional tablecloth contrasts with the empty barbed wire basket and the steel mesh tortilla cloth from which flour tortillas seem to fly away. The play of light and shadow gives a ghostly air to the installation. Referring to this composition, the artist comments: "Imagine a quiet meal at home with an undocumented parent and a loud knocking at the door. The authorities have arrived. Even the tortillas are scared."[17] Yet in this

most terrifying of moments, the sacred reemerges through the image of the Virgin of Guadalupe stitched in a cloth (figure 45).

If Latinos/as/x entering the United States must disappear from view even before they arrive, Jimenez Underwood makes them visible by pushing the limits of the sacred. In her artwork, pain and despair become so material and so real that they are impossible to cover up. Thus the sacred crosses over the cultural, where ghostly images of beauty (re) emerge in flowers, tortillas, and the Virgin to give solace and hope to the undocumented. In Jimenez Underwood's fiber art, spirituality manifests itself as a healing form that resists oppression and assimilation, and as a politics that generates social justice for the oppressed. As such, Jimenez Underwood's artwork represents not an essentialist notion of the sacred but rather a provisional, political sacred that spoils and denaturalizes holistic and universal notions of nationhood.

Traveling a Different America

Jimenez Underwood travels a different America by shifting the focus from local and national narratives to larger ones of colonial expansion and transnational globalization. Empowered by the rich traditions of her Indigenous (Huichol, Yaqui, Mexica, Chicana) spirituality, she exposes the failure of these systems that claim to pursue the betterment of all while actually remaining indifferent to, or possibly ignorant of, the poor of color and the poor around the globe. In *American Dress. Virgen de Tepin (Chili)* (1999), the artist takes a panoramic view of the Americas through the metaphor of a red velvet dress, which represents the land, Mother Earth (figure 27). The theme of territorialism and national boundaries is symbolized by golden threads, which through fine embroidery cover the skirt of the dress. Within gold-threaded rectangles, the artist imprints icons of the Lady of Guadalupe, the Aztec goddess Coatlicue (mother of all creation and the gods), and a map of North, Central, and South America. Some rectangles are blank and several encase an *X*. Barbed wire is used to create smocking in the uppermost part of the dress.

American Dress. Virgen de Tepin (Chili) refers to the experiences of violent colonization, miscegenation, and transculturation that, beginning in the sixteenth century, placed the Indigenous people of the Americas in an "in-between" cultural situation. The venerated Mother

Coatlicue-Guadalupe, representing cultural and spiritual mestizaje, facilitates crossing through nepantla, "the land in the middle." In Jimenez Underwood's words:

> The intent was to depict the physical rape of the Americas, with the ancient deities watching. The dress/land was embroidered, silkscreened, and stitched with barbed wire. It seems the first thing a conqueror/colonist would do was to grid and divide up the land. The "slicing" up was stitched in gold thread to reflect the gold that was taken from this land to decorate and empower a Church, castle, Pope/Queen, King, etc. The grid is covering the entire skirt of the dress. There is a miniscule amount of land in the Americas that is still autonomous (American-Indigenous-controlled). The "x" symbolizes the dual nature of the Christian Catholics who followed the *Virgen de Guadalupe* icon, on the one hand (they love Her), but on the other they are also quick to own and rape (develop) Her. I tried to match the red color to the *chile tepin*, one of my favorite American spices, which still grows wild in some parts of Mexico. The barbed wire represents the colonial domination of the continent. It is a horrific modern contribution to our land. The damage it has done to the eco system of our continent is unimaginable.[18]

As the artist suggests, *American Dress. Virgen de Tepin* exemplifies an intense ideological battlefield that, as Walter Mignolo asserts, produces "subalternization of knowledge and legitimation of the colonial difference."[19] According to Mignolo, this difference engenders "border thinking." In his words, border thinking entails a fractured enunciation "enacted from a subaltern perspective as a response to the hegemonic discourse and perspective. Thus, border thinking is more than a hybrid enunciation. It is a fractured enunciation in dialogic situations with the territorial and hegemonic cosmology (e.g., ideology, perspective)."[20] *American Dress* enacts dialogic situations that mirror a battlefield between the supremacy of European culture and value systems and the instability, openness, and spirituality of visual imagery from Mesoamerican art. By acknowledging these cultural, economic, and environmental borders, Jimenez Underwood evokes not only forced colonial expansion (marked by the barbed wire) but also how first/third world and north/south divides are the result of colonial legacies. The blank golden rectangles and those encasing an *X* can be interpreted as territories (and experiences) that have been written out of history; the

grid can be interpreted as the connections between Western thought and its globalizing experiments, patriarchal Christianity, and environmental destruction.

In *Diaspora* (2003), another map installation created for the San José Museum of Art's exhibition *Un/Familiar Territory*, the artist constructed a floor piece consisting of a large circular cloth that resembles the earth and delineates the continent of the Americas, which is rendered in a brocade (figure 30). An overlay of white gauze billows over parts of this continent, and concentric circles made of barbed wire and covered with computer wire are suspended overhead. "The scene created is a view of the Americas from outer space."[21] *Diaspora* draws on ancient Mexican Indigenous symbols, including the flower, which the artist uses generously in the piece. In the Nahua culture flowers are a powerful symbol of the supernatural, spiritual world. They represent Xochitlalpan, the Flowering Land, also known as the Celestial Land, of which the elders speak.[22] In *Diaspora*, Jimenez Underwood turns this utopian symbol into a dystopian representation that speaks of the displacement of peoples from their original homeland. Conquest and genocide of the continent's Indigenous peoples are represented as white silk fog descending from the east. The two hoops made of barbed wire offer the souls a way to the afterlife. In looking at the American continents from above, Jimenez Underwood interrupts the usual Western perspective and travels a different America: that of the Indigenous peoples who suffered dispersion and annihilation by conquest and colonization.

Jimenez Underwood's south-north cartography destabilizes both the idea of culture as monolithic and static, and the margin-periphery model of analysis. The artist resists the dominant north-south, western-eastern perspective by availing herself of Indigenous spirituality as a form of cultural resistance. She juxtaposes the Virgin of Guadalupe with Coatlicue in both Americas and engages with the pre-Columbian symbol of the flower to stage her artwork within the larger context of the continent and its layered histories of conquest and colonization. By embracing the spiritual and material elements that have dignified and nurtured Indo-Hispanic cultures for more than five hundred years, she celebrates the local (the chili of Tepín, Coatlicue, and la Virgen). Yet, she does it not with nostalgia, but with a clear awareness of the global master narrative that perpetuates the fantasy of a homogenous mass of Western, white, first-world citizens. In celebrating the local, Jimenez Underwood resists conflating the local and the national and turns her

emphasis of the local into a strategy to dismantle the master narratives of the global, which tend to render invisible the legacies of colonialism in the Americas.

On Flags, Maps, and Colonial Legacies

Jimenez Underwood's compelling visual narratives express the interconnectedness of postmodern societies, insisting on beauty in the midst of struggle and celebrating the experience of being in nepantla, as this experience has enabled the artist to see and understand the world through a tricultural lens. She structures her artwork around the referent of the lost or colonized territory and manipulates the Mesoamerican concept of nepantla and spiritual mestizaje to challenge dominant ideologies and the racialization of the borderland. Border crossing, which emerges from the state of being in nepantla, serves to produce an alternative epistemological approach to dominant ideologies. Using the border as an organizing trope, the artist travels with "mental nepantilism," accepting her interstitial existence and committing to social action by constructing "a new subject who can re-inscribe Chicana history into the record."[23]

Jimenez Underwood's flags, maps, and tortillas represent a political strategy to dismantle colonial legacies still active in the US-Mexico borderland and the Americas. As the artist states: "Art can shower the nation with power and grace. Art can liberate society from old modes of perceptions."[24] Her fiber art emerges from an anticolonial struggle against cultural and intellectual domination, serving as a strategy for "decolonizing the imagination"—to use Emma Pérez's term—and for liberating spiritual energies, which the artist accesses by shifting the frame of reference or by creating new contexts through which to view the familiar.[25] Jimenez Underwood's artwork validates an ancestral memory, where "beauty, grace and flowers soothe the quiet rage that has permeated the Americas for more than five hundred years."[26] A site of struggle and spiritual survival, Jimenez Underwood's fiber art celebrates the crossing of the borderland because this crossing enables us to rethink identity and history. Thus, the US-Mexico border becomes a space for symbolic productions that defy material relations of power and privilege. Her artwork exemplifies Sandoval's technologies of resistance in the methodology of the oppressed, for it invites the spectator

to operate both within and outside of religious/national/ethnic/class ideologies to transform power relations through a process of shifting location that destabilizes ideologies and thrives in oscillation. Through these technologies working in concert, the artist travels a different America where the undocumented embodies the sacred and becomes visible, where national consumerism is denounced, and where a just narrative for the poor and the Indigenous is allowed to emerge through new modes of perception.

ANN MARIE LEIMER

Garments for the Goddess of the Américas

The *American Dress* Triptych

As early as 2007, art historical criticism generated by leading Latinx scholar Constance Cortez places the work of fiber artist Consuelo Jimenez Underwood firmly under the theoretical umbrella of the postcolonial.[1] In her essay, Cortez refers to Jimenez Underwood's work as "topographies," a term used to describe the three-dimensionality of the artist's wall hangings and installations.[2] Topographical maps refer to two-dimensional drawings that use lines or blocks of color to indicate the shape of distinct physical features; the elevation or depression of natural phenomena such as lakes, mountains, and canyons; and the presence of rainfall or its lack. Summarizing the overall nature of the artist's oeuvre, Cortez explains that "the textile becomes a map through which we travel" and that the artist "provides viewers with a personal cartographic journey through which they can view with clarity the impact of real and imagined lines of demarcation."[3] This visualized journey is nowhere more evident than in the works examined in this study, *American Dress. Virgen de Chocoatl* (1999) (figure 26), *American Dress. Virgen de Tepin (Chili)* (1999) (figure 27), and *Undocumented Nopal. 2525 AD* (2019) (figure 81), which contain Jimenez Underwood's signature elements—visual depictions of specific geographic areas, mapmaking conventions such as parallels and meridians, delicately fashioned grid lines, and silkscreened images of deities such as the

Virgen de Guadalupe and the Mexica Earth Goddess *Coatlicue*, and yet compose a unique place in the artist's production both in form and in function.[4] What "personal cartographic journey" does the artist provide for the viewer? What "impact" does Jimenez Underwood make visible with her beautifully rendered "lines of demarcation"? Using the lens of the spiritual, this study locates *Tepin*, *Chocoatl*, and *Nopal* within multiple worldviews and spiritual traditions where clothing acts as a ritual or healing object, provides a close examination of the Mesoamerican figure of Coatlicue and Her role within the *American Dress* series, and investigates the multivalent symbolic meanings of chili, cacao, and nopal (cactus).[5]

American Dress. Virgen de Tepin (Chili), American Dress. Virgen de Chocoatl, and Undocumented Nopal. 2525 AD

During the late 1990s, Consuelo Jimenez Underwood produced *Tepin* and *Chocoatl*, works that gestured to the dress as form. The artist used the same media for each work, constructed them immediately one after another, and viewed *Chocoatl* as a "companion piece" to *Tepin*.[6] She originally intended to make a triptych, the third work recognizing the significance of nopal, to the cuisines, material cultures, and symbolic lexicons of the Américas, but she was unable to complete it because of time constraints.[7] The artist produced the final work in the series, *Undocumented Nopal. 2525 AD* (2019), in early spring 2019, the variance in title and form reflecting the political, social, cultural, and environmental developments of the past two decades. The impetus for the *American Dress* triptych resulted from a trip to Spain in 1995 when Spanish viewers and news reporters repeatedly asked her what her "roots" were. When she replied "Californian Mexican American," they responded with laughter and said "Americana, Americana," emphasizing her nationality over ethnicity or regional affiliation.[8] She "thought to [her]self, 'Darn right, for I come from the land of chili, chocolate, and nopales.'"[9] When Jimenez Underwood returned to the United States, the concept for the triptych took shape. The inspiration for the work's form occurred when she was "thinking of the Américas" and realizing that "we only have fragments of pre-contact textiles."[10] She stated that "the idea was to create a dress, a landscape, a map of sorts, that presents a visual reference to my cosmic identity embedded in this material world of reality."[11] Significantly, she

sought to merely "suggest a dress, a fragment of the dress."[12] Although all three works resemble dresses, they are in fact wall hangings that have more in common with the quilted and embroidered fabric of *Border Flowers Flag*, also known as *Election Flag* (2008) (figure 41), and *One Nation Underground* (2013) (figure 63), and the grid demarcation of *Sacred Jump* (1994) (figure 14) and *Ingles Only* (2001) (figure 28). Initially, the viewer reads the works more as garments than as flat wall hangings because of their Empire, or high-waisted, silhouettes. Only upon closer inspection does their two-dimensionality become evident.

In another gesture toward identity construction, *Tepin*, *Chocoatl*, and *Nopal* acknowledge and celebrate three of the artist's favorite foods— chili, chocolate, and cactus—all indigenous to the Américas, like the artist. Jimenez Underwood "grew up loving chili," an affection she shared solely with her father among the entire family, and remembers that she was just learning to walk when she first encountered a "beautiful yellow" one in her mother's garden. For the artist, this was an existential moment of great import, a moment when she became aware of being alive, a moment of "I am, I think, I exist." With clouds overhead and earth underneath, she observed a chicken enjoying a chili and soon followed suit. To this day, she remembers that first spicy taste. The word *Tepin* in the title refers to chiltepin (chiltepictl in Nahuatl), a small, round, red, intensely hot fruit that gives Jimenez Underwood great delight, as she considers herself a confirmed aficionado. Her passion for the heat and spice of chili endures, and the respect she has for this Indigenous plant shaped her wish to "celebrate the eating of chili of the Américas" in *Tepin*.[13] Similarly, in *Nopal* the artist celebrates a lifelong relationship with the nopal (*nopalli* in Nahuatl), the prickly pear cactus or *Opuntia*. Her intention in making this work was to give thanks to the plant for its life-sustaining nutritive and healing powers, as well as its function as a mordant or fixative for natural dyeing.[14] Whereas the artist views chili as "the fire that cooks the food" and chocolate as a "treat," she understands nopal fundamentally as an "always available" food source, stating that it often was "the only thing we had in the house" and that "I would not be here, if not for this food."[15] Her intention, then, in *Nopal* is to reflect "a relationship between the plant and me," to "give honor to the food" and to her ancestors for "developing this incredible plant which grows anywhere and can provide so much."[16] The plant then symbolizes physical survival and daily sustenance that create the very fiber of human life and allow for its continuity.

In addition to referencing Indigenous plants, the artist honored spiritual figures of the Américas in the artworks when she incorporated depictions of the Virgen de Guadalupe and Coatlicue, whose Nahuatl name translates as "Snake(s) Her Skirt." Jimenez Underwood has used Mesoamerican imagery since the 1970s when she embroidered family clothing with Mexica deities such as Quetzalcoatl (the Feathered Serpent) and Maya figures styled after those in the precontact *Dresden Codex*. The Virgen de Guadalupe appears repeatedly on a denim jacket the artist embellished for her husband, Marcos, in both stamped and small-scale embroidered forms complete with mandorlas and crescent moons. Coatlicue graces the same jacket stamped in blue pigment or fabric paint. In addition to ornamenting quotidian family garments, the artist snuck the figure of Coatlicue into her work from graduate school onward and views this deity as the "original," the "precedent," or the "older version of the Virgen de Guadalupe."[17] Debra J. Blake has stated that "Chicana feminists adopt variable strategies and subjectivities to negotiate the conundrums of their specific existence, recognizing the multiple systems of power that affect them, recognizing themselves and their experience as transcultural and diverse. It is no coincidence then that they identify Mexica Goddesses as their primary representational symbols. The numerous aspects of the mother earth goddesses, including Cihuacoatl, Coatlicue, and Coyolxauhqui, portray various behaviors and many narratives depict their strategic resistance."[18] Jimenez Underwood's inclusion of Coatlicue and the Virgen de Guadalupe epitomizes Blake's notion of "strategic resistance," especially when we consider that the artist made *Tepin* expressly for the Virgen de Guadalupe and, therefore, for Coatlicue.

Tepin, *Chocoatl*, and *Nopal* constitute a sharp deviation from much of Jimenez Underwood's art production because they are not woven but rather handsewn from fabric and then embellished with buttons, barbed and copper wire, silkscreened images, and gold metallic thread. The artist constructed *Tepin* from two lengths of red silk velvet: a bodice measuring 28 inches wide × 12 inches long attached to a skirt measuring 34½ inches wide × 43½ inches long. She gently gathered the skirt onto the bodice, which explains the variation in width. On the reverse, unseen by the viewer, Jimenez Underwood backed *Tepin* with a brown transparent fabric that stabilized the work and encased a single small, rectangular piece of wood at the top with mounting hardware that easily enables public display. The artist signed the piece on the wooden

slat with "c/s @ AMERICA—*Chile Tepin* '94–'04."[19] She sewed the entire artwork by hand with a lightweight brown thread, her precise hand stitches visible in measured increments on the side and bottom hems of both the red velvet and the brown lining material. Jimenez Underwood couched the bodice with nineteen lengths of randomly interspersed three-inch-long red barbed wire, each piece wrapped in delicate, gold-plated copper wire.[20] The effect is startling, creating an unpredictable wavelike texture with large folds somewhat resembling labia, especially because the folds often overlap and obscure the pieces of barbed wire that help produce them. The artist sewed a single dissimilar red button on each side of the bodice at the seam, which demarcates the skirt from the bodice, and hand-gathered the skirt to the bodice. She has used buttons inherently in *C. Jane Run* (2005) (figure 33) and intentionally in *Diaspora* (2003) (figure 30), where they "were used to represent the cosmos."[21] We can extend that symbolic value to the buttons in *Tepin* as well.[22]

Jimenez Underwood established a reference to the land of the Américas in *Tepin* by dividing the skirt into thirty-six rectangles of unequal size delineated by a simple running or straight stitch in gold thread, or, as the artist describes, "all measured and properly identified in a golden grid."[23] The artist organized *Chocoatl* and *Nopal* in a similar manner. The lines that create the gridlike pattern represent the parallels of latitude (horizontal) and the meridians of longitude (vertical), the divisions of space intensifying the references to mapping, to spatial divisions, and to geographic borders. The artist made silkscreens of the major "players" that "mark" her identity, the Virgen de Guadalupe, Coatlicue, and a map of the Américas as continent(s) and hemisphere(s). These three silkscreened images, along with a boldly painted black *X*,[24] repeat throughout the lower sections of both *Tepin* and *Chocoatl*. She silkscreened or painted one of these four distinct images inside twenty of the thirty-six rectangles in *Tepin*; its other rectangles remain unadorned. The Virgen de Guadalupe and the map of the Américas appear twice as frequently as the *X* and Coatlicue, in what the artist terms an "intuitively deliberate" arrangement.[25] According to the artist, of the four images silkscreened or painted on the velvet, the placement of the Virgen de Guadalupe came "first, landing where She want[ed] . . . followed by our most ancient one, Quatlique."[26] Then the artist printed the map of the Américas, "hovering around them both, hoping the Mothers do not forget them," and painted the thick black

X as the final identifier of our still-colonized status.[27] In an important essay from this anthology, Clara Román-Odio likens *Tepin* to "an intense ideological battlefield" and states that the "rectangles . . . encasing an *X* can be interpreted as territories (and experiences) that have been written out of history; the grid can be understood as the connections between Western thought and its globalizing experiments, patriarchal Christianity, and environmental destruction."[28] The result is a powerful statement of personal, hemispheric, and cosmic identity.

The artist constructed *Nopal* from sea-green dupioni silk and, in a deviation from the earlier two works, attached a section of brown and purple woven fabric for the bodice, stitched fourteen pieces of barbed wire to the skirt with green thread, and placed three successive registers of extensive embroidery on the upper half of the skirt. Overall, the work is approximately ten inches wider and five inches longer than its predecessors. Jimenez Underwood alternated silver and gold metallic threads to delineate eight rows of eight variously sized rectangles, produced with a running stitch, that create a total of sixty-four rather than the previous thirty-six boxlike shapes. The gold and silver threads remind us why the various waves of conquerors and colonizers came to the Américas and what continues to drive global corporate structures in the present. Jimenez Underwood continued her previous practice of using painted and silkscreened images of the Virgen de Guadalupe and Coatlicue and a map of the Américas, and she again intuitively inserted these images inside selected rectangles. The bold *X*s so prominent in *Tepin* and *Chocoatl* are now absent, but significantly, the artist included two representations of the Mexican flag in silver fabric paint, a formal and conceptual choice that further interrogates the notion of ethnic, cultural, national, and spiritual identity.

In another formal departure, Jimenez Underwood structured the work in three layers: (1) the silk dupioni, (2) a cotton batting, and (3) a calico backing with a printed design invisible to the viewer. The artist connected these separate layers by attaching a dark brown fabric with black stripes vertically along both sides of the work.[29] She defined the ovoid shape of the nopal's "paddle" that composes much of the skirt with a heavy outline stitch of gold and green threads that appears to perforate all of the work's three layers, thereby emphasizing the plant's exterior edges. In contrast, most of the other stitching lies solely on the surface of the work. *Nopal*, then, constitutes a quilted fabric wall hanging, complete with a woven area, and three distinct registers of embroi-

dery placed in the upper half of the skirt. For the embroidered sections, the artist used various types of sewing thread from her vast collection; she chose them for their color and shine, rather than using the more traditional cotton embroidery floss. The hand stitching overlaps effusively, executed with a version of the straight stitch that resembles a seeding or speckling stitch because of its random repeats in every direction.[30] These small repeated stitches appear on the upper section of the nopal and are rendered in a shiny jade green thread that enhances the lighter green dupioni underneath and may remind viewers of prickly cactus espinas (spines). Immediately above this section, a portion of orange, red, and yellow-green embroidery follows the external shape of the nopal and suggests a partial mandorla, an oval form that frames a holy person. Last, Jimenez Underwood fashioned the third section of embroidery with two areas of red and purple threads that bracket the nopal on the right and left sides and that lie directly below the woven material, where the visual feast continues. The woven area consists of a brown "ground" interlaced with red and green threads that stands for "a sad earth ready to be reborn" and a purple "figure" that represents barbed wire, "a piece that survived the holocaust. It is beat-up barbed wire from the future."[31]

In addition to the variations discussed above, the artist has expanded the concept of the work, as indicated by her reference to holocaust and by the title, which refers to the song "In the Year 2525"; written by Richard Lee Evans in 1964, which became a worldwide hit. The song ponders the future of the world in roughly millennial increments, revealing an increasingly bleak and disembodied existence. For Jimenez Underwood, the nopal she honors is indestructible and can survive despite a "holocaust." She believes that "In 2525, we will still have nopal and Coatlicue, not necessarily chili, not chocolate."[32]

The formal aspects of *Tepin*, *Chocoatl*, and *Nopal*, such as color, texture, and life-size scale, encourage multiple readings. One can experience the trio for their beauty alone; the suppleness of the crimson silk velvet of *Tepin* provokes an intense desire to touch the "flesh" of the garment, the reddish-brown tones of *Chocoatl* promote a craving for this sweet substance, whereas the color of chili infuses both works with heat and spice.[33] *Nopal* intrigues with the lush green sheen of its surface overlaid with profuse multicolored embroidery recalling the Virgen de Guadalupe's radiating mandorla. The unbelievably soft texture of *Tepin*'s fabric and its crimson color heighten the sensuous and

erotic aspects of the work. Its scale implies a female body; the velvet fabric suggests supple, tender skin, while the color can allude to blood, passion, sacrifice. Jimenez Underwood has repeatedly stated that she addresses "horrible" subjects—border violence, the effects of colonization, environmental deterioration, racism—but that she must treat these issues in a beautiful manner.[34] This is vitally true in *Tepin* and *Nopal*, where the ugly undercurrent of their subject matter tempers their physical beauty.

The artist declared that one of her intentions for *Tepin* was "to depict the physical rape of the Américas, with the ancient deities watching."[35] Jimenez Underwood made the dress not only for the earth but also for Coatlicue, the "Virgin of the Américas." She views the work as "Her Dress, beautiful, but damaged," and personifies Mother Earth and Her creatures with the defiant words, "You rape me, but I am still beautiful."[36] The damage that the artist mentions can be understood as multiple: injury to the body of the earth, to the Indigenous Américas, and to the bodies of its women, past and present. This further helps us understand how the silkscreened images of the Virgen de Guadalupe and Coatlicue function: they serve as observant and compassionate witnesses. Therefore, we can view the dress as the land that composes the Américas, as Mother Earth, and as the purposefully violated bodies of plants, animals, and humans that inhabit Her.[37] We can imagine the colonized land of the Américas torn from Indigenous peoples, pierced by fence posts, and "sliced up" into parcels exploited for economic gain.[38] Jimenez Underwood presents Our Mother (Earth) as degraded but resilient.

Clothing as Ritual Garment

The dress as form in the history of art emerged in the mid-twentieth century as a vital force for a social critique of consumerism and gender disparities, and as a means to reference issues of the body, the vagaries of the fashion industry, and the patriarchal standard of beauty. Feminist artists from the 1960s onward used the dress to challenge patriarchy and to combine sculpture with performance, animating the dress and other clothing through live fashion shows. Chicanx artists have an extensive history of engaging with the dress form, notions of the body, performativity, and ephemerality.[39] Ester Hernández's 1997 *Im-*

migrant Woman's Dress deserves particular mention because its production is coeval with the first two works in the *American Dress* series: it contains stamped images of the Virgen de Guadalupe and Coatlicue's daughter, the Mexica Goddess Coyolxauhqui; it honors female power and endurance (in this case, the artist's grandmother fleeing the Mexican Revolution); as an installation, it includes transparent fabric containers of corn kernels and ground chili; and, as a whole, it speaks to the then current debates on immigration and the continuing realities of today's asylum seekers and other border crossers. Additionally, artists have incorporated a variety of materials including paper, plastic, fabric, and found objects to produce works that delight or disgust the viewer, such as Annie Lopez's breathtaking cyanotypes printed on commercial tamale wrapper paper, Isabelle de Borchgrave's extraordinary paper couture fashions, or the "meat dress" Lady Gaga wore at the 2010 MTV Video Music Awards.[40] In *Tepin*, *Chocoatl*, and *Nopal*, however, Jimenez Underwood moves beyond wearables (which were never her intention), objects in the service of performance, either social, cultural, or artistic, homages to the female and to feminine power, and critiques of the societal limitations placed on women and moves into the realm of the spirit.

If we apply the lens of the spiritual, vital new dimensions of these works become apparent.[41] In addition to a performance of identity, the dress can also be understood as a ritual garment made expressly for sacred purposes. In diverse religious and spiritual traditions throughout the world, devotees have produced garments that adorn three-dimensional devotional figures and deities as a form of spiritual practice.[42] In many Buddhist traditions, practitioners honor the bodhisattva Jizō Bosatsu,[43] the patron of travelers and protector of children, by creating items of clothing such as hats, bibs, or aprons. Sculptures of the bodhisattva in temples, in meditation gardens, along roadsides, and in other public spaces are dressed in these items, generally red in color, as a form of intercession on behalf of those who are suffering in this world and in the next. Significantly for this study, Jizō Bosatsu means "Earth Womb" and has direct connections to the earth mother–earth daughter archetype.[44] Further, this figure vows to be "present for all suffering beings" and therefore serves as an empathetic witness, much like Jimenez Underwood's notion that depictions of Guadalupe and Coatlicue placed in *Tepin*, *Chocoatl*, and *Nopal* observe the destruction of Mother Earth.[45] According to Taigen Daniel Leighton,

"In seeing Jizō as an 'earth daughter' caring for all suffering beings, we may recall the Buddhist practice of seeing all sentient beings as one's mother. . . . We come into existence in each moment totally mutually dependent, and interdependent, with all phenomena. Thus all beings are like our mothers, helping us give birth, and are worthy of our love."[46] Arising from Indigenous worldviews, the worldview espoused by Jimenez Underwood—that all creatures are connected—finds resonances with the idea of shared suffering and with the Buddhist concept of interdependence.[47]

Similarly, Catholic believers, historically and in the contemporary period, have made garments for statues of the Virgin Mary and the Christ Child. An example of this spiritual practice exists at the *capilla* (chapel) dedicated to Santo Niño de Atocha in Chimayo, New Mexico, where believers knit, crochet, or purchase shoes for the Christ Child and leave them as an offering at the shrine.[48] The practice derives from a story associated with this version of the Christ Child where the Holy Child is said to walk so frequently and so far at night performing miracles that His shoes wear out. Believers provide shoes so that the Child can continue His healing endeavors. A final example of Catholic practice having to do with ritual clothing making and ritual adornment of holy figures is that of La Conquistadora, an advocation of the Virgin Mary housed in a side chapel of the Cathedral Basilica of St. Francis of Assisi in Santa Fe, New Mexico.[49] Throughout history, Catholic women have dressed statues of the Virgin Mary as a form of service to the community, as an expression of spiritual devotion, and as a demonstration of a personal relationship with this sacred figure. Sacristanas, or female lay practitioners functioning within the Cofradía de La Conquistadora (the organization that encourages devotion to this figure) attend to the statue of La Conquistadora, maintain Her side chapel, organize dedicated ceremonial events, and ritually adorn Her at various times throughout the liturgical and civic year.[50] The dressing of the Virgin, performed solely by the sacristana, generally occurs monthly, with the primary exception of a nine-day ritual (novena) in June, during which the statue's raiment is changed daily.[51] In contrast, both women and men perform the ritual or devotional practice of making garments for La Conquistadora and consider these acts a votive offering, a physical manifestation of a request petitioned or a request granted. María Martinez Dean, a previous official seamstress for the cofradía, has stated that "every garment is a prayer, offering, or petition to Christ through his

mother."[52] "Votive vestment-making" produces a material object given directly to this advocation of the Virgin Mary as a gift.[53]

Although spirituality and the sacred infuse Jimenez Underwood's work, these artworks were not produced in this precise tradition, nor were they created to adorn specific, sacred, three-dimensional figures. Conceived as fragments, the works were made precisely to honor the Virgin of the Américas in her precontact and colonial syncretic forms. Let us now consider what Jimenez Underwood views as the Goddess of the Américas and the origin of the Virgen de Guadalupe, the Mexica Goddess Coatlicue.[54]

Contemplating Coatlicue

As previously discussed, Jimenez Underwood places silkscreened images of two deities associated with the Américas, the Mexica earth goddess Coatlicue and the Virgen de Guadalupe, in the *American Dress* triptych.[55] Scholars most commonly translate the Nahuatl word *Coatlicue* as "Snakes-Her-Skirt" or "She of the Serpent Skirt" because of the multitude of snakes that appear in surviving depictions of this figure.[56] The most well-known representation of Coatlicue consists of a larger-than-life-size sculpture carved from basalt or volcanic rock, currently housed in the National Museum of Anthropology in Mexico City. Initially buried after the conquest of Central Mexico by Spain in 1521 because of its earth-centered imagery, the sculpture was accidentally uncovered on August 13, 1790, by municipal workers preparing the Zócalo (México City's central plaza) for the installation of water pipes. The Zócalo previously constituted the precontact sacred ceremonial district of the Mexica capital Tenochtitlan, with its religious structures such as the Templo Mayor (Great Temple), which were largely destroyed and quickly replaced by Catholic churches as part of Spanish colonization and forced conversion efforts. The Metropolitan Cathedral, whose construction began in 1573, lies within this area, diagonally across from the original site of the Templo Mayor, where several significant sculptures have been uncovered since the initial disinterment of Coatlicue. On September 4, 1790, Coatlicue was removed from the ground and placed in front of the National Palace on the Zócalo.[57] Historian Antonio de León y Gama observed the sculpture when it was first uncovered and contributed significantly to its historiography when he drew front, side,

and reverse views, publishing these illustrations two years later.[58] Even this scholarly interest could not prevent Coatlicue from further disrespect. Catholic clergy continued to view Her as a "devilish idol" and as dangerous, especially when Indigenous people began to make offerings and conduct rituals in front of the sculpture.[59] The Spanish viceroy of New Spain and the second Count de Revillagigedo, Juan Vicente de Güemes Pacheco de Padilla y Horcasitas, directed the sculpture to be moved to the patio of the Royal and Pontifical University of Mexico, where She was "measured, weighed, and drawn" and soon reburied once again.[60] While traveling through Mexico in 1803, German explorer Alexander von Humboldt prevailed upon the Bishop of Monterrey Feliciano Marín to disinter Coatlicue so that he, like de León y Gama before him, could make drawings of the sculpture. Shortly afterward, She was buried for the third time.[61] Coatlicue permanently emerged from the subterranean depths in 1824 at the behest of naturalist and curiosity collector William Bullock.[62] At that time, Bullock made a plaster copy of the work to display at the exhibition *Ancient Mexico*, termed London's "first exhibition of Mexican art" that he produced later that year.[63] The original sculpture was exhibited in the National Museum of Natural History's Hall of Monoliths in Mexico City and then relocated for the last time to the National Museum of Anthropology, where She reigns to this day.

The most comprehensive colonial account of Coatlicue comes from Fray Bernardino de Sahagún, whom noted Mexican anthropologist Miguel León-Portilla called the "first anthropologist."[64] Sahagún, a Franciscan friar, arrived in Central Mexico eight years after the Conquest to participate in Spain's missionizing agenda, but he spent much of the rest of his life recording the customs, practices, histories, and beliefs of Indigenous peoples. In 1547, Sahagún began work on what became a bilingual (Nahuatl and Spanish) twelve-volume treatise known as the *Florentine Codex*, which provides a vast amount of information on the peoples of Central Mexico, including an account of the Conquest from the perspective of the Mexica. This monumental task would take the next twenty-four years of his life.[65] He was supported in this effort by his knowledge of Nahuatl and the labor of Indigenous artists who drew more than two thousand images that illustrate many of the codex's volumes. This codex, along with the *Codex Aubin*, the *Codex Mendoza*, and the *Codex Telleriano-Remensis*, among others, comprise some of the earliest visual records of precontact Indigenous life. Taken together with

written narratives and studies compiled by conquistadores and other religious leaders, these records increase our understanding of Mexica life and worldviews. However, Mesoamericanist art historian Manuel Aguilar-Moreno reminds us that these texts are "biased" and counsels that "these early chronicles should be read with caution as they are written by Spanish hands" using "a Catholic and Spanish lens."[66]

In the first chapter of Book Three of the *Florentine Codex*, Sahagún briefly recounts the birth of the Gods at Teotihuacan (City of the Gods) and then treats the story of Coatlicue at length, including Her destruction at the hands of Her daughter and the birth of Her son. What follows is the generally accepted narrative compiled from a variety of sources. Coatlicue, "known for her devout nature and virtuous qualities," was cleaning and making penance at the temple on the top of Mount Coatepec (Snake or Serpent Mountain) near the Toltec city of Tula, sweeping up feathers from birds given as sacrificial offerings.[67] As She collected the feathers, She picked them up and tucked them, according to most versions, in the waistband of Her skirt; in other accounts she puts them in Her "bosom."[68] Still other documents state that the "ball of feathers floated down from the skies."[69] When She finished what I suggest is a cleansing ritual, She reached to retrieve the feathers, but they were gone.[70] As a result of this act, She became pregnant through what is considered to be a virginal conception. Her daughter, Coyolxauhqui (Bells-Her-Face or Painted with Bells), and her four hundred sons, known as the Centzon Huitznahua or the Four Hundred Southerners, soon realize their mother's condition; finding it offensive, they plan to kill Coatlicue because She brought shame to the family honor.[71] Coatlicue learned of Their intentions and, when She became both fearful and "deeply saddened,"[72] Her son Huitzilopochtli spoke from the womb in an attempt to reassure Her. As Her children ascend Coatepec to enact Their plot, led by Coyolxauhqui, Coatlicue gives birth to Huitzilopochtli; some accounts state that He appears at the moment of Her death.[73] Huitzilopochtli emerges from Coatlicue's head, full grown and fully armed with shield, spear thrower (*atlatl*), darts, and the magic fire serpent, or *xiuhcoatl*, which resembles a slender club with a snake's head at the top.[74] Huitzilopochtli cannot prevent His mother's demise, and Coyolxauhqui successfully commits matricide by decapitating Coatlicue. Huitzilopochtli then uses His xiuhcoatl to impale and behead His half-sister, whose body breaks into pieces as it rolls down the temple staircase to the bottom of Coatepec. He then chases His four

hundred half-brothers around the mountain four times and slays most of Them, with some escaping, as Their name suggests, southward.[75]

The sculpture of Coatlicue stands at 256 centimeters—slightly more than 8½ feet—and is the largest of all Mexica sculpture, giving credence to the concept of the hierarchy of scale that positions Her as one of the most powerful of Mexica deities. The depiction visually refers to Her demise because where Her head should lie, we find two coral snakes facing each other, fangs drawn. These "writhing" snakes stand in the place of Coatlicue's head and hands to iconographically indicate the consequence of Her decapitation and dismemberment, flowing or gushing blood. Moreover, Miller and Taube suggest that we read Her visage as "a face of living blood."[76] Around Her neck She wears a necklace of severed hands and human hearts, with a human skull at waist level functioning as the necklace's pendant.[77] The necklace partially covers Her breasts, which are often defined as pendulous or like those of an old woman, and most poetically described by Aguilar-Moreno as "weary from an eternity of feeding all creatures."[78] This reference emphasizes Her role as mother and as one who nurtures all beings. A knotted maternity belt consisting of a rattlesnake encircles Her waist; the belt's ties fall downward and lie in front of the intertwined mass of rattlesnakes that form Her skirt, their rattles clearly visible at the skirt's base. Snakes also stand for Her arms and hands; a bifurcated tongue emerges from each serpent's mouth directly under multiple talons representing Her feet.[79] Her legs are covered in feathers and between them a final serpent slithers forth, its head directly between Her clawed feet. Aguilar-Moreno characterizes this snake as a symbolic penis, whereas Miller posits it as "both menses and penis."[80] A significant addition, rendered largely invisible because of its location on the bottom of the sculpture, is a carving of the Mexica rain god Tlaloc as Earth Monster with an open maw.[81] Finally, the sculptor dated the work on the upper back with 12 Acatl (12 Reed), one of the twenty day names in the 260-day Mexica calendar, or *tonalpohualli*.

As Earth Mother, Coatlicue represents the duality of life and death in complementary opposition. And considering that She is the mother of more than four hundred children, it is no wonder that She is also understood as a symbol of fertility and one who bestows fertility! In Her role as mother, She can be seen as Our Mother, "the mother of the people."[82] Archaeologist and anthropologist Felipe Solís Olguín emphasizes Her dual role as creator and destroyer when he views Coatlicue

as the "sustainer of all humanity and source of all life but also ruler of the ultimate destination of the dead."[83] Significantly for this study, Matos Moctezuma and Solís Olguín suggest that Coatlicue's skirt represents the Mexica notion of the earth's surface as consisting of a "network of snakes," thereby reinforcing the understanding of Her as Earth Mother.[84]

Another key aspect of Coatlicue that helps us think about Jimenez Underwood's use of this image in *American Dress* is that Coatlicue as Earth Goddess is the Mother of Huitzilopochtli, the Mexica's patron deity. Huitzilopochtli, in His role of patron deity, also instigates the great migration of the Mexica from their paradisiacal island home of Aztlan to the new capital Tenochtitlan, which I find an apt symbolic reference to the themes of migration and border crossing in the work of Jimenez Underwood.[85] What could be a more appropriate parallel to the experiences of contemporary border crossers than the journey fraught with danger, deprivation, humiliation, family separation, and enslavement suffered by the Mexica? This migration, documented in the postcontact *Codex Boturini*, begins with the Mexica's exodus from Aztlan at the behest of their patron. The second folio (page) shows that the migrants' first act is to create a temple or shrine constructed of tule (bulrushes, *Schoenoplectus acutus*) for Huitzilopochtli, represented solely by a small mummy bundle with the god's head crowned with His hummingbird headdress. Placed in the center of the quickly made temple, speech scrolls emerge from His mouth. Huitzilopochtli will direct the Mexica migration in conversation with four sacerdotes (spiritual specialists) over the next two hundred years; the journey concludes when an eagle with a snake in its mouth appeared on a cactus in the middle of an island. These symbols are found on today's Mexican flag and signaled to the Mexica the precise location of their new capital city, from which they would eventually rule Central Mexico.

Further, in an important essay, Mesoamerican art historian Cecelia F. Klein offers a "reinterpretation" of the figure of Coatlicue and points out four limitations in the earlier accounts: an undervaluing of the significance of Her skirt, the presence of the date "12 Reed" on the reverse of the sculpture, the dramatic visual relationship with a sculpture titled Yolotlicue or "Hearts-Her-Skirt," and the correspondence to three other sculptures that also represent Coatlicue, of which only fragments remain.[86] Klein advances a comprehensive and convincing argument based on colonial texts such as the *Historia de los mexicanos por sus*

pinturas (*History of the Mexicans as Told by Their Paintings*) and the *Leyenda de los soles* (*Legend of the Suns*), several codices, and the work of art historian Elizabeth Hill Boone.[87] In this argument, Klein unpacks these early texts and recounts a very different version of the commonly accepted narrative describing the origin of the Mexica world and the creation of its Five Suns, where the gods, the humble Nanahuatzin and the "haughty" Tecuciztecatl, sacrifice themselves at Teotihuacan to bring light into the world.[88] In her reading based on John Bierhorst's account of the *Leyenda*, five deities sacrifice themselves to bring about the movement of the sun, three of them, Xochiquetzal, Nochpalliicue, and Yapalliicue, are female.[89] The suffix *iicue*, found in the names of the last two females, means "skirt" in Nahuatl and links to its similar presence in the word *Coatlicue*. Klein goes on to suggest Coatlicue as Creator Goddess who, with other female deities, "gave up their lives to give birth to and energize the fifth and present sun."[90] The *mantas*, or rectangular cloth panels that constitute the goddesses' skirts, allow Them to be "returned to life in the form of their skirts" and "venerated by the Mexica during their stop at Coatepec along the migratory route from Aztlan."[91] Here is another example of sacred or ritual clothing infused with power that becomes the site of spiritual practices and ritual observances. Lastly, Klein thinks that the Coatlicue sculpture takes its "unusual" form not because of Her role as Mother of the Mexica patron deity, but because She was a primordial creator Goddess who, long before the Mexica left Aztlan, voluntarily gave Her life to help create a habitable world. Like Her companions, She appears in stone as She looked when She returned to life: a personification of the quintessential female garment representative of Her name and gender. Klein states, "Because this distinctive skirt embodied the formidable generative powers of all women—that is, of Woman—those powers could continue to be accessed down through time by the living."[92]

Chili, Cacao, y Nopal

In the *American Dress* triptych, Jimenez Underwood celebrates the trinity of chili, cacao, y nopal as markers of Indigenous identity and as much-appreciated gastronomic gifts from the American earth. Besides their welcome flavor, however, they possess spiritual and cultural significance that lends depth to our understanding of this series. Each

of these plants has been repeatedly represented in postcontact codices such as the *Boturini,* the *Mendoza,* and the *Florentine,* where their precontact function and importance are aptly demonstrated. In the *Codex Mendoza,* produced at the behest of and named after the first viceroy of New Spain, Antonio de Mendoza, Indigenous scribes toiled alongside Catholic friars to record the religious, economic, and social workings of the Mexica empire twenty years after the conquest.[93] Divided into three sections, the codex records in images and in Nahuatl and Spanish texts the founding of Tenochtitlan, the life cycle of the Mexica, and the tribute paid to the Mexica by subjects of their vast empire. In the second section, the account documents the use of chili as a disciplinary tool and of cacao as a ritual component of the wedding ceremony, whereas the third section demonstrates cacao as monetary tribute payment. When Mexica children transgressed, their parents held their faces above a fire where chilis were roasting; the resulting chili smoke caused great discomfort, as depicted by the water glyph emerging from the child's eyes, signifying tears (folio 60). The Mexica wedding ceremony took place around the age of fifteen and was celebrated by the tying together of the bride's and groom's cloaks, the burning of *copal* incense, the consumption of tamales, and the ritual drinking of a beverage made from cacao (folio 61). Because the cacao drink was generally reserved for warriors and nobles, the wedding ceremony comprised one of the few times most people enjoyed this delicacy.[94]

The depiction of cacao in another precontact codex, the *Codex Féjérváry-Mayer,* reveals its critical role in the Mexica worldview. We find a representation of cacao on the codex's first page, not merely as a foodstuff but as an integrated part of the Central Mexican cosmos. According to Mesoamerican scholar Michael Coe, "the cacao tree appears as part of a cosmic diagram . . . laid out to the four directions and to the center. It is the Tree of the South, associated with the color red, the color of blood."[95] Jimenez Underwood used cacao in the *American Dress* triptych to construct her "cosmic identity" as an Indigenous American and to acknowledge her love for this native plant. I find it interesting that cacao in the *Féjérváry-Mayer* is equated with the cosmos as well as the color red, rather than brown, and that the rich color of the second piece of Jimenez Underwood's triptych, *Chocoatl,* is a reddish-brown, perhaps referring to the combination of these two plants, cacao and chili. Notably, sugar was nonexistent in the Américas and cacao in its original form was rather bitter; therefore, chili and other flavorings

were often added to ameliorate its intensity. When the artist views *Tepin* and *Chocoatl* as "companion piece[s]," she celebrates a relationship that existed from the earliest American civilizations.

The shape of the cacao pod and the *tuna* (*nochtli* in Nahuatl), the purple-red fruit of the nopal, both symbolically represent the human heart, associated with the human sacrifice believed necessary for the movement of the universe and the daily arrival of the rising sun. Mexican archaeologist Alfonso Caso has indicated that the Nahuatl word *cuauhnochtli* translates as "eagle tuna" and stands for the heart of sacrificial victims, especially in folio 2 of the *Codex Mendoza*, where Caso believes that the nopal pictured as part of the founding of the Mexica capital indicates heart sacrifice.[96] Klein has demonstrated the importance of Nochpalliicue (Red-Her-Skirt) as one of the Goddesses that sacrificed Themselves for the benefit of humankind; Her name connects Her to Coatlicue and to the nopal, which stands for the human heart as sacrificial offering.[97] Jimenez Underwood's use of the nopal then links her construction of identity in *American Dress* to the national identity of the Mexica, to their initiation of empire, to the national identity of the Mexican people today as symbolized in their flag, to the spiritual practice of sacrificial offerings, and to the generative power of the female as embodied by Nochpalliicue.

Conclusion

Consuelo Jimenez Underwood takes the viewer of the *American Dress* triptych on a "personal cartographic journey" of great depth, nuance, and complexity, a cautionary tale that visualized the "impact" of colonial division and distribution of American lands, peoples, and resources, and one that provides a postapocalyptic vision where plants *sin papeles* (without papers) endure, preserve the memories of past civilizations, and "radiate" with sacred, sacrificial energy. Although this nearly destroyed world retains beautifully executed "lines of demarcation," they are increasingly erased and only the most resilient remnants of life remain, Coatlicue y nopal.[98] The works examined in this essay celebrate Indigenous foodstuffs, plants native to the Américas, and when the artist elevates chili, chocolate, and nopal to the level of the sacred, these plants in all their mundane and symbolic power become aspects of the Goddess of the Américas. Their continued existence testifies to

a world before European contact and exploitation; recalls the extraor-
dinary contributions and traditional knowledge systems of precontact
American civilizations; reveals their multivalent functions as symbolic,
quotidian, and gustatory; and reminds us that life is pain and pleasure,
spicy and sweet.[99] Jimenez Underwood uses a titular and formal allu-
sion to the dress that equates the sacred female body with the earth and
with earth as mother, Indigenous virgin, Goddess, and divine power.
Therefore, the works constitute an offering to the sacred feminine, to
the Goddess of the Américas, and to the Indigenous bodies that have
endured. Significantly, Jimenez Underwood embeds in the artworks a
pressing petition for the health and preservation of the planet and an
ominous warning to those who ignore the urgency of this plea. I see the
careful, intentional process of making these works by hand as an act of
love, an act of spiritual devotion to Mother Earth, and as a call of ac-
tion to honor and protect Her. Understood within these contexts, the
American Dress triptych can certainly be seen as Jimenez Underwood in-
tended, as a statement of deep, profound, and prideful American Indig-
enous identity and as garments that join the lineage of sacred clothing
infused with power by the intentional, painstaking labor of the maker.

KAREN MARY DAVALOS

Space, Place, and Belonging in *Borderlines*

Countermapping in the Art of
Consuelo Jimenez Underwood

Gloria E. Anzaldúa's allegorical account of the border as *"una herida abierta"* (an open wound) poignantly conveys the trauma to tissue that is unable to heal.[1] Anzaldúa penned this phrase to address the social laceration caused by the disparities between Mexico and the United States, the racialization and social abjection of Mexican Americans, and the militarization of the border, which was launched in the 1970s.[2] Artist Consuelo Jimenez Underwood is also concerned with reoccurring injury at the border, but she is equally attentive to the environmental devastation and human atrocities created by the US-Mexico boundary and the hegemonic desire to reinforce it. In *Borderlines*, a series of gallery-specific, temporary mural-like works that feature elements of cartography, particularly the geographic and physical features of the border region, the boundary line, the peninsula of Baja California, or other physical characteristics particular to the city in which the work is installed, Jimenez Underwood depicts the power and energy of the international boundary line and its reinforced barricades. Painted directly on a gallery wall at each exhibition venue, the overwhelming majority of works in the series function as installation art by design, as they "interact with . . . extant architecture in a given

exhibition space."[3] Monumental in scale, the series conveys the beauty, life, and potential hope found in the region.[4] As such, the installations are a counterhegemonic visualization of space, place, and belonging. The *Borderlines* series' cartographic elements, such as the scientific representation of geography, and the works' composition and color envision a "decolonial imaginary," a conceptualization of personhood and space that is less dependent on colonial relationalities, notions of personhood, and the natural world.[5]

This essay seeks an understanding of the decolonial visualization of space and belonging in the work of Consuelo Jimenez Underwood. Although the series *Borderlines* engages a primary element of colonial hegemony and epistemology, the artist's use of cartographic properties—the lines of latitude and longitude, the conventions of proportion and scale when depicting a three-dimensional space onto a two-dimensional surface, and orientations of north and south—exposes and challenges the ideological function of Western maps in engendering, producing, and securing colonial domination. The installations use earthly contours, national and state boundaries, flowers, and plants, as well as color and texture to convey alternative meanings about the nonhierarchical human relationship to the natural world. These alternatives visualize a decolonial space and belonging.[6] More critically, the sublime beauty and grace of *Borderlines* in juxtaposition with the historicization of space (i.e., how animals, plants, and humans inhabit space over time) acknowledges the interconnectedness of humanity and nature.[7] The series conveys how these interdependencies are transnational. That is, a decolonial sense of belonging and place emerges from a deliberately posed tension between the aesthetic qualities of the work and the social and historical realities created by the international boundary line.

Western Cartographic Tradition: Visualized Domination

> Neither of these two "national histories" (Mexico and the United States)
> have provided the space in which to tell the story of this population.
> JUAN GÓMEZ-QUIÑONEZ, *ROOTS OF CHICANO POLITICS, 1600–1940*

Scholars of cartography argue that maps are not neutral representations of the earth's surface but a visual attempt to normalize power relations and Western ontology and epistemology.[8] Since the sixteenth

century, European mapmaking has been based on Euclidean principles
of projective geometry "in order to create a 'realist illusion' of three-
dimensional space on a two-dimensional surface."[9] Cartographic prop-
erties such as "conventions of scale, longitude, latitude, direction, and
relative location" are used to "'scientifically' depict a static landscape."
As such, within the grid of longitude and latitude, all locations are
known by their coordinates, which posit the "very existence" of space,
even if unexplored by Western surveyors.[10] In his analysis of the Renais-
sance world map, *Universale Descrittone* (1565) by Paolo Forlani, Chris-
tian Jacob observes that the grid "guarantees that all places (of the two
hemispheres) belong to the same coherent and knowable world . . . ,
even though conjectural."[11] Similarly, Raymond B. Craib notes in his
analysis of Antonio García Cubas's compilation of maps to produce
Carta general de la República Mexicana (1858), a national map of Mexico,
that the graticule not only produces a mathematically derived order
for space but also "supposedly [is] a mirror of the natural order of the
universe."[12]

By the end of the seventeenth century, maps and globes positioned
the Northern Hemisphere, the location of European seats of power, on
the upper portions of representations of Earth.[13] This orientation of
Earth's continents is read as an objective reflection of reality; space is
naturally "northern" and "southern." Although some scholars suggest
that the preference for northern orientation may also be connected to
"the growing use of the land compass with a north-pointing needle,"
Western cartography clearly reinforces European hegemony.[14] Western
maps create spatial reality; they do not simply reflect spatial reality.

Western maps also naturalize power and authority through the de-
marcation of international boundaries.[15] Space is conceptualized as a
set of geopolitical territories; other histories and approaches to space
are typically diminished or ignored. Indeed, place-names are not main-
tained across geopolitical boundaries: the river that separates the
United States and Mexico is known alternatively as the Rio Grande and
the Río Bravo. J. B. Harley concludes that "in modern Western society
maps quickly became crucial to the maintenance of state power—to its
boundaries, to its commerce, to its internal administration, to control
of populations, and to its military strength."[16] Conventions of cartog-
raphy, such as orientation and scale, create and reinforce "territorial
expansion and control, whether the context [is] colonial, commercial,

military or political."[17] Thus, maps are crucial to the regimes of colonialism and imperialism.

Therefore, a powerful symbol of authority is the national boundary line. Nation building cannot be imagined without the simple and effective tool of boundary demarcation in order to communicate geopolitical territory, to claim sovereignty, and to organize national defense strategies that control population movement. Increasingly since the mid-twentieth century, the United States' regional hegemonic power has been oriented toward the national boundary line and its maintenance. US hegemony and so-called national security apparently depend on an impermeable border at the southern international boundary. As Donald Trump's 2016 presidential election indicates, boundary demarcation is essential to appeasing "white fragility" and entitlement. Trump's strategy to emphasize border security plays to his supporters' anti-Mexican racism, but it also supports a vision of an "insulated environment," one that even progressive whites defend.[18] Because the ability to control human movement has increasingly drawn scrutiny from those worried about the state of the nation, it has become a tool for soothing white people's fears.[19]

Granted, some nations—Israel, Saudi Arabia, the United States, and China among them—have built walls to create a physical barrier against those outside the nation-state, and these structures do impede natural and human existence. Nevertheless, boundary walls or fences do not terminate the migration of humanity, even though Trump promised as much through his presidential platform. Furthermore, natural habitats and Indigenous populations existed long before the Treaty of Guadalupe Hidalgo, the Mexican republic, and the Spanish colonial world. Ecosystems of plants and animals and Indigenous communities continue to straddle national boundaries. The physical barricades and other technological strategies to control migration damage the natural environment and human relations on either side of the border. For example, the use of "all-night artificial lighting" and concrete and metal barriers threatens biodiversity in the border region, a tragedy Jimenez Underwood frequently amplifies through the use of negative space in her work, areas devoid of color to signify the absence of life.[20] Without international coordination of conservation for migrating species and adjacent wildlife habitats, the US-Mexico border will continue to have "the highest rates of species endangerment in the United States."[21] This

international demarcation is more than the articulation of national rights to land, water, and people; it also conveys values about land, animals, and plants, as humans are presumed to dominate and control space at the expense of other species.

I am not suggesting that the international boundary that marks the border between Mexico and the United States is a fable. It simply refuses the past, the natural world, and human experience. Leslie Marmon Silko, in the *Almanac of the Dead* (1991), reminds us that Yaqui "were here before maps." Geopolitical boundaries are "imaginary lines" for Yaqui or Yoeme people who moved freely across the region before 1848.[22] Certainly, the Treaty of Guadalupe Hidalgo (1848) and the Gadsden Purchase (1856) determined the border between these two nations, and its defense has permeated popular discourse since the Carter administration.[23] Furthermore, Clinton-era enforcement policies pushed migrants into more dangerous routes, which increased migrants' fatalities.[24] However, even the border between the United States and Mexico has changed and been disputed since it was established by the Treaty of Guadalupe Hidalgo in 1848. Within four decades of the treaty's signing, the International Boundary and Water Commission was formed in 1884 to address the meandering waterways and the differences in territory that arise when a river changes its course. For example, in the nineteenth century, "nearly 600 acres of Mexican territory shifted to El Paso as a result of the gradual erosion of the river's southern bank, a process that was accelerated by flooding."[25] Mediation between the two nations continued well into the twentieth century, and continuous management of the boundary line is required because of the riverway's winding course and changing shoreline. My goal is to point out that the borderline is not static, nor is it effective; and when such management is desired, it is not a prudent use of resources, as the natural world and humanity continue to find ways to traverse the international border zone.

For instance, twenty-first-century technology cannot stop human migration. In San Diego County, the forty-six miles of fence is ruptured "about 550 times a year."[26] Underground sensors, floodlights, and surveillance cameras, even the double barricade that covers thirteen miles of the San Diego County–Mexico border are rendered useless by fog. Human smugglers, *coyotes* as they are known in Spanish, use axes and power saws to cut small holes in the metal mesh fence in less than a minute, and people can slip through the two-foot-by-two-foot opening

when coastal fog is dense. This portion of the fence requires intensive maintenance, which is costly. In 2009 the federal government estimated a cost of approximately "$1 million per 100 yards" to build and maintain a wall in the more rugged canyons of San Diego County.[27] Even border patrol agents recognize that the barriers are not impermeable and that the walls only encourage alternative routes and strategies.[28]

The feverishly pitched anti-immigrant discourse, most recently originating from the Trump administration, which imagines hordes of so-called illegal aliens bringing crime and drugs into white neighborhoods, portrays this fable as a national security issue and does not illuminate the contemporary or historical reality of the region. Historicization would require a rethinking of international policy around labor and trade, and around national policy on drugs and guns, that fosters human movement. It would also call attention to refugee and human rights and an application of democratic principles of liberty and justice for those detained by the United States, especially asylum seekers who are guaranteed international protection. It would reconcile the hundreds of cultural communities that predate the international boundary line that have been forced to limit their movement, land use, and rights. Margo Tamez examines the Lipan Apache and Euskara Indigenous peoples of the Lower Rio Grande Valley, particularly those of El Caloboz Ranchería, who hold grant titles to places on both sides of the river.[29] She finds that these and other "defenders of the sacred sites and burial grounds, culturally significant sites, agricultural fields, water rights, oral histories, traditional medicinal plants, and ecological economies related to flora, fauna, and mammalogy" have experienced injustices perpetrated by Spain, Mexico, and the United States.[30] Most recently the grant title holders lost access to their land under President George W. Bush when the United States built a fence on the levee north of the US-Mexico boundary. Although the "levee is located contiguously on Lipan Apache land title holder traditional lands," the fence is represented as the US-Mexico boundary.[31] Tamez documents that El Caloboz Ranchería, which traverses the US-Mexico border, was illegally occupied by the United States and that it and other Indigenous populations have had an extensive "pre-empire presence" in the region. The levee itself is a "bitter memory" since it was constructed by the US Army Corps of Engineers in the 1930s "without community consultation or consent, according to . . . Lydia Esparza García, a direct descendant of the people placed under" the original land grant of 1743.[32]

Tamez astutely argues that loss of legal land titles is the result of racialization of Indigenous peoples, who have been conceived of as inferior and backward by Spain, Mexico, and the United States. Their multiple racializations within ongoing colonial logics reinforces racism and sexism, thereby supporting the militarization of the region.

Consuelo Jimenez Underwood's series *Borderlines* installs alternative realities about space and belonging that reconsider the colonial distribution of power in the borderlands. The series is a form of countermapping, a visual strategy to "appropriate the state's techniques and manner of representation to bolster the legitimacy" of alternative claims to relationships, memory, and space.[33] Similar to the Maya principle of interconnection, In'Lakech (tú eres mi otro yo/you are my other me), Jimenez Underwood's art embraces a politics of individual and collective engagement with the world.[34] She visualizes a world that acknowledges these vital transnational connections between flora, fauna, and humanity. As such, the artist engages the "relational sensibility" that Miwon Kwon proposes for "site-oriented art" and that artists Glenn Ligon, Renée Green, James Luna, Fred Wilson, and Amalia Mesa-Bains actualize in their installations, presenting relationships and power dynamics "not commonly seen in the white mainstream art world."[35] By exposing and critiquing the human-centric spatial understanding of the border and acknowledging the habitats of plants and animals that traverse the international boundary, Jimenez Underwood registers them as adjacent lives, not disconnected beings or insignificant things. Her art visualizes a world that acknowledges these transnational connections and the ways in which humanity and the natural world share interdependent ecosystems. Foregrounding the implications of interconnection, the series implies the illegitimacy of the international border. It fosters "oppositional consciousness" for viewers who see themselves and their claims to space as exceeding the nation-state's notion of belonging (white, heterosexual, male, Christian, and materially secure).[36]

Playing with Cartographic Forms

Attentive to maps since the second or third grade, Jimenez Underwood has long understood how maps "naturalize" reality and relationships.[37] Maps provided her with global awareness, but it was not the innocence and awe expected by the romantic view of children. She recog-

nized during primary school that maps chart exploration, division, and conquest. Avoiding a simplistic view of maps, the artist has frequently experimented with mapmaking conventions, laying latitude and longitude lines over so-called scientific depictions of geographic territories (e.g., *Land Grabs* [1996; figures 17–22] and *Diaspora* [2003; figure 30]), compositions in the shape of state boundaries (e.g., *Ingles Only* [2001; figure 28]) or national boundaries (e.g., *Mi Oro, Tu Amor* [1994; figure 13]), and renderings of the geopolitical boundary line between Mexico and the United States (e.g., *Four Xewam* [2013; figure 60] and *One Nation Underground* [2013; figure 63]).[38]

In the series *Borderlines*, Consuelo Jimenez Underwood creates massive "site-oriented art" installations that draw on cartographic properties to depict the beauty and tragedy of the US-Mexico border zone.[39] At each site, the artist studies the city's history and borderlines, social and environmental tensions, and audiences to produce mixed-media works that are unified by a potent visual element: the shape and contour of the US-Mexico boundary line created directly on the wall of the gallery. In general, this sensitivity to the site allows Jimenez Underwood to engage the actual location of her installation and conceptually reconfigure it through a nomadic practice that is repeated at each gallery or museum at which she produces a work for *Borderlines*. In some ways, her site-sensitive installations link the series to Diane Gamboa's *Paper Fashions*, performed throughout Los Angeles in the 1980s, and Guillermo Gómez-Peña and Coco Fusco's performances of *Two Undiscovered Amerindians Visit the West* in 1992 by referencing the intersections of place, race, and gender. However, the various sites of *Borderlines*—Washington, DC; Reno, Nevada; Syracuse, New York; and four locations in California: Los Angeles, Carson, Fresno, and Santa Clara—become linked through the migratory practice of the series, which "defies commodification" by "insisting on" the mobility of this site-sensitive work.[40] Moreover, *Borderlines* critically invokes mobility, not simply as an artistic practice, as Kwon suggests in her analysis of site-sensitive works, but as a political, historical, cultural, and environmental action that resists and challenges the nationalist ideologies that impinge movement. The series, therefore, is a conceptual maneuver that expands our understanding of place and mobility by physically, discursively, and visually questioning who is able to travel, why, and under what conditions.

A central visual component of *Borderlines* is the three-dimensional line, which is composed in layers of multiple media. Although monu-

mental in scale, the installations exceed the category of a mural because the constructions of the borderline extend beyond the wall's surface, frequently more than ten inches.[41] The installations are not simply using the wall as canvas; the wall also serves as a foundation for the three-dimensional forms, including large nails and fabric flowers, that protrude from it, and it thereby becomes sculptural in form. The large nails are a usage of Christian iconography to insinuate the crucifixion of Mother Earth. The artist also uses thread, fabric, wire, and beads to aesthetically and physically heighten the borderline, and these are suspended from the nails that are strategically placed in order to indicate the presence of the actual barricade. The installations frequently include power wands, a term the artist coined to describe constructions of name cards for the twin cities on either side of the border, strings of small flowers, beads, and ropes made of colored safety pins (a signature media for the artist).[42]

Decolonial Visualizations of Space and Belonging

LA Borderline (2014) includes the most precise cartographic conventions in the depiction of the coastline in Southern California and Baja California as well as the international boundary line between the United States and Mexico (figure 70). Clearly duplicating modern maps of the southern region of the United States and the northern region of Mexico, the installation comprises the finely detailed geographic features of the Baja California peninsula—the Gulf of California (also known as the Sea of Cortez), the Bay of La Paz, Isla Angel de Guarda/Guardian Angel Island, Tiburon Island—and the shoreline of Mexico, particularly Vizcaino Bay and Punta Eugenia on the Pacific coast. The landscape is rendered in deep green, suggesting the living qualities of the borderlands in general and the "lush" and verdant landscape of California, the state in which the installation was created. Captured in negative space is a map of the Southern California freeway system, a strategy that signals the site of the installation at California State University, Dominguez Hills, a designated Hispanic-Serving Institution for its large enrollment of Latina/o/x students. For Chicana/o/x residents of Southern California, freeways are the daily barricades that must be negotiated and traversed, as the highway system bisects several Mexican American neighborhoods of Los Angeles.[43]

Reinforcing the presence of natural life-forms in the borderlands, ten monumental-in-scale flowers break from Western cartography. The flowers are symbolic of the plant and animal world and its beauty. Throughout the series, Jimenez Underwood uses fabric cutouts to portray the official flowers of the border states: Texas (the bluebonnet), California (the poppy), New Mexico (la yucca), and Arizona (el saguaro). Not only are these flowers indigenous to the region, they grow in ecosystems that are currently endangered by the construction of a barricade and the militarization of the border. Their disproportionate size, soft texture, and placement against the green field demand attention, and the tension between the large textile flowers, which are placed on either side of the boundary line, and the borderline itself convey the insurgent message of the series. The dynamic visual energy created by the critical and aesthetic tension between the placement of the idyllic flowers in various stages of bloom and the long line that bisects the space is a compositional technique found throughout the series. As with another installation, *Undocumented Border Flowers* (2010) (figure 53), the artist directly and indirectly engages the national conversation by sarcastically asking, "Will [flowers] require documentation as well? How? Yikes!"[44] This humorous expression of shock alerts us both to the absurdity of this idea and its potential harm to the natural world, and to the daily jeopardy of unauthorized migrants and refugees who live under the threat of deportation, incarceration, family separation, and harassment. The artist's sarcasm also requires reflection on the irony of Indigenous peoples' movements across the landscape: they must carry proof of citizenship, a form of belonging that is not of their making and that collapses their specific Indigenous identities into ethnic, racial, and national social categories, including "immigrant."[45]

The installation for which she penned these witty remarks was created for the 2010 exhibition *Bay Area Xicana: Spiritual Reflections/Reflexiones Espirituales* at the Triton Museum of Art in Santa Clara, California. It names the political theme of the series: the acceleration of the militarized border zone and the concurrent ideology that criminalizes migrants, which makes it seem as though even flowers require documents because they inhabit a landscape that straddles the US-Mexico boundary line. With *Undocumented Border Flowers*, and elsewhere in the series, the natural world occupies a site of illegality. Yet through the massive flowers, the artist reinforces an alternative vision of the borderlands: viewers witness the capacity for life.

If *LA Borderline* teems with the potential for wildlife—and thus allegorically for human redemption as well—then *Undocumented Border Flowers: Día* (2011), installed for *Undocumented Borderlands* at Conley Art Gallery of California State University, Fresno, depicts the source of life, the earth (figure 57). Comparatively less meticulously detailed than the geography of *LA Borderline, Undocumented Border Flowers: Día* is a minimalist landscape rendered in flat and luscious shades of brown, as the artist wanted to capture the color of the soil in Fresno and the way that the nutrient-rich earth sustains agricultural production for the nation. The color also signals that Fresno is a capital of agrobusiness because of the brown-skinned laborers, a large portion of whom are Mixtec and Triquis, Indigenous Mexicans who have been increasingly migrating to the San Joaquin Valley since the 1980s.[46] This part of the borderlands provides food for American tables, even though the very bodies that cultivate this food are not welcomed by the two nations: the United States racializes Indigenous people as subhuman and Mexicans as undesirable, and Mexico refuses to provide sufficient resources and rights for its Indigenous, rural, and women residents, who must look for a better life elsewhere.

The Fresno installation also illustrates the aesthetic force of the series. The massive mural-format work is placed on two adjoining walls, and the brown swath of color does not contain the geographic details of *LA Borderline,* although Baja California is identifiable in *Undocumented Border Flowers: Día.* Rather, the composition of the landscape is evocative of the geographic features. The artist minimally employs the physical shape of the international boundary line as an aesthetic strategy. It is less precise, but the recognizable downward arch and geometric precision along the southern border of Texas is clearly featured. The purple-hued boundary line is doubled by the negative space that surrounds it, and it is this technique that visually announces the gravity of the situation: boundaries create dead zones, distance, and injury. In contrast to the subdued brown swath of color are the "energy lines" of various lengths that extend from the boundary line.[47] The artist uses pastel and chalk sticks and applies them directly atop the brown paint to generate the colors of these energy lines, which signal the intensive emotional arch of the borderline. The lines are kinetic gestural expressions. The energy with which the artist must have drawn these lines is evident in their frenzied movement on and arrangement along the purple-hued line; the energy lines double the visual intensity of the borderline.

The energy lines reflect the artist's memory and observations of crossing, which I posit is a collective affective response to the border. She recalls that people approach it with trepidation and apprehension. They become impatient while waiting at the border stations, but they control their emotions for fear of reprisal, and then migrants feel joy and a sense of release after passing through the border. The energy lines also indicate the transnational movement of people and plants—the vivid and complementary colors extend nearly the entire width of the work. Viewers must reconcile this affective response to demarcation and militarization. Similar to the flowers, the energy lines are another visual reference to survival and alternative strategies of existence.

The paradox between the message (the barricade injures human and natural existence) and the aesthetic (the life and beauty along the border) is deliberate, and it underscores the series' ironies. *Borderlines* considers how ecosystems that traverse the international boundary line survive the unnatural barricade but also implies that human life can find hope despite the wall, restrictive and inhuman policies, and racist and sexist ideologies. In several works, the artist registers hope in the glistening, thin wire that is loosely woven into the architecture of the borderline. Hidden beneath or snuggled within the warp of threads, fabrics, and heavy-gauge wire that is suspended between the nails lies Jimenez Underwood's suggestion that hope is possible, and although difficult to find, it has the potential to change the borderlands into relational space. This alternative world is imagined through the tensions she explores—beauty and death, devastation and life—and the visual reconciliation of interconnectedness: all living things depend on and impact each other. No one being or population is independent, and thus all beings must recognize and be accountable to those with whom they share the planet.[48]

Whereas most installations do not overtly render the human experience at the border, one work in the series, *Undocumented Border X-ings. Xewa (Flower) Time* (2016), offers direct commentary on the shared trauma between the natural inhabitants of the border region and the human populations (figure 73).[49] This installation, part of "Stories of Migration" at the Textile Museum of George Washington University in Washington, DC, includes one of her signature icons—the caution sign for immigrants—and the signature elements of the series: the state flowers and the international boundary line. Yet, the composition of this mixed-media work is decidedly abstracted and symbolic. It also

merges image and text, which appears in the bottom register of the installation. Geographers, map enthusiasts, and viewers familiar with the series may recognize the contours of the US-Mexico border, but without the granular details to the Pacific coastline or the precise physical shape of Mexico and the American Southwest, the borderline becomes a scar across the rose, the central image of the work. In this way, the installation expresses a compelling visual friction: a rose, named American Beauty—the official flower of the District of Columbia—is covered by the outline of a family portrait and a gash. It is an ironic compositional strategy in which the caution sign and borderline literally cut into American Beauty, a potent visual sign. The overlapping images create a polyvalent message, signifying a break from American ideals of democracy and liberty, a challenge to notions of American aesthetics, and a reconsideration of the federal government's approach to immigration.

The placement and revision of the caution sign illuminates the installation's feminist commentary about migration. Although the outline of the family resembles the figurative composition of the caution sign developed by John Hood for Caltrans, Jimenez Underwood alters the work by placing the female figure at the front of the group. Here the artist draws on her own family experience in which her mother led the family across the border.[50] The image also visualizes the more recent pattern in which "migration has become feminized."[51] The female, indicated by her flowing hair, leads the group—as did the artist's mother—and signals the power of women who maintain their families across vast geographic expanses. It also visualizes the centrality of relationships as the last two figures grasp hands as they run. The hand of the mother reaches back to the figure behind her, but their grasp has been broken, suggesting the economic, political, and social conditions, including heteropatriarchy, that force mothers to separate from their children in Mexico as they search for a new life across the border.

The three figures have a ghostly quality because the color of their silhouette is nearly lost in the rich pigment of the rose and the international boundary line.[52] However, the artist is not conveying the disappearance of migrants—Indigenous or otherwise; rather, she historicizes space by including more than two dozen names of Indigenous people in the bottom register. "Nansemond, Mattaponi, . . . Patuxent, Choptank . . ." The list documents Indigenous civilizations that inhabited what is known as Maryland and the New England area at the time of European colonial exploration by John Smith. Indigenous people

continue to inhabit the continent, requiring viewers to recognize that the place was identified and inhabited before colonialism. It also visualizes a connection "we are rarely asked to make" by spatially joining American Indians with indigenous flowers from the borderlands.[53] Indeed, Jimenez Underwood's statement about the installation indicates her proposal that the borderlands flowers, "cousins" of the American Beauty, will influence federal policy through "Flower Power," a conversation among the natural world with Indigenous spirit "semi-hosts" to accompany the meeting.[54] By historicizing the boundary line, engendering movement, and recognizing Indigenous habitation in the hemisphere, the artist considers new notions of belonging that challenge not only settler colonialism but also the frameworks of Chicana/o and Latina/o studies that erase Indigenous communities under the rubrics of ethnicity and immigration.[55] These elements of the installation imagine a decolonial referent rather than notions of space and belonging as determined by US nationalism and hegemony in the region and colonial logics that continue to dehumanize Indigenous and trans people, Mexicans, migrants, and women. As the artist's statement clarifies, the flowers have joined in solidarity, countering settler colonial politics of Mexico and the United States. The flowers offer instruction to inhabitants of the borderlands, with their wisdom about the power of solidarity. If this wisdom is ignored, both nations risk creating wastelands along the border.[56]

Four additional installations continue the artist's mixed-media approach and use of minimal details to render the geography of the American Southwest and Northern Mexico.[57] Constructed for the 2013 exhibition *Welcome to Flower-Landia* at the Triton Museum of Art, *Welcome to Border-landia!* (2013) omits the large-scale textile state flowers and uses instead patches of flower-patterned fabric cut to the silhouette of the saguaro, bluebonnet, poppy, and yucca as well as green mesh to suggest the natural elements that grow in the borderlands (figure 68). The artist also omits the geographic outline of Mexico and the United States, though a lower portion of the installation mimics the peninsular shape of Baja California. The only reference to a Western cartographic convention is the suggestion of a boundary line, and the pattern on the gallery wall follows its contours in shades of green and yellow. A similar evocative style that is an abstraction of the border region is found in *Borderline Premonitions: New York* (2015) for *Borderlines: The Art of Consuelo Jimenez Underwood* at ArtRage Gallery, Syracuse, New York (figure 71);

Mountain Mama Borderline Blues (2015) for *Mothers—The Art of Seeing* at the Nevada Museum of Art in Reno (figure 72); and *Undocumented Border Tracks* (2017) for *Mano-Made: New Expressions in Craft by Latino Artists* at the Craft in America Center, Los Angeles, California (figure 78). These installations also comprise color patches and large textile flowers, although the one created in Nevada is the darkest in hue and compositionally breaks away from the contours of the borderline.[58] In these four mural installations, the boundary line is unequivocally produced across the center register of the works, but in each work the artist uses a different range of techniques. The borderline is the central visual element and the most dynamic portion of the installations, with thread, wire, nails, and other mixed-media constructions layered over and composing the border.

The complex and rich details of the borderline require further description and analysis. I focus on *Welcome to Border-landia!*, an installation in which the composition is dominated by a set of concentric lines. At the center of the image is a dark crimson line surrounded below and above by yellow and then moss-green lines. These concentric lines are more abstracted than the compositions of the borderline of other works in the series. The meticulously detailed coastline of Baja California in the bottom left register of the work is the only visual anchor to a map of the region. The crimson line matches the general geographic shape and contour of the US-Mexico boundary line, particularly the telltale straight line at the California and Arizona border and the downward slope of the Rio Grande/Río Bravo.

The crimson borderline itself is a mix of media: acrylic purple- or red-hued paint applied directly to the surface of the gallery wall, which is layered on top with energy lines in pastel and chalk—pink, white, and beige. The final layer of the borderline gives the installation three-dimensional and even sculptural qualities. Large nails painted gold (for US currency) and silver (for Mexican currency) protrude from the crimson line at locations where a barricade has been constructed in California, Arizona, and Texas.[59] From these large nails, the artist suspends multiple textiles and wire. The use of thread, fabric, and wire incorporates the most basic form of weaving, as the textiles and wire are suspended or stretched like warp between two poles. It is a proto-weaving technique that echoes the artist's expansive understanding of what constitutes weaving, particularly her use of safety pins to interlace and join or create textiles. This proto-weaving technique follows

the crimson borderline and creates a neo-baroque effect from layered multimedia. The three-dimensional quality of the proto-woven suspension of largely red thread, ribbon, fabric, and wire gives the work aesthetic and compositional depth but also critical weight.

Whereas the crimson coloration focuses the composition, the boundary line is surrounded by space devoid of color that symbolically indicates the "dead zone" on both sides of the border.[60] The combination of the sculptural form and the negative space reveals the dramatic, spectacular, and transformative effect of this installation. The negative space bisects this and nearly every other work in the series, and it symbolizes death, fragmentation, and devastation caused by the construction of the wall and the anti-Mexican sentiment that traumatizes the lives of people in the border zone and beyond. It also references the barren zone between a primary and a secondary barricade, a security strategy used for more than thirty-six miles along the international boundary line.[61] While the double barricade forcefully disrupts the migration patterns and ecosystems of flora and fauna, Homeland Security uses multiple technologies that unleash environmental and ecological scars on the region. For example, the white space of the installations can also render the twenty-four-hour floodlights that unnaturally illuminate more than seventy miles of the international boundary line.[62] The beauty of the borderline clashes with its inherent destructive force at the actual space between the United States and Mexico; the installation functions as witness to the division of people, animals, and geographic place.

Placed near and along the set of these concentric lines is a chaotic and overlapping arrangement of large fabric cutouts and "power wands," strings of beads, chains of small safety pins, and name cards, which announce the twin cities at the border, such as San Diego and Tijuana, El Paso and Juárez, or Nogales and Sonora. The name cards indicate that places and relationships predate the international boundary line and are disrupted by it. They also signal material inequalities at the border. The name cards are composed of photographs of the shelves at grocery stores on both sides of the border. The images are nearly identical because it is "the same food but different prices," observes the artist.[63] In the same way that the gold and silver nails map the role of "currency, money, and power" in creating and sustaining the border, the artist maps the economic disparities at the border and how these disparities are multiplied along the border at each site of a twin city.[64]

The final installation under discussion, *Flowers, Borders and Threads, Oh My!* (2013), expands the concept and strategy of boundaries and unnatural borders to the entire globe (figure 59). Also exhibited as part of *Welcome to Flower-Landia* at the Triton Museum of Art, it works in conversation with *Welcome to Border-landia!* and extends interconnectedness to the global level. The installation is compositionally distinct from the bulk of the series in that it is a map of the earth, not simply the region between the United States and Mexico. The artist places the boundary line in the American continent and extends it across the Atlantic Ocean, Africa, and the Indian Ocean, where it reaches the Australian continent. The work implies that the hegemony and social hierarchies that operate in the United States continue across the planet and thus are causing damage around the world. That is, Jimenez Underwood visually implies that the colonial systems that forged the US-Mexico boundary also exist throughout the world and perpetuate injury everywhere. As evidence of this devastation, the state flowers are ghosts, rendered in white fabric and placed on each continent and island. "[The dead flowers] define the land."[65]

Equally indicative of the artist's critique and warning is the color of the borderline: now the boundary mark becomes a human scab. It is made of purple and mauve acrylic paint, echoing and yet amplifying to the international level Anzaldúa's poetic description of the border. Even the energy lines are muffled within the scab. They do not extend beyond nor do they vividly compete with the borderline. The title of the work duplicates the lyrics of the phrase from the *Wizard of Oz*—"Lions and tigers and bears, oh my!"—to register fear. Dorothy and her two companions chant this line as they begin their journey along the yellow brick road to Oz, but just as they reach a feverish pitch, a lion roars and they stop. This lion, however, turns out to be quite cowardly. Jimenez Underwood's clever title offers additional lessons. It is an incantation that alarms and distracts the speakers. In the movie, lions, tigers, and bears are not the real source of harm. It is the witch. Jimenez Underwood's title urges spectators to reconsider the source of their fears, grapple deeply with sources of injustice, and acknowledge their own making of boundaries that separate humanity and the natural world. Oh my!

Conclusion

Similar to her Chicana feminist artist peers, Consuelo Jimenez Underwood has been visualizing Chicana critical thought for decades.[66] I underscore the conceptual aspect of her art because I want to acknowledge its critical and aesthetic contribution, which puts Jimenez Underwood in conversation with writers such as Chela Sandoval, Emma Pérez, María Lugones, and Walter Mignolo, participants in various intellectual lineages of decolonial thought, as observed and extended by Laura E. Pérez.[67] Jimenez Underwood's series is a "third space feminist practice," and she uses a "decolonial imaginary . . . as a theoretical [or conceptual] tool for uncovering hidden voices . . . relegated to silences, to passivity."[68] Although Emma Pérez "locates the decolonial within that which is intangible," Jimenez Underwood offers visual articulations of decolonial sensibilities.[69] Moreover, the artist adds to this conversation. The series makes visible Lugones's observation that "*coloniality* does not just refer to racial classification. It is an encompassing phenomenon" that includes the intersectionality of gender and sexuality but also the spirit world and the land.[70] Jimenez Underwood visually and conceptually emphasizes the natural world and its indigenous residents, and therefore, her decolonial imaginary makes indigenous flowers and inhabitants central to the beauty and life force of the borderlands. More significantly, the natural world is not adjacent or secondary to human experience. Indeed, the series disentangles the colonial dichotomy that distinguishes humanity from the environment. All living things are rendered as vital, relational inhabitants of the borderlands and the planet.

This complex understanding of our world is found in the artist's consistent rendering of the boundary line between Mexico and the United States. It is wholly beautiful and devastating, comprising graceful flowers and a dynamic three-dimensional line. This elaborate three-dimensional component of the installations bisects the works and creates a stunning, aesthetic arrangement. Each installation has a chromatic grace and neo-baroque elegance, an ornate fullness that is harmonious across the surface of the gallery walls. As such, the series depicts a tension between beauty and destruction and between the natural world and humanity without reference to the national and colonial agendas of Mexico and the United States. Furthermore, the use of bricolage undergirds the juxtaposition and tension of the series. The works employ both visual movement and stasis, splendor and demise,

potentiality and obstruction. In this way, the beautiful boundary line is meant as ironic intervention, or decolonial possibility. The installations juxtapose the artist's rendering of the international boundary and the political, social, environmental, and cultural impact of the actual barricade that interrupts human and natural habitats. The contrasting forces raise questions about relations between humanity and the natural world. How can we allow the world to flower? How can we allow people to flourish? The answers lie in the dissolution of the barrier and the ideologies that imagine we are separate from each other or separate from the natural world. They lie in the ability to love, which is "understood," suggests Sandoval, "as a form of political action."[71]

This decolonial imaginary as proposed by Jimenez Underwood requires a new understanding of space and place and how we belong to them. Conquest is not viable in her worldview; love is the sustaining practice. Here, the map-based art holds the potential to transform colonial thinking.[72] The series does not erase the histories of colonialism, imperialism, and US hegemony but references the visual tools, or cartographic properties, of these histories to offer another view that accounts for human and animal mutuality and relationality. Juxtaposed with the beautiful features, which include the borderline, the installations signify what is at stake, what is lost and erased by the boundary, and how that boundary is also porous and resisted. Therefore, rather than abstract space, she provides new coordinates for liberation, a freedom that is interdependent, not individuated.[73] It is a freedom that moves toward the decolonial.

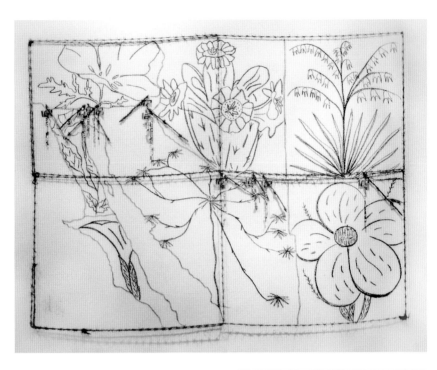

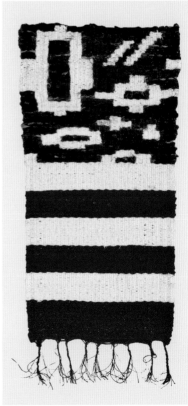

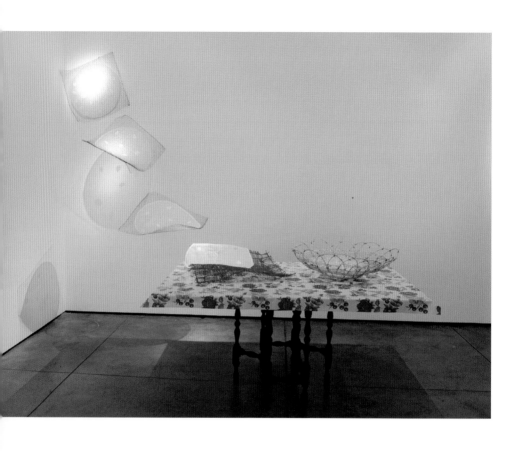

FIGURE 50

Consuelo Jimenez Underwood, *Undocumented Tortilla Happening, Albuquerque,* 2009. Mixed-media installation, 12 ft. × 7 ft. × 8 ft. 516 Arts, Albuquerque, New Mexico. Photograph by Margot Geist.

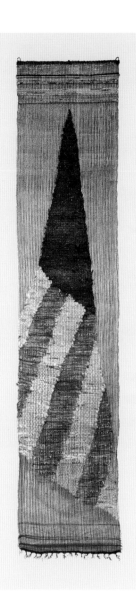

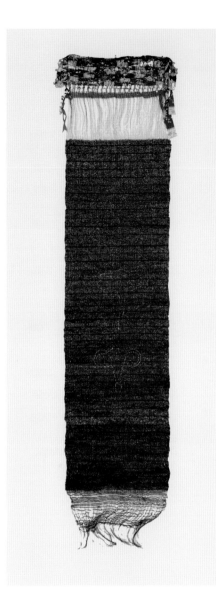

FIGURE 51

Consuelo Jimenez Underwood, *Consumer Flag*, 2010. Woven wire, Target bags, and *New York Times* delivery bags, 8 ft. × 24 in. Photograph by Bill Apton. Private collection.

FIGURE 52

Consuelo Jimenez Underwood, *Rebozos for Our Mothers: Mother Mundane*, 2010. Woven fiber, wire, linen, silk, rayon, gold and silver threads, 70 in. × 20 in. Photograph by James Dewrance. Collection of the artist.

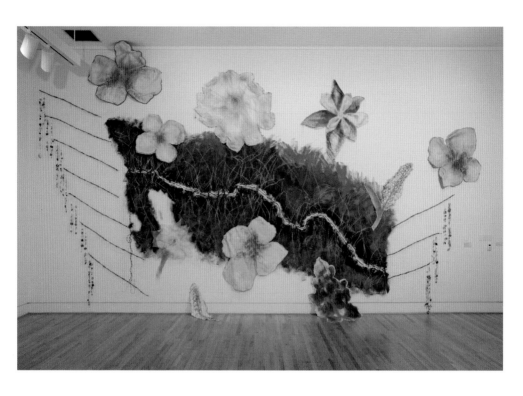

Consuelo Jimenez Underwood,
Undocumented Border Flowers, 2010.
Mixed-media wall installation, 17 ft. ×
24 ft. × 5 in. Triton Museum of Art,
Santa Clara, California. Photograph by
James Dewrance.

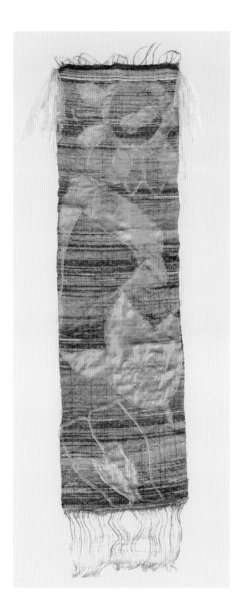

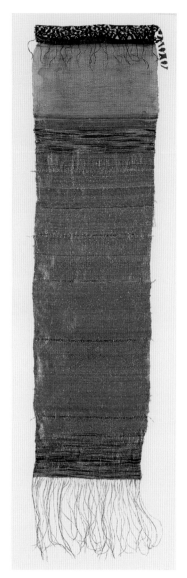

FIGURE 54

Consuelo Jimenez Underwood,
*Rebozos for Our Mothers: Mother Earth
(Flower)*, 2011. Woven fiber, wire, linen,
silk, rayon, gold and silver threads,
85 in. × 20.5 in. Photograph by James
Dewrance. Collection of the artist.

FIGURE 55

Consuelo Jimenez Underwood,
*Rebozos for Our Mothers: Mother Ocean
(Water)*, 2011. Woven fiber, wire, linen,
silk, rayon, gold and silver threads,
90 in. × 20 in. Photograph by James
Dewrance. Collection of the artist.

FIGURE 56

Consuelo Jimenez Underwood, *Sun Set/Rise CA* (1 of 4), 2011. Woven fiber, linen, and cotton threads, 3.5 in. × 3 in. Photograph by James Dewrance. Collection of the artist.

FIGURE 57

Consuelo Jimenez Underwood, *Undocumented Border Flowers: Dia*, 2011. Mixed-media wall installation, 17 ft. × 28 ft. × 6 in. Conley Art Gallery, California State University, Fresno. Photograph by Julia Bradshaw.

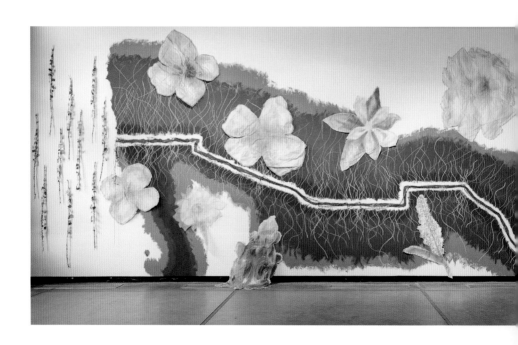

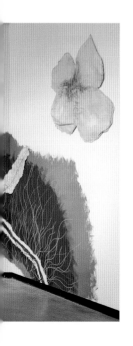

FIGURE 58

Consuelo Jimenez Underwood,
Double the Fun, 2013. Linen
and silk threads, 3.75 in. × 5 in.
Photograph by Bill Apton.
Collection of the artist.

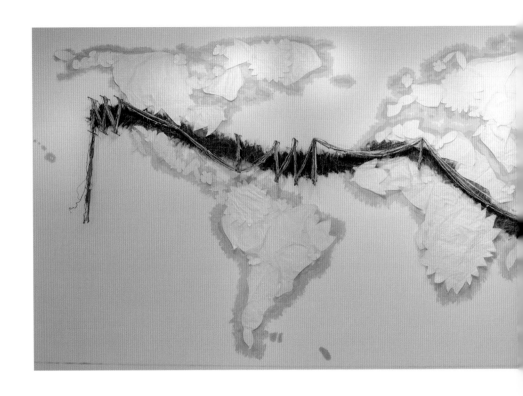

Consuelo Jimenez Underwood, *Flowers, Borders, and
Threads, Oh My!*, 2013. Mixed-media wall installation,
17 ft. × 45 ft. × 10 in. Triton Museum of Art, Santa Clara,
California. Photograph by James Dewrance.

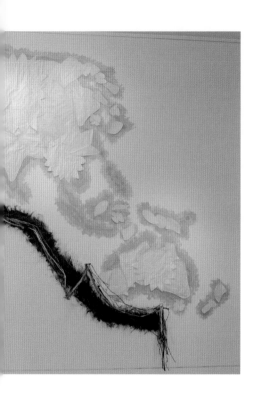

Consuelo Jimenez Underwood, *Four Xewam*, 2013. Silk, linen, and cotton threads, 97 in. × 19 in. Photograph by Ron Bolander. Collection of the artist.

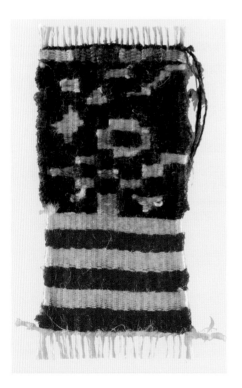

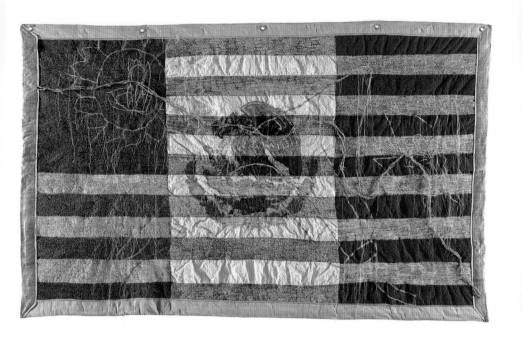

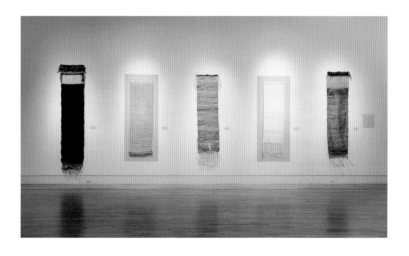

FIGURE 64

Consuelo Jimenez Underwood,
Rebozos for Our Mothers, installation
view, 2013. Woven wire, linen, silk,
rayon, gold and silver threads. Photo-
graph by James Dewrance.

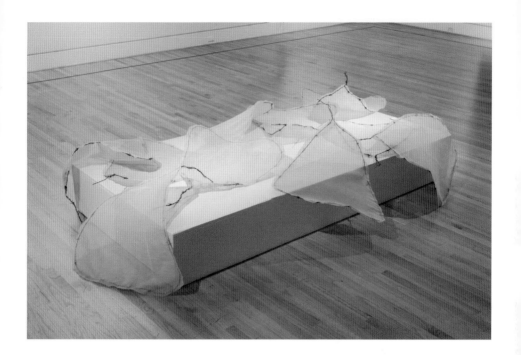

FIGURE 65 (OPPOSITE, LEFT)
Consuelo Jimenez Underwood, *Rebozos for Our Mothers: Mother Moon (Sky)*, 2013. Woven wire, linen, silk, rayon, gold and silver threads, 70 in. × 20 in. Photograph by James Dewrance. Collection of the artist.

FIGURE 66 (OPPOSITE, RIGHT)
Consuelo Jimenez Underwood, *Rebozos for Our Mothers: Virgen de Guadalupe (Spirit)*, 2013. Woven wire, linen, silk, rayon, gold and silver threads, 70 in. × 20 in. Photograph by James Dewrance. Collection of the artist.

FIGURE 67
Consuelo Jimenez Underwood, *Tenured Petals*, 2013. Fiber, mixed media: natural dyed cotton, copper wire, thread, 6 in. × 40 in. × 96 in. Photograph by James Dewrance. Collection of the artist.

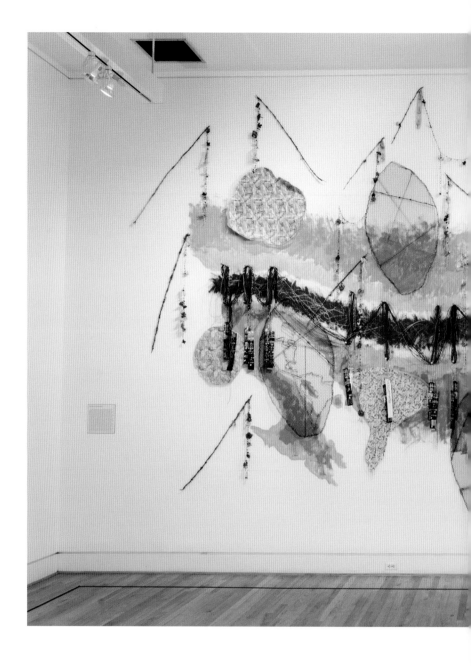

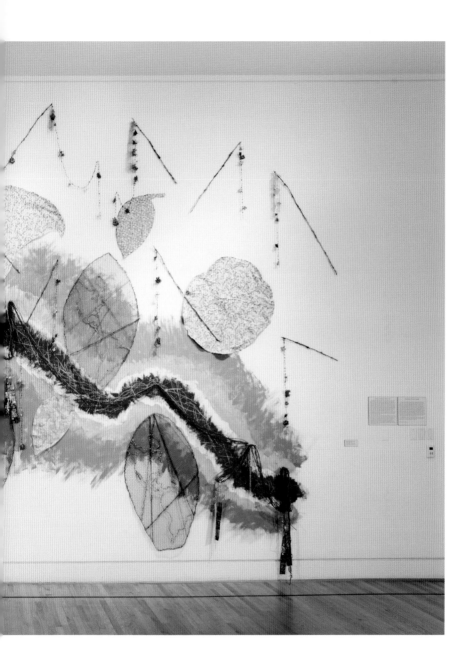

FIGURE 68

Consuelo Jimenez Underwood, *Welcome to Border-landia!*, 2013. Mixed-media wall installation, 17 ft. × 25 ft. × 6 in. Triton Museum of Art, Santa Clara, California. Photograph by James Dewrance.

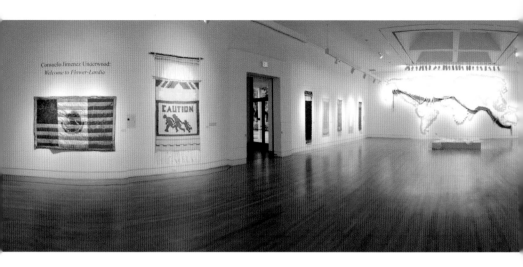

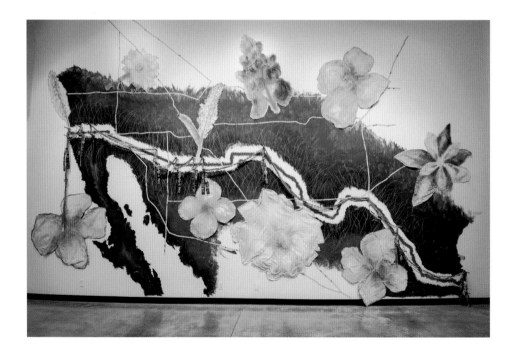

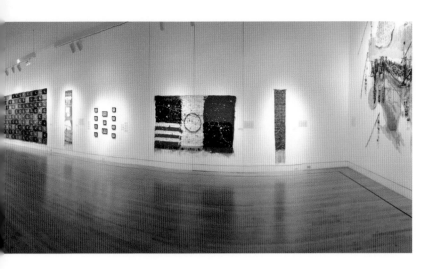

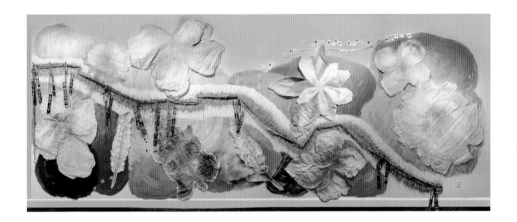

FIGURE 71

Consuelo Jimenez Underwood,
Borderline Premonitions: New York,
2015. Mixed-media wall installation,
10 ft. × 24 in. ArtRage Gallery, Syra-
cuse, New York.

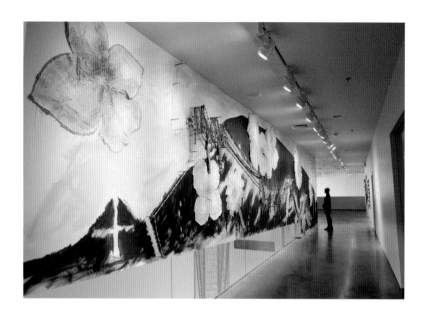

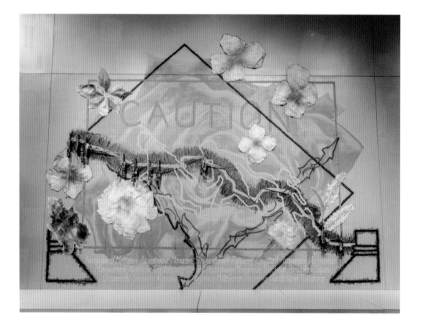

FIGURE 72

Consuelo Jimenez Underwood,
Mountain Mama Borderline Blues,
2015. Mixed-media wall installa-
tion, 10 ft. × 35 ft. × 5 in. Nevada
Museum of Art, Reno.

FIGURE 73

Consuelo Jimenez Underwood, *Undocumented
Border X-ings. Xewa (Flower) Time*, 2016.
Mixed-media wall installation, 27 ft. × 27 ft.
× 5 in. Textile Museum, George Washington
University, Washington, DC.

FIGURE 74

Consuelo Jimenez Underwood, *Father, Son and Holy Rebozo*, 2017. Woven wire, linen, metallic and cotton threads, 40 in. × 19 in. Photograph by Madison Metro. Collection of the artist.

FIGURE 75

Consuelo Jimenez Underwood, *Inside the Rain Rebozo*, 2017. Woven wire, linen, and wool thread, 50 in. × 20 in. Photograph by Madison Metro. Collection of the artist.

FIGURE 76

Consuelo Jimenez Underwood, *Mother Rain Rebozo*, 2017. Woven linen, metallic, silk, and wool thread, 67.5 in. × 14.5 in. Photograph by Madison Metro. Collection of the artist.

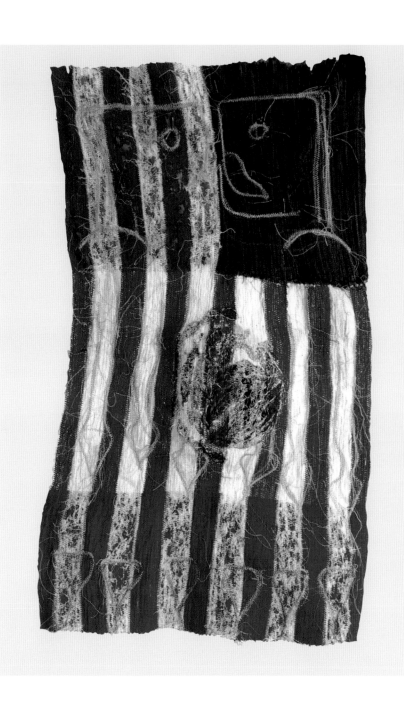

FIGURE 77

Consuelo Jimenez Underwood, *Quatlique-landia*,
2017. Nylon Mexican flag, cotton, and metallic
thread, 30 in. × 17.5 in. Photograph by Madison
Metro. Collection of the artist.

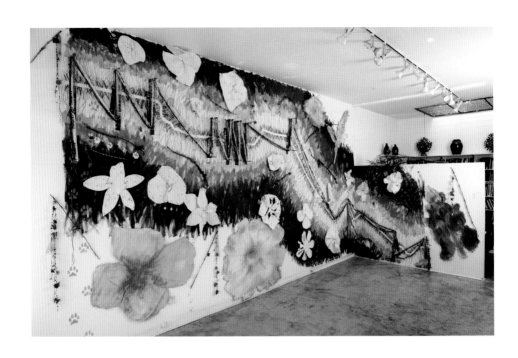

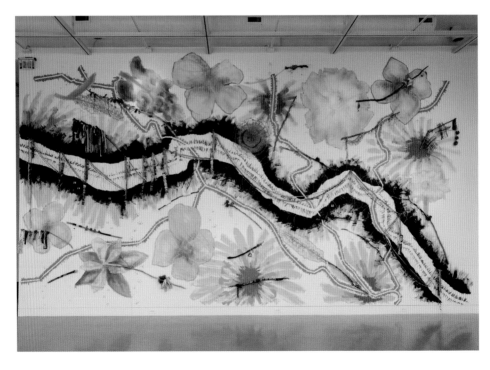

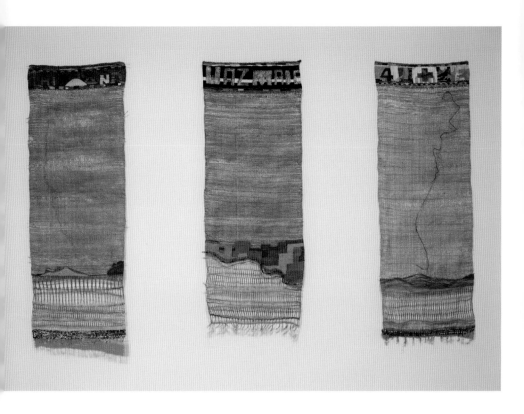

FIGURE 78 (OPPOSITE, TOP)
Consuelo Jimenez Underwood,
Undocumented Border Tracks, 2017.
Mixed-media wall installation: wall
1, 12 ft. × 21 ft.; wall 2, 7 ft. × 9 ft.
Craft in America Center, Los Angeles,
California. Photograph by Madison
Metro.

FIGURE 79 (OPPOSITE, BOTTOM)
Consuelo Jimenez Underwood,
*American Border Charge: Power Wands
and a Basket*, 2018. Mixed-media wall
installation, 15 ft. × 26 ft. 108 Contem-
porary, Tulsa, Oklahoma. Photograph
by Rebekah Hogan.

FIGURE 80
Consuelo Jimenez Underwood,
Woody, My Dad and Me, 2018.
Woven wire, linen, metallic and
cotton threads, three rebozos,
18 in. × 50 in. each. Photograph
by Clayton Flores. Collection of
the artist.

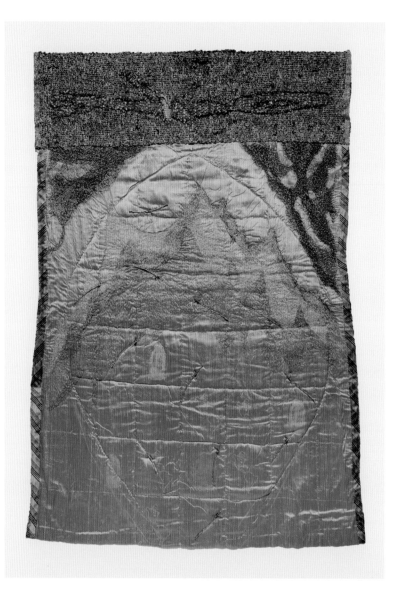

FIGURE 81

Consuelo Jimenez Underwood,
Undocumented Nopal. 2525 AD,
2019. Silk, hemp, and cotton
fabric, linen and wire warp;
cotton and synthetic embroidery
thread, barbed wire, 70 in. × 48 in.
Photograph by James Dewrance.
Collection of the artist.

FIGURE 82 (OPPOSITE, TOP)

Joan Austin, *Ocean Lights*,
1985. Linen warp, linen, Mylar,
acrylic paint, glass-shot weft,
59 in. × 78 in. Collection of the
Mingei International Museum,
San Diego, California.

FIGURE 83 (OPPOSITE, BOTTOM)

Joan Austin, *Waves of Grace*,
1978. Paper, silk thread, 6 in. ×
8 in. × 7½ in. Collection of the
Mingei International Museum,
San Diego, California.

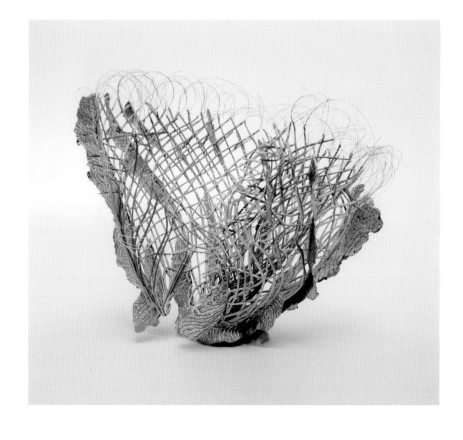

FIGURE 84

Yreina Cervántez, *Big Baby Balam*,
1991–2017. Collection of the artist.

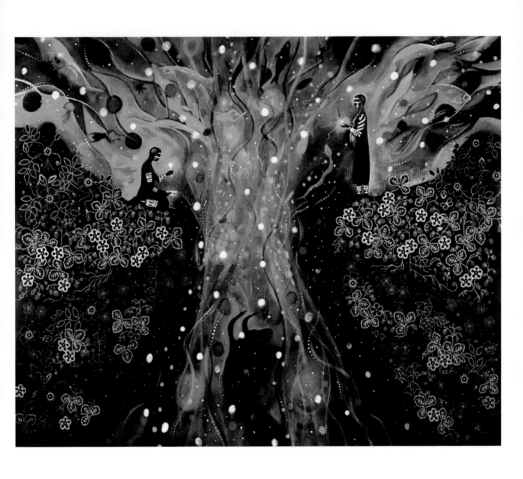

FIGURE 85

Christi Belcourt, *Offerings to Save the
World*, 2017. 55.25 in. × 72 in. Collection
of the artist.

Delilah Montoya, *La Guada-lupana*, 1998. Photo mural, 14 ft. × 10 ft. × 4 ft. Collection of the Museum of Fine Arts, New Mexico Museum of Art, Santa Fe.

Delilah Montoya, *San Sebastiana: Angel de la Muerte*, 2004. Movie poster, ink jet on Mylar, 35 in. × 24 in. Photograph by the artist. In the collection of the artist.

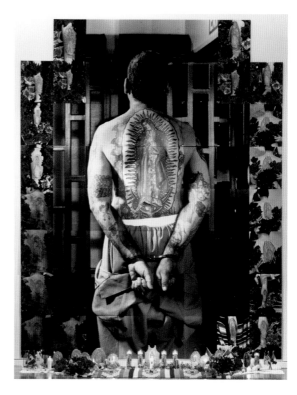

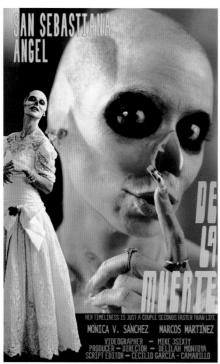

Celia Herrera Rodríguez, *Red Roots/Black Roots (Tree of Life)*, 1999. Window screen, acrylic paint, wood, linoleum, cotton fabric, nails, 8.3 ft. × 8.3 ft. × 8 ft. Photograph by Fan Warren. Collection of the artist.

Celia Herrera Rodríguez, *Cositas Quebradas (broken little things)*, 1999. Detail of artist performance, *Cositas Quebradas*.

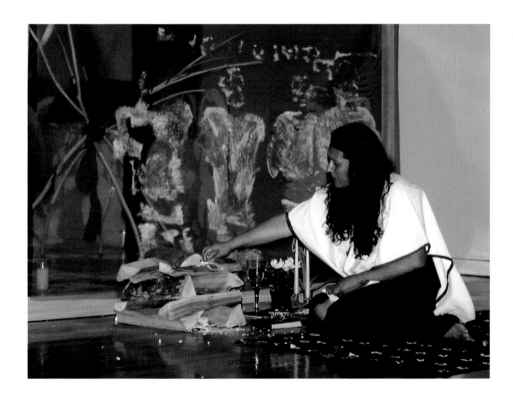

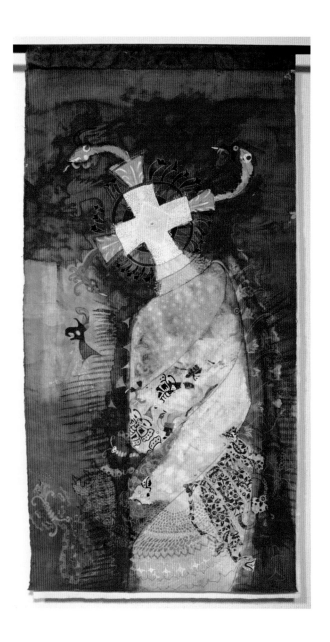

FIGURE 90

Celia Herrera Rodríguez, *Ojo de
Sabiduría*, 2004. Watercolor on
Kozo (Japanese handmade paper),
29 in. × 55 in. Photograph by Leslie
Bauer. Collection of the artist.

FIGURE 9I

Georgina Santos, *33 Acteal inoxidable*,
2008. Found shoes, wooden blocks,
stainless steel rods. 6.2 ft. × 8.2 ft.
(7.8 in. × 11.8 in. per frame). Collection
of the artist.

FIGURE 92

Georgina Santos, *Nichos de olvido*,
2009. Tin niches, dirt, lace, fragments
of shoes, 3.9 ft. × 1.1 ft. Collection of
the artist.

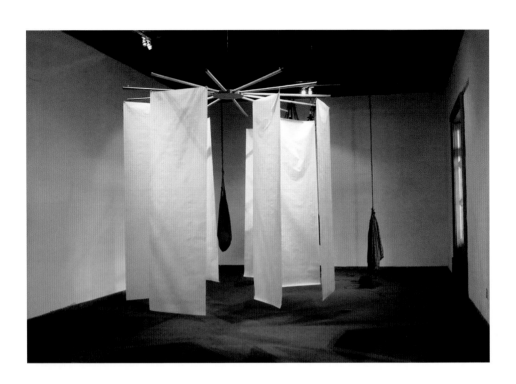

FIGURE 93 (OPPOSITE, TOP)
Georgina Santos, *Bajo el rebozo*, 2011. Instal-
lation, ten rebozos, embossed Japanese bark
paper, 6.5 ft. × 1.9 ft. each.

FIGURE 94 (OPPOSITE, BOTTOM)
Georgina Santos, *Venas con memoria*, 2011.
Installation, chiles de árbol, stones, baskets,
paper, approximately 26 ft. × 16 ft.

FIGURE 95
Georgina Santos, *Reflejo de ausencia y espera*,
2011. Installation: wooden hoops and cotton
thread. Approximately 4.9 ft. × 9.8 ft.

CRISTINA SERNA

Decolonizing Aesthetics in Mexican and Xicana Fiber Art

The Art of Consuelo Jimenez Underwood and Georgina Santos

Los tejidos son los libros que no pudo quemar la colonia.

SLOGAN AT A PROTEST TO DEFEND THE INTELLECTUAL PROPERTY RIGHTS OF MAYAN WEAVERS IN GUATEMALA

I've always thought that my literary antecedents were not writers but weavers. . . . What is telling a story but keeping track of those threads?

SANDRA CISNEROS

Like the Maya weavers quoted in the epigraphs above who re-mind us of the proximity between Indigenous women's textiles and the precontact codices, famed Chicana writer Sandra Cisne-ros observes that storytelling is an art form akin to weaving.[1] Cisneros's epic novel *Caramelo* symbolizes this connection, as the author shapes her transborder narrative around an heirloom rebozo that threads together the stories of several generations of the narrator's Mexican and Mexican American family. Much like story-tellers in Indigenous traditions, Indigenous weavers also hold and

create cultural memory and learning. Guatemalan Maya weavers propose laws that defend their textiles as the collective intellectual property of their communities and ask that their weavings be recognized as forms of knowledge.[2] In this manner they remind us that intellectual production in Abya Yala exists in a multiplicity of forms that extend beyond what is recognized as legitimate ways of knowing within colonialist Eurocentric frameworks. The editors of the anthology *Tejiendo de otro modo: feminismo, epistemologia y apuestas descoloniales en Abya Yala* similarly reference a connection between weaving and knowledge in their book's title, as they choose the language of weaving to thread together the words of Indigenous, Black, and other minoritized women in Abya Yala who write from distinct cosmovisions and ways of knowing.[3] Together, Maya weavers, Chicanx/Xicanx artists, and decolonial feminist theorists recognize that weaving is a form of knowledge creation that reflects the intellectual and creative labor of women in Abya Yala.

Like Cisneros, the Indigenous and mestiza fiber artists Consuelo Jimenez Underwood and Georgina Santos use textiles such as rebozos, which are part of many Indigenous women's everyday lives, as narrative tools that unravel hidden stories and histories of Mexican and Xicana Indigenous and mestiza women across the continent. In *Rebozos de la Frontera: Dia/Noche* (2001), Xicana Indigenous artist Consuelo Jimenez Underwood skillfully weaves a pair of rebozos in homage to "that Indigenous woman that crosses the border and has no time to weave," using materials that highlight the effects of border policing on the conditions of an Indigenous immigrant woman's life (figure 29).[4] Jimenez Underwood constructs a pair of day and evening rebozos, "with colors that blend into the desert landscape"—one in red, the other in blue—to serve as protective covers from the dangers of daytime and evening border crossings.[5] Although they look like typical rebozos when viewed from a distance, the *Rebozos de la Frontera* are not stitched together with thread; instead, they are composed of small square fabrics woven together with safety pins and barbed wire. Each square has the word CAUTION and the silhouette of an immigrant family running, taken from the Caltrans freeway crossing sign, silkscreened on them.[6] The barbed wire and caution signs call to mind the dangers immigrant women and their families face while crossing the border or while trying to make a life in the United States under the imminent threats of deportation and anti-immigrant violence. As Jimenez Underwood notes, "millions of little caution signs is my code way of saying if you're Indigenous, you're

always going to be under the scrutiny of the border patrol."[7] Her art speaks to the experiences of Indigenous people in the diaspora who are not often recognized as Indigenous because of US and Mexican racialized constructions of "mestizo" and "illegal alien" subjects.

Rebozos de la Frontera invokes the weight of the spirits who have passed in addition to those of living bodies. The Mesoamerican concept of balanced opposition is visible in the title's allusion to day and night, which conjures the associated cycle of life and death.[8] Reminders of the fragility of life—in the face of immigration policies that cause death—are woven into the materiality of the rebozo: for instance, the pieces of fabric that make up the rebozos invoke the articles of clothing left behind in the desert or on the bodies of immigrants who die while crossing. The repetitive pattern of warnings and bodies created by the caution signs is a further reminder of the innumerable fatalities that necessitate the creation of such grim roadside markers.

But these rebozos, like most of Jimenez Underwood's artwork, convey much more than an image of oppression or death. They also represent the will to survive, as they evoke the creativity and resilience of Indigenous immigrant women. Jimenez Underwood's use of safety pins and wire as a means of holding the rebozo together highlights immigrant women's ingenuity and strength in the face of precarious conditions. Her use of tough unconventional materials as she weaves together metal and textile demonstrates the way immigrants create dignity and beauty out of difficult circumstances. The metal from the safety pins and barbed wire also lend weight to the rebozos, giving them a shield-like quality that makes *Rebozos de la Frontera* into a contemporary, feminized form of Mesoamerican war armor to protect Indigenous Mexican women during their dangerous border crossings.[9]

Like the heavily quilted cotton tunics that warriors wore as armor along their feathered body suits, *Rebozos de la Frontera* can similarly be viewed as protective shields for Indigenous immigrant or migrant women who must brave the war zone created by militarized US-Mexico border policies. Some characteristics of Consuelo Jimenez Underwood's metallic rebozos are similar to some of the purposes of precontact shields for Mesoamerican warriors. Nahua war armor (in chimalli, in tlahuiztli) had both defensive and symbolic functions in addition to religious significance.[10] Whereas the insignia and other decoration on Mesoamerican armor were symbols of place, identity, and protection that conveyed the rank of a warrior, Jimenez Underwood's border

rebozos reflect the more humble social standing of Mexican Indigenous and mestiza women who immigrate to the United States, where they are criminalized as "foreigners" and "illegal" subjects undeserving of human rights and dignity. The highway caution sign works as a protective insignia that the artist weaves, almost like an invocation, into the rebozo. As a traffic sign, it admonishes viewers to avoid inflicting harm on immigrant families who may be passing through, while cautioning immigrants that there is danger on their path.

In addition to portraying the impact that anti-immigrant border policies have on the lives of Mexican immigrants, Consuelo Jimenez Underwood interrogates the legitimacy and destruction caused by the artificial line that separates the United States from Mexico. In her ongoing *Borderlines* series (2009–), Jimenez Underwood creates large fiber art installations in the form of maps that depict the negative ecological effects of the border on life-forms (plant, animal, human) that are divided by the border (see, for example, figure 53). By visualizing the negative impact that the border has on the flowers and vegetation that grow on both sides of the line, she attempts to raise concerns about border issues in a nonthreatening way. Jimenez Underwood depicts the borderline as a red gash made from thread, nails, and red barbed wire that divides the map, thus evoking Gloria E. Anzaldúa's metaphor of the border as "a 1,950 mile-long open wound . . . where the Third World grates against the first and bleeds."[11] A white, unpainted area that the artist describes as a dead zone—devoid of plant, animal, or human life—occupies the land that immediately surrounds the borderline. Similarly, in *Land Grabs: 500 Years* (1996) (figure 17), Consuelo Jimenez Underwood directly questions the colonial imposition of borders by showing how European settlers encroached on native lands in the Americas. This piece, which the artist made in response to the Christopher Columbus quincentennial, is composed of five small wooden frames, or looms, that hold five unfinished weavings. Each weaving depicts a map that registers the five-hundred-year imperial history of shifting territorial lines that resulted from European colonization. A candle hangs below each map, along with pieces of corn and gold. The maps include *UK/France Invasion*, *Hispanics Below*, *Louisiana Purchase*, *Line of Demarcation*, and *Mexican Acquisition* (figures 18–22). Through this piece, Jimenez Underwood reinserts a historical narrative of US imperialism that has conveniently been ignored in anti-immigrant rhetoric that marks Mexican and Latinx immigrants as illegal foreigners and outsiders.

Following Consuelo Jimenez Underwood's ongoing challenges to the colonial cartographies of the US-Mexico border, made visible in her *Land Grabs* and *Borderlines* series, I look outside the boundaries of the United States to examine Jimenez Underwood's art production alongside that of contemporary Indigenous-mestiza textile artists in Mexico. Specifically, I examine Consuelo Jimenez Underwood's art in relation to the work of Georgina Santos, a feminist fiber artist who has worked with communities of weavers in the Mexican states of Puebla, Estado de México, and Zacatecas. Consuelo Jimenez Underwood and Georgina Santos are two artists of Indigenous and mestiza Mexican descent who live within the boundaries of different nation-states, each shaped by what Josefina Saldaña-Portillo describes as the distinct "racial geographies" of Mexico and the United States.[12] Despite being situated in differing racial geographies, these two artists share perspectives as Indigenous and mestiza artists who challenge dominant discourses of art as they create artworks that express Indigenous knowledge, values, cosmologies, and connection to place using Indigenous art forms like weaving. Pairing Jimenez Underwood's and Santos's art allows me to contextualize decolonizing and Indigenous-mestiza art practices in a larger, hemispheric perspective. A transborder analysis of the art of Mexicana and Xicana fiber artists who are thinking through decoloniality expands our understanding of the distinct ways decoloniality is articulated through the diverse knowledge systems of Indigenous and mestiza women across Abya Yala. Taken together, Jimenez Underwood's and Santos's art contributes to a transborder archive that illuminates the distinct yet interconnected struggles of Indigenous and mestiza women and artists across vastly different landscapes that are, nevertheless, connected by the violent histories and economies of US and Mexican neoliberal states.

The Politics of Textile as a Decolonizing Art Form

Textiles, in the form of woven plant, animal, or synthetic fibers, are among the most pervasive cultural texts produced by the women of Indigenous nations across Abya Yala. Like the ancient amoxtli (codices), weavings interlace creative, spiritual, and cultural philosophies through visual compositions comprising glyphs, colors, and symbols. Similar to the Mesoamerican codices, Indigenous women's textiles are

an important cultural artifact through which artists articulate import-
ant memories, cosmologies, and knowledges.

Indigenous Mexican textile arts are one of the art traditions that
link the art produced by Consuelo Jimenez Underwood and Georgina
Santos. Both artists rework ancestral art forms to unravel the legacies
of colonialism and neocolonialism in ways that are informed by In-
digenous, decolonizing, and feminist perspectives that challenge the
destruction caused by European and Euro-American heteropatriar-
chal systems. At the same time, the artists' adoption of weaving, an
art form associated with two marginalized groups—Indigenous peoples
and women—performs a very particular rejection of aesthetic value sys-
tems that privilege Euro-American conceptions of "art." Feminist art
historians Rozsika Parker and Griselda Pollock note that "in art his-
tory the status of an art work is inextricably tied to the status of the
maker."[13] It follows that colonial value systems would deny the artistic
value of Indigenous textile art as a racialized art form belonging to In-
digenous people, while patriarchal ideologies further marginalize it as
a "domestic" craft because of its association with women. As fiber art
historian Elissa Auther reminds, categories of "art" versus "craft" are
"discursive constructions reflecting an unequal distribution of power,
status, and prestige in the art world."[14] It is therefore not surprising
that textile art is one of the forms through which Indigenous weavers
and other artists of Indigenous and mestiza descent challenge the dom-
inance of male-defined Eurocentric aesthetics along with the commod-
ification and appropriation of their work and labor by Western art and
fashion industries.[15] Jimenez Underwood and Santos refuse to accept
the gendered, raced, and classed distinction between "art" and "craft"
that devalues the aesthetic and intellectual creations of Indigenous and
mestiza women by measuring them against the white, upper/middle-
class, male-centered standard that has historically been privileged by
Western art institutions.[16] A decolonizing aesthetic practice involves
resistance to male-defined Eurocentric aesthetic standards, and it goes
beyond opposition.

Decolonizing aesthetics names the process through which artists like
Consuelo Jimenez Underwood and Georgina Santos liberate our under-
standing of aesthetics from the Western definitions of art, taste, beauty,
and expression that have been imposed as universal values by mascu-
linist European and Euro-American art cannons. I cite Laura E. Pérez's
decolonizing critique of "aesthetics," which, she argues, "refers not to

culturally and historically specific elitist European and Euro-American values in narrowly defined notions of taste or beauty but, more generally, to the conceptual and formal systems governing the material expression of the activity within societies that we refer to as artmaking."[17] I use *decolonizing* rather than *decolonial* to acknowledge that decolonization is an ongoing process of dismantling the present-day colonial systems of power that maintain rule over Indigenous territories and people, including belief systems rooted in colonial ideologies. In this analysis, *decolonizing aesthetics* refers to artistic and cultural practices by formerly colonized peoples that involve artists' attempts to continue, recover, or rethink cultural practices that stem from ancestral tradition at the same time as they deconstruct the Eurocentric values, tastes, and definitions imposed upon artistic activity, which have led to a devaluation of non-Western art forms. As Laura E. Pérez asserts, the "decolonizing, culturally hybrid spirituality and aesthetics" of Chicana artists reflect Mesoamerican aesthetics and philosophies, yet they are not defined by an Indigenous worldview alone; they are often composed from a multifaceted vision that draws from African, Asian, and other non-Western worldviews and artistic languages, putting them in dialogue with European and Euro-American cultural forms.[18]

Located at the interface of various movements, Consuelo Jimenez Underwood's and Georgina Santos's textile art offers different, though at times overlapping, critiques from those expressed by Euro-American feminist fiber artists. As Indigenous and mestiza artists with decolonizing and feminist perspectives, Jimenez Underwood's and Santos's feminist fiber art production is influenced by Mesoamerican textile art and other aesthetic traditions. Their decolonizing aesthetics are situated within and between the "third spaces" of Mexican Indigenous textile art, feminist fiber art, and border art, among other traditions, therefore making distinct articulations that differ from those of Euro-American fiber artists.[19] Consuelo Jimenez Underwood's and Georgina Santos's art contributes to and is influenced by various artistic, political, and spiritual movements. The intersectional and decolonizing vision of their art cannot be captured by the label of feminist fiber art alone, as it obscures their connections to Mexican textile art, Mexican feminist art, and Border Art. Consuelo Jimenez Underwood contributes to political and aesthetic conversations in Chicana and Border Art by exploring life on the borderlands and portraying immigrant experiences.[20] Georgina Santos's artwork is influenced by the work of the Mexican

feminist artist and the lesbian feminist activist communities that she has participated in. As formally trained artists with graduate degrees in the visual and fine arts, both artists use textile art to question the elitism of mainstream art institutions that minimize the cultural production of Indigenous and working-class people. The concept of being situated in a "bordered" or "third space" location between various art traditions is useful when it comes to Xicana and Mexicana artists who navigate multiple cultural spaces, identities, and movements and who position themselves critically between or within them. Writing about Xicana artists, art historian Constance Cortez observes that "their ambivalent relationship to male-centered colonial cultures and Euro-American feminism situates their artistic production within a bordered space, a decolonial imaginary as noted by Emma Pérez."[21] Thus, although these two Xicana and Mexicana feminist fiber artists share certain critiques and aesthetic influences with Euro-American fiber art, their bordered position along with their intersectional analyses of power produce a critical difference in their work that aligns them with a tradition of Indigenous and woman of color thought more so than with Euro-American feminism.[22] Their decolonizing aesthetics articulate alternative knowledges and methodologies of artmaking that link their work to the antiracist decolonizing struggles of Indigenous and women of color artists and thinkers.[23]

Euro-American feminist fiber artists of the 1970s and '80s brought a feminist perspective to the earlier challenges the Arts and Crafts Movement had made to the low status attributed to the so-called decorative arts, critiquing the gendered and elitist division that Western culture had placed between art and craft, artist and artisan.[24] Feminist fiber artists' revalorization of textile art was partly a critique of the way in which elite, male-defined Western art canons disregarded the creative production of working-class and middle-class European and Euro-American women because of its association with the "feminine" and "domestic" realm of "craft."[25] Yet as Euro-American feminist fiber artists questioned hierarchies of gender and class in Eurocentric male-defined art, they largely did so without naming the key roles of racism and colonialism in determining the dominant art standards, let alone the role that race and colonial power have in shaping the conditions of women's lives, including their own privileges as white, middle-class women.

For Jimenez Underwood and Santos, weaving and other forms of textile art matter because of this art form's historical link to female

creativity and labor and, just as significantly, because they recognize textile art as an Indigenous art and knowledge form that offers decolonizing pathways toward more ethical, ecological, and balanced ways of living than those offered by colonial, capitalist systems that depend on the overexploitation of Indigenous land, labor, and resources.[26]

Indigenous Epistemologies in the Diaspora: The Art of Consuelo Jimenez Underwood

> Everyone seemed to enter a diasporic configuration in a land where coloniality foisted yet another identity upon migrant populations. A kind of colonial diaspora emerged, created by colonial relations inherited in the Southwest. In other words, populations dispersed through a land named, renamed, bordered, measured, mapped, and fenced to restrict more movement, whether dictated by Spanish colonialists, Mexicans, or Euroamericans—all have mapped and demarcated with artificial lines land where travel persists through time.
>
> **EMMA PÉREZ**, *THE DECOLONIAL IMAGINARY*

In *The Decolonial Imaginary*, Chicana historian and decolonial theorist Emma Pérez observes that "to settle upon Chicano/a experiences as only immigrant erases a whole other history, the history of diaspora, of a people whose land also shifted beneath them."[27] Anglo settlers in the present-day US Southwest imposed colonial borders and immigration narratives that shifted the way we see the land and the diasporas that have long peopled this territory. In the passage above, Pérez is writing specifically about Texas and the migrant diasporas that have populated the Hasinai lands that compose much of present-day Texas. Pérez is referring to various diasporas that have crossed these lands, including non-Hasinai Indigenous nations like the Comanches and Apaches, along with people who migrated north into Hasinai territory from Mexico, many of them also of Indigenous descent. Emma Pérez points out that Anglo settlers renamed and remapped the Indigenous land they invaded and claimed as theirs, in the process giving a new identity to the Mexican diasporic populations who arrived following migration routes that existed long before Anglo occupation.[28] Mexicans—whether recent immigrants or seventh generation—were marked as illegal foreigners on land their relatives called home long before the border existed.

Like Pérez, Consuelo Jimenez Underwood's art responds to the era-sures of colonial history by making visible the colonial production of the US-Mexico border and the ensuing displacement of Indigenous people and ecologies. A large part of her artwork questions the lega-cies of the practices of mapping and claiming land that were central to the invasion and occupation of Indigenous territories by European settlers in the Americas. As the daughter of a Mexican/Huichol father and Chicana mother, and as a girl who grew up in a migrant agricul-tural worker family that moved constantly between Mexico and the United States, Consuelo Jimenez Underwood's art expresses the ex-perience and viewpoint of Indigenous Mexicans in the diaspora. As a US-born migrant, she belongs to one of the "many indigenous nations in diaspora who through a five hundred year project of colonization, neocolonization and de-Indianization have been forced economically from their place of origin, many ending up in the United States."[29] Ad-ditionally, Jimenez Underwood's art is rooted in her vision as an Indig-enous woman with firsthand knowledge of crossing the border. As she expressed in an interview, "My work expresses the quiet rage that has permeated the Americas for more than 500 years. My mentors, both physical and spiritual, have been the millions of anonymous American Indigenous women weavers who perished during the colonial period."[30] With these words, Jimenez Underwood reminds us that both the mate-rial and spiritual planes have an influence on her art, which draws from deep genealogies of Indigenous women's knowledge and history.

Jimenez Underwood's mixed-media fiber art installation *Diaspora* (2003) illustrates this (figure 30). In *Diaspora*, the artist uses cloth, safety pins, barbed wire, and flowers to overlay an intricate view of the Amer-icas from her perspective as an Indigenous woman, placing it in ten-sion to the colonizer's restrictive vision. The clash between two modes of seeing, Indigenous and European, is represented by juxtaposing circles—one is the circular map that comes from colonial cartographic practices, and the others are three hoops that represent an Indigenous understanding of the interrelated circle of life.[31] *Diaspora* depicts a map in the shape of a circle that offers a satellite view of the Americas. The land is portrayed on a circular cloth that the artist sewed together from flower-patterned cloth. The map shows the Americas as a land-mass without political boundaries, yet the spatial organization of the Mercator projection, along with the grid reference lines that crisscross the land, show that this territory has been measured and surveyed by

a Eurocentric eye. A crumpled white gauze partially covers the surface of the map while three metal hoops hover above it. Jimenez Underwood's map of the Americas references more than the land's physical geography; it simultaneously evokes a grander cosmological understanding by constructing a symbolic landscape, much like the mapping practices of Jimenez Underwood's Wixárika (Huichol) ancestors. Some Wixárika paintings are representations of a cosmological map "showing the world and the deities that inhabit it."[32] This is partly what Consuelo Jimenez Underwood is doing in *Diaspora*, which invokes the spiritual geographies of these territories where all of the ancestors of the original peoples are buried. In interviews, Jimenez Underwood explains that the flowers that abound in this piece symbolize the spirits of the ancestors who serve as bridges between physical and spiritual worlds. The spirits-as-flowers are, according to the artist, "the anonymous folks that come and go and die—they become flowers"; the spirit flowers she places across the land therefore symbolize "the flight of souls coming in and out of the world."[33] The spirits that inhabit this territory are not contained or erased by colonial borderlines; instead the artist represents them as flowers that live (and die) unbounded. In contrast, the grid reference lines that she draws over the landmass of the Americas depict the colonizing vision of the occupier. These grid lines on the map stand as reminders of the role that maps and visuality had in the process by which Europeans reduced the vast territories of Abya Yala to the newly fabricated America of their colonial imagination. The grid lines evoke the cartographic practice Emma Pérez describes, by which Indigenous land was "bordered, measured, mapped, and fenced"—first in the interest of empire and later for nation building.[34] Tellingly, Jimenez Underwood has made the grid lines from barbed wire, a material that she uses in other work to mark the US-Mexico border.

Diaspora presents Indigenous and European cosmovisions, showing how they clash and intertwine upon one landscape. Consuelo Jimenez Underwood's *Diaspora* shows that the territory in question is crossed by competing cultural visions with very distinct ways of perceiving the land and ecosystems. In this way, Jimenez Underwood honors a spiritual ontology that has been denied by Cartesian and now capitalist philosophies that view land, culture, and people as commodities rather than as entities that are integral to the survival of our global ecologies. Moreover, as Clara Román-Odio remarks, "by acknowledging these cultural, economic, and environmental borders, Jimenez Underwood makes evident

not only forced colonial expansion but also how First/Third World and North/South divides are the result of colonial legacies."[35]

Like *Rebozos de la Frontera*, this installation weaves together materials of everyday life, such as safety pins, sheets, and buttons, to create a poetic artistic composition that challenges colonial aesthetics and logics through her choice of form, techniques, and materials, in addition to the piece's thematic content. Laura E. Pérez calls attention to the artist's specific aesthetic intervention, noting that "through her use of the loom and needlework (quilting and embroidery), [Jimenez] Underwood boldly makes reference to the occluded creative legacies of women's 'domestic arts' and Native American 'folk arts' within patriarchal Eurocentric cultures."[36]

Bajo el Rebozo: The Art of Georgina Santos

Born in Toluca, Estado de México, with family roots in Puebla and Guerrero, Georgina Santos is a mixed-media artist who works predominantly with textile art, installations, and performance, in addition to drawings and graphic art. Currently based in Bolivia, Santos studied visual art at the Escuela Nacional de Pintura, Escultura y Grabado "La Esmeralda" in Mexico City and earned a master of arts degree in visual art from the Universidad Nacional Autónoma de México. Santos cites feminism and activism as two of the biggest influences on her artistic production.[37] Her aesthetic and political practice is influenced by textile art, feminist art, performance art, and lesbian feminism, among other movements. Santos creates work as an independent artist but also has been part of collaborative projects, including the Mexican lesbian feminist art collective Las Sucias.

In her earlier art, Santos attempted to create images that could bring attention to violence against women without objectifying women and without denying their ability to represent and speak for themselves. As a feminist activist concerned with the violence directed at women, particularly Indigenous women in Mexico, Santos began to question the power dynamics inherent in any representation of subaltern "others," even when done in the spirit of solidarity. Chicana art scholar Yvonne Yarbro-Bejarano notes that "the politics of visual representation figures prominently in international feminist debates about gendered violence, including how to denounce the violation of women's bodies without

graphic sensationalism that might overwhelm or alienate the viewer or reproduce the discursive violence encoded in cultural understandings of the female body."[38] As part of her own feminist methodology Santos therefore sought ways to denounce violence without exploiting images of women affected by violence (the racial, sexual, or minoritized "others"). Her goal was to develop a practice that sought to interrupt both the material and the symbolic exploitation of people's misery.[39]

In her installations *33 Acteal Inoxidable/33 Stainless Acteal* (2008) and *Nichos de Olvido/Niches of the Forgotten* (2009), Santos uses found objects—including women's shoes abandoned in fields, streets, and roadways—as signifiers for the piles of discarded women's shoes and clothing that are sometimes the only material evidence of women's disappearances and of the femicides that take the lives of impoverished Indigenous and mestiza women in Mexico and across the Americas (figures 91 and 92). *Nichos de Olvido* is composed of five brass Oaxacan niches (nichos) filled with dirt, lace, and torn pieces of shoes the artist found in an Indigenous community in the Northern Sierra of Puebla. Using a similar aesthetic, *Acteal Inoxidable* is an installation composed of thirty-three shoes Santos compiled from Indigenous communities across Mexico, which she pierced with stainless steel rods and mounted on wooden blocks painted black. The installation commemorates the women who died in the 1997 massacre of forty-five Maya tzotziles—most of whom were women and children—by Mexican paramilitary forces in Acteal, Chiapas.[40]

Georgina Santos's shoe installations call to mind Chicana artist Celia Alvarez Muñoz's mixed-media installation *Fibra y Furia: Exploitation Is in Vogue* (1999–2002), dedicated to the missing and murdered women of Ciudad Juárez. Celia Alvarez Muñoz's memorial included rolls of cloth, shoes, and garments like a red prom dress, jean cutoffs, and a maquiladora worker's dress. A large shoe installation was placed in the center of the room, in front of an altar arranged around a large photograph of a victim's legs. Muñoz reproduced the fragmentation of the murdered women's mutilated bodies through the clothing and photographs that she included in the exhibition. Moreover, as Benita Heiskanen argues, her displays of "a range of women's garments without bodies are a critique of the fashion industry, with subtle cues linking the Juárez femicides with the surrounding transnational economic affairs."[41]

Mexican and Chicana activist artists are not alone in using culturally specific signifiers such as dresses and shoes to mark the traces of

missing and murdered Indigenous and mestiza women across Abya Yala, nor in their challenge to colonial borders. Adding to a transborder archive of decolonizing aesthetics, Indigenous activists in Canada have likewise responded artistically and politically to the femicides that occur north of the United States–Canadian border. For example, the *Red Dress Project* (2010), coordinated by Métis artist Jaime Black, is a public art installation of red dresses that raises awareness about the high incidence of missing and murdered aboriginal women in Canada. *Walking with Our Sisters* (2012), by Métis artist Christi Belcourt, is a commemorative art installation composed of more than 1,760 moccasin vamps donated and decorated by hundreds of individuals to represent missing and murdered Indigenous women in Canada and the United States. Both of these campaigns circulate binationally and disobey the border between Canada and the United States that imposes on the sovereign territories of various Indigenous nations.

Like Consuelo Jimenez Underwood, Georgina Santos uses rebozos and weavings—in addition to shoes and other garments—to depict the conditions of Indigenous and mestiza women's lives. In her series of paper rebozos titled *Bajo el rebozo/Beneath the Rebozo* (2011), Santos draws upon the rebozo as a symbol that invokes sexualized cultural constructions of women's bodies, especially as these are evoked in everyday misogynist language and culture (figure 93). The *Bajo el rebozo* installation was exhibited in 2011 at the Museo de Arte Moderno in Toluca in a solo show of the same title. It was composed of seven white paper rebozos that hung vertically from a radial set of wooden spokes that were attached to the ceiling. In contrast to Consuelo Jimenez Underwood's ornate *Rebozos de la Frontera*, Santos's white paper rebozos appear almost bare—devoid of both weight and color. One has to look at the rebozos closely to read their hidden messages. What is beneath the rebozo? What does this cultural shroud cover? In *Bajo el Rebozo*, Santos stripped away color and ornamentation from the rebozo to reveal the messages directed at the women who wear this cultural garment.

Santos created the rebozos out of long (6½ feet × 2 feet) pieces of white Japanese bark paper. She embossed decorative designs on each rebozo along with a popular saying, or dicho, that reveals the misogynist language that has come to be seen as almost intrinsic to popular Mexican culture. The dichos on the rebozo included statements that likened men's treatment of women to their treatment of produce, everyday objects, or fieldwork, using sexualized humor that reinforces vi-

olence and misogyny: *"por la mañana a la siembra y por la tarde a la hembra* (in the morning to the field, and in the evening to the woman)," *"el papel y la mujer sin temerles a romper"* (no need to fear tearing paper, nor women), *"la mujer y el melón se calan por el pezón"* (test a women for ripeness, like you do a melon—by the nipple or stem). In this installation, Santos lifts the cultural shrouds of the rebozos to uncover the violence that has become normalized in the popular language and humor of everyday life.[42] Santos describes her motivation for this piece, stressing that there are misogynist beliefs that are repeated in Mexican humor and dichos, which Mexicans have come to uncritically accept as normal parts of traditional Mexican culture, "día a día nos encontramos con un entramado de signos, dichos, costumbres o tradiciones en los que se encuentran arraigados actitudes como el machismo o la misoginia y que por ser ya tan naturalizados, estos se vuelven invisibles y pocas veces nos percatamos de su existencia. Es por esta última razón que utilicé la técnica de gofrado para la pieza que le da título al proyecto de exhibición. Las impresiones son tan sutiles que no son fácilmente perceptibles. Es necesario acercarse y mirar detenidamente."[43] Her embossing technique on white paper intends to make viewers look more closely at the subtle messages that are almost imperceptibly embedded in the cultural garments or narratives that Mexicans accept as custom.

While discussing the cultural associations of the rebozo in Mexico, Santos observes that Mexican nationalist imagery frequently uses the rebozo to authenticate the beauty and sexuality of mestiza women.[44] Images of sexualized mestiza women wrapped seductively in rebozos appear repeatedly in Mexican popular culture and have their roots in the romantic discourses of Mexicanidad that male artists produced during the early nationalist period of Mexican art. In *Becoming Modern, Becoming Tradition: Women, Gender, and Representation in Mexican Art*, Adriana Zavala provides two examples—Saturnino Herrán and Ramon Lopez Velarde, two well-known modernist artists who created erotically charged images of mestiza women dressed in regional garments (very often Indigenous), including rebozos and huipiles in their attempts to "Mexicanize" modernist iconography.[45] Specifically, in Herrán's classic painting *El Rebozo* (1916) and Lopez Velarde's poem "Tenias un rebozo de seda" (1916), the rebozo figures prominently in the two artists' erotic depictions of the bodies of the female protagonists, whom they construct as objects of sexual desire. Sexualized images of women in traditional Mexican regional dress went on to become part of

Mexican popular culture, and they continue to circulate in calendars, advertisements, and national art museums.

Santos therefore interrogates the rebozo as a symbol that reveals the ways in which state and corporate interests exploit romanticized images of Indigenous or mestiza women. Treating the rebozo as a cultural text, Santos also questions the social and religious norms that dictate when women's bodies are to be covered or uncovered, asking why "with Catholicism a rebozo becomes a sign of faith, decency, modesty, trust, an almost chastity armor."[46] For Santos, the rebozo is a cultural garment that reveals the contradictory expectations of sexual purity and hypersexualization that patriarchal culture places on women.

The embossing technique on white paper that Georgina Santos used in *Bajo el Rebozo* is reminiscent of Consuelo Jimenez Underwood's white-on-white embroidering technique in *Virgen de los Caminos/Virgin of the Roads* (1994) (figure 15). *Virgen de los Caminos* is a quilt made of embroidered and quilted cotton and silk that Jimenez Underwood created in response to Proposition 187, the California ballot measure that sought to deny state services, including health care and education, to undocumented immigrants.[47] As a child's quilt, *Virgen de los Caminos* is intended to honor the child that belongs to the family in the migrant crossing sign.[48] An image of the Virgen de Guadalupe with a skeletal face appears in the center of the quilt. Embroidered images of barbed wire symbolize the border between Mexico and the United States. The word *caution* and an image of the immigrant family running are stitched repeatedly with white thread into the white background, rendering them "as ghosts, stitched forever in the running position."[49] The migrant crossing sign is almost imperceptible, just like real-life immigrant families are to those who deny them basic rights. Both Consuelo Jimenez Underwood and Georgina Santos prompt their viewers to scrutinize the cultural images and messages they receive and to look beyond the seemingly visible.

The artists' visual choice to denounce violence without turning primarily to figural representations of women's bodies is a further example of their feminist methodology. By not depicting sensationalized images of murdered or brutalized women, Consuelo Jimenez Underwood and Georgina Santos avoid a discursive and symbolic reenactment of violence while still denouncing it. They are also refusing to further objectify, exotify, or commodify the bodies of women of color for the sake

of a political or artistic statement. Instead they devise alternate visual strategies to denounce oppression by speaking through cultural markers like the rebozo and migrant crossing sign.

Whereas Consuelo Jimenez Underwood's art shows the impact of border policing and anti-immigrant policies on Mexican immigrants and other inhabitants of the geographical borderlands, Santos's work captures life for women living farther south of that militarized borderline. Georgina Santos's art production offers snapshots of life for women who are far from the US-Mexico border yet share some similarities with Mexican immigrant women, as their lives are both impacted by US economic policies that lead to poverty, migration, and family separation. Her installation *Venas con memoria/Veins with Memory* (2011) speaks about the economic and cultural reality of the northern Mexico community of Zóquite by using *chile* as the central element of her installation (figure 94). Chile has been one of the primary means of economic survival for the inhabitants of Zóquite, a primarily mestizo rural community in Zacatecas that has seen a rise in migration as cultivation of chile, and of other crops, no longer supports the local economy. *Venas con memoria* is composed of hanging strings of chiles de árbol, stones, baskets, and small slips of paper that provide statistics to contrast the low prices paid to those who farm or harvest the chile with the price the consumer is asked to pay. The piece highlights the uses and cultural significance of chile within Mexican history and cuisine based on Santos's conversations with the women in Zóquite—as both food and medicine, and even as a form of punishment when burned[50]—but it also references the links between forced migration and global economies that have transformed the lives of women in Zóquite as they face increased migration to the United States and family separation. Women in Zóquite struggle to sustain themselves and hold together the social fabric of communities that have been transformed by the loss of family members (many of them men) to migration.

Santos created *Venas con memoria* after residing and working with a collective of women weavers in Zóquite as part of her *Bordándo-nos* (Embroidering Ourselves) project. Her six-month residence and collaboration with women from the Eco-textiles de Zóquite weaver's collective allowed her to compose this and other works. She was interested in cultivating an artistic practice that allows her to have horizontal relationships with women. At the end of her residence, Santos coordinated

several art exhibitions with fiber-based art made by herself and some of the Zóquite weavers. A related piece that Santos exhibited alongside *Venas con memoria* is *Reflejo de ausencia y espera/Reflection of Absence and Waiting* (2011) (figure 95). This installation ruminates on the relation between absence and waiting that is part of women's lives in a town that suffers from the absence of family members due to long work hours or migration. *Reflejo de ausencia y espera* is about Zóquite womens' experience "de siempre estar esperando al esposo, al hermano, al hijo que se iba a trabajar. Estar esperando las cosechas, estar esperando todo ese tiempo, como tiempo pasivo pero a la vez no porque estás haciendo muchas cosas."[51] As Santos has learned through her work with weavers in Puebla and Zacatecas, it is sometimes during this intermediary waiting time that women find time to embroider or weave: in the pause between the end of one chore and the next task, or as they wait for children or partners to come home from school or work. For some of the women in the Eco-textiles de Zóquite collective, the primary draw to join a group of women weavers was the social community the collective provided them with. Santos found that, more so than the act of weaving, it was being in community and dialogue with other women that kept them coming back to the meetings.

Georgina Santos's piece, *Por Siempre 21/Forever 21* (2017), is a comment on the maquiladoras that have become one of the primary modes of economic survival for women in the Nahua-speaking community of Hueyapan, Puebla, where she pursued an apprenticeship with local weavers. Santos's *Forever 21* installation takes the form of a small wood box, or nicho. The box frames a small weaving composed of uncolored wool interwoven with a strip of brand label ribbon with the phrase *Forever 21* stamped on it. Santos bought the Forever 21 label ribbon from a maquiladora in the Northern Sierra of Puebla that produces clothing for the fashion retailer. A small black shoe, similar to those she used in her earlier shoe installations to reference disappeared and murdered women, lies inside the box.

Santos has familial ties to Hueyapan, as this is the community her father migrated from. While working with local weavers she learned about the impact the maquiladora industry is having on their community. Santos found out that the women of this largely Indigenous community that is known for its famous weavings find it more profitable to work in the maquila than trying to make a living from their artisanal textiles.

Santos's *Forever 21* nicho symbolizes a maquiladora system that contributes to the continued displacement and exploitation of Indigenous women weavers located far from the US-Mexico border—in Puebla. This displacement repeats an old colonial practice of exploiting the labor of Indigenous and mestiza weavers to grow Mexico's textile industry and, in the process, taking women away from their own textile production. The labor exploitation of Indigenous and mestiza women did not begin with the era of the transnational maquila; it has long roots in the forced labor of African, Indigenous, and mestizo peoples who worked as spinners and weavers in colonial-era workshops, many of which were located in Puebla.[52]

Conclusion

Indigenous textile art and artists' struggles to defend their aesthetic creations against cultural and economic imperialism are profoundly political. The politics of Indigenous cultural creations are especially evident in current battles to fight the corporate theft of Indigenous textile designs, which are so readily plagiarized by fashion designers and industries.[53] Indeed, the epigraph that opened this essay, "weavings are the books the colony was unable to burn," was a slogan at a demonstration held in 2016 in Guatemala by a collective of Maya weavers who are demanding constitutional protection for their ancestral textile designs. It is no surprise that textile art is one of the forms through which Indigenous weavers and other artists of Indigenous and mestiza descent challenge the dominance of male-defined Eurocentric aesthetics along with the commodification and appropriation of their work and labor by capitalist art and fashion industries. As fiber artists rooted in Mexican Indigenous/mestiza weaving practices and decolonizing struggles, I consider Consuelo Jimenez Underwood and Georgina Santos to be part of this aesthetic tradition and political conversation, as they adapt ancestral forms and techniques to unravel the legacies of colonialism and neocolonialism in ways that are informed by Indigenous and feminist epistemologies. Jimenez Underwood and Santos recover ancestral art forms like weaving and merge traditional and nontraditional materials to put their ideas about art, politics, and knowledge into practice. In the process, they yield decolonizing art forms informed by feminist and Indigenous methodologies that question the Western patriarchal

culture and neocolonial practices that continue to exploit Indigenous women's art, labor, and bodies. Viewed together, their artworks offer poignant snapshots of a transborder landscape that frames the lives of Indigenous and mestiza women in violent ways, while they nonetheless remain active agents of ingenuity, political action, and creativity. In this way, Santos and Jimenez Underwood align with the Maya weavers in Guatemala who demand that textile art be recognized as part of the Indigenous knowledge systems in Abya Yala, in which women play a central role as artists and as leaders of the resistance to contemporary forms of capitalist imperialism.

CARMEN FEBLES

Reading Our Mothers

Decolonization and Cultural Identity
in Consuelo Jimenez Underwood's
Rebozos for Our Mothers

In April 2015 I was introduced to the work of Consuelo Jimenez Underwood through a lecture she delivered at Idaho State University. Much of her art poses and generates questions about the activity of Western colonial hegemonic actors related to assumptions of control or mastery over the spaces, forces, and beings with which they share inhabitance. Her work takes as its primary space of exploration the US-Mexico (b)orderland,[1] and though she offers no definitive answers, Jimenez Underwood consistently discloses the source of her inspiration—prodding and guiding spectators, and scholars like myself, toward "Las Madres" as a guiding voice and departure point. Coatlicue–Guadalupe–Earth Mother are manifested in Jimenez Underwood's work as interconnected, overlapping, and distinct spiritual manifestations of ancient wisdom and creation. My initial question for the artist regarding the representation of maternity in her work was whether she perceived the possibility of salvation or redemption for the divine matriarchs. My question stemmed primarily from representations of the Mothers, and specifically of La Virgen, in work such as *Virgen de la Frontera* (1991) and *Virgen de los Caminos* (1994), which feature overt representations of La Virgen occupying the physical space of the (b)order, bearing the scars of the barbed wire that crosses her (see figures 9 and 15).

The artist responded by describing for me the recently completed *Rebozos for Our Mothers* series, which comprises *Mother Mundane* (2010); *Mother Earth (Flower)* (2011); *Mother Ocean (Water)* (2011); *Mother Moon (Sky)* (2013); and *Virgen de Guadalupe (Spirit)* (2013) (figures 52, 54, 55, 65, and 66).[2] Whereas I perceived the Mother in these pieces as gravely harmed and violently disfigured by the barbed wire that represents the human-imposed boundary known as the US-Mexico (b)order, the celebratory communion of the Mothers in the *Rebozos for Our Mothers* series more overtly signals the transcendent potential in (b)order crossing. In the press release for the Idaho State lecture, Jimenez Underwood is quoted as saying that she uses "threads instead of words" because that is her "primal voice."[3] This essay explores the *Rebozos for Our Mothers* series (2010–13) (figure 64) as a manifestation of that primal voice. I posit that in the creation of the *Rebozos* series, the artist acts as tlamatini, or scribe, assembling the sacred stories of five Mothers of creation as a guiding "text" that simultaneously pays homage to the Mothers and signals that to properly honor them necessitates eliminating the artificial (b)orders that humans have created.[4] While individual rebozos pay respect to the unique attributes of each, the rebozo as overarching form serves to remind onlookers that the Mothers are a consubstantial presence that wraps and envelops all existence, without regard for human-imposed (b)orders or boundaries.

As a woman of tricultural heritage, Jimenez Underwood understands herself to be rooted in multiple, simultaneous, overlapping, and interwoven (b)order identities, which she seeks to highlight, honor, and enrich rather than disentangle or bind.[5] As Clara Román-Odio has demonstrated, Jimenez Underwood's identity is deeply informed by her lived experience as a migrant.[6] The artist's childhood, lived in geographic fluidity, informs the way in which she perceives La Tierra holistically as her home. In any geographical coordinates, the Earth is/ was present and receptive. Her reverence for La Tierra is the departure point of the syncretic spiritual perspective the artist brings into the gallery.[7] With the rebozos, the artist bridges cultural (b)orders between matriarchal deities, comingling them in the in-between space of nepantla, conceived of as a generative space.[8] As a nepantlera, or "one who facilitates passage between worlds," Jimenez Underwood embraces global spiritual manifestations of the creative and regenerative force of the natural world—conceived of as a maternal force.[9] Here, La Virgen figures as one among a pantheon of matriarchal creators—one of a co-

hort of powerful feminized deifications of all that is and was. In other works, the artist has articulated her dismay at the Catholic trinity of Father, Son, and Holy Ghost, from which is omitted a female creator, the Mother.[10] With *Rebozos for Our Mothers*, she rights that wrong and reminds the spectator that across ancient and modern societies, the attribution of creation to Mothers, both divine and mundane, is virtually ubiquitous, notwithstanding the fact that matriarchs are systematically demoted from the status of divinity and marginalized in—when not omitted from—various world religions, in particular Western Catholicism. Through *Rebozos for Our Mothers*, Jimenez Underwood insists on paying proper homage to five mothers of earthly and celestial creation.

Jimenez Underwood equates "art" with agency and voice, particularly for those who may be silenced in other spheres. As such, her aesthetic aim is to make available and visible that which would otherwise be forgotten. Previous studies have applied a variety of Chicana feminist epistemologies to elucidate how Consuelo Jimenez Underwood employs oppositional consciousness, or methodology of the oppressed, as articulated by Chela Sandoval and practiced in the work of Gloria Anzaldúa, to challenge and problematize binary subjectivities of United States/Mexico (b)order subjects, and Chicanas in particular.[11] In *Chicana Art* (2007), Laura E. Pérez offers a framework for approaching spiritual and aesthetic alterities in Chicana visual culture. Specifically, she examines the spiritual and religious imagery, in particular the representation of La Virgen, in Jimenez Underwood's *Sacred Jump* (1994) and *Virgen de los Caminos* (1994) (figures 14 and 15). I aim to situate *Rebozos for Our Mothers* (2010–13) (figure 64) within this discussion, taking as a point of departure Irene Lara's conceptualization of Tonanlupanisma as a theory and method of healing with which to enact a nondichotomizing "decolonial imaginary" that recognizes the agency of women and Indigenous peoples, legitimizes Indigenous and other spiritual worldviews founded on the interrelatedness of all living things, and challenges the Western binary between spirituality and sexuality, spirit and flesh.[12]

Jimenez Underwood's Tonanlupanisma conception of the Mother(s) is grounded in mestizaje, maternity, and womanhood as the source of power. The artist embodies a knowledge-based praxis born of lived experience that simultaneously enacts and recalls a specific worldview and is irreducible to that singular attribution. Jimenez Underwood often uses the word *infiltrate* to describe what she attempts to do in

her work: infiltrate materials, perspectives, and voices, particularly of women from non-Western European cultures whose knowledge(s) and forms of expression have been systematically subverted and suppressed. In *Rebozos for Our Mothers*, she evokes the nepantla positionality of the Mothers themselves as the source of their endurance and resilience. By paying homage to the creative, reproductive, and transformative powers of the Mothers, she invites her spectators to recognize those attributes in all mothers.

Consuelo Jimenez Underwood, Tlamatini

Tlamatini refers in Nahuatl to "someone who knows something." Tlamatinime have been characterized by scholars of Nahua culture as preservers, interpreters, and disseminators of knowledge. Cherríe Moraga translates tlamatini as "scribe" and theorizes that "the Chicano scribe remembers not out of nostalgia but out of hope. She remembers in order to envision. She looks backward in order to look forward to a world founded not on greed, but on respect for the sovereignty of nature."[13] I posit that through *Rebozos for Our Mothers*, Jimenez Underwood uses thread to recall and (re)present the history of the Mothers, and thus of creation, from a matriarchal perspective.[14] In so doing, she performs as a Chicana tlamatini, or scribe. Reaching into the "pasts" that are made manifest to her as a nepantlera, she weaves together sacred "knowledges" of and about the Mothers that have been forcibly segregated from each other and relegated to the status of extra-orthodox popular devotions as a result of their reframing and recontextualization within Western ontology. By recollecting through weaving the matriarchal origins of all creation, Jimenez Underwood is able to make visible a rich history of reverence for the Mothers and what they have provided and endured, and to call forth hope for a world founded "on respect for the sovereignty of nature."[15]

These rebozos defy easy categorization in aesthetic and cultural terms. Jimenez Underwood has inscribed the garments with elements from the lifeways of Yaqui, Huichol, and other peoples of Uto-Aztecan descent, along with aesthetic and cultural influences represented from Andean as well as European and sometimes Asian cultures. What is ultimately manifested is a juxtaposition of the spiritual/sacred with a keen ecological sensibility in response and resistance to the devastation

of the (b)orderlands wrought by centuries of US and European colonialism. Borrowing from Moraga's theorization of the tlamatini, I aver that, through the art of weaving, Jimenez Underwood brings together marginalized knowledges regarding maternal creation, and preserves for posterity the sacred wisdom of and about the natural Mothers. In visually uniting the *herstories* of the maternal creators, the artist highlights for the spectator their interconnectedness and brings increased potency to the story of each through the copresence of all.[16] As tlamatini, Jimenez Underwood is clear that she receives the inspiration for the rebozos from the Mothers, and that the garments are both tribute to them and message from them. The rebozos themselves may be thought of as paratexts—wraps that recontextualize and reframe the natural Mothers as prisms through which to "see" existence. The rebozo is offered as a content holder—a space that contains stories, and in particular herstories. Onto the garments the artist *inscribes* a powerful pluri-ethnic reclamation of the Mothers as a source of divine creation and sustenance. The divine Mothers, from whom stems all maternal creation, are presented as living, potent, and ubiquitous presences that connect and embrace the disparate elements of the societies in which we reside, refusing to cede to the artificial boundaries violently imposed by human beings, which are represented in all but *Mother Moon Rebozo* (2013) through the inclusion of barbed wire in the inner warp of each. Therefore, in the same gallery space, and often in the same piece, Jimenez Underwood lays bare the effects of what Moraga terms greed, which becomes manifest as a patriarchal, colonialist mindset juxtaposing its effects with the resiliency and the potent creative, restorative, and regenerative forces of the natural Mothers. The *Rebozos for Our Mothers* series offers an image of the Mothers not as stoic, virginal, passive presences to be honored from afar, but as warrior women engaged in battle over the survival of all their offspring, fighting in spite of the wounds they've endured at the hands of their would-be colonizers.

The Rebozo

Since 2010, Jimenez Underwood's primary way of signifying Mother has been in the form of the rebozo, a multipurpose garment of transcultural origins that is made, worn, and used (particularly but not solely) by Indigenous and mestiza women throughout the geography

of colonial New Spain, which includes Central America and the US Southwest.[17] As the artist attests, the rebozo, a humble woven garment associated with third world women—and with craft, and with basic necessity—is itself "infiltrated" into the gallery as a work of art.[18] The association of the rebozo with divinity in the *Rebozos for Our Mothers* series challenges assumptions about the humble nature of the garment or of the wearer. For the artist, the rebozo connotes the power in all that is "feminine" and feminist, containing within it the potential for decoration and abrigo (warmth), but also all the practical utilitarian purposes of the garment as a tool: for carrying children, for carrying crops, for carrying weapons, and so on.[19] The rebozo is simultaneously pliable and portable, but also deceptively tough and resilient. In addition to its numerous purposes related to childcare and birthing, the rebozo offers its wearer protection—from the sun, from the wind, from storms, and from prying eyes. The noun *rebozo* signals the capacity of the textile to rebozar, to envelop, harbor, and contain all. In addition, the rebozo has the potential to serve as a vehicle for infiltration for what is displayed on it and what is wrapped or embedded within it. It is this final signifying potential that is perhaps most transgressive, because in and through the act of de-(b)ordering spiritual and cultural "knowledges," *Rebozos for Our Mothers* challenges both religious and gendered conventions related to Western Christian religion and patriarchal assumptions about the nature of creation.

Jimenez Underwood has on various occasions spoken about the order in which the rebozos were created, highlighting the fact that she is inspired by the Mothers to weave rebozos in their honor.[20] Thus, the artist/scribe works to discern and faithfully transmit through her weaving the messages conveyed to her by the Mothers as she receives them. Performing as tlamatini through the *Rebozos for Our Mothers* series, Jimenez Underwood transcribes the wisdom of the Mothers onto rebozos themselves, and in so doing she brings to the forefront the notion that the wearer of the garment has a story worthy of being told and recorded and remembered. The artist has divulged that the rebozos were conceived from "lowest to highest," which is borne out by the chronological order of completion: *Mother Mundane* was the first of the rebozo series to be completed, in 2010 (figure 52). *Mother Earth (Flower)* and *Mother Ocean (Water)* both were completed in 2011 (figures 54 and 55). The celestial Mothers, *Mother Moon (Sky)* and *Virgen de Guadalupe (Spirit)*, were the last to be created in 2013 (figures 65 and 66).[21]

Terrestrial Rebozos

Mother Mundane

Mother Mundane (2010), displayed as the first of the five *Rebozos for Our Mothers* (figure 52), was the first completed rebozo in this series. Jimenez Underwood has disclosed that she was first inclined to make a rebozo for la Virgen de Guadalupe. Try as she might, the artist attests, she found herself unable to make the Virgen rebozo without first making one in honor of her own mother, the mundane (birth) mother.[22] In addition to the artist's own mother, *Mother Mundane* (birth) honors Jimenez Underwood's paternal grandmother, a woman of Huichol heritage, who for the artist "is embodied by the rebozo."[23] *Mother Mundane* "flaunts her defining uterus" as a celebration of female reproductive power.[24] From top to bottom, three images of a uterus appear down the length of the rebozo, each clearer than the previous one. The emergent uterus signals a growing confidence in the self-awareness and self-proclamation of the female body that comes with age, with wisdom, and with liberation. Jimenez Underwood elucidates the similarity in the form of the uterus to the ram's head, a traditionally masculine symbol associated with power, leadership, initiative, and virility. Here the artist transposes the power associated with the ram's head onto the uterus, which is represented in three stages of emergence throughout the piece—barely visible at first and clearly exhibited in the third image. Simultaneously, the *Mother Mundane* rebozo signals the labor and pain of female fertility, reproduction, and loss of fertility. The rebozo's deep rusty maroon color reminds the spectator of dried blood, simultaneously signaling menstruation, blood loss during childbirth, and child loss. In addition, the emerging uterus, the organ that becomes more visible from top to bottom in the piece, is also a declining uterus, coming into view only as it evolves down the length of the piece. Thus one can infer maturity and time as associated with the discovery or enactment of the full potency of female and maternal power. Yet at once, because midlife is associated with declining fertility and increased reproductive challenges for women, the full emergence of the uterus at the bottom of the piece also hints at a barbed truth—that a woman may come into full awareness of the organ, or that the uterus and its power may become fully "visible" to her, precisely when it ceases to perform its reproductive function as a gestational space. Hence the loss of fertility through menopause or other causes brings full cognizance of the significance of

the uterus as a symbol of womanhood. The fact that the uterine image is embroidered with wire underscores this double-edged reality, signaling that each new phase of visibility or presence may be accompanied by pain or an awareness of declining fertility or absolute infertility.

In the 2018 exhibition *Thread Songs from the Borderlands, Mother Mundane* appeared without the other four rebozos from the series, accompanied instead by *Four Xewam* (2013), *Inside the Rain Rebozo* (2017), and *Mother Rain Rebozo* (2017) (figures 60, 75, and 76).[25] Acting as tlamatini, Jimenez Underwood seems to remind the spectator that the Mothers are not five but infinite, in that they represent all creation. Furthermore, like a cutting from a mother plant that can be nurtured to flourish in its own right, the rebozo series reflects and promises the potent generative and regenerative force of the natural Mothers.

Mother Earth (Flower)

When the complete series of five *Rebozos for Our Mothers* was exhibited in the 2015 exhibition *Mothers—The Art of Seeing, Mother Mundane* was hung first, on the left from the viewer's perspective, followed by *The Virgin of Guadalupe (Spirit). Mother Earth (Flower)* was in the central position, followed by *Mother Moon (Sky)* and then *Mother Ocean (Water)* on the far right. Regarding the sequencing of the work at that exhibition, specifically whether it was intended to invoke Huichol cosmology (wherein Earth Mother occupies the center and four offspring emerge from that core, representing the four cardinal directions), Jimenez Underwood stated, "I never knew there were five cardinal points for the Huichol, I always *knew* for me there were five. It only made sense. The central cardinal point (YO-*my spinal cord standing straight*)."[26] The "central cardinal point" the artist assumes, associating herself by extension with Mother Earth, speaks to the nepantla experience from which she generates her art and that is manifested in it. For Jimenez Underwood, "the Earth Mother is the planet, flora and fauna,"[27] and it is there that she finds her center, which is the primary reason that *Mother Earth (Flower)* (2011) occupies the central position in the *Rebozos for the Mothers* series.

The rebozo in honor of the Earth Mother features the four US-Mexico (b)order flowers—the California poppy, Arizona saguaro, New Mexico yucca, and Texas bluebonnet—that have become the ambassadors of the artist's *Borderlines* series. Flowers, or Xewam, as the artist likes to remind us, are what the Indigenous people, both Yaqui and Huichol,

call the young.[28] Thus, if the *Mundane Mother* found herself empowered through the act of birth, *Mother Earth* is wearing the evidence of her abundance, both protecting and offering forth the flowers as her creation and her gift. The backdrop for the flowers is a rich tapestry of desert earth tones as they appear during the day: from sepia and umber to yellow and dusty brown. In *Mother Earth (Flower)*, the association of the deity with corn is represented through a weaving technique that results in a granulated effect, which is in both color and texture reminiscent of maize kernels. The (b)order flowers that appear on the garment are a reminder of the fecundity of native wildlife, uncircumscribed and undeterred by the imposition of artificial human boundaries.

Mother Ocean (Water)

Mother Ocean (Water) (2011) was the third rebozo to be completed. According to the artist, Mother Ocean is "ecologically painfully aware of her precious five seas" (Atlantic, Arctic, Southern, Indian, and Pacific). The title as well as the hanging order invoke the five oceans for the spectator. All the rebozos except *Mother Moon (Sky)* contain wire in their inner warp, but *Mother Ocean (Water)* is perhaps most visibly impacted by the wire. For *Mother Ocean (Water)*, Jimenez Underwood used silver wire to create barbed wire that partitions the rebozo into five pieces, a segment for each of her five children. The straight, barbed lines remind the spectator of the violence caused by artificial human fragmentation of what is an interconnected set of bodies, indivisible and interdependent. The impact of human disregard for the diverse ocean ecologies—through development and infrastructure as well as agricultural and industrial practices—is visible on the *Mother Ocean* rebozo. Jason Chalmers has offered that "from an Indigenous perspective, the land will always remain beyond colonial violence and imposed structures and, when the settler stops imposing them, the land will always emerge to reconstitute and reclaim its relationships."[29] Embodying that sentiment, *Mother Ocean* bears the scars of human attempts to bound, divide, and control the oceans. And yet, although the evidence of human effect is visible on the rebozo, the piece itself is not defined nor confined by the barbed wire; rather, the wire is an unfortunate presence on a powerful, free-flowing landscape. *Mother Ocean (Water)* wears beautiful, untamed fringe at the bottom, promising continuity and ultimately liberation.

Celestial Rebozos

The two celestial rebozos featured in *Rebozos for Our Mothers* are *Mother Moon (Sky)* (2013) and *La Virgen de Guadalupe (Spirit)* (2013). They are unique in the series in their restrained use of barbed wire. If the three terrestrial rebozos are characterized by their mettle and by their resilience in spite of the metal that traverses them, *Mother Moon (Sky)* and *La Virgen de Guadalupe (Spirit)* are portrayed as above or beyond the wire, having transcended it.

Mother Moon (Sky)

Mother Moon (Sky) (2013) is woven from soft cotton fibers in various shades of white and blue (figure 65).[30] This piece is, according to Jimenez Underwood, the only "rebozo" of the series "to escape the wire" as its inner warp.[31] The elaborate fringe on the piece is concentrated at the bottom, leading the eye to trail downward from the top of the piece. Visually, the spectator perceives a white, iridescent glow, light as well as soft. The moon, symbol and protector of the feminine powers of cyclical (re-)creation and reproduction, is representative of the duality of loss and renewal.

The Chicana scribe's work in remembering the depth of the intertwined potency of the natural Mothers may most manifest to this observer in the celestial rebozos, particularly in the Mother Moon rebozo. If, in the Catholic trinity, Father, Son, and Holy Spirit are conceived as coeternal and consubstantial presences, the recognition of the coeternal and consubstantial workings of the natural Mothers can be traced across global societies and throughout historical time. Furthermore, the linkages between the natural Mothers have a basis in scientific reasoning, with Mother Moon governing the tides of Mother Ocean. The Virgin Mary is often represented in Catholic iconography standing on a crescent moon. In spiritual and cultural traditions across societies, Mother Moon is associated with female fertility and with birth. The "Harvest Moon" has also been recognized and celebrated by cultures around the world and throughout history as a symbol of the end of the summer season and the peak time for agricultural harvest—we could draw many more associations.

Virgin of Guadalupe (Spirit)

The *Virgin of Guadalupe (Spirit)* (2013) was chronologically the last in the series to be completed (figure 66). *Virgen de Guadalupe (Spirit)* is the most controlled of the five *Rebozos for Our Mothers*, exhibiting a very linear, rectangular shape and scant variation in color. Across the golden shawl are woven horizontal silver lines at uniform, fixed intervals, connoting the careful plan and conscripted articulation of the Guadalupan narrative. And yet, toward the bottom of the piece, the white lines broaden and loosen, as if the careful design that flows down from the top were unfinished. Farther down, leading into the loose white fringe, is a multicolored, horizontally woven bar that clashes with the homogenous integrity of the rest of the piece. The imposition of color challenges the spectator to recall that the Virgen de Guadalupe cannot ultimately be separated from her "messy" (mestiza) origins. She is the female relation of, and copresence with, all mothers, including Mundane Mother, Earth Mother, Ocean Mother, Tonantzin, and Coatlicue, and all other Mothers that are otherwise, or not yet, invoked or manifested. She embodies all of them; nevertheless she is encapsulated by none.

Jimenez Underwood draws some of her inspiration from the apparition narrative of the Virgen de Guadalupe, revealing the interrelatedness of the visual, geographic, textural, and relational aspects of the narrative that defy categorization or dichotomization. The artist frequently points out that La Virgen is typically depicted wearing a rebozo. The artist recognizes La Virgen's appearance to, and her perpetual reappearance on the woven ayatl (cape) of, the Indian Juan Diego as decolonial acts in and of themselves. In *Borderlands/La Frontera*, Gloria Anzaldúa theorizes that the new mestiza is one who "has a plural personality and who operates in a pluralistic mode."[32] La Virgen implicitly embodies Anzaldúa's new mestiza in that she represents linguistically, culturally, spiritually, and geographically the Nepantla positionality of the Chicana scribe in irreducible and irresolvable fashion. The Virgin of Guadalupe is featured as a copresent part of a pantheon of sacred Mothers—generators of all that is, who stand in contrast with the Catholic Holy Trinity, from which the Mother is, in the artist's view, omitted or obscured. In addition, the inclusion of the rebozo in honor of Guadalupe, conceived as a celestial Mother—indeed, the Mother of all Mothers—subsumes Christianity (and in fact humanity) within the limitless domain of her reign, which is, according to Jimenez Underwood, the cosmos itself.

Visual representations of la Virgen de Guadalupe typically feature her cloaked in a gold-trimmed blue garment covered in stars. For the artist, "The best [of La Virgen's attire] is the rebozo, representing the Heavens."[33] Jimenez Underwood's rebozo in honor of Guadalupe acknowledges the imperceptibility of La Virgen to humanity (the impossibility of staring at the sun). Thus the gold and silver signal her radiant glow, cast down from the heavens. Unlike *Mother Mundane, Mother Earth (Flower)* and *Mother Ocean (Water)*, la Virgen de Guadalupe's rebozo was spared the inclusion of barbed wire in the inner warp because, says Jimenez Underwood, "I decided not to put 'strife' and 'struggle' into the work.... She sees enough of that."[34] Whereas the rebozo may not be traversed by barbed wire, it is certainly a presence on, in, and through La Virgen's dress and mandorla, as Laura E. Pérez has previously addressed.[35] Jimenez Underwood understands La Virgen as the wearer of a dress that contains and reflects everything that is—"the nails, the trees, accrued wealth, the oceans, guns, etc. the planet and everything on it is Her dress"; the artist conceives her as both protector and "wearer" of all that is, including humanity and humanity's actions.[36] It is Guadalupe's rebozo that holds all that is more-than-Earth, that envelops and contains Earth, in the form of the cosmos. Whatever mark humanity might leave on La Virgen's dress, it cannot encircle the cosmos with barbed wire.

Jimenez Underwood says of Guadalupe: "The image of the VdG is a cosmic portrait of the known world. She stands on the Moon that shines on all the continents, [and] the sun behind Her shines on all."[37] As the artist has stressed to me in various communications, and as she explains in the description of the piece available on her website, *Virgen de Guadalupe (Spirit)* was woven with "golden threads that were spun in Japan intended for kimono embroidery."[38] The imported gold and silver threads from which La Virgen's rebozo is woven carry within them implications of colonialism, trade, globalization, and all human perceptions of the associated metals. Jimenez Underwood acknowledges, "The gold and silver threads were cut off a loom in Japan, sold off by the pound. I wondered if the *oro* and *plata* came from the Americas. Would the VdG care?" But ultimately, it was "time for the precious metals to come home to the Americas and be woven into a cool rebozo."[39] The gold and silver of the rebozo are resignified by the artist as symbolic of "THE Mother, who stands upon the moon, which shines down on all the

continents, and has the sun behind her, which shines down on all" and belongs to none.[40]

Although Jimenez Underwood may have created *Rebozos for Our Mothers* from lowest to highest—from the mundane to the divine—through her choice of medium and materials, and in the intermingling of them in order of presentation, she underscores that there is mundane in the divine and divine in the mundane. Guadalupe's woven origins do not escape Jimenez Underwood's attention, and neither should they escape ours. After all, in the miraculous narrative, the Virgen de Guadalupe, like Jimenez Underwood, is a fiber artist representing herself in, on, and through the medium of weaving, integrating natural and autochthonous fibers in her work, and doing so to challenge a divide—to bridge a (b)orderland. The Guadalupan narrative also problematized the pious/pagan binary that characterized Spanish, and more broadly European, colonialism. Davíd Carrasco points out that Native believers were able to assimilate the Guadalupan apparition because "to the native believers, Guadalupe's appearance on the sacred hill was a continuation of the emergence of sacred ancestors or divinities at a local altepetl, the mountains or water where the dead still dwelled and supplied seeds and forces of fertility."[41] The routine contact with and awareness of the "other" and the "more-than-human" that coexisted with them allowed the native people to integrate and assimilate the apparition with ease. On the other hand, it took Juan Diego three attempts to convince the Spanish archbishop that the message conveyed to him in Nahua, that a temple should be built to the Indigenous virgin on the hill at Tepeyac, was legitimate. His success was ensured by the miraculous appearance of the Virgin's painted image on a woven fabric. The result of her (b)order crossing is that "*Guadalupe* is special because she integrates the tensions of the Indian and the Spaniard, and *mestizo* and Indian into one community of faith and devotion."[42] By representing the Virgin in woven natural fibers, Jimenez Underwood underscores her understanding of Guadalupe as a Mother, tied to the Earth and the broader natural world. As Chicana tlamatini, the artist must operate within and insist on the zone of that "furious cultural mixture" that is not just Guadalupe's space of being and becoming, but her own.[43]

New Rebozos ("Offspring Rebozos")

I contend that *Rebozos for Our Mothers* (2010–13) (figure 64) is a decolonial statement that offers an expression of the nepantla experience from which "Art is the generative expression of creativity, not the violence of colonial domination, and it is in Indigenous art's resistant motion to disavow the repetition of such violence that it recuperates the spirit of ancestral memory and place, and forges new pathways of re-emergence and return."[44] The notion of "re-emergence and return" is evinced in the recent and ongoing expansion of the pantheon of rebozos. Since 2013, Jimenez Underwood has added *Four Xewam* (2013), *Inside the Rain Rebozo* (2017), and *Mother Rain Rebozo* (2017) (figures 60, 75, and 76), to which the artist refers as portraits that bookend but are not included in the original series of *Rebozos for Our Mothers*. The newest rebozos, as exhibited and in content, are related to and stem from one or more of the original five Mothers. These "offspring" pieces signal to this viewer the fecundity of the Mothers honored in the series, and they serve to remind us both that maternity takes diverse and complex forms and that the fertile potential of maternal being cannot be circumscribed by the boundaries imposed by Western patriarchal boundaries and expectations. The act of looking back through the "herstories" of the sacred/spiritual Mothers drives Jimenez Underwood's rebozos forward, allowing them to replicate, diverge, and evolve in complex and unbounded ways.

Four Xewam

In 2013, in the midst of completing the *Rebozos for Our Mothers* series, Jimenez Underwood wove *Four Xewam* (2013) (figure 60). *Four Xewam* evokes the Yaqui and Huichol traditions of describing children as Xewam—as both the achievement of and promise to the Mothers who labored to cultivate and nurture them. Whereas the four (b)order flowers are embroidered (*inscribed*) on *Mother Earth (Flower)* (2011) (figure 54), in *Four Xewam* they come into their own, having reached a maturity and reverence worthy of their own piece. Although the piece is not specifically named a rebozo, certainly it is, in its form and content, a hat-tip to the garment. Aesthetically, *Four Xewam* flows vertically and comprises four woven squares, each depicting one of the four US-Mexico (b)order flowers featured on *Mother Earth (Flower)*. Each square is connected to the next by loosely woven white thread. The bottom of the piece is

adorned with the fringe—white in this case—that is characteristic of each of the rebozos. The effect for the spectator is that each flower appears to be a rebozo in the making—a potential rebozo that is still evolving. The loose white weave that interconnects each (b)order flower has the potential to eventually become the bottom fringe for an independent, fully evolved floral Mother rebozo.

Mother Rain Rebozo

The newest rebozo in honor of a natural mother is *Mother Rain Rebozo* (2017) (figure 76). *Mother Rain* invokes the Huichol practice of narrative tapestry weaving and features an intricately embroidered, brightly colored head of the serpent Rain Mother, which is "where rain is made."[45] It is the drought-ending creation of *Mother Rain Rebozo* that most overtly proclaims the tangible transformational power of the Mesoamerican relationship with the natural Mothers. Jimenez Underwood offers that her inspiration for the piece was the 2017 California drought, and that she was aware of the need to give to, and "not ask more of," the deity. As she worked on the piece it began to rain; the rain continued until the concern passed from drought to flooding.[46] Thus, the rebozo is not merely a work of art but a spiritual practice—an ofrenda made by Jimenez Underwood to the Mother to tangibly impact the physical geography of California. In *Mother Rain Rebozo*, the artist is signaling the consequences of ecological damage and climate change by commemorating the costly California drought, which lasted from 2011 to 2017. At the same time, in the syncretic fashion that underscores Jimenez Underwood's notion of the interconnectedness of all life across all imposed (b)orders, *Mother Rain* pays homage to the rain serpent and in so doing drives curious onlookers to discover that the rain serpent might be traced to a number of Indigenous cosmologies. The rebozos, and perhaps most overtly *Mother Rain Rebozo*, seem to affirm and embody Davíd Carrasco's assertion that "the more modern Mesoamerica becomes, the more it will recover its pre-Hispanic roots."[47] Perhaps more aptly, the piece affirms that those roots are deeper and more expansive than territorial and historical delineations would imply. A quest to locate the specific spiritual origins of a female serpent rain deity yields a complex and extensive web of partial or potential inspirations from across the Indigenous cultures of the Americas and belief systems of the aboriginal people of Australia.[48]

Jimenez Underwood offered her weaving as a prayer to the natural Mother to bring much needed rain, which arrived plentifully as she labored on the rebozo.[49] The rebozo is a protective garment and also a prayerful promise, signaling that if the rain returns, it will be appropriately cared for, respected, and cherished. In this way the piece is both an acknowledgment of the power and reverence of the natural Mothers, and an admonishment and example to the viewer, implying that the remedy for such disasters resides in a respectful and receptive relational encounter with the natural world and the quest for a sustainable method of coexistence with it.

Inside the Rain Rebozo

The playful *Inside the Rain Rebozo* (2017) is an acknowledgment and celebration of rain as life sustaining and as an aesthetic force (figure 75). "Each drop of rain must contain all the colors—each drop contains a rainbow," quips the artist. "What would it be like if we could stand inside it?"[50] *Inside the Rain Rebozo*, like *Four Xewam* (2013), signals a turn toward the offspring of the Mothers, further expanding the potential for decolonial manifestations and configurations.

No Shortage of Mothers

Indicative of the fact that she envisions her task of honoring the natural Mothers as far from complete, Jimenez Underwood is working on the representation of Mother Wind/Sky. To that end, in 2017 she created a series of four tapestry studies depicting Mother Wind/Sky, which have been exhibited at the Cleveland Institute of Art Reinberger Gallery.[51] Guided by contemporary ecological and sociological events as they unfold, the artist is sometimes compelled to set aside one envisioned project for a time in order to prioritize another that feels more urgent, as was the case of the rebozo she envisioned in honor of Mother Wind, which was set aside by the pressing need to create *Mother Rain Rebozo* in the face of the droughts and wildfires that plagued California through 2017.[52] In 2018 and 2019, however, conversations with the artist and an Instagram post from her indicate that she was revisiting the subject of Mother Wind/Sky in her work.[53] Enacting the tlamatini, Jimenez Underwood allows a syncretic spiritual history of mother-

hood to guide her. The rebozos honor a multifaceted spiritual pantheon of natural Mothers and their respective powers. In her role as scribe, the artist herself is deferential to her inspiration, functioning as an intermediary—allowing the Mothers to express themselves in and through the rebozos. Jimenez Underwood has maintained that the rebozos are a product of a call or inspiration to create them that she receives from the natural Mothers; thus more rebozos continue to emerge as the artist feels inspired by the Mothers to weave their stories into the growing pantheon.[54] The rebozos assert and acknowledge Jimenez Underwood's perception that the natural Mothers are allied with the artist in her commitment to visually articulate and challenge the ongoing destruction of the (b)orderland through the continuous and increasing imposition of artificial boundaries and barriers. Thus the role and effect of the natural Mothers in the gallery space is not nostalgic but dynamic and palpable—like the artist herself—discovering, developing, and deploying the powers of their respective offspring (*Inside the Rain Rebozo* and *Four Xewam*, for instance) to counter the violent destruction being waged upon the (b)orderland. The tlamatini is, after all, not a mere transcriptionist but a teacher—both a harborer and a purveyor of inherited wisdom and an interpreter of the contemporary application of that knowledge. In continuing to generate rebozos to honor an ever-expanding population of Mothers that comprise, create, and represent nature itself, Jimenez Underwood signals their ubiquitous omnipresence in the gallery and in the world. Countless natural Mothers are interacting with us and with each other now; it is simply that the artist has not yet had time to honor each of them with a rebozo.

JENELL NAVARRO

Weaving Water

Toward an Indigenous Method of
Self- and Community Care

Rebozos are my delirium, my life, my joy. I will meet death
with threads in my hands.

EVARISTO BORBOA

Puro hilo, puro hilo, puro hilo!

CONSUELO JIMENEZ UNDERWOOD

Introduction: El Rebozo as Indigenous Resistance and Joy

Indigenous women in the Americas have been weaving plants and
thread in a variety of formats for thousands of years—definitely be-
fore settler colonial conquest. Some of the types of weaving include
textile weaving, basket weaving, bead/shell/quill weaving, and fin-
ger weaving. For instance, for more than three thousand years In-
digenous women of Oaxaca have been weaving textiles with stories
of the land, ecosystems, and the entire biosphere represented in
their patterns.[1] California Indians have been weaving baskets for
thousands of years and continue to use different techniques, from
watertight weaves to loose weaves, for daily use of their baskets in
cooking, fishing, and gathering, and North American Indigenous
bead/shell/quill weaving dates back thousands of years before con-

tact to when the purposes of weaving were both aesthetic and sacred and geographic location determined the beads used.[2] Given this brief history and the fact that these forms of weaving continue today among Indigenous peoples, it is clear that these forms of weaving undoubtedly constitute Indigenous epistemologies and operate as a method for storytelling—where storytelling is understood as an act of resistance to colonization because it holds and transmits memory, culture, and knowledge.[3] As artists and storytellers, then, Indigenous women who weave create a localized form of record keeping in the process—making these women archivists in their own right. In order to examine how Indigenous women localize knowledge in their woven arts and imbue them with cultural or sacred meaning (or both), it is important to look at one special woven garment: the rebozo (shawl). In the Americas, Indigenous women have other names for various types of shawls as well, depending on the region, context, and use of the garment.[4] The rebozo can be a storyteller in many ways. For example, for many Indigenous people the rebozo tells the story of ancestral homelands because the particular style indicates where one is from geographically. The designs in the shawl also tell stories about Indigenous cosmologies and sacred ecosystems. For example, the two-headed eagle is often portrayed in the fringe of many rebozos. This image tells the story of Indigenous people such as the Huichol who utilize the two-headed eagle as representation for their spiritual leaders to indicate that these people can see in many directions. In addition, for many Indigenous women in the Americas the rebozo is understood as a relative—one that provides protection, elicits joy, or sometimes mourns the loss of loved ones, as the garment is used from birth to death.[5] The rebozo, in this context, is past, present, and future bound together in the threads that meet on a loom between the vertical warp and the horizontal weft. Therefore, rebozos literally and symbolically carry the life and death of the community.

Born in 1949 in Sacramento, California, Consuelo Jimenez Underwood is a master weaver and fabric artist in California. She has woven many rebozos and textiles dedicated to both human and nonhuman Indigenous relatives. Jimenez Underwood's commitment to our nonhuman relatives such as water, earth, moon, buffalo, *chile*, and corn coordinates the spirituality of her art, through which she honors the spirits of those entities that have sustained Indigenous life and lifeways. More specifically, her rebozos titled *Rebozos for Our Mothers: Mother Ocean (Water)* (2011) (figure 55) and *Mother Rain Rebozo* (2017) (figure 76) are

two water-themed rebozos that stand out among the rest because they illustrate an Indigenous method of self- and community care in an era of deep injustice and pain—and because to weave rebozos for the ocean and rain is to revere the rite/right of water as that life-giving force to all living beings. This is a well-established spiritual practice among Meso-american communities who venerated many water gods and goddesses before conquest.[6] The *Mother Ocean* and *Mother Rain* rebozos, there-fore, can be read within this spiritual veneration of water in order to reveal potent artistic worldviews against ongoing settler desires to elim-inate Indigenous peoples.[7] Specifically, within the interstices of these rebozos' weave, we find life, stories, and Indigenous knowledge opera-tionalized as Indigenous resistance and joy. Certainly, these rebozos as record-keepers are not the full force of our mounted efforts at decolo-nization,[8] but they beautifully and aesthetically serve to establish the import of Indigenous art in decolonizing our lives and lands, because they continue as daily reminders that Indigenous peoples are still here and that our knowledge systems continue to guide us.

To fully examine the significance of these threads/rebozos and weav-ing practices, in what follows I briefly survey the historical and contin-ued meaning(s) of rebozos, underscore the method of spirit first used by Jimenez Underwood, and consider the significance of form *and* content in her art. Additionally, I consider parallels with two other Indigenous artworks: Yreina Cervántez's *Big Baby Balam* (1991–2017) (figure 84) and Christi Belcourt's *Offerings to Save the World* (2017) (figure 85). Both of these artists, like Jimenez Underwood, place water at the center of their creative praxis to emphasize in their paintings their respective Indige-nous worldviews of protection, healing, and spirit. Moreover, the meth-ods of producing Indigenous art, along with the final cultural products created, record our roots, heal our present lives, and forge decolonial paths to our futures. Indeed, as these artists record the importance of water in their textiles and paintings, they are transmitting Indigenous cultures to the next generations—following what many in Indigenous communities call a seven generations model whereby decisions are made considering how our current actions will affect seven generations to come. Thus, when water is protected and revered in these artworks, the Indigenous future is also woven into them.

Our Roots Are Woven: A Brief History of *El Rebozo*

> More than a garment, more than an object, a *rebozo* is our history.
>
> CARMEN TAFOLLA AND CATALINA GÁRATE GARCÍA, *REBOZOS*

The woven arts have been present for millennia among Indigenous communities in the Americas. Some suggest that the rebozo has no "pre-Hispanic origin" because "the first published mention of this garment by name dates to the Dominican friar Diego Durán in 1572."[9] This position, however, upholds the written Spanish nomenclature attached to the garment during colonization and does not take into account the Indigenous precursors to the rebozo—namely, the many woven fabrics, including shawls of all shapes and sizes, created by diverse Indigenous populations before the invasion of settlers. As a result, one must excavate and accentuate the "texts" of Indigenous lives that, in many cases, have been recorded in weaving and textiles before and after the onset of settler colonialism in the Americas. One garment of great import is the rebozo.

Rebozos are woven on various types of looms, manual or mechanical, and still others are woven off the loom by hand.[10] Two main types of looms are used to make rebozos: the backstrap loom and the floor loom. The backstrap loom is simple in its technology and very mobile, as it includes only a few sticks that are used to establish the warp and weft, rope, and a strap tied around the waist or hips of the weaver. One primary benefit of the finished product from a backstrap loom is the thread count. Some master weavers can use up to 6,400 warp threads on the backstrap loom, which creates greater detail in and a nice weight to the finished rebozo. However, it takes about three to four months to finish a rebozo on a backstrap loom. In contrast, the floor loom, also called a foot loom or a treadle loom, is a standalone loom that is not attached to the weaver. It is operated with a series of foot pedals that lift the warp threads to pass them through the weft threads. The foot pedals make the weaving process faster; a rebozo can be finished in about a week. The thread count is smaller, however—usually about three thousand to four thousand threads—meaning the design will not be as intricate as, and the weight of the rebozo will be lighter than, those created on a backstrap loom.

Importantly, master weavers of rebozos have traditionally divided

the labor of making a rebozo into various specialties: winders make and wind the wool or other materials, weavers weave the body of the shawl, fringers only specialize in various fringing techniques, and pressers press the garments with particular pleating styles depending on regional preference. Despite this compartmentalization, some master reboceras/os (rebozo makers) can do everything, but for the most part the division of labor among these artists allows them to develop and master specific skill sets, which provides ways multiple individuals or communities make a living from being winders, weavers, fringers, or pressers.[11]

Teresa Castelló Yturbide has for decades investigated the deep and complex history of the rebozo in México.[12] For example, she details the rich Indigenous geography of the rebozo, showing that the backstrap loom was made by Indigenous weavers *before* contact with colonizers. Castelló Yturbide also notes that many Indigenous groups used this loom with weaving materials that were native to their regions, rather than with materials imported into their Indigenous communities, even though Indigenous trade routes were well established at that time. The Otomí-Pame, whose ancestral territories are in the central highlands of México, for example, wove with native plants such as ixtle (agave fiber) to make astonishing textiles that included shawls.[13] Their weaving skills were so astute, Castelló Yturbide notes, that they easily translated to weaving silk or wool after colonial disruptions of their culture.

Moreover, some Indigenous groups such as the Nahuas, particularly those of Hueyapan, Morelos, still use the Nahuatl word for the backstrap loom, which they call a xoxopaztle. Again, this naming illustrates a linguistic tension between the Native and settler communities before, during, and after conquest, but it ultimately reasserts the existence of their weaving practices and instruments on their precontact lands and in their own language.[14] Obviously, naming is important to the colonial context because place-naming, baptismal renaming, and so on, have historically indicated a colonial/power relationship between Natives and settlers. These naming practices also reasserted settlers' "godlike" complexes because it allowed—and still allows—them to imagine that they can speak things, people, and places into existence and assert dominion over them. Xoxopaztle, the Nahuatl name for the backstrap loom, then, signals a linguistic and cultural refusal of the colonial order and a challenge to the "doctrine of discovery" that undermines those colonial naming practices. The Nahua and many others, in fact, continue to use the xoxopaztle as their preferred instrument for weaving,

which also illustrates the long-lasting effectiveness of the backstrap loom as a tool of Indigenous design.[15]

Rebozos also come in diverse designs with specific geographically and community-determined aesthetics. In Michoacán, for example, the Purépechas create a variety of styles depending on their location in the state. Purépechas in Aranza make lacy cotton rebozos with a gauze weave; in Tangancícuaro, the rebozos are made from fine cotton and dyed with the ikat process, then ironed with stiff pleats; and in areas of the state like Paracho and Ahuirán, they make ribbon rebozos, so named because they are dark blue rebozos with light blue stripes. In contrast, the Mixtecs and Zapotecs of Oaxaca weave very thick cotton rebozos dyed with natural pigments and fringed with complicated knotting in a macramé style. The Otomí weavers remain some of the most sophisticated weavers in all of México, and they now make most of their rebozos from silk and cotton with elaborate loose fringe that illustrates designs such as two-headed eagles, trees, and deer.[16] Additionally, the shapes of rebozos might be large-scale rectangular, large or small triangular in a poncho style, or a small size for head shawls.

The spatial locale of rebozo making is significant because many reboceras/os weave in their homes. Although the home has been subjected to domestication and patriarchal subordination in colonial contexts, many Indigenous women proudly continue their egalitarian cultures in the home, cutting against the grain of settler definitions of home as where women are to be relegated to cooking, cleaning, and child rearing. Settler spatiality also refuses Indigenous women a place of import in the home and in society writ large. As Mishuana Goeman has asserted, there needs to be a "(re)mapping" of settler spatiality in order to "move toward geographies that do not limit, contain, or fix the various scales of space from the body to nation in ways that limit definitions of self and community staked out as property."[17] Thus, when women weavers create a space for financial opportunity and artistic mastery in their homes, they operationalize a refusal of the patriarchal order designed by settlers in the Americas to subordinate women to economic dependence on men and to eliminate their cultural knowledge. Some men who are weavers intervene in the patriarchal structure of the home as well when they weave because this cultural *labor* is often framed as "women's work" after contact with colonizers. For instance, Don Evaristo, a master rebocero, organizes his home distinct from settler domestic spatiality because his home is a loom. Specifically,

as Yanes reports, "Don Evaristo takes about a month to make each re-
bozo. His house is adobe with wooden beams, and his backstrap loom
hangs from one of the beams in his bedroom, stretching from there to
his waist. The loom is the house; nothing else matters."[18]

Don Evaristo and other master reboceras/os create beautiful rebo-
zos, but aesthetic elements are only part of the traditional uses and
functions of the rebozo; these garments also have practical and spiri-
tual utilities. Many weavers, for example, turned to this art form to cre-
ate garments in which to carry their children. This use of the rebozo is
still prominent today, and styles vary to carry babies close to one's chest
or on the back. Many others wear rebozos like a coat or light jacket; in
this way, it is a garment that protects one from the elements. The spir-
itual and ceremonial uses include lace rebozos woven to wear on the
head and many shawls made for use in Indigenous ceremonies. Weavers
also make these garments for the dead—as shrouds to clothe their loved
ones as they pass to the next world. Many reboceras/os in fact under-
stand the practice of making scented shawls for wrapping the dead as a
sacred act. Historian Emma Yanes asks:

> Why fear death if, when the time comes, we will be enveloped in a
> pleasing, subtle fragrance, with notes of lavender and mint? Why not
> simply accept it if we come to its door cleansed, purified, as if we had
> just come from the *temascal* [sweat lodge]? Why should we not die if
> the pre-Hispanic *yauhtli* plant [Mexican tarragon or Mexican mint
> marigold] will ward off evil and lead our soul to a better place? Why
> not leave our body behind like a butterfly's cocoon if anise and cinna-
> mon will inhibit its putrefaction and may allow our body to remain as
> a witness to past loves that are nothing but that—or the wounds, scars
> that will not be infested by insects or parasites the day we die since we
> will be protected by sage, clove, apple mint and Drummond's false pen-
> nyroyal? To die peacefully one does not need canticles or prayers, only
> the embrace of a scented *rebozo*.[19]

Today, Fidencio Segura, also a prominent artist from Tenancingo,
makes these scented rebozos. Segura says he uses the "original recipe"
on his scented rebozos that both his parents and grandparents used
when they made them. He adds that the scent is supposed "to seduce
death, to make it believe that we are still alive by refusing to accept
the stench of our own rotting flesh."[20] Thus, the robocera/o becomes

an intermediary between life and death, the living and the dead, by "shrouding" the dead with the sweet scent of life (in most cases, fruity or floral scents).

Equally important to making the "rebozo de aroma," or the scented rebozo, is the process of gathering the plants from which to obtain the scents. This process is very long and labor intensive. Most reboceras/os get the plants from medicine women who harvest them only during dry seasons to avoid a damp smell in the plants. The alchemists who make the scent, like Segura, use a recipe containing cinnamon, Mexican tarragon, Spanish moss, red apples, dark brown star anise, pink and yellow roses, and lavender.[21] These sacred plants together make "our underworld sojourn more pleasant."[22] In this regard, rebozos de aroma are not only the woven threads (hilos) that carry one to meet death; they also bookend life because they form the counterpart to the rebozos that help mothers carry their newly born infants.

While rebozos carry the newborn and bury the dead, they also serve Indigenous women throughout their lives in multivalent life-giving acts. According to Chicana feminist writer Enriqueta Longeaux y Vásquez, "Out of the Mexican Revolution came the revolutionary personage 'Adelita,' who wore her rebozo crossed at the bosom as a symbol of the revolutionary women in México."[23] Hector García Manzanedo, a professor of sociology, reports that "during the Mexican Revolution, women desperate to save their families' food supplies from plunder stuffed ears of corn into the bosoms of their *rebozos* . . . wrapping the *rebozo* tightly around them till their family's sustenance was assured."[24] The soldaderas of the Revolution of 1910 "carried infants or guns, tortillas or bandages, courage and faith safe within the folds of their *rebozos*," making them not only the physical/biological transmitters of life for their people but also the spiritual and cultural transmitters of life for their communities.[25] All of these noted uses of the rebozo, as a result, continue to underscore the evidence of Indigenous women's knowledge, strength, and wherewithal that is located in this beautiful garment that is still widely worn today.

Our Stories Are Woven: Indigenous Protection and Healing

> Human beings have no other way of knowing that we exist, or what we
> have survived, except through the vehicle of story.
>
> **DEBORAH A. MIRANDA**, *BAD INDIANS*

Consuelo Jimenez Underwood, the daughter of migrant farmworkers,
has been weaving thread for more than forty years. Throughout her
childhood, she would travel with her family each year on the California
migrant farmworker route, picking crops like onions in Mexicali and
tomatoes in Sacramento. When I asked her how she learned to weave,
she replied: "My dad's grandmother was a Huichol Indian. She is the
weaver in my blood."[26] But Jimenez Underwood really developed an
affinity for weaving as a child when she watched as her father would
sit in their garage in Sacramento, California, and weave on his loom on
rainy days when there was no work. Jimenez Underwood affectionately
remembered how he would make dresses for her in the style of paper
doll dresses, weaving the front and back of the dresses separately and
then sewing them together. She also noted, however, that these beau-
tiful moments only lasted for about two to three years, after which her
father stopped weaving. She said he stopped because her "tíos made fun
of him for weaving, saying it was 'women's work.'"[27]

In 1981, Jimenez Underwood received a BA in art from San Diego
State University, where she studied with Joan Austin and honed her
talent with different art forms. She says that Austin taught her tech-
nique and form, not necessarily content.[28] She continued to pursue
graduate education and received a master's degree in art in 1985 from
San Diego State University, and then she earned a master of fine art de-
gree in 1987 from San José State University (SJSU). It was at SJSU where
she realized that the content of art was very significant—sometimes it
was even more important than form. Consequently, she says, "You have
to learn to weave something very tight before you can weave some-
thing messy";[29] this is a methodological/philosophical foundation for
her work. Her education displayed this process: she learned to weave
"tight" from Joan Austin and then later discovered that she could make
fine art that is "messy."[30]

After earning her MFA, Jimenez Underwood taught at SJSU in the
School of Art and Design; she retired as a full professor of art in 2012.
During her time there, she developed the Fabric and Textile Studio

and was the only artist committed to fabric art. Coincidently, because of the aforementioned history of weaving as connected to Indigenous women and Indigenous cultures, this art form has been constantly devalued in mainstream artistic spaces such as university programs, museums, and "official" archives. Jimenez Underwood says, nevertheless, that "fabric was always more beautiful than smearing paint on a surface," adding that she felt she had an inner calling to work predominantly with "threads and hands."[31] She also recounts that throughout her career many women painters have admitted to her—only in quiet voices, as if ashamed—that they, too, were once fabric artists. By contrast, she notes that her commitment to thread was never something she wanted to hide.[32] Consuelo Jimenez Underwood, then, learned the art of weaving indirectly from her grandmother and directly from her father—both of whom connect her to the Indigenous practice of weaving. Then, she formalized her art training in institutions of higher education but remained committed to weaving and textile art as an organic, spiritual, cultural/Indigenous art form that did not need validation from these institutions.

Spirit First as an Indigenous Method

Jimenez Underwood's weaving technique is not a calculated or prescribed process. In fact, one of the most vital elements to her making a loving rebozo is how her studio space is spiritually maintained. Significantly, her weaving space and loom are dedicated to all the viejitas who were the women weavers that came before her. She calls them the "makers and spirits" of her studio because she firmly asserts that nothing magical can be made unless our elders are all around us.[33] Her other noted artistic influence is Vincent van Gogh—in which he underscored his aesthetic to "exaggerate the essential and leave the obvious vague."[34] This statement hangs in Jimenez Underwood's studio and, along with the viejitas, reminds her of this artistic purpose.

Jimenez Underwood's method for choosing what materials to weave is also led by spiritual considerations rather than artistic conventions. She tends to the spirit of her nonhuman weaving materials before she weaves with them because, she says, "the spirit of the material is the voice of what needs to be said" in the art that is produced.[35] Thus, for example, in her studio she asks, "Who wants to say the message? Do

you, silk? Do you, cotton? Do you, linen? Who can speak this message?"[36] Then, once the spirit of the materials has been tended to, she compiles the threads. This constitutes her weaving method: it is first and foremost guided by spirit. Her intentional effort to honor the materials before she begins weaving "draws the focus away from 'yo' and acknowledges that the materials are the stars that will stick around forever," she says.[37] Moreover, the technique Jimenez Underwood utilizes for each piece varies because of her adept skill set and her affective disposition toward weaving and the materials. She notes that the multiplicity of weaving techniques mean so much to her. However, as she attempts to answer the question about which weaving techniques she prefers, she exclaims, "How do I answer? It's like what type of food do you like. I *love* a good cinnamon roll *and* menudo! Are we talking about breakfast, lunch, or dinner? All weaving techniques are dessert! I love all weaving! It's all beauty."[38] In other words, she is not bound to one weaving technique because that might limit the possibilities of the art and the spiritual messages in both the process and the final product. Thus the act of weaving for her is an act that connects her with the elders, with her grandmother, with her father who wove little dresses for her out of love in their garage, and with the spirit world in general.

These details about artistic method and technique for Jimenez Underwood emphasize her Indigenous process to weaving that cuts firmly against the expectations of Western art. Western practitioners or curators often expect an ordered and structured artistic practice that neatly aligns with colonial aesthetics and control, whether realized or not. Historically, these elements of control created elite art and art spaces where, in the nineteenth century and beyond, Indigenous people were put on display in glass cases and treated as sources for "salvage anthropology" that would collect the final vestiges of what was assumed to be dying peoples/cultures.[39] Although the art world has moved past some of these colonial aesthetics and forms of violence, residues remain in the form of evacuated feeling in art and exertion of power over Indigenous perspectives on art and Indigenous artists themselves.[40] Jimenez Underwood's method of tending to the spirits first relies on "genealogies of [Indigenous] re-existence in artistic practices."[41] Namely, her method sustains ancestral guidance by inviting the viejitas into the studio, protects the storytelling capacity of Indigenous art as sacred, and heals those who come into contact with these artworks by "exaggerating the essential." In her own words, she aims to "make every hilo count,

[and] make every thought count." She cautions: "If it doesn't mean any-
thing [to you], don't use it!"[42] Thus, as she created her *Mother Ocean* and
Mother Rain rebozos she remained intimately attuned to making every
thread count and constructing meaning along with a shawl.

In considering the trajectory of her art career, Jimenez Underwood
says that she always wanted to make rebozos. She recalls that as she and
her family traveled along the migrant farmworker route up and down
the state from Sacramento to Mexicali each year, they would attend the
elaborate Día de los Muertos events in Mexicali, during which every
woman wore a rebozo. As a child, she would walk through those cel-
ebrations, and she says that the sound that captivated her young ears
was always the soft, beautiful swooshing of moving rebozos. Along with
this memory, she also remembers an integral part of being an Indige-
nous woman meant that you *had* to be able to make a shawl.[43] Thus,
along with the viejitas in her studio, she honors all the women in her
life who have worn rebozos and continues the tradition that all Indige-
nous women maintain the knowledge of making them. These personal,
artistic, and philosophical histories, as a result, inform her art and her
artmaking processes; two of her pieces in particular exemplify these
histories and these commitments. The first appeared in her stunning
rebozo series titled *Rebozos for Our Mothers* and is titled *Mother Ocean*
(figure 55). The other shawl is titled *Mother Rain Rebozo* (figure 76).

Mother Ocean (Water)

Mother Ocean was woven in 2011 and is "ecologically, painfully aware of
her precious five seas."[44] This rebozo is fifth in the series. It was first
displayed at the Triton Museum of Art in Santa Clara, California,
in 2013 as part of Jimenez Underwood's solo exhibition titled *Welcome
to Flower-Landia*. The materials used to "speak this water mother's mes-
sage" are wire (as the inner warp), linen, silk, rayon, and gold and silver
threads. The pronounced blue tones in this rebozo shift from the top
down—from light blue and silver blue to deep aqua and turquoise to a
rich cobalt blue. I read the *Mother Ocean* rebozo within a range of con-
ceptual understandings that include a call from this mother to protect
and not pollute the water, to honor water as an origin of life, and to see
this work of water protection as ongoing. For example, within the in-
terstices of *Mother Ocean*'s weave, Jimenez Underwood tells a story of
water protection in which she suggests that we must take up the work

of water protection because water makes our existence possible. This concept is particularly important in a settler society where Indigenous ecological knowledge has been marginalized and devalued, in which our waterways continue to be threatened and contaminated, and in which there are many ongoing attempts to privatize water in capitalist ways that make "mother ocean" another commodity for profit.[45]

Jimenez Underwood created *Mother Ocean* to honor the vital natural element of water because "the earth, like our bodies, is mostly water." She adds: "Water is able to sustain heat or cold, freeze or float objects. And, water is absolutely necessary for us to live."[46] Indigenous peoples have recognized water as a life-giving force for millennia and have always worked as ancestral stewards of waterways, rivers, lakes, and other bodies of water. Today, it is mostly Indigenous youth and women who are taking up the battle to protect water from settler corporate abuses such as contamination, overuse, and privatization. Thus, *Mother Ocean* is woven to honor life as it is sustained by water but is also connected to current struggles by Indigenous peoples across the Americas.[47]

In addition, in the interstices of the *Mother Ocean* weave, Jimenez Underwood carefully works with the thread to mimic the movement of water, which she says gently tells a story of thriving Indigenous life as adaptable and active. Indeed, when viewed closely, the meetings of the weft and warp appear as drops of water holding tightly to one another. Jimenez Underwood states, "Water likes water. In general, even as it spreads, drops cling to each other as long as possible."[48] Inside of this rebozo, as a result, there appears to be horizontal movement of the water akin to the way in which the crest of a wave will overturn and repeat its motion. Jimenez Underwood quickly cautions, however, that while that motion is very healing and soothing, our oceans and waterways also "demand . . . respect" through the sheer power of their waves and currents, and in spirit. This demand extends to this rebozo because it also reasserts the notion that water, like the maintenance of Indigenous culture, is very powerful.[49]

Mother Ocean also illustrates the refusal of water to remain stagnant or still and represents another analogy for Indigenous philosophies. As the mother of Indigenous life, water moves because it is persistently changing, cleansing, and healing all living things. As a result, water alone resists settler logics that frame Indigenous life as solely in/of the past and as one with a *fixed* notion of nature. This resistance is evident because nature and indigeneity are never fixed. As Laura E. Pérez poi-

gnantly notes, "The natural world is in constant motion—fluid, porous, changeable, inexhaustibly enigmatic."[50] Jimenez Underwood captures this fluidity and beautifully weaves it into its design, dedication, and spirit in the threads of *Mother Ocean*.

In addition, the silver and gold threads woven throughout this rebozo operate as a reflective portion of the artistry. As water represents life and is necessary to sustain all life, the reflective elements in these threads provide an opportunity for humankind, animals, and sea life— all of Mother Ocean's children—to see their literal selves in the piece. In still other words, this threading allows us to see ourselves in *Mother Ocean* but also to see the ocean as our mother, to remind us of the origins of all life. Moreover, this reflection shatters the settler demand to separate ourselves from the natural world, to understand our own ontology as dichotomous, and it challenges the settler impulse to dominate and own all natural resources. In fact, the reflection of the water makes an offering of relation—showing us that we are fully integrated people with our land and sea relatives.

Finally, the unfinished fringe of *Mother Ocean* is productively incomplete and should engender a desire to continue its work to resist abuse or contamination of all bodies of water, including human bodies that are mostly water. Consequently, Jimenez Underwood's understanding of water as our mother, and as a sacred entity to be respected and honored, serves as a resurgence and reaffirmation of Indigenous women's knowledge and work. It is, as a result, Indigenous feminist art that depicts Indigenous feminist understandings of the natural world.

Mother Rain Rebozo

In 2017 Jimenez Underwood also honored another element of water: the rain. Titled *Mother Rain Rebozo*, this rebozo perhaps brings Jimenez Underwood full circle in her love for weaving because, as I noted earlier, she fell in love with weaving in part by watching her father weave dresses for her on rainy days in their garage in the 1950s. The *Mother Rain* rebozo is smaller than the *Mother Ocean* rebozo. It was first shown at the Mission Cultural Center for Latino Arts in San Francisco in 2017 for the *30th Solo Mujeres* exhibition. According to Jimenez Underwood, the materials that chose to speak the messages of *Mother Rain* are linen, wire, and wool.

The top portion of this rebozo presents a colorful design of materials

that show the vibrancy of the celestial realm before the rain begins to fall. The central figure at the top of this design is a woven abstract depiction of Coatlicue—an Aztec earth goddess who gave birth to the sun and stars. Although a complicated figure, she is widely known and depicted wearing a skirt of serpents that she swishes around to honor the water because the serpents are associated specifically with rain.[51] In *Mother Rain*, there is a break in the pattern of the rebozo: Coatlicue's body can be seen in the long patterned portion of the shawl where "the water falls for free."[52] Therefore, the largest portion of *Mother Rain* is the middle segment of the rebozo where the raindrops fall in motion, and that movement is best viewed in this textile from slightly afar. This middle segment (the pattern below Coatlicue's face) also depicts Coatlicue wearing her skirt; the patterned serpent-like diamond heads seem to move in the rebozo to honor the rain.

This rebozo is not, however, only about Coatlicue. The patterned diamond portion also teaches Indigenous life lessons. Some of these narrative lessons are simple and others are more complicated. For example, Jimenez Underwood notes that "water moves along the path of least resistance."[53] This concept, as a result, becomes infused in the woven thread and its representations of water/rain. This lesson is also a hopeful one. It suggests that one should be able to move through life with the same fluidity and adaptability as water, even if doing so is not always a reality for Indigenous peoples because of human beings in/of the dominant culture who are not living harmoniously with all relations, human and nonhuman. Thus, as water seems to move through the diamond-shaped portion of *Mother Rain*, the lesson of Indigenous balance is taught.[54]

By contrast, *Mother Rain* implicitly carries with it another lesson based on the relationship of the land to water/rain. Jimenez Underwood is a California-based artist and has borne witness to the effects of the severe drought in California from the year 2000 to the present. The implicit lesson, as a result, is that we should honor the rain and celebrate every drop that falls because our local climates and environs are being negatively altered each year by human-made climate change. Indeed, our entire biosphere continues to be at risk because of settler colonialism, the attendant structure of predatory capitalism, and the logics/practices of "modernity." In short, settler colonialism instills the structure of racial and predatory capitalism whereby the land and almost all nonhuman natural relatives are turned into property. The logic

of property assumes that land or water can be owned, or that, at a minimum, it should be possessed by human beings for profit in the capitalist market. This logic was furthered during the Age of Enlightenment—and since—in an attempt to eliminate Indigenous worldviews that understand the land and water as relatives, as family members to be cared for and protected, and replace them with a colonial perspective of "things" that generate profit.[55]

The final lesson in Jimenez Underwood's water-themed rebozo is that it teaches us the ways in which water, like the rebozo, tends to life and death for the entire world. As I noted above, rebozos are traditionally used to carry newborn babies but also to shroud deceased loved ones. In this way, the traditional functions of the rebozo and the water themes emphasize the universal concept that "water is life" and, without it, we guarantee death.[56]

Intertwined Futures: Indigenous Women Artists as the Charge

> Our voices rock the boat and perhaps the world. They are dangerous.
>
> **DIAN MILLION,** *THERAPEUTIC NATIONS*

Many current Indigenous women artists also recognize and depict the significance of water in their art. Yreina Cervántez and Christi Belcourt, for example, have created many visual artworks that reinforce the idea that we should have respect for our water relatives. These artists, like Jimenez Underwood, also open up our sense of beauty to liberate us from the restrictive hold that settler aesthetics have placed on art and visual representation in the Western world. Taken together, all three of these artists pursue healing and protection in their art forms, honor Indigenous ancestors and our living elders, and unapologetically present viewers with Indigenous epistemologies that are vast, complex, sacred, and—most importantly—dangerous to settler logics of domination in the Americas. As such, these Indigenous women artists awaken our souls and minds to a healthier and more just world in the implicit and explicit pedagogical functions of their art. In privileging Indigenous knowledge and engaging in Indigenous cultural practices, their art works maintain a system that represents and preserves Indigenous epistemologies and Indigenous worldviews. Thus, their Indigenous water-themed artworks formulate a specific constellation of

Indigenous knowledge that reaffirms the notion that "water is life" and enacts what M. Jacqui Alexander calls "dangerous memory"—a type of memory that is a spiritual/sacred possession and, once utilized, works as an "antidote to alienation, separation, and the amnesia that domination produces."[57] In short, these three artists work toward building kinship in their art that weaves together the human and nonhuman elements of our society as an integral lesson of Indigenous knowledge that has been continuously reasserted by Indigenous peoples— especially in the wake of the Bolivian Water Wars in Cochabamba and El Alto, the Dakota Access Pipeline protests, and the toxic waters in Flint, Michigan—among many others now.

Big Baby Balam

By making connections with the natural world, and the sacred energy therein, Indigenous women artists provide visual representations of Indigenous justice. Yreina D. Cervántez, like Consuelo Jimenez Underwood, produces this type of art. Cervántez was born in Garden City, Kansas, in 1952 and raised near Mt. Palomar in San Diego County close to the Payomkawichum (Western People, Luiseño) and several reservations. She is one of the most prominent Chicana artists, and most of her artistic renderings showcase Indigenous themes. She has been producing art for more than thirty-five years; watercolor, printmaking, and muralism are her strongest media. Cervántez's *Big Baby Balam* is a deeply spiritual and intimate watercolor painting. The painting, twenty-six years in the making, is a self-portrait framed by "sacred energy that represents the celestial world."[58] Although Cervántez began work on this painting in 1991, she intentionally left it unfinished that year. She began working on it again in 1994 when the Zapatista uprising coordinated war on the Mexican state because of the implementation of the North American Free Trade Agreement that repealed the protection of Indigenous communal landholdings from privatization or sale. Even then, however, Cervántez left the painting unfinished. She returned to *Big Baby Balam* years later, when corn, a sacred Indigenous entity, came under attack by big corporations like Monsanto. Finally, the self-portrait was finished in 2017, just in time for the exhibition on her work titled *Movements and Ofrendas* at the Vincent Price Art Museum in Los Angeles (figure 84). This museum is the site where the painting was most recently displayed for the public.

The history of this painting obviously provides the sociopolitical and personal backdrop of the process of making it, but the moments of historical injustice during which Cervántez worked on the painting explicitly infuse it with a radical Indigenous politics. The painting, for example, is filled with Mesoamerican symbolism "to honor the ancestors and reclaim the meaning of [those] symbols."[59] The title pays homage to the balam, or jaguar, as a spirit guide. The image is particularly significant because the jaguar is an animal that hunts in the daytime and nighttime and on land or in water—and like water, it shows adaptability and fluidity. According to beliefs of the Maya, the jaguar also traverses earthly and spiritual worlds.[60] The jaguar's stealth and its ability to go between the earthly world and the spiritual world, then, suggest that it could be a guide for understanding ways to organize against settler oppression. Specifically, settler colonialism—as a structure, not an event—remains ongoing with continuous redesign in the structure. This means that in order for decolonization to be realized, we have to be adaptable and fluid and have many strategies in place to defeat it. The symbolism of the jaguar underscores this kind of multivalent strategy making.

In addition, the entire painting is water-based—it is a watercolor image. Aside from its water base, Cervántez tattooed numerous water glyphs on her self-portrait's face in the form of cloud spirals that swell with water as a sign of regeneration and energy. Cervántez suggests that these spiral glyphs are also closely associated with agriculture in general. Nonetheless, the flamed eyebrow in the self-portrait represents the Olmec sky serpent, who is directly related to the celestial water dragon.[61] Cervántez also painted her eyes glossy and her hair shining and wavy like moving water. Likewise, the green jade shading throughout the painting is a water reference, as it represents a Mexica allusion to rain. Cervántez says, furthermore, that the celestial and underworld realms represented in the painting are also part water symbols. Specifically, she notes that "the circle above the left eye is a portal into another realm . . . and the opening of the baby jaguar mouth is an invitation to the caves that lead to the underworld; the underworld return to water."[62]

The Olmec rain god also sits on the right side of the painting with sacred maíz atop her head (from the viewer's perspective). This is significant not only because the Olmec rain god was said to be the precursor to other Mesoamerican rain gods, but also because it suggests a

transformative relationship between Indigenous people like Cervántez and the rain/gods. Indeed, in the self-portrait, Cervántez, like the classic renditions of the Olmec jaguar, has a downturned mouth. Cervántez's huipil also carries the jaguar's markings. In other words, Cervántez layers these rain god and jaguar images and other water symbols in the self-portrait to suggest the many ways in which Indigenous peoples are connected, and to suggest the ways Indigenous artists often carry these histories and connections on and within themselves and express them through their art. Ultimately, then, it is clear that these Indigenous histories and beliefs are seemingly inscribed on the image of her body.

This painting also portrays a particular intimacy, rendered as a collective intimate relationship with water, seen through the artist's own intimacy with the huipil. Cervántez carefully wraps the jaguar pelt huipil around herself in a sacred, adaptable stance to land/water, earth/sky, and night/day. In doing so, as Laura E. Pérez has noted, "the artist represents herself as both animal and human . . . [and] the spiritual self [is] represented by the animal double."[63] Cervántez also painted the huipil in an earthy red tone because she says that many Olmec sacred masks and sculptures had cinnabar in them, and she wanted this color to invoke this sacred element.[64] Cervántez, therefore, wraps herself in a shawl that is pigmented with cinnabar and designed as a jaguar pelt (related to the Olmec rain god) to assert an Indigenous knowledge system that upholds life, self-care/healing, and community. Ultimately, it is a spiritual posture or, once again, a spirit-first method for explicating Indigenous knowledge systems via the visual arts because some forms of knowledge must be *seen* to be understood.

Offerings to Save the World

Christi Belcourt, like Consuelo Jimenez Underwood and Yreina Cervántez, also upholds important Indigenous worldviews in her artworks. Belcourt is a Michif (Métis) visual artist who works in the media of painting and beadwork, with a deep respect for Mother Earth and the traditions and the knowledge of her people. In addition to her paintings, she is also known as a community-based artist, environmentalist, and advocate for the lands, waters, and Indigenous peoples. She is currently a lead organizer for the Onaman Collective, which focuses on resurgence of language and land-based practices.[65] Belcourt's *Offerings to Save the World* is a rich, bold, and active painting that stages Indigenous

women as the center and core of efforts to physically and spiritually protect the planet (figure 85). The piece is acrylic on canvas. In it, Belcourt positions two Indigenous women at the edges of the center of the world, from which water bursts forth in every direction. These women bless the water and all the water relatives within the waves coming out of the core of the world/universe, including fish, jellyfish, and sea turtles. As the Indigenous woman on the right side (from the viewer's perspective) stands at the edge of the world, a light glows brightly within her womb. She is a life-giver in the making. She represents a recognition of the fact that all humankind is first formed in the water of the womb—that when a pregnant woman's "water breaks," it signals the birth of life.

The Indigenous woman on the opposite side of the canvas, by contrast, kneels on the land as she delivers her "offerings to save the world." Like the other woman, her offerings are gently carried into the water in multiple directions but mostly trickle down to bless the sea turtle swimming upward to the light.

The sacred energy in Cervántez's work is also intricately tended to here by Belcourt in *Offerings to Save the World*. This sacred posture is shown as a reverence all relatives have for the healing power of the water, but it is especially prevalent in the depiction of strawberry plants that adorn and bless the earth on each side of the painting. The strawberry plant is a special plant valued by many Native North American peoples. For Belcourt, as a Mischif (Métis) artist, it prominently appears in much of her artistic canon (including her paintings, textile work, and beadwork). The strawberry is a "heart berry," and many Native people think of it as a plant with properties that encourage reconciliation. It is also associated with love and happiness. Some California Native tribes even celebrate this plant with strawberry festivals because they believe it brings renewal in the springtime. Like water, moreover, the strawberry plant is intimately understood as women's medicine, and many Indigenous people use the leaves and stems to make prenatal or postpartum teas. Furthermore, in this painting the water expands throughout the image as these agents of change give our Mother Earth various offerings. Overall, *Offerings to Save the World* suggests a balance of life brought about by Native women: the water allows the women to live and, in turn, the "water" in their wombs allows all of humanity to be born; all of this is symbolically represented by the strawberries as heart-shaped symbols of love, reconciliation, and the rebirth of springtime.

When read together, then, the water-themed artworks of Jimenez Underwood, Cervántez, and Belcourt illustrate the ways that Indigenous women are charged with guiding and giving birth to the future through their transmission of life, knowledge, and culture. Just like an electrical charge that creates an experience of force in a magnetic field, the sacred energies displayed in these artworks also relay a posture of force as it places Indigenous women at the center of Indigenous futurity. As the charge that sparks action in their communities, these makers remind us to uphold respect and protection for water so that sacred energies are always carefully maintained. Again, this cuts against the grain of Western methods of art production, as a large emphasis on affect and the spirit/spiritual rather than on form or control constitutes the primary methodology in which their art is created.

Just like the rebozo, these artists and their artworks tell stories, transmit Indigenous knowledge, and offer a resurgent aesthetic through privileging spiritual meaning and alter/Native methodologies for creating art.[66] The resurgence that is most promising in these artworks is found in the fact that these three artists are ensuring that art and life are inseparable for Indigenous artists. As Martineau and Ritskes argue, "Indigenous art reclaims and revitalizes the inherent creative potentiality of art to be activated in political struggle, not as an inseparable aesthetic but embedded in the embodied daily life experience of Indigenous Peoples."[67] Furthermore, this type of resurgent aesthetic shows that "Indigenous resurgence [can] break the vow of silence and invisibility demanded of Indigenous Peoples by settler society."[68] Therefore, these artists and their art are "tied" together like the knots at the bottom of the rebozo that allow for its fringe. As such, these artists maintain their Indigenous cultures and traditions against the pressing and persistent settler logics/practices of elimination of Indigenous peoples and cultures. As Deborah Miranda states, "culture is lost when we neglect to tell our stories, when we forget the power and craft of storytelling."[69] Therefore, as artivists (artists and activists) and storytellers, Jimenez Underwood, Cervántez, and Belcourt establish contemporary archives of Indigenous knowledge in their art practices and in their artworks.[70] Without a doubt, these artists are memory-makers and, in remembering, they resist!

OFF THE LOOM —
INTO THE WORLD

ROBERT MILNES

Consuelo Jimenez Underwood

Artist, Educator, and Advocate

Consuelo Jimenez Underwood's passion and commitment are clear in her art. They are also evident in her public presentations and her formal and informal interactions with people. These arenas of impact overlap in her teaching. For three years in the late 1980s she taught as a graduate assistant and adjunct faculty member at San José State University (SJSU) in San Jose, California. Then, for twenty years, from 1990 through 2009, she was a full-time faculty member there. During that time, Underwood influenced a generation of students. In her role as a visiting artist and guest lecturer at other sites, she expanded this impact internationally. In this essay, I explore the influence of her beliefs and her art on her teaching and public presentations as reflected in her experiences and in comments by and artworks of students, colleagues, and others who have been influenced by her.

I first met Jimenez Underwood in 1990, when we both started new positions at SJSU. Jimenez Underwood was a newly appointed tenure-track faculty member and I was the new director of the School of Art and Design. I was immediately struck not only by the creative and social content of her work, but also by her passionate teaching. She revitalized the weaving and textiles classes with her energy, spirituality, and direction, and she soon began teaching additional classes. Her accessibility and commitment were

immediately felt in the classroom and in the community. She served as a panelist for the Art in Public Spaces program in San Jose from 1991 to 1993. In 1992 she served as juror for "Speaking in Tongues: Ethnic Influences in Contemporary Tapestry and Fiber Art" at the Center for Tapestry Arts in New York, and in 1993 she was invited to speak at the Cleveland Institute of Art and the San Francisco Craft and Folk Art Museum. In 1994, she visited Spain to speak at the Escuela de Arte Aplicadas in Granada.

It was evident to anyone who worked with her closely that Jimenez Underwood is unique: a deeply and spiritually focused artist and craftsperson who was destined to influence international audiences through her work. Throughout the next decades, the scale and focus of her work expanded and crystalized. Heritage symbols—the Virgin of Guadalupe, food such as tortillas, the natural landscape and native flora, politically charged images of flags, road signs depicting migrant families, and, increasingly, the US-Mexico border and the barbed wire and wall that represented it—became central motifs in her work. These images, both positive and negative, were central to her life.

The Education Network

Studio art classrooms in higher education are places where relatively small groups of people come together to explore a common subject or process from very different individual points of view. As a result of the extensive class hours and studio access outside of class, university art departments and art schools can become like residences, homes away from home for students. In these places it is not uncommon to find students working all night on art projects. This works extremely well for those who can participate, but the expectation may prove to be a barrier to students with families or work schedules that may not allow them free time to participate in the extensive coursework *and* interactions outside of class time.

One essential aspect of this environment is to provide a space in which to explore individual student and faculty perspectives. In an effective studio environment, this evolving process engages both faculty and students in self-discovery. The studio can become a hothouse where ideas and techniques blossom quicker than they would, and take on new directions that they may not have, in isolated working con-

ditions. The support for wide-scale exploration of new concepts from each individual's perspective provides a fertile ground for solutions the individuals may not have realized on their own. Jimenez Underwood established just such a stimulating environment in her classroom at San José State University, accommodating the different lifestyles of her students perhaps more than other instructors. Her teaching arose from her background and featured a personal directness that awoke new understandings in students.

Studying

In Consuelo Jimenez Underwood's artwork and life, the border between Mexico and the United States is a dominating factor and theme. She was raised in both Mexicali and Calexico, twin cities where she daily crossed the border while growing up, and the border was always a powerful reality. The border is both a physical element and an emotional challenge to her. The physical and political dualities of inclusion/exclusion, permission/denial, crossing/stopping, and inside/outside in her daily life all meshed with emotional states of fear, defiance, and self-realization in her life, artwork, and teaching. To her, a border is a barrier or boundary, something that should be identified, examined, and crossed. Her awareness of borders and barriers in artwork are central to her artistic creation, to her professional development, and to her teaching—to helping students understand and overcome their own challenges and expand their abilities.

Jimenez Underwood started her higher education at community colleges in Escondido and San Marcos, California. There she focused on religious studies while taking art classes. The art classes she took as electives pushed her toward a focus in painting as a fine arts medium, because that is what "artists" did. The school environment was a struggle for her because she had two children, and she was away from school a number of times during her higher education career. When she decided to finish her undergraduate work, she looked at two schools near where she lived, San Diego State University (SDSU) and the University of San Diego. Accepted to both, she decided to go to SDSU because it had a stronger traditional studio approach to art and craft and she felt that she would learn more technical information there. This attention to material and process is a cornerstone of her teaching and artwork.

In her development as an artist and faculty member, three faculty mentors—Joan Austin, Tony May, and José Conchado—stand out to her, people who helped her realize her own potential and provided her with pathways of inclusion into fields of which she had no initial awareness. Joan Austin taught weaving and fibers at SDSU, where Jimenez Underwood studied as an undergraduate. Whereas her original focus was in painting, Jimenez Underwood's father had been a weaver, and though she had not considered weaving as a future practice when she first began studying art, it became increasingly clear to her that this was her special field. Austin, a graduate of the Cranbrook Academy of Art, was the daughter of a fisherman. She knew fibers and knots and taught her students the importance of both materials and the context of their work.

Jimenez Underwood completed two degrees with Austin at SDSU, the first a BA in applied design (called "Crafts" when she entered the program) in 1981. She chose to complete a BA degree instead of the more extensive BFA because of the extra time and cost of attending an additional year. She considered the BFA, designed to prepare students for graduate school, an expense and not a necessity: it was designed to let her further develop her work, but she felt that she could do that on her own. After receiving her bachelor's degree she spent several years with her family, though she did return to SDSU to complete a master's degree in applied design, which she received in 1985. Achieving this degree was a pivotal effort for her because her thesis required research into the history of textiles. She undertook research in the archives of the San Diego Museum of Natural History in Balboa Park, where she initially encountered the Peruvian weavings that were to become such important references for her. For the first time she realized the timeless quality of textiles, "how wonderful a weaving could be."[1] Many of the pieces were burial shrouds, some of the few ancient textiles that were preserved. The shrouds—thin, gauzy materials surrounded by elaborate borders, those edges of the fabric where so much detail occurred—became a critical early image in her professional work. She saw these same sorts of boundaries/borders in some of the color fields by Jules Olitski, a painter who also was important to her development as an artist. Her own landscape works from the period include formal border elements, as do her later shrouds.

She and her family had moved to the Bay Area because of a job opportunity for her husband, Marcos. Finally able to pursue a terminal

degree in art, in 1985 she considered the schools in the Bay Area, including the San Francisco Art Institute, San Francisco State University, and the California College of Arts and Crafts, all of which had weaving and textiles programs and classes. She applied to San José State because of what she saw as a joyous atmosphere of work in the Art Department. She was accepted there, but upon arrival she found that she was the only graduate student in weaving and textiles! The graduate program was difficult for her because of this solitude and because the fibers instructor was more conceptually focused, whereas Jimenez Underwood wanted to "push the loom." Two faculty there also became her mentors: Tony May for the graduate program and teaching, and José Conchado, who taught her how to have a career as a faculty member. Tony May was sympathetic to her artistic direction and helped her develop the concept and context of her work. Jimenez Underwood said, "San Diego State was more about form"; she "learned to break the form at San José State." May also helped her develop teaching skills in the color classes he taught and in which she assisted. She received her MFA in 1987.

At SJSU, she confronted a significant cultural barrier to becoming a professor: she had no Latina role models. Jimenez Underwood undertook to cross this barrier in the same way she had crossed others, by determining to do so and by finding out what the barrier was all about. Her mentor in this was José Conchado, at that time an associate dean in the School of Humanities and the Arts. While she was a graduate student, she was offered the opportunity to teach weaving and fibers as an adjunct faculty member, which she did during her MFA studies and after graduation. When she graduated, however, she thought she would pursue a full-time art career instead of teaching, but her former instructor Joan Austin planted a seed that led Jimenez Underwood on a different path. Austin contacted Jimenez Underwood after she had completed graduate school and told her of the importance of giving back, of pursuing a teaching career to help others as she had been helped. It was this suggestion of giving back through teaching that led Jimenez Underwood to reconsider. Conchado took her to faculty meetings and other meetings on campus to show her the overall world of faculty, encouraging her to apply for a full-time position and not "get stuck" in part-time positions. She applied for and was offered a sabbatical replacement position in North Carolina, at which time she talked to the chair of the Art Department at SJSU, Steve French, who countered with an offer for a full-time position at San José State. French had been

able to negotiate special diversity hiring positions for the department. Jimenez Underwood accepted the offer and took over the coordination of the weaving and fibers studio.

Teaching

San José State University's Art Department called the main studio areas either Pictorial Arts or Spatial Arts, with subsets of media-based classes such as weaving and textiles, ceramics, glass, jewelry and metalsmithing, sculpture, painting, printmaking, and watercolor, as well as art education. Whereas the individual studio areas, generally under the coordination of one or two faculty, were in many ways almost tribal in how students and faculty self-identified with them, the combination of the classifications of weaving and textiles, ceramics, glass, jewelry and metalsmithing, and sculpture in a single Spatial Arts area helped to ensure the incorporation of contemporary approaches to art making in fields grounded in traditional materials and techniques. It helped engage the students in broader conversations than might have happened in other academic structures. In her teaching, Jimenez Underwood emphasized both technique and material while focusing on content issues as students developed their approach to the materials.

At the time Jimenez Underwood taught at SJSU, the School of Art and Design enrolled more than two thousand students in its BA, BFA, MA, and MFA programs. She was part of the conceptual art environment and at the same time adept and engaged through her educational background and personal goals in the practice of craft. To research her involvement in this environment, along with speaking with her I interviewed her students and colleagues at San José State and a museum director in the community, querying them about her approach to teaching, their interactions, their current activities, and her impact on their work, on the school, and on the broader arts and crafts communities. Among her former students and colleagues I talked with were six women and two men; five were students and three were colleagues. The students included one undergraduate and four graduate students.

Individual students came to Jimenez Underwood's classes either serendipitously or because they knew of her work. Erica Diazoni was an undergraduate student without a declared major when she passed the weaving studio on her way to a logic class taught in the same build-

ing. She had learned a bit about weaving from a neighbor while in elementary school and was intrigued that it was offered in college, so she signed up for weaving as an elective. As it was an autumn semester, she thought it would be a great opportunity to make something as a Christmas present. The first day in class Jimenez Underwood told the students they would learn spinning, dyeing, and weaving but would "not be making scarves for our mothers for Christmas." "I had no idea what I was in for," confessed Diazoni. "I thought I signed up for a class to learn how to weave, but I was really about to learn how to be an artist."[2]

Jimenez Underwood would bring in weaving and textile alumni as assistants in the classes. The classes often included multiple sections, with beginning and advanced students working on different projects in the same classroom. Jimenez Underwood would introduce projects in the class and the alumni and graduate students would help explain technical information to the newer students. Diazoni, as an undergraduate student, helped beginning students with loom setups and dyes. Jimenez Underwood challenged the students' decision-making and aesthetic choices. Diazoni said, "She was always asking them 'why?'" in regard to their choices. "She flies in the door, books and papers rattle, she imparts knowledge and leaves. Everyone looks around like 'What?' She shakes everyone up—you do not really know what you are going to learn. She teaches you how to be an artist, not so much how to do something." A student would be using red wool, and Jimenez Underwood would challenge them: "Why red? What does that *represent*?" The students were continually challenged to explore their own conceptual and aesthetic issues. Consuelo, Diazoni said, "was a mind reader."

Diazoni mentioned her childhood experience learning weaving from a neighbor and her fantasy of being a weaving princess. The experience became tremendously meaningful later in her life. She studied with Jimenez Underwood for three years, taking a number of weaving classes and special studies classes with her and eventually completing a BFA in Spatial Arts. Jimenez Underwood showed a special talent for supporting students, helping them through the maze of degree requirements and encouraging new experiences. Presented with the opportunity to study weaving in a short workshop in England, Jimenez Underwood supported Diazoni and helped her arrange to go. It was a world-changing opportunity for Diazoni. She went back to England after graduation for a ten-month postgraduate program in Tapestry at West Dean College. In 2016 she earned an MFA in art in public spheres

at the Ecole Cantonale d'Art du Valais in Sierre, Switzerland, gradu-
ating with distinction and receiving the Prix Excellence. Jimenez Un-
derwood's passion for textiles and her intensity about art were major
influences on Diazoni, and although the political issues in Jimenez Un-
derwood's work are not themes in Diazoni's art, the conceptual ques-
tioning of assumptions and boundaries clearly became part of her work.

At the graduate level, Jimenez Underwood taught weaving and tex-
tiles and also graduate seminars and special studies with students work-
ing in a variety of media. Many of the graduate students she worked
with were focused on other media or in a more open area of installation
and performance art. Victoria May was one of these students. She at-
tended graduate school at San José State for four years while commut-
ing from Santa Cruz and received her MFA in 2001. She had completed
her undergraduate degree at UCLA and came to SJSU to study photog-
raphy, but printing on fabric led her to textiles. She took a number of
independent study classes with Jimenez Underwood, who also served
on her thesis committee. Her studio was adjacent to the weaving and
textiles classroom, and she would work there while the undergraduate
classes were in session. May substituted for Jimenez Underwood several
times, sometimes starting projects with students and then returning to
share in the critique sessions. She felt that Jimenez Underwood kept
the parameters of the projects very open, not wanting the students to
feel that any particular result was expected.

"Most of our conversations were about how materials merged with
ideas. . . . Consuelo seemed more to meet me where I was instead of
imposing her own way of working on me. She gave me general enough
feedback that I could find my own way but still be inspired and guid-
ed."[3] May felt that sometimes the advice she got from others seemed
to be more about the directions they were going in their own work.
She said, "Consuelo was better at 'compartmentalizing,' separating her
teaching from her own work." For example, one of the first times May
met Jimenez Underwood, she was trying to make a garment form. May
had put sand inside it to form it and it was not working. Jimenez Un-
derwood suggested quilting it, which was a solution to May's work and
not something from Jimenez Underwood's practice.

Since she graduated, May's work has been sculptural and installation-
based; it incorporates a variety of materials, and textiles and stitching
figure significantly in the work. Jimenez Underwood always talked
about walking the line between craft and concept. Early on she quoted

van Gogh to May and others; the quote is about not telling everything: "Exaggerate the essential, leave the obvious vague." "Consuelo would also tell me to 'complexize' my work, which gave me permission to go crazy with craft and detail, but in a way that always held with the concept." May feels that her work has become bolder and cruder, which may also be an influence from Jimenez Underwood. May still visits with Jimenez Underwood at her home in Cupertino. May finds her to be generous in sharing her own art process and exchanging feedback, and feels that Jimenez Underwood continues to be a thoughtful advocate for May's work and teaching.

Another student who came to San José State University's graduate program to study photography and connected with Jimenez Underwood is Wura-Natasha Ogunji, who received her MFA in 1998 and currently lives in Austin, Texas, and Lagos, Nigeria. Her work is primarily installation and performance art. Ogunji has received a John Simon Guggenheim Memorial Foundation Fellowship (2012) and grants from the Idea Fund in Houston (2010) and the Pollock-Krasner Foundation (2005).

Ogunji had graduated from Stanford and gravitated to SJSU because of the scale and diversity of the art program. She took several graduate seminars and independent studies with Jimenez Underwood, who also served on her thesis committee. Commenting on Jimenez Underwood's teaching, Ogunji said:

> She is an amazing teacher. She was one of the first professors who took my work seriously in the sense that she saw the entire picture of what I was trying to create. There was not a separation between the materials I was using and the narratives I was exploring. They are always interconnected and she was able to see that immediately. I think that's why her questions were the most difficult and important to answer; she has this amazing ability to go immediately to the core. As students these kinds of questions are so important because we are really trying to get at a personal style and aesthetic. We are working to make work, which is the clearest expression of our unique language.[4]

Ogunji said that was the reason so many students connected with Jimenez Underwood. "(She) had an ability to tap into the individual's excitement about creating." Jimenez Underwood "had the ability to cut through questions and get at the heart of things." She pushed Ogunji to a place where:

I had to be completely honest with my own voice as an artist and she listened to that voice and let me know it was not only important, but also critical to have in the world. Professor [Jimenez] Underwood walks through the world with such deep integrity and this, of course, translates into her teaching. I think the best teachers and artists show us what is possible in the world. In that way, they carve a space for their students and for other artists. Consuelo does that with extreme grace and power. Her strength as a teacher is deeply connected to her strength as an artist. The way she creates and the issues that she is thinking about inform both her path as an artist and as an educator.

Ogunji now maintains a practice as a visual and performance artist making performance-based videos. Her drawing practice happens largely in the studio, whereas the performances occur in public places.

George Rivera, former executive director of the Triton Museum of Art in Santa Clara, California, confirmed Jimenez Underwood's ability to work with students, stating that her students would tell him that people opened up and confided in her because she has an ability to connect with them, particularly students who were using mixed approaches to their work: mixing media and technique, using craft materials—outsider or hybrid work. She is very nurturing. "She would go to their openings, and when she was there, she was really there for the artist having the show, not to conduct her own business." Other artists, Rivera said, "would be at the show sort of promoting their own agenda, but not Consuelo."[5]

When Rivera thinks about the artists and students who have told him about Jimenez Underwood as an instructor, the "old soul" and human quality she possesses were the dominant qualities and were mentioned far more often than her gender or ethnicity. They felt inspired by her—that anything was possible. The students' work had nothing to do with her work particularly; her impact was to draw from them what they were doing. "Here was an artist who could communicate well to the age and experience of the students. As an active artist, she was out there promoting her work, struggling to make it right. She was able to convey the importance of her work without intimidation. Consuelo was someone who was figuring out her approach and issues and students connected with this."

Laura Ahola-Young was a Pictorial Art graduate student working in painting who struggled with her direction in the program and her

personal circumstances. She already had a child and became pregnant during her graduate studies. She felt there was little support for her among the faculty. Jimenez Underwood, she felt, was different and recognized something in her and her work that other faculty did not. Ahola-Young said Jimenez Underwood took her under her wing. As she neared the end of her graduate career, Ahola-Young began to make angry paintings about being a mother, apparently a problematic direction for some faculty. As a result, she decided to move back to Minnesota to be with her family. She said no one but Jimenez Underwood and herself thought she would finish her degree. She wrote Jimenez Underwood's phone number in huge numbers on her studio wall in Minnesota because she knew she could call her any time. She never did, but it helped her.

Talking about Jimenez Underwood as an instructor, Ahola-Young said Jimenez Underwood talked often about her own work and would share her struggles. She would talk about how she worked on something for hours and at the very end, in the last ten minutes, it totally failed. Jimenez Underwood had just started making politically focused pieces. She shared all these experiences and thoughts with her students and was a favorite of the graduate students. Ahola-Young said that when Jimenez Underwood talked to you, she was focused on you, confirming Rivera's comment. She felt that Jimenez Underwood gave her the courage to work on political issues in her own work. When she was enrolled at sjsu, she worked with a number of students who were Mexican American and whose work came from a direction of magical realism. Ahola-Young studied that movement, and as she is now living in a region with nuclear waste disposal sites, she includes her concerns about health and environmental issues in her artwork. "Consuelo was a great role model for someone to be a mother and artist."[6] Ahola-Young remembers Consuelo saying, "You can do this." Ahola-Young is now an assistant professor in painting at Idaho State University, where many of her students are—like she had been while in college—mothers or pregnant. She thinks back to Jimenez Underwood and the way she supported her and tries to be there for her own students. Possibly as a result of working with Jimenez Underwood, Ahola-Young, still a painter, does not see much difference between crafts and fine arts. She received a grant the first year she was at Idaho State and brought Jimenez Underwood to the campus as a visiting lecturer. When Ahola-Young approached the fibers teacher, the instructor was so excited—Jimenez

Underwood was her hero! Ahola-Young made a new connection through Jimenez Underwood.

A graduate student who attended San José State University specifically because of a previous interaction with Jimenez Underwood is Jonathan Brilliant, now a sculptor from North Carolina who had met Jimenez Underwood at the Penland School of Crafts where he was studying woodworking and she was teaching a summer session in fibers in 2003.[7] He met her through other work-study scholarship students who were working with her in the fibers class. He had always planned on going to graduate school, but he said he was at the time just focusing on where he lived and what he was doing, not thinking beyond his own boundaries. Jimenez Underwood encouraged him to apply to SJSU, which he did. In the autumn of 2004, he began taking classes there, which had a huge impact on his work. Jimenez Underwood, however, had entered the university's early retirement program that year and was teaching only every other semester, so he was not able to consistently work with her. He worked with her independently whenever she was on campus, and he found her, like other students had, to be encouraging of his individual direction. She stressed working with the hands but especially with the mind, an overlap of conceptual work. Brilliant calls his own works installation art or sculpture; they are large-scale drawings in space using found materials and, in his most recent large-scale installations, woven structures made of wooden stirring sticks. All of his artwork, using a variety of materials, is built in situ residencies at schools and museums throughout the country.

A significant event for both Jimenez Underwood and Brilliant occurred in 2005: the fifth biennial InSite Festival in Southern California and Northern Mexico, which took place on both sides of the border between Tijuana and San Diego. The SJSU faculty and (primarily) photography students, coordinated by photography professor Robin Lasser, were going to the festival. Lasser had applied for and received a permit to do temporary art projects at Border Field State Park and the group would create their own temporary installations in the park adjacent to the ocean at the border. She encouraged Jimenez Underwood and Brilliant to develop projects and join them. While driving down, Jimenez Underwood told Lasser about her history and her relation to her Indigenous roots, which were Indian and Mexican, not Spanish. She was interested in going to the border but feared it—she had not visited the border in many years. As an Indigenous member of society, she said she

"wears a cactus on her face." Lasser asked her whether that referred to a relation to the land, and Jimenez Underwood said that would be a positive spin. In her mind it was really about discrimination.[8]

The visit was of critical importance to both Lasser's and Jimenez Underwood's future work. For Jimenez Underwood, it was at this time that the border became the defining image and theme in her work. On her website, describing the project she created in 2005, Underwood notes: "The new border was being referred to as the Tortilla Wall (that lasted only a couple of years). I needed to create a giant tortilla de maize and present it to the border and then offer it to the Mother Ocean as a token of love and mucho respect. On the one hand I get very angry lamenting the fact that our species (humans) are building such atrocities like this wall, and at the same time I realize with amazement, these are insignificant gestures, the world will last forever."[9]

During their travel to and from the site, Brilliant remembers Jimenez Underwood citing how tortillas outsold white bread and their importance as cultural symbols. Jimenez Underwood made giant tortillas out of dyed corn husks and fabric, perhaps six to eight feet in diameter. She entered the sea with them and attempted to sit on them, meditating. The tide carried her artwork out to sea and across the border (figures 35–37).

Lasser remembers that while they were making the pieces, a security guard drove down the hill, "screeching to a stop" near where they were working. She said he was very red faced and threatening, using his authority and fear tactics. Jimenez Underwood was the only person among them who had fear of the border, and his actions materialized her fears. It was a lesson for everyone about what it means to have open public space, who has the right to use it, and the possible abuse of power. The experience brought Lasser and Jimenez Underwood much closer.

Robin Lasser's work before 2005 focused on video and photographic installations primarily on the subject of eating disorders. Her work took on new dimensions and themes from the time Lasser and graduate student Adrienne Pao installed the "Miss Homeland Security: Illegal Entry" dress tent piece at the border; Jimenez Underwood provided the title. After that work, many of the ecologically and politically themed dress sculptures that Lasser created, either herself or with Pao, were titled "Miss . . ."

Lasser recounted that Jimenez Underwood's teaching was the same as her approach to everything in life—straightforward—and that she

had a way of connecting students to their subject matter, of leaving off those veneers between oneself and one's art-making practice. "There is a freeness, a looseness yet intensity to the purpose." At the same time, although she stressed the importance of the work itself, Jimenez Underwood made sure that the materials and craft did not outweigh the subject matter—that the message was at least equally important. Lasser gave the example of Jimenez Underwood's own work: the large flowers that she created in later works, which were big and joyous, combined with barbed wire. There is always an insistence that we remember the scar, the border in the middle.

Lasser and Jimenez Underwood were talking recently about what they each were doing. Lasser mentioned the "urban village" project she is working on in San Jose, with the "border crossing" between Nagle Park (a wealthy community) and the Santa Clara Street community. The new urban village is asking people to reconsider the area as a united front, and this sense of the space inhabited by disunited people resonated with both artists. Lasser was also recently working in India on a project involving handlooms, which have become a political issue in the country. The government is supporting mechanical and high-tech fabric solutions, while the artists and craftspersons are reacting against this, as their work pertains more to history and culture. Jimenez Underwood always insists that we not forget our history. Rewriting it is something else as well. When Lasser talked to Jimenez Underwood about the project in India and the handlooms, Jimenez Underwood became silent. She said she was uncomfortable talking about it or having an opinion because she did not directly know about the relation of the people to weaving, to the looms, process, and materials. She told Lasser that Lasser was a connector, that she was a weaver of people and someone who would find commonalities. Lasser felt that Jimenez Underwood was someone who would call out characteristics in you that you did not know you had, which was a strong feature of both her teaching and her social interactions.

By the early 2000s Jimenez Underwood's artwork became more and more consuming as her recognition in the art world grew. During the 2004–5 academic year, she was on sabbatical; Nazanin Hedayat Munroe (formerly Nazanin Hedayat Shenasa) replaced her on the faculty. Hedayat Munroe had received her MFA at the Cranbrook Academy of Art. Jimenez Underwood advocated for her appointment because of her strong credentials in the field and because she would add a multi-

cultural dimension to the program. This was Hedayat Munroe's second teaching position; she had moved to the Bay Area when she finished at Cranbrook. Hedayat Munroe met with Jimenez Underwood several times during her first semester at San José State to touch base and compare notes on the program. "My work draws from my culture and her work draws from hers."[10] While Jimenez Underwood had no direct influence on Hedayat Munroe's artwork, she had a definite impact on her teaching. Hedayat Munroe found Jimenez Underwood to be very supportive as a colleague and great to work with, someone who was very calm as a person and very serious about her own work.

She affirmed that Jimenez Underwood had a great knack for letting people determine their own path for the projects they wanted to pursue. She was very good at saying, "These are the techniques, these are the parameters," at not only letting students choose project work but also setting them up to perform—"a nice balance of structure and freedom." Hedayat Munroe adopted that approach from Jimenez Underwood and uses it in her own teaching. When Jimenez Underwood returned and entered the early retirement program, Hedayat Munroe continued to teach part time and enrolled in the MA program in art history at SJSU. She completed a thesis on Islamic textiles in 2007, and Jimenez Underwood served on her thesis committee.

In 2010 Hedayat Munroe moved to New York, where she has taught visual arts of Islam in the City University of New York system and works at the Metropolitan Museum in the education department. She started annual textile courses for the Gallery and Studio Programs at the Metropolitan Museum in 2012. "You should always, as an instructor, design courses to provide students with what they need," a lesson she also learned from Jimenez Underwood. Munroe is now working on a PhD in the history of textiles through the University of Bern, Switzerland.

Impact and Legacy

Consuelo Jimenez Underwood expanded her approach to teaching through public presentations, workshops, and participation on jury panels internationally. In 2013, her solo show *Welcome to Flower-Landia* opened at the Triton Museum of Art in Santa Clara, California. Her work was also featured there in 1992 in *California Artists: Consuelo Underwood*. George Rivera, the director of the Triton Museum of Art, has

known and worked with Jimenez Underwood since 1987, when the San José Museum of Art did an exhibition of emerging artists from the region and both were in the exhibition. They have been in communication ever since. Rivera stated that the impact of Jimenez Underwood's public presentations was remarkable.

Visitors at the opening of her 2013 show asked him about the work, particularly people who were skeptical about the theme or put off by it. He would have people meet Jimenez Underwood, and she would melt whatever concern they had. She was so approachable and sincere. He said that even the most skeptical would fall for her and her work. Rivera felt that her message was strong but that she was not antagonistic. Jimenez Underwood would talk about how the wall or border could be in your family or some other aspect of your life, not necessarily just the US-Mexico border. Given the chance to talk about her work, she was so inclusive—it was about everyone's lives. The metaphor was large enough to encompass everyone.

Through the years, Rivera has been on panels with Jimenez Underwood in conjunction with group shows where they presented her work at the Triton Museum of Art. The museum created educational settings where the moderator could help direct and focus the conversation. Jimenez Underwood, as a panelist, was always listening and "in the moment." She would listen to the other panel members and give them the best response based on their comments, "not a canned speech." Rivera felt that she would be the one person you would want on a jury judging you, someone who could see that there was something others were not seeing. Jimenez Underwood's repeated participation as a juror, panelist, and board member for national organizations bears this out.

Her students and colleagues at sjsu also commented on the lasting impact of her teaching on their work and the broader arts community. Victoria May said she knew that people outside the academic setting had great respect for Jimenez Underwood simply as an accomplished weaver, even without having a sense of the importance of her teaching or message. May remarked on the changing directions in art programs within the academy, that Jimenez Underwood kept weaving alive as long as she could in the face of the dissolution of weaving and textile programs nationally. This effort was critical in the community and in the alumni art and craft network throughout the Bay Area. Unfortunately, soon after Jimenez Underwood retired, the weaving and textiles classes at sjsu were discontinued. Programs rely on effective faculty,

interested students, funding, and advocacy. They diminish or vanish as these pillars weaken. But her impact was broader than just in the particular field of art or the particular school. She was also a role model for multicultural artists in all fields and for all those using textile in arts. "She heightened awareness of Mexican immigrant issues in a beautiful, thoughtful, and provocative way," May said. Jimenez Underwood contributes edgy, political work with a distinctively female sensibility that goes far beyond mere craft, raising the bar for the conceptual in textile work. May felt that she blends sensuality and the objectivity of materials and geography with fierce politics and passionate spirituality. Jonathan Brilliant added, "When you just meet someone as a person, you sometimes are not aware of their impact out in the world" and that years after he was out of school "he realized how important her influence was." As he was doing residencies around the country, Brilliant started to run into people who knew Jimenez Underwood and her work.

Robin Lasser, Jimenez Underwood's colleague at SJSU, related that toward her retirement, Jimenez Underwood was talking to her about the Smithsonian and other institutions collecting her work. The celebration of the arts of the Americas was a main focus in California during the early 2000s. Museums were highlighting the work of artists from throughout the Western Hemisphere. Jimenez Underwood's work, attitude, and interests, along with her background, were a perfect fit at the time. Because of her family connections, Jimenez Underwood maintained work in two countries. Lasser said that so many people talk about living in a "third place": being from one country, living in another, struggling for identity in a new reality. People in this circumstance provide new ways to be global citizens, and Jimenez Underwood is a great model for that, especially within the art world. Lasser feels that "the local identity of artists and the arts in some ways has been usurped in a global marketplace and transient embrace, particularly (for) hybrid individuals and cultures." Nazanin Hedayat Munroe confirmed that Jimenez Underwood's multicultural identity has made a tremendous difference, that she has been very much a pioneer. As someone with a bicultural identity, Hedayat Munroe knows that one ends up treading a line: as an artist, you want your work to stand up as art, not solely as a cultural identity. She feels that Jimenez Underwood absolutely stepped up to the opportunities and challenges in her life.

Higher education should be a world-changing experience, and Jimenez Underwood is both proof of its impact and an important con-

tributor to that experience for her students and colleagues. For students, the higher education experience is not just about finding a career, not always about gaining expertise; it is more broadly and effectively about finding an effective path through life. For faculty, it is not just a career; it is a purpose and a platform. Sometimes, maybe in the best of situations, the relationships between a particular faculty mentor and their students become positive, life-defining moments for both. Jimenez Underwood grew through her educational experiences, through her own determination, and through the assistance of several mentors. Her education, and specifically the way specific mentors opened her eyes to new circumstances, helped embolden her approach to teaching, to her artwork, and to her life as an artist. She is passionate, intuitive, and direct in her thoughts and interactions. Her teaching experience helped broaden and expand her worldview and enabled her to take up critical topics in her artwork and with audiences internationally. She conveyed this passion to her students, in turn becoming a memorable mentor to them. Her sometimes uncanny grasp of the student's need in the moment enabled her to help individuals who were challenged by higher education structures and practices to become successful artists and sometimes faculty members themselves. Her artworks and presentations to the public have the same transformative powers.

MARCOS PIZARRO

Being Chicanx Studies

Lessons for Racial Justice from the Work
and Life of Consuelo Jimenez Underwood

I knew Consuelo Jimenez Underwood before I even knew her. I
went to college with her daughter, Velina, who was a powerful ac-
tivist committed to the Chicanx community. She was someone who
brought strength, passion, humor, and vibrant energy to the move-
ment on our campus. It was this relationship that led me to reach
out to Jimenez Underwood when I realized we were colleagues at
San José State University. We met for coffee and I quickly under-
stood that she was who I wanted to be as a thinker, scholar, and
person. Her mind is expansive, her creativity is always at work, and
her theoretical complexity is striking in its precision and applica-
bility to the daily lives of Chicanx people. I invited her to a class
that I was teaching because I wanted my first-year students in Chi-
canx studies to see who they could become. From that first lecture
that I witnessed, Jimenez Underwood became my model for Chi-
canx studies practice.

My own approach centers racial justice teaching practices
and principles, as I work with teachers, future teachers, and oth-
ers committed to justice in their communities, families, and daily
lives. As a former schoolteacher and someone who continues to
actively work in high school classrooms, I am committed to de-
veloping and implementing a Chicanx studies practice that ana-
lyzes and unpacks the history and ongoing forms of oppression in

the United States and that models how communities of learners can engage in consistent actions that challenge, replace, and even transcend the multiple forms of oppression that dominate the landscape of daily life in this country by centering the strengths, power, and intellectual insights of disenfranchised communities. This is how I understand the Chicanx studies project. Before meeting Jimenez Underwood, I had not encountered models of Chicanx studies that fully and holistically embodied this approach (although many had demonstrated a commitment to these objectives). Conventional approaches to content dominated our coursework: faculty-centered classrooms relying on convention-bound readings with little opportunity for holistic student engagement or for students to learn how to actually embody racial justice insights and practices.

Frustrated by the lack of imagination and creativity in the teaching of Chicanx studies in the early 2000s, I created and taught a first-year course that pushed students to find and develop their voices through artistic expression. I knew that what the students bring into the classroom and their own visions of the world they want to create are critical to Chicanx studies. Our students had something to say, but they were rarely acknowledged nor encouraged to nurture their voices. This course was designed as a means to help them do just that, and Jimenez Underwood came to share her work so that students could see what fully embodied artistic voice looked and sounded like. In doing so, she walked us through her life story. She explained how severely her migrant farmworker family struggled throughout her early childhood. She did not mythologize this experience but sought for us to feel it deeply with her. Then she deftly reminded us that this reality did not define her or her family—that in fact it was how they responded to these realities that most holistically demonstrated who they are. She explained that she always knew that she and her family had things to say that the world needed to hear, and then she described the first ten-year plan she created as a child to guide her on that path. She showed us how she developed a theory for understanding the ways in which racism, capitalism, and sexism shaped opportunity for her and her family in the United States, and how she identified and nurtured the tools that she had learned from her family for thriving despite this reality. During the course of that hour, Jimenez Underwood embodied a lived theory of transformation that each of us could replicate. Through reliving her evolving life story with us, she demonstrated three essential compo-

nents to her practice: acknowledging the pain that has been wrought within the Chicanx community through historical and institutional oppression; recognizing and affirming the beauty of the community in our perseverance, creativity, and ability to thrive; and using the power of applied theory as a weapon to combat oppression and live on a path of beauty.

It took me quite a while to process the power of her teaching, but as I did, I realized that this approach is always present in her artwork. I had experienced it profoundly in the first piece of hers that I ever saw, just a short time before we first met. One of her rebozos was part of a 2000 group show titled "*Imágenes e Historias*/Images and Histories: Chicana Altar-Inspired Art." *Buffalo Shroud, Almost 1,000 Left* (1995) is an eight-foot-long weaving that radiates light from the gold threads that constitute most of the work (figure 16). The piece is comprised of one thousand small squares, each with a buffalo hoof print on it, referencing the fact that buffalo, which were the heart of sustenance for many Plains Nations and Indigenous peoples, had been intentionally decimated through both policy and practice, leaving only about one thousand of the more than 60 million that existed before "westward expansion." The description of the piece included an infamous photo of two white men standing next to and on top of a pyramid of thousands of buffalo skulls. In the gallery, I was drawn to the beauty of the piece—it literally brought me from across the room to within inches of the weaving. I laughed as I saw the clever way Jimenez Underwood included the words "In Gold We Trust," with the *l* in a darker thread so that it also read "In God We Trust." Finally, I read her statement and saw the photo of the buffalo skulls and I felt as though I had been punched in the gut. That feeling was the physical manifestation of my anguish about and uneasiness with this historical reality and how it sits with me and us now, invisible but ever present. I also felt just as deeply the beauty of the shroud and how inspiring the weaving was: delicate, precise, surprising, and captivating. Jimenez Underwood was teaching us history in a way that implicated us in our present, while always reminding us to look for and rely on the beauty within us as a concrete form of resistance. She wove theory, pain, and beauty into her work in a way that left me pondering and wanting to work toward transformational practices that I could live with my own Chicanx community.

I had not put all these pieces together at that time; in fact, they only fully aligned for me much later, as I spent time with her mural *Undoc-*

umented Border Flowers (2013) (figure 53). This piece is a 12 × 20–foot map of North America with a barbed wire slash across it; the barbed wire is nailed to the wall with spikes and represents the US-Mexico border. The border, however, is overwhelmed by huge and beautiful flowers that bring light and life to the gallery space. During one of my visits to the gallery, Jimenez Underwood told me that when she thinks about the border and the atrocities that are leveled against the Mexican and Indigenous peoples there as a result of politics and greed, she imagines transcending this reality and looks to the border-crossing flowers for a model of how to do just that. Like all of her work, this mural pulled me in, demanding that I look closely at the border and understand it for what it is: a violent and systematic assault against Mexican, Chicanx, and Indigenous peoples. Her mural required me to pull back, however, in order to find and acknowledge the beauty, to understand it as a remedy, as a transformative path for our communities. Finally, this mural left me with a charge: to move forward, out of the gallery and back to my own life and community, with the wisdom she had bestowed through her complex praxis, to seek real revolutionary possibilities.

Spending an evening with a group of students from our master's program in the gallery where *Undocumented Border Flowers* was showing, Jimenez Underwood upended their understanding of what they should be doing as emerging Chicanx studies scholars. She bounced around the gallery with exuberance and wonder. She spoke of her work and its evolution and what she hoped for those who visited the gallery. She also forced us to confront one of the perennial questions that so many Chicanx studies students find overwhelming: What do we do? As we cover both the harsh histories and disconcerting contemporary realities of our communities, Chicanx studies students and teachers can become despondent and might even surrender to anger or sadness. Jimenez Underwood did not shy away from these realities but confronted them head on. Then she took us to another level, reminding us of the power and beauty of our communities and ourselves, embodying the hope that she learned as a child from her family.

When I think back to that night, I hear Jimenez Underwood's voice and one phrase she repeated as she walked us through the gallery: "Isn't that beautiful!" I have heard her say that with excitement countless times as she looked at and shared her own work. This is her most important lesson for me. She knows and teaches that we can transform and transcend the atrocities we face only by seeing our own beauty

and then replicating and building on it. As she repeatedly plants this seed through her work, she helps me understand that Chicanx studies is how we live. That night in the gallery, the students also began to understand this. They wanted to engage in knowledge production, in the pursuit of beauty. They wanted to create, and before they left, many had already begun to do that, thinking out loud about how they wanted to honor their families and even beginning to write their own poetry. In her artwork and teaching, and in how she lives in and walks through the world, Jimenez Underwood has taught me what Chicanx studies must be.

I began this essay by suggesting that the power of her approach can be found in the way that she and her partner, Marcos, raised their daughter. I was unsure whether that was the best way to open this essay or if I should include it at all. But as I reflect on what Jimenez Underwood has meant to me, I continue to flash back to times I spent in her home, with her partner, their children and grandchildren, and her father. The beautiful way that she has created family and practices revolutionary love on a daily basis is the embodiment of Chicanx studies that I had always sought. She lives a lesson I began to learn while spending time in a continuation school years ago. One of the teachers, Pablo Viramontes, told his recovery group that he wanted them to live one life. Pablo was suggesting that we cannot live fragmented lives that allow us to hide addiction from others and thus from ourselves. He wanted the youth to know that they could not simply put on a face of integrity for him, but that it would have to be part of who they are always. Jimenez Underwood taught my students and me that same lesson: we cannot hide from the oppression our communities have confronted for generations, just as we should not ignore the beauty and power these communities have always created through resistance. She reminded us that we could build theories of practice that are revolutionary and transformative. Jimenez Underwood lives one life: always, consistently teaching by doing in all facets of her being, manifesting revolutionary love and integrity as she builds relationships, speaks, cooks, raises her family, laughs, fights back, and weaves.

VERÓNICA REYES

Blue Río Tapestries

Consuelo Jimenez Underwood gave an artist's talk in November 2014 at the Chicano Studies Research Center at the University of California, Los Angeles, where she met prize-winning poet Verónica Reyes. Upon learning she was a poet, Jimenez Underwood asked Reyes to write a poem for her. The poem "Blue Río Tapestries" emerged from, in the poet's words, "a bridging of two mediums," an honoring of a conversation between the visual and the textual, the artist and the writer. An artwork in itself, the poem appears as the poet intended, using punctuation, precise spacing, color, and variations in scale and formatting in strikingly innovative ways to create a visual tapestry whose rhythms and patterns make visible the motion of the artist at her loom and the impact of Jimenez Underwood's work on the world.

Prologue[1]. The Loom :: Her Story

On the tierra lay an old cottonwood branch gnarled by the sol
Moist oils from a mano weathered it to become a loom

The dried-desert rama the length of two brazos like the river
 sna___
 k⎺ing___ across warm polvo

Inside the branch hung in the work room
Inside the adobe walls cool the casita
Inside someone, most likely, la dueña
 picked, carried, treated this branch: a working tool
 a new *life*, a new *gift*

The upright loom like la luna hangs from the dry mud-straw wall
 the loom
 s-w-a-y-s
 gently

weaving yarn stretching from / el norte to south / woven from west to east / scripting

As a chiquita, she watched her elder tejiendo on a simple loom in the garage
She imagined her ancestors, her abuelos de esos tiempos antiguos sewing stories
 brown manos dancing, dancing, bailando
 like a red-cafecito mariposa skirting air
Consuelo beamed cariño to him, her sangre, her abuelita
 her corazón swelled with pride
 as if two full-bloom rosas
 warming her alma

She learned to weave with wooden shuttles on a precious loom
in a small Calexico backroom, a c—o—o—l cuartito
 needle and thread needle and thread
 needle and thread
the loom worked pressed flourished everyday items
 shawls cobijas tapetes la vida
homemade cositas ropa for the familia
 for their neighbor for their gente

The cottonwood rama so precious to this everyday task/ritual
Her abuela, a doña, taught her: :respect for la Virgen y la rama
"Gracias a la vida. For the majestic beauty of an upright loom."

Prologue[2]. The Thread

One blue —t—h—r—e—a—d—~
 we__ — a — __ves—~
 in out in out breathe
 inhale air—brown city skies
 musty air clogging
 nostrils
 factory spume
 hovering
 wavering
 near the brown río

 *

She held the thin fiber, a blue metallic thread
 between her forefinger
 and thumb

 held it as if a blue icicle from Colorado
 so frío so gentle so fragile

One blue —t—h—r—e—a—d—~
 the beginning
 the craft
 of her
 of her
 Art

Inside *Mother Ocean (Water)* rebozo blue agua trickles
 sings to imaginary water lilies
 a few notes
 spliced qua/rters
 whole (drops)
 plop, plop
 down
 a watery chorus

Water beads dream to be a sea of blue —t—h—r—e—a—d—~
 an ocean of desert blue notes: "CAUTION"
 —string~ along the blue
 horizon as if the blue
 resin, as if the blue
 cielo can embrace
 /Tonantzin's edge/

Artwork anointed with (un)documented esperanza
Hope for the migrant on both sides of the linea
Hope in the turquoise sky, in the azure distance
Hope, blue-threaded esperanza, waits waits

In her home the weaver and tapestry dream to exist:

One blue—t—h—r—e—a—d—~ waits patiently for the loom, the weaver's touch

 In San José, she comes into her work studio and admires the beautiful loom
 How serene her floor loom appears in morning light
 How gracious her loom sits awaiting her hands to breathe art
 How her peaceful loom appears as if an ancestor waiting to speak to her:
 each thread—each color—each pulse becomes—a cuento

One blue—t—h—r—e—a—d—~ waits patiently for the loom, for the weaver's spirit

 In Cupertino, she walks into her studio and places her brown mano on the loom
 Remembering, each thread's a breath of a larger story to be sketched
 Each hued thread hums a note to her, *Listen mujer, listen to Ixchel*
 Let el telar enter your alma and share the people's story.

One blue—t—h—r—e—a—d—~ waits for the artist's alma, cariño and vision:

 In Gualala honored by the Pomo, ancient redwoods exist in *Mother Mundane* tierra
 Consuelo in a single-petal skirt, huipil, and dark-tinted sunglasses touches her loom
 She prepares a spool of cobalt-metallic thread a wisdom piece: *Rebozos for Our Mothers*

 needle and thread needle and thread
needle and thread needle and thread

One blue—t—h—r—e—a—d—~ waits for the Artist:

 Consuelo Jimenez Underwood

I. The Weaver

She speaks the language of thread——~
like the blue yarn lining at the edge
of the cerulean earth's horizon
 —stitched together into—
 —turquoise cielo—
 —reflecting the sky hovering Nuevo México~

In her mano the blue thread's supple
 malleable
She sits on her wooden stool
 prepping her BODY for the work

In *Consuelo*'s studio colors
 drip every where
yellow red jade lavender
Fat hued spools stream across
 kissing window sill to walls
The rainbow room, windows/ventanas
 pour
 i
 n
 g
 luz, a northern Califas-damp sunshine,
 as if the sol peeked through the gray rebozo
 wrapping San José
 patron saint of travelers
 campesinos
 niños
 trabajadores
 in the field, se llama el fil

Gente shades of atole to cafecito like a taza in la madrugada
traverse the muddy roar mirroring a wiry blue thread
a dusty frontera seeps
 into the pores, orifices: ears, boca

In her artist studio up on the loma, light
 draped the room like her textiles:
 amarillo flowers
 pasted on a map
 almost as if spirit flowers

[remember: tune back in time to the 1950s—she imagined flowers pasted with masa glue]
[remember: her Apa in the garage weaving on a simple frame. Lesson 1. Respect el telar]

When she was *little* little sitting in the solecito, she gazed dreamily
 mesmerized by her abuela's manos fluttering in the dry desert air
 tejiendo a cobija a beanie a doily
 large-working manos singing bailando in the sala
 composing a piece—a symphony of cobalt-hued thread

A five-year-old Consuelo fell in love
 the rhythm~ hypnotizing~
 the minute detail riveting
 pulling her *young* alma
 tugging her corazoncito—^{acuérdate}
 Honor this Craft
 this Gift
 this Arte

And in the gleam of this beautiful niña's onyx eyes
 her abuela saw something—una cosa rara. que curioso.—
 el futuro in her nieta, her granddaughter from this lado
 ————————a young artist————————

Feathery luz dangled blues greens reds y más
 colores as if precious agua dripped along woven wire
and she caressed the thread between three fingers and thumb
weaved each one and her manos became a paloma
 p—-u—-l—-l—-i—-n—-g—-~ thread tautly

The artist/weaver crafted imagined crafted
 new textiles—allowing two working seasons
 (re)imagining *Virgen de Guadalupe (Spirit)*

Her brown working manos danced in the studio
Her mind her body her spirit
 became one————artwork

Speaking thread ^{needle and thread} ^{needle and thread} ^{needle and thread}
Weaving craft art politics
Speaking thread ^{needle and thread} ^{needle and thread} ^{needle and thread}
Weaving Xicana Mestiza ideology
 Community Spirit
Speaking thread ^{needle and thread} ^{needle and thread} ^{needle and thread}
 and copal hovers
 like Coyolxauhqui, *Mother Moon (Sky)*
 over // along el río //
Seeping inside Consuelo's alma calling her:
 Honor your relatives—Become a weaver—A textile artist

II. Blue Thread——~

One blue thread pulled tight tight like yarn nailed into a border wall installation
A little Mexican girl in Brownsville wears a blue *blue* trenza as if carrying un río

 Waves of lapis yarn braid her dark brown hair
 A glint of El Paso-Juárez frontera
 trails along her back

 *

standing near the graffiti canal, the wind flaps two international flags
 murky agua in quiet fits beneath the surface from waders streaming
 down the edge of Texas like west paisano / a sharp border navaja /

up norte en Nuevo México, Nevada, Colorado along the rocky montañas
the clear clear water roars alive; the tierra laced with migrant mammal tracks
and off in the distance—a Mexican coyote howls in the noche
 un painful grito

 a familiar sound a familiar sound a familiar sound
 as if steel blades—machinations, n.a.f.t.a.—cutting deep
 the (*silence*) screaming, writhing leaving brown female bodies

 ◊
 ◊ half/buried ◊
 ◊ in ◊ desert ◊ sand ◊
 ◊ ◊ ◊

 like a helicopter hovering over Segundo Barrio on la frontera
 a familiar sound a familiar roar a familiar noise a familiar edge
at the edge of the 5 freeway peering at ocean waves, a *Kaut Tortilla* floats
at the edge of the 10 freeway peering at el Río Bravo colonias huddle
and a Mexican coyote yips to the blinking estrellas floating in brea sky

 *

Undocumented Yellow Flores speckle the jagged-lined tierra
Border water inhales exhales a shimmering turquoise shawl
 trailing from San Ysidro, CA
 to Brownsville, TX
 a horizon cupping an ocean rebozo tinged with café
 emerging from Consuelo's working manos

the craft artist pulling one blue metallic thread, a woven wire
 one after the other after another after the other after one
the soothing rhythm entrances her soul into textured sueños
her mind drifting into the movement of dancing hands

the beads of tiempo absorbing | her mente | her body

in the desert, the river water warm
 inviting like a blessing
 soothing the strained body
 mesmerizing the wader
 the current powerful underneath
the beauty enticing with suppleness

the blue shawl *so*— plumita soft to the eye
on the palm the touch hard like barbed wire
 between here and there between here and there
the beginning so simple so enchanting so mesmerizing
 One Blue Thread

the craft artist working working working each fiber
slowly emerging thread by thread into new life: Art
 One Blue Rebozo: *Mother Ocean (Water)*

III. ⊂⊃ Border Art ⊂⊃

⊂⊃ silver pins. ⊂⊃ silver seguros ⊂⊃ pierce. ⊂⊃
the gray fabric squares ⊂⊃ gray linen squares ⊂⊃
⊂⊃ gold safety ⊂⊃ oro pins line the cloth ⊂⊃
⊂⊃ **CAUTION** ⊂⊃ CAUTION ⊂⊃ **CAUTION** ⊂⊃

⊂⊃Warning ⊂⊃ signs streak ⊂⊃ atop of the burlap border ⊂⊃
 ⊂⊃⊂⊃⊂⊃ hombre, mujer y chamaquillo ⊂⊃ ⊂⊃⊂⊃
running, running caught midflight /a swooping águila/
they are a black snapshot on yellow metal /a mexican familia corriendo/
as if escaping a blocked prison: American made via Mexicano labor
/stamped/ branded/ embroidered/ stamped/ branded/ embroidered/
 made in pinche //n.a.f.t.a.//.a.t.f.a.n//n.a.f.t.a.//a.t.f.a.n.//

 ¿Is this a Nahuatl word? ¿la Palabra?
 foreign—dirt, really—gravel, really a
 río, a chorrito de cafecito on white
 imported into beautiful Mexica land
 hecho de mano, silkscreened linen de sabiduría femenina
 crisscrossing-threading a Huichol relation stitch by stitch
 stitch by stitch by stitch by her, *Consuelo*

They are 1x1 patch leather squares like gray nebula clouds floating across fences
 floating across bordered air bordered trapping molecules like red|brown gente
⊂⊃ silver safety pins ⊂⊃ one two tres ⊂⊃ glint to the sky
and la diosa gazes down far from beyond ⊂⊃ el sol ⊂⊃

 She sees desert montañas ríos shaping
 reshaping the tierra gravel land
and orange poppies green saguaros white yucca blue bonnets
bathing the fertile soil like documented/undocumented beings
 NORTH SOUTH **CENTER** EAST WEST
along the Tijuana borderscape skirting hardened dirt/ rock/ arroyo/ desert
 ocean to Gulf of México

on old maps oily-yellowed paper ⊂⊃ a thick-jagged black marker
 pierces ⊂⊃ the earth's ⊂⊃ red-brown fabric ⊂⊃
 like ⊂⊃ silver seguros ⊂⊃pinching⊂⊃stabbing⊂⊃pinching⊂⊃
 Tonantzín's full brown body: ⊂⊃ a mujer's body ⊂⊃
 her shawl embracing her ⊂⊃ Mexica cuerpo ⊂⊃

 ⊂⊃**CAUTION**⊂⊃**CUIDADO** ⊂⊃ CAUTION ⊂⊃**CAUTION** **CUIDADO**⊂⊃

Nombre, hay gente allí running corriendo running for life for a life for a *better* life
corriendo chased across freeways desert sacred tierra by a mean-glowing spirit more

frightening than pinche cortes/ father serra/ el cucuí/ a white ghost
⊂⊃ safety pins. ⊂⊃ silver safety pins ⊂⊃ lines ⊂⊃
⊂⊃aligns⊂⊃

Dark reddish brown *Mendocino Rebozo* like clotted sangre adorns a gleaming white wall
draping a gallery, a museum
a white, white wall ⊂⊃ a white, white wall like ellos/them—a white, white wall

⊂⊃**CAUTION**⊂⊃**BORDER ART**⊂⊃CUIDADO⊂⊃**BORDER ART**⊂⊃**CAUTION**⊂⊃

```
∩∩∩      ∩∩∩      ∩∩∩      ∩∩∩      ∩∩∩
UUU      UUU      UUU      UUU      UUU
∩∩∩      ∩∩∩      ∩∩∩      ∩∩∩      ∩∩∩
UUU      UUU      UUU      UUU      UUU
∩∩∩      ∩∩∩      ∩∩∩      ∩∩∩      ∩∩∩
UUU      UUU      UUU      UUU      U∩U
∩∩∩      ∩∩∩      ∩∩∩      ∩∩∩      ∩∩∩
UUU      UUU      U U U    UUU      UUU
∩∩∩      ∩∩∩      ∩∩∩      ∩∩∩      ∩∩∩
UUU      UUU      UUU      UUU      UUU
∩∩∩      ∩∩∩      ∩∩∩      ∩∩∩      ∩∩∩
UUU      UUU      UUU      UUU      UUU
∩∩∩      ∩∩∩      ∩∩∩      ∩∩∩      ∩∩∩
UUU      UUU      UUU      UUU      UUU
∩∩∩      ∩∩∩      ∩∩∩      ∩∩∩      ∩∩∩
UUU      UUU      UUU      UUU      UUU
 ◊                 ◊                 ◊
                   ◊
```

IV. Undocumented Border Flores: mapas

In Calexico, in Mexicali, in San Ysidro, in Tijuana, in Brownsville, in Laredo, in Nuevo Laredo,
in Tucson, in Santa Teresa, in El Paso, in Juárez, in jardines of little Chihuahuita overlooking
el Río Bravo

In Mexican jardines of las colonias rosados, morados, lime, yellow, anaranjados, cobalt dipped
del barrios, flores—yellow petals, white cups, blue bowls, white bundles dangle
florid apparitions appear on both sides of the river of the desert of the map's black dotted line
as if purple, gold, orange poppies
 hefty green prickly saguaros
 strong spindly desert yucca
 dazzling blue bonnets / $^{cannot\ exist}$/$_{cannot\ exist}$ /
 Yet
They flourish in bountiful gardens on both sides pampered/tended by hardworking manos

Jimenez Underwood firmly stands in front of her border wall installation
 Undocumented Border Flowers map a painted mixed media art towering
 over her like a waterfall pouring yellow blue orange flores

A cobalt border map lining this side your side this side your side
 México-Los Estados/US-Mexico/Los Estados/Los Estados Unidos Mexicanos
 always el otro lado always the "other" always the "other" as if we are shadows

In la foto the Río Bravo crowns her as an honored daughter of Malintzin Tenepal
 an intellectual transfronteriza, an artistic scholar
 empowered by las viejitas' concept $^{needle\ and\ thread}$ $_{needle\ and\ thread}$ $^{needle\ and\ thread}$
 weaving her interconnectedness like gender sex race class
 in an oak-wooden loom blooming
 azul, white flores
On the white white wall, little cobalt-yellow xochitls sprinkle
 textile-art map blossoming gigante flowers like new vocabulary
and Consuelo, the artist, stares/gazes straight into/from
 a tri-cultural lens reflecting her migrant gente

In the art museum the large scale ARTWORK
 hovers like la Virgencita
 de
 Tepin
 soft blue wing mapas sewn in ancestral memory
 encouraged by las viejitas by her abuelita
onyx eyes gaze pass, onyx eyes look beyond
 the narrow patriarchal single lens
 / C. Jane Run. / Run, Jane, Run! /

In McAllen, in Sierra Vista, in Antelope Wells, in Del Rio, in Acuña, in Agua Prieta, in Reynosa, in Nogales, in Nogales, in Lukeville, in Hombres Blancos, in Fort Hancock, in El Porvenir

Rosas like la Virgen de Guadalupe Flowers like La Diosa Tonantzín
Appear across both sides of a steel wall
 of a river
 of a desert
Undocumented flores, xochitls sin papeles/undocumented xochitls transfronterizas

On a blue woven fiber mixed media border map Xochitls migrate, exist on both sides like air:

—Poppies—
 —Yucca—
 —Saguaros—

 —Blue—
 —bonnets—

Permeating blooming with Adelita's fierceness // planting a revolution //
like Consuelo Jimenez Underwood's large scale installation artwork:
 Undocumented Border Flowers

V. Artist Plática

The afternoon jueves sol exhales warm waves
into the hazy-blue LA sky basking in sunlight
as if a silver Mexican peseta dangles
over a steaming desert soft cafecito sand
 a polvito really—a sheath clinging
 on the body, sediment in boca
 like in el paseo del norte

The LA glass-steel horizon plasters the city's lining
Consuelo, an established artist, waits in the library
The audience orange poppy petals floating in time
Consuelo lounges waiting, sitting, chatting, waiting
dreaming inside before the lecture, *her* artist talk

 *

In San Jose, she *waited* for her tenure
Dossier file nitpicked selecting choice pieces
She w—a—i—t—e—d for galleries| museums| curators
 to **WAKE** up!!!

 See *HER* as an Artist
 "this is not Craft *vs.* Art" an old white cube mantra
 Those constrained days/lens are gone
 They <u>must</u> be gone to BREAK open the white cube

She *waited* for the Art Establishment/ the System
 to WAKE **up**: :**OPEN** their eyes/ their minds:

 See the role of Latina mujeres artists
 Mendieta Maresca y Santa Cruz
 See the role of Xicana Mestiza artists
 Baca López Carrasco Cervantez
 like *her*: Jimenez Underwood

 *

At the Xicanx resource center, the poet waits gingerly
And when CJU steps into the book-lined room
the room of five, seven applauds as if a hundred
Her plática the significance of Border Art
 The need | The desire to create art
 Respect las viejitas de tiempos antiguos
 Textile art embedded/woven in el telar

like a needle, a punta: Xicana Mestiza ideology
 —grassroots politics like red-brown raíces—

The value/importance of the thread needle and thread
One blue —t—h—r—e—a—d—~ reveling sabiduría

Mother Ocean (Water) rebozo lay on the mesa shimmering a beautiful arroyo
running, streaming across rusty sediment as if over *Mother Earth (Flower)*
Warm turquoise muddy water tumbling downstream pa' México
 tossing, pushing pierdas like red-yellow maize kernels

(Suddenly, it dawned inside the Xicana poet)
 The poet saw el Río Grande a hundred years ago on la frontera
 The poet saw la gente, Mexicanos, wading across el Río Bravo
 The poet saw Xochitl Sin Papeles like the Undocumented Flowers
 La poet saw caballitos, yeguas, galloping across fresh clean agua
 The poet saw burros trudging along the río lugging bolsas
 The poet saw gente Indígena, her gente, Mestizos wading across
 ←—allí allá acá de allá de acá de allí pa' allá and the poet remembered the purpose of art—→

In the blue río tapestry reflecting ocean swells
Consuelo, craft artist, braided land~water~sky
"Touch. Feel this." She prodded her audience
Her mano glided over the thread, the beads
as if a curandera, a sobadora *healing* a BODY
Her firm-brown hand drifted across the arte
 feeling/absorbing the rebozo's energy
like in her studio, sunlight shimmered in
 glinted on the clear golden beads

(Suddenly) flashes of luz/light:
 dry land
 clear río
 lapping waves
 a corn husk tortilla
 floating on the beach
 near the shore
—Border——no man's tierra/no man's mar/ no man's land/ no man's ocean——Frontera—

On the table, the *Rebozos de la Frontera* awed—*Dia/Noche*
And everyone was mesmerized
And Consuelo, this visual artist, so—
 Graceful
 Grateful
 ¡Powerful!
And la mera mera Chicana Mestiza artist nodded, "Gracias."

VI. Consuelo's Manos

Her manos are rich as her voice deep, copal~~ beautiful
Her manos mirror a working mujer's hands like her abuelita
 Thick
 Strong
 Loving
Her manos thread galvanized barbed alambre like trenzas negras
 inside: a white stitched virgen, the dead lupita la muerte
 a calavera cradled in a white shawl
Her manos worked fabric, linen, safety pins, glass beads, husks
These hands are her *artist* tools
Vital to her as a thread to an upright loom
 as sangre to her corazón

 *

And her manos dipped, fluttered in the air as she spoke
sharing her story: her art, her loom, her choices, her vision
"May I feel your hands?" the jota poet tilted her chin up to her
She smiled, a hint of a glint in her deep cafecito eyes, nodded
Opened her brown manos, palms up embracing Mexica luna
In her palm she cradled la frontera in her life line
 inside bordered flores / flowers bloomed
 teeny poppies yucca enterrado

←-◊-→—◊—◊-←-◊-→Califas Poppy←-◊-→—◊—◊—◊-←-◊-→

 ←-◊-→—◊—◊—◊-←-◊-→New Mexico Yucca←-◊-→—◊—◊-←-◊-→

 ←-◊-→—◊—◊-←-◊-→Arizona Saguaro←-◊-→—◊—◊-←-◊-→

 ←-◊-→—◊—◊-←-◊-→Texas Blue←-◊—◊—◊-←-◊-→
 ←-◊-→—◊-←-◊-→bonnets←-◊-→—◊—◊-←-◊-→

Flores sin papeles naturally sprinkled along the | her life line
 beneath barbed
 ←-◊-→wire←-◊-→
Tejiendo vida from her mano like a sculptural installation
She cupped Tonantzín in her arte engrained in her
Her working manos, her brown hands soft so—*soft*
Tender to the poet's hand gliding across 2000 miles
Sauvecito as new petals flourishing along her life line
so supple—and strong as a maquiladora's manos
 like her mamá's / her abuela's / mujeres Indígenas
These were / are the manos / of an artist: Consuelo.

VII. Consuelo's Vision

Lesson 1. Respect el telar
Lesson 2. Listen to las viejitas, really las doñas
Lesson 3. Respect the craft of _needle and thread_ _needle and thread_ _needle and thread_
Lesson 4. Create. Imagine. Envision. A new visual-textile-vocabulary artwork / this is her
 responsibility / to weave art form / paying homage

In her alma / Consuelo sees the art / breathes in arte / artistry flows in her corazón / ¡EXIST!
In the white room / appearing as if wrapped in _Mother Mundane_ / a burgundy rebozo swathes her
upper body / she stands in front of her mapas
 Dabs of yerbas buenas / give a good life / protection for the soul
raices as strong as a nopal, chaparral pocking la tierra aquí / allá / acá

Inspired by land plantas her politics her beliefs her ancestry arte y Spirit

In her youth, in Calexico, a young Chicana Huichol dreamed _needle and thread_
Her desire: to be a footnote grew~grew~grew into a book of _Art, Weaving, and Vision_
Little by little by little like a blade of zacate / a drop of agua / a thread of a rebozo
Bit by bit by bit she mapped ancestral memory / personal quest / crossing fronteras /
creating / establishing her artistic voice / with _needle and thread_ _needle and thread_ _needle and thread_

Consuelo envisioned: Art is power. Like little xochitls' fighting to survive.

~◊~

A wader in the agua reflects her arte; her long dark hair flows down her back
 carrying their story carrying her memory carrying their dreams

Along the río's banks ocotillo, rooted nearby, immense flores populated
 Tijuana San Jose Mexicali El Paso Matamoros
A home girl educated in el barrio—a public school system / art school / y la vida
Her voice as rich as café de la olla (hecho de barro) / strong and powerful / as copal's blessing
Her voice pulls in listeners / pulls in her communities empowering her audience
This home girl Chicana / This home girl Mestiza / She weaves her gente's voice / vida

Consuelo's vision as stunning as her Borderlines series in homage to her raíces:
 Border X-ings [2009] _Undocumented Border Flowers_ [2010] _Undocumented
 Border Flowers: Dia_ [2011] _Welcome to Border-Landia_ [2013] _Flowers and
 Borders and Threads, Oh My!_ [2013] _LA Borderline_ [2014] _Mountain Mama
 Borderline Blues_ [2015] _Borderline Premonitions. New York_ [2015] _Undocumented
 Border X-ings. Xewa (Flower) Time_ [2016] _Undocumented Border Tracks_ [2017] y más

⊃ ⊂ CAUTION ⊃ ⊂⊃ **CHICANA** ⊃ **ART** ⊂⊃ **X-ING** ⊂⊃ ⊂ CUIDADO ⊃ ⊂

∞CS∞

Introduction

1 L. Pérez, *Chicana Art.*

2 Mesa-Bains, "A Chicana Aesthetic."

3 For feminist "intersectional" approaches see Crenshaw, "Mapping the Margins"; for "simultaneity of oppressions" see Combahee River Collective, "A Black Feminist Statement."

4 For images and analysis of these art works, see Griswold del Castillo, McKenna, and Yarbro-Bejarano, eds., *Chicano Art*, 35, 250; Malagamba-Ansótegui, *Caras vemos*, 14; Leimer, "Cruel Beauty, Precarious Breath" (2016), 222–33.

5 For information on Richard A. Lou and *The Border Door*, see Lou, "The Border Door," 83–93; P. Chávez, "Through *The Border Door*," 94–100; Latorre, "Public Interventions and Social Disruptions," 101–8; and Berelowitz, "The Spaces of Home," 351–73.

6 Chávez, Grynsztejn, and Kanjo, *La Frontera/ The Border*, 147; Maciel and Herrera-Sobek, eds., *Culture across Borders*, 133.

7 For information on the *Space in Between* project, see "Margarita Cabrera." Also see "SPACE IN BETWEEN," Margarita Cabrera website, accessed September 12, 2021, http://www.florezcacreativa .com/space.html.

8 For more information on the work of Margarita Cabrera, see Ruiz-Healy, *Margarita Cabrera: Collaborative Work*; Ramos, "Margarita Cabrera," 188–121; and Noriega, "Margarita Cabrera," 120–23.

9 Farrington, *Creating Their Own Image*, 155–63.

10 Mignolo, *Darker Side of Western Modernity.*

11 *Watchful Eyes*, 31.

12 Gouma-Peterson, *Miriam Schapiro.*

13 Pérez, *Chicana Art*, 15.

14 Mignolo, *Local Histories/Global Designs*; Delgadillo, *Spiritual Mestizaje.*

15 On decolonial aesthetics see L. Pérez, *Chicana Art*; and Mignolo and Vázquez, "Decolonial AestheSis."

16 Martineau and Ritskes, "Fugitive Indigeneity," x.

Chapter One: The Hands of Consuelo Jimenez Underwood

1 All quotes from Kenneth R. Trapp are taken from our conversation in June 2016.

2 All quotes from Consuelo Jimenez Underwood are taken from the January 16, 2012, interview with her during filming for the "Threads" episode of *Craft in America.*

Chapter Two: Charged Objects

1 Cesar Chavez formed the National Farm Workers Association (NFWA) in 1962 with Dolores Huerta, Gil Padilla, and Julio Hernandez, an effort described by Ferriss and Sandoval in their book *Fight in the Fields* as "a grassroots group that would build strength slowly, almost one worker at a time" (62). Describing the broader context, they wrote: "Chávez and the original UFW [United Farm Workers of America] activists faced . . . an epic struggle for labor rights and justice . . . [one that] exploded in California, just as the shock waves from the civil rights movement in the South were spreading across the nation" (2). In 1965 the NFWA joined with the Agricultural Workers Organizing Committee to strike against grape growers. "The strike lasted for five years and was characterized by its grassroots efforts— consumer boycotts, marches, community organizing and nonviolent resistance—which gained the movement national attention" (Wikipedia, s.v. "Delano Grape Strike," last modified June 23, 2021, https://en.wikipedia .org/wiki/Delano_grape_strike). In 1966 the

two organizations agreed to join together as the UFW, continuing with the black eagle as their symbol and "¡Si Se Puede!" as their motto.

2 Consuelo Jimenez Underwood, in-person interview with the author, June 12, 1995.

3 To give a few examples: Jimenez Underwood assigned chapters of Weiner and Schneider's *Cloth and Human Experience* for her advanced weaving classes in the mid-1990s. Glen Kaufman, a well-respected fiber artist and teacher, described his Cranbrook MFA students: "Some—most of them had no . . . printing or dyeing experience, no background in history." See "Oral History Interview with Glen Kaufman," 26. (Note that page numbers in the oral history interviews cited throughout this chapter refer to the interview transcripts.) The Cranbrook Museum collection held historical textiles that he "used . . . a lot in teaching" (23). On the basis of that experience, Kaufman then pulled together material for a full lecture course in textile history, covering "from the Stone Age to the present" (67), which he taught between 1972 and 2012 while he led the Fiber Department at the University of Georgia, Athens. He said that "art historians deal with architecture, paintings, sculpture, minor arts, photography, printmaking, but seldom even the word 'fiber'—textile, tapestry—seldom even passes their lips" (27).

4 Giorgio Vasari wrote *The Lives of the Artists*, in which he provided biographies of select painters, sculptors, and architects in Italy from the thirteenth through sixteenth centuries. The narratives he created of a continuous advancement of not only skill but also perfection of artistic ideas focusing only on painting, sculpture, and architecture gained him recognition in his own time. His book continued to influence opinion three hundred years later, as the field of art history formed, through today. Rowland and Charney note in their reexamination of Vasari's achievement, *Collector of Lives*, that "a good deal of what we read in Vasari is either carefully manipulated fact or pure fiction. . . . Vasari wrote with an agenda, and much of his information is wrong, sometimes by his own deliberate choice" (16–17).

5 Elissa Auther, in her introduction to *String, Felt, Thread*, stated, "The emergence of the hierarchy of art and craft originates in the Renaissance when the first claims were made for painting and sculpture as 'liberal' rather than 'mechanical' arts. . . . And by the nineteenth century, associations of such work with ideas of usefulness, skill, adherence to traditional form, or the use of 'lesser' media like wood, clay, or fiber, were commonly accepted as distinguishing craft from art" (xv).

6 Paula Gustafson (February 25, 1941–July 11, 2006) was a Canadian potter who explored spinning, dyeing, and the making of textiles, and she wrote about and advocated for crafts and the arts. She published *Salish Weaving* in 1980. Wikipedia, s.v. "Paula Gustafson," last modified November 14, 2020, en.wikipedia.org /wiki/Paula_Gustafson.

7 Heller, Mallinson, and Scheuing, eds., *Making a Place for Tapestry Symposium 1993*, 55. Sparrow makes a reference to plain weave, or tabby, a basic weave structure where a weft thread travels horizontally across the warp threads (warps are perpendicular to wefts and are pulled taut by the loom) while alternating above one and below the next.

8 "Oral History Interview with Consuelo Jimenez Underwood," 30.

9 This phrase, "¡Sí, se puede!" ("Yes, you can!"), often comes with Jimenez Underwood's discovery of a challenge or goal that marks her path forward. It erupts decisively when she sees how to make a statement with her art, or how to weave, teach, and engage other people in her ideas.

10 Wendy Kaplan, in her introduction to *The Art That Is Life*, writes: "John Ruskin (1819–1900), the first professor of art history at Oxford University, and the most influential art critic of his day . . . [was one] of the sternest critics of industrialization and the only Arts and Crafts reformer to reject the use of machinery altogether" (53). William Morris (1834–1896) became the most well-known figure to embrace and popularize Ruskin's ideas of combining rustic or organic aesthetics with social ideals in the Arts and Crafts Movement. The exhibition

Anarchy & Beauty: William Morris and His Legacy, 1860-1960 appeared at the National Portrait Gallery in London in 2014-2015, with a catalog by Morris's biographer Fiona MacCarthy. An article on the show appeared in the *Guardian*. See Cooke, "Anarchy & Beauty" (accessed July 19, 2020).

11 Wendy Kaplan, in her essay "America," writes: "The moral aesthetics of American reformers derived from Britain, most notably from John Ruskin and William Morris. Their writings were best-sellers; reading groups met throughout the United States to discuss them. . . . Arts and Crafts ideals and designs were disseminated via hundreds of organizations modeled on London's Arts and Crafts Exhibition Society. British art journals such as *The Studio* were widely available; an American edition, *The International Studio*, began publication in 1897, four years after the magazine was founded in London" (248).

12 Eileen Boris, in her essay "'Dreams of Brotherhood and Beauty,'" in *The Art That Is Life*, notes the tendency for arts and crafts enterprises in the United States to take an industrial slant: "By [1906] Stickley was linking handicrafts 'to the actual doing of good and useful work,' a concern that led him to promote manual training and vocational education . . . to justify not only better working conditions, however, but the segmentation of labor and the tracking of specific groups of children into industrial wage work" (217).

13 In "America," Kaplan includes other areas of influence on the United States, from the social support for new immigrants at Jane Addams's Hull House in Chicago, to the fine craft of Louis Comfort Tiffany's firm, to the prairie school architecture of Louis Sullivan and Frank Lloyd Wright, the American Arts and Crafts of Greene and Greene in California, and the invention of Mission style furnishings.

14 T'ai Smith describes the continuity of the Bauhaus weaving program in the context of the school's overall changes in vision in *Bauhaus Weaving Theory*, xiv.

15 In 1919 Gropius gave his address to students, saying: "The coming years will show that for us artists the crafts will be our salvation. We will no longer stand by the side of the crafts but be a part of them. . . . All great works of art in past ages sprang from absolute mastery of the crafts." Then, in 1922, as part of a project to build a stage at the Bauhaus, he wrote: "To be capable of creating moving, living, artistic space requires a person whose knowledge and abilities respond to all the natural laws of statics, mechanics, optics, and acoustics. . . . We shape the movement of the organic and the mechanical body, the sounds of voice, music, and noise." See Wingler, *The Bauhaus*, 36, 58.

16 The Bauhaus became associated with the saying "less is more," which is attributed to architect Ludwig Mies van der Rohe, director of the Bauhaus from 1930 to 1933, around the time he emigrated to the United States. Louis Sullivan, an American architect in Chicago, used a similar phrase, "form follows function," in an article he wrote in 1896. Wikipedia, s.v. "Form follows Function," last modified May 1, 2021, https://en.wikipedia.org/wiki/Form_follows_function.

17 Although Black Mountain College often gets cited as a unique college with a distinct lack of restrictions, much of its reputation came from the Bauhaus through Josef Albers, who ran the college's visual art program from 1933 to 1949. "Albers insisted that there was no hierarchy of materials: anything could be interesting if it was used properly. Leaves, mica, chunks of wood, and eggshells were all valid materials for exercises. The idea was revolutionary in American art education." Koplos and Metcalf, *Makers*, 151–52.

18 Albers wrote two seminal books, *On Designing* in 1959 and *On Weaving* in 1969. See also a 2018 retrospective exhibition and its catalog, published the same year by the Tate Modern in London. Coxon, *Annie Albers*.

19 Albers, *On Designing*, 6.

20 Albers, *On Designing*, 43.

21 Where Vasari described craft making as mechanical, Albers saw the division as conceptual. In *String, Felt, Thread*, Auther contextualizes Albers's frustration, which she had expressed in her 1940 article for *The Weaver*, a quarterly magazine for hand-weavers:

"Weaving played a major role in this [Appala-
chian craft] revival and provides the immediate
context for [Albers's] sharp critique of 'recipes'
and 'traditional formulas, which once proved
successful.' Albers argued that 'such work, is
often no more than a romantic attempt to
recall a *temps perdu*' and that it reflected the
state of 'isolation' and 'degeneration' in which
American hand-weaving found itself in the
period" (19).

22 Albers, *On Designing*, 47.

23 As noted by Krystal R. Hauseur, Guermon-
prez had an early influence on the work of Kay
Sekimachi. Hauseur, "Crafted Abstraction of
Ruth Asawa," 153.

24 See Bray, *Tapestries of Trude Guermonprez*, 6.

25 *Craft Horizons* began in 1942 as a magazine pub-
lished by the American Craftsmen's Cooper-
ative Council, a New York–based association
of craft organizations. It included ceramics,
jewelry, woodworking, and weaving. By 1955,
under editors Conrad Brown and Rose Slivka,
the magazine "turned increasingly away from
'how-to-do-it' articles and reports from clubs
and associations to more professional and art-
critical reporting." Koplos and Metcalf, *Makers*,
183, 225. In 1979 the magazine was renamed
American Craft. Wikipedia, s.v. "American
Craft Council," last modified September 6,
2021, https://en.wikipedia.org/wiki/American
_Craft_Council. *Fiberarts* magazine was based
in Asheville, North Carolina, had national
and international distribution, and published
issues between 1975 and 2001. Initially focused
on weaving, it expanded to cover all fiber art
techniques and materials (knit, lace, quilt, felt,
stitched, basketry, dyes, etc.). Spilman, "Guide
to the Records."

26 As an example of industrial production, Guer-
monprez designed fabrics "for her major cli-
ents, like Holland America Line and Owens
Corning Fiberglass; other pieces in this archive
are related to Guermonprez's work for custom
curtains made for major synagogues and her
designs, interior fabrics, screens and rugs real-
ized in conjunction with J. P. Oud, Architects
Associated, New York; Eric Mendelsohn, War-
ren Callister, etc." Trude Guermonprez Col-

lection, Cooper-Hewitt Smithsonian Design
Museum, accessed September 23, 2021, https://
www.worldcat.org/title/trude-guermonprez
-collection-1950-1976/oclc/51806627.

27 A group called Designer Craftsmen of Califor-
nia was founded by Trude Guermonprez and
"other local craftsmen" in northern Califor-
nia, as noted in Nathan, Sekimachi Stocksdale,
and Mayfield, *The Weaver's Weaver*, 25. See also
Kaplan, "Introduction," where she writes: "The
concept of the designer-craftsman, though not
unique to California, was most successfully
realized there, particularly in ceramics" (39).

28 "Oral History Interview with Consuelo
Jimenez Underwood," 35–36.

29 A piece like Austin's *Medusa #3* (1973) is
included as a photograph in Hampton, *San
Diego's Craft Revolution*, 146, the catalog of an
exhibition of the same name, which Hampton
curated. The text does not include informa-
tion about materials or process, but the piece
appears to involve woven and plaited elements
extending from a spherical structure above,
possibly made by using basket techniques.

30 Cranbrook Academy of Art in Bloomfield
Hills, Michigan, included a textile design (now
fibers) program, which had been founded in
1932. See "History of Cranbrook Academy of
Art," Cranbrook Academy of Art, accessed June
14, 2018, cranbrookart.edu/about/history/. It
formed directly from Arts and Crafts ideals
through George Booth, its founder, an admirer
of the American Academy in Rome, "a program
involving scholars-in-residence and students;
education occurred primarily through informal
contact." Booth hired Eliel Saarinen, an archi-
tect from Finland whose wife, Loja Saarinen,
founded the textiles studio and designed tex-
tiles "primarily to provide quality fabrics . . . for
the buildings he designed." Koplos and Metcalf,
Makers, 151n15, 128. It developed into a program
with the arrival of Marianne Strengell from
Finland in 1936; she taught and then led the
department through 1962. Cranbrook's unusual
approach of artist-in-residence-style teaching
and its reputation had an immense effect on
fiber arts in the United States. It helped estab-
lish the careers of a first generation of fiber

artists and teachers including Ed Rossbach, Jack
Lenor Larsen, Mary Jane Leland, Ted Hallman,
Glen Kaufman, Adela Akers, Walter Notting-
ham, Sherri Smith, Gerhardt Knodel, and many
others. For more on its influences on subse-
quent fiber artists, see Cranbrook Academy of
Art, *Hot House*.

31 "Oral History Interview with Marianne
Strengell," 24.

32 "Oral History Interview with Ted Hallman," 31.

33 "Oral History Interview with Gerhardt
Knodel," 46.

34 A black-and-white image of *Wall Tapestry*
appears in Hampton, *San Diego's Craft Revolu-
tion*, 147.

35 In her introduction to *String, Felt, Thread*,
Auther writes that "by the mid-eighteenth
century the separation of the fine arts from the
mechanical arts (occupations such as brick-
laying, leatherworking, blacksmithing, among
many other crafts) was settled. And by the
nineteenth century, associations of such work
with ideas of usefulness, skill, adherence to tra-
ditional form, or the use of 'lesser' media like
wood, clay, or fiber, were commonly accepted
as distinguishing craft from art. The institu-
tionalization of the art/craft distinction on the
basis of these characteristics remains evident in
the relegation of craft objects to the category of
decorative arts in museums and their general
exclusion from the history of art" (xv).

36 Bourgeois, "Fabric of Construction," 33f. When
examining critical writing about fiber art exhi-
bitions that sought to allow fiber art to stand
as art rather than as craft, Auther brings in
this *Wall Hangings* review by Bourgeois as a case
where the reviewer "exhibits concern about the
categories of art" and refuses "to grant fiber a
meaningfulness attributed to the materials of
fine art." To write as though an artist working
in other materials would not have the ability
to reach the levels demanded of art, suggests
Auther, hides an ongoing "anxiety about the
potential slippage of full-blown abstraction
into a lesser decorative mode, a situation [critic
Clement Greenberg], as well as European
modernists writing before him, perceived as
threatening to the superiority of painting in

the hierarchy of the arts." Auther, *String, Felt,
Thread*, 33–34.

37 According to Ferne Jacobs, "Joan [Austin]
learned how to knot; she went to Cranbrook to
learn basket making. She researched basket-
making techniques. And I want [basketmakers
and fiber artists] to know that everybody who is
working with basket-making techniques really
owes her a debt. She's the one who did the
research, and she was the first person doing it."
"Oral History Interview with Ferne Jacobs," 25.

38 In *Old Mistresses*, Rozsika Parker and Griselda
Pollock write in great depth to make "a critique
of the structural sexism in the discipline of Art
History itself . . . [and to link] the investigation
of past histories of art and dominant regimes
of visual representation to the comprehension
and critical valuation of art made by women in
the present" (xvii). They point to an ideology
of femininity in the eighteenth and nineteenth
centuries that took place at "the intersection
of . . . a social definition of women and their
role, with the emergence of a clearly defined
separation of art and craft" (58). In contrast to
Louise Bourgeois's refusal as an artist to accept
certain materials as art (i.e., the status of mate-
rials), Parker and Pollock point out how "in art
history the status of an art work is inextricably
tied to the status of the maker" (68). Further,
they describe how women's position as artists
is "a secondary status because of the different
place the tasks are performed," a difference
"between private and public activities, domes-
tic and professional work" (70).

39 Auther, *String, Felt, Thread*, 124.

40 Christopher Tilley writes: "Things are mean-
ingful and significant not only because they are
necessary to sustain life and society, to repro-
duce or transform social relations and mediate
differential interests and values, but because
they provide essential tools for thought. Mate-
rial forms are essential vehicles for the (con-
scious or unconscious) self-realization of the
identities of individuals and groups because
they provide a fundamental non-discursive
mode of communication." Quoted in Bristow,
"Continuity of Touch," 46.

41 Guatemalan cloth has a long history as a Maya

heritage production, woven by hand at narrow widths of about eighteen inches (body width) on backstrap looms. Cloth from each village has distinctive characteristics. The United States imported it in the 1970s and early '80s as some weavers acquired more efficient floor looms, particularly a dense warp-faced cloth dyed with black-and-white ikat patterns within a solid bright color (red, purple, green, etc.). Jimenez Underwood said that she purchased the fabric used for the lower edge of *Home of the Brave* at a powwow at Stanford, California, in the 1980s. Consuelo Jimenez Underwood, interview with the author, July 11, 2020, Cupertino, California.

42 For more on the work *LA Borderline*, see the essay by Karen Mary Davalos, this volume.

Chapter Three: History/Whose-Story?

I offer my sincerest thanks to the artists Celia Herrera Rodríguez, Consuelo Jimenez Underwood, and Delilah Montoya. Access to their artwork and insights—both born of la conciencia de la mestiza—made this chapter possible. I am also indebted to Laura Ellingson and Andrea Pappas, both of Santa Clara University, who helped me to negotiate arguments involving theory and content during the final stages of my work.

This essay was first published in the spring 2007 issue of *Chicana/Latina Studies: The Journal of Mujeres Activas en Letras y Cambio Social.*

1 See Ashcroft, Griffiths, and Tiffin, *Post-Colonial Studies*, 186–92, for a current summary of debates surrounding the spelling and usage of *postcoloniality*.

2 Ashcroft, Griffiths, and Tiffin, *Post-Colonial Studies*, 186.

3 Ashcroft, Griffiths, and Tiffin, *Post-Colonial Studies*, 188.

4 Slemon, "Scramble for Post-Colonialism," 16.

5 Acuña, *Occupied America*, 2; Goldman, "When the Earth(ly) Saints Come Marching In," 52.

6 Sandoval, *Methodology of the Oppressed*, 60.

7 Anzaldúa, *Borderlands/La Frontera* (1999).

8 Anzaldúa, *Borderlands/La Frontera* (1999), 101–2.

9 E. Pérez, *Decolonial Imaginary*, xvi. In art-related

venues, Anzaldúa and I have explored this same space under the designation of nepantla, an Aztec term that references both the state and site of transition and transformation. Anzaldúa, "Border Arte," 110; Cortez, "The New Aztlan."

10 This work was part of a traveling exhibit titled *Imágenes e Historias/Images and Histories: Chicana Altar-Inspired Art* and was shown from fall 1999 through fall 2000 at three venues: Tufts University Gallery in Medford, Massachusetts; the de Saisset Museum at Santa Clara University in Santa Clara, California; and the Landmark Art Gallery at Texas Tech University in Lubbock, Texas.

11 Kracht, "Kiowa Religion in Historical Perspective."

12 Furst, *Visions of a Huichol Shaman*, 27–28.

13 Young, *Quest for Harmony*, 252–53.

14 The literature on Guadalupe-Tonantzin is extensive. Throughout the Americas, the icon constitutes a site of desire and takes on different semantic loads according to the desires of the devotees and the historical situation. For Guadalupe-Tonantzin's transformation from Indigenous cult symbol to criollo nationalist symbol during Mexico's colonial period, see Peterson, "The Virgin of Guadalupe." For a comparison between Malintzin and Guadalupe as binary opposites, a discussion of the idealization of Guadalupe by Mexicans and Chicanos, and the reassessment of both icons by contemporary writers, see Alarcón, "Traddutora, Traditora." For the use of Guadalupe as an important cultural icon modified by Chicana artists during the Chicano movement, see Venegas, "Conditions for Producing Chicana Art."

15 Anzaldúa, *Borderlands/La Frontera* (1999), 52.

16 Jimenez Underwood, telephone interview with the author, November 2, 2001.

17 I have borrowed part of the section title from the exhibition catalog *Our Saints Among Us: 400 Years of New Mexican Devotional Art* by Barbe Awalt and Paul Rhetts. The volume features santos from the extensive collection of Awalt and Rhetts and presents them according to "major devotional themes." With few excep-

tions, all of the sacred imagery is stylistically conventional in appearance. In the present essay, Montoya confronts this canon by offering alternative sites of devotion and giving a rather nontraditional voice to one of its santos.

18 This situation has resulted in the production of homogenous histories that exclude other ethnic groups, including women. In recent years, a number of studies have challenged canonical representations of New Mexican histories and relations between different cultures. In *Matachines Dance*, Sylvia Rodríguez examines Indian-Spanish relations and the mitigation of the conquest via the performance of the Matachines Dance. Deena J. González, in *Refusing the Favor*, confronts notions of female passivity in her examination of Spanish-Mexican women and the challenge they posed to Euro-American colonizing institutions.

19 Meier and Ribera, *Mexican Americans/American Mexicans*, 93. Meier and Ribera provide an early example of this: the 1890s formation of the Santa Fe Ring, a group of wealthy Euro-Americans and twenty rich Hispanic landowners who joined forces and defrauded hundreds of poorer farmers in order to acquire more land (93).

20 Luis Tapia, interview with the author, April 5, 2004, Las Golondrinas, New Mexico.

21 Sorell, "Behold Their Natural Affinities," 23.

22 Ybarra-Frausto, "Rasquachismo," 156.

23 Accessed in 2007 at http://www.uh.edu/-dmontoy2/, the video is no longer available at the artist's website.

24 For a traditional representation of Sebastiana in her cart, see Charlie Carrillo's *Mi Comadre Sebastiana* in Awalt and Rhetts, *Our Saints among Us*, 12.

25 Yorba, *Arte Latino*, 88–89.

26 As noted by Ann Marie Leimer, Montoya's grandfather was a member of the Penitente Brotherhood, and it is likely that the artist became aware of the confraternity's devotional images through him. Leimer, "Crossing the Border with *La Adelita*," 35.

27 Delilah Montoya, telephone interview with the author, October 5, 2004.

Chapter Four: A Tear in the Curtain
This essay was first published in the 2006 exhibition catalog for *Tortillas, Chiles and Other Border Things: New Work by Consuelo Jimenez Underwood*, an exhibition that took place at Movimiento de Arte y Cultura Latino Americana (MACLA), March 10–April 29, 2006, San Jose, California.

1 Held, *Weaving*, 4.

2 "Codex Mendoza," https://codicemendoza.inah.gob.mx/inicio.php?lang=english.

3 Cordry and Cordry, *Mexican Indian Costumes*, 9.

4 Zamudio-Taylor, "Amalia Mesa-Bains," 145.

5 Aaron and Sachs Salom, *Art of Mexican Cooking*, 12.

6 Conveyed in conversation with the author. But also see Ybarra-Frausto, "Cultural Context."

7 Interview with the artist, February 2006.

Chapter Five: Prayers for the Planet
I thank Consuelo Jimenez Underwood, who provided slides, PowerPoints, brief informal reflections on her rebozos (shawls), sketches, and materials from other of her exhibitions. In addition, I visited her at her studio many times over the years to see the works of the *Welcome to Flower-Landia* exhibition in progress and to discuss them with her. I discussed this exhibition, and this essay, with the artist extensively on August 18 and 19, 2013. This essay was written for the exhibition catalog to be published on demand in the future by María Esther Fernández. Countless texts have gone into my understanding of traditional Indigenous cultures' understanding of the desirability of a non-human-centered balance between all life-forms on the planet, including Domingo Martínez Paredez's works from the 1950s through the 1970s, five of which are now translated into English by Ysidro Ramon Macias and collected: Macias, *Domingo Martinez Paredez Mayan Reader*; and Cajete, *Native Science*.

1 Bird migration routes and natural water use and circulation have also been disrupted, and farms bisected and properties seized. Indeed, Homeland Security's border wall program has

been implemented through national forest and wildlife refuges and private property otherwise normally protected by law. In 2005, however, Congress granted the Homeland Security manager unprecedented power to waive any existing law that stood in the way of the border wall's construction (REAL ID Act, sect. 102). To date, thirty-six environmental laws protecting national parks, endangered animals, and water have been "waived." On March 1, 2018, Mongabay reported in "Judge OKs Waiving Environmental Laws":

> On Tuesday [February 27, 2018], a federal judge in California ruled that the U.S. Department of Homeland Security did not abuse its authority in waiving dozens of environmental laws to build sections of wall along the border between the U.S. and Mexico. The ruling frees the department to waive laws for future border wall construction projects. . . . In August and September the department waived more than 30 laws, including key environmental laws, to expedite construction of three border wall projects in California. The projects include the construction of eight wall prototypes, now completed, and the replacement of two sections of existing border fencing. . . . Conservationists have issued dire warnings about the potential impact of a wall traversing the entire border. Numerous species would be negatively affected, including bison, pronghorn, bighorn sheep, bears, foxes, salamanders, and even certain bird species, they say. "President Trump insists on constructing a wall along the entire border: if he achieves making this a reality this barrier will rewrite the biological history of North America. A history that for millennia allowed animals to travel along the grasslands and forests from Mexico to Canada," Rurik List, an ecologist at Universidad Autónoma Metropoliltana-Lerma in Mexico, wrote in an issue of *Jornada Ecológica* this summer. "The future of the bison and so many other species that the two countries share is at stake at the border."

International law with Mexico has also been ignored with respect to shared water rights and responsibilities of the Rio Grande. Numerous studies report that due to various factors, the economies of both the United States and Mexico being major ones, migration had dropped before the Secure Fence Act of 2006, as it has continued to do, and that the border wall has not been notably efficient in deterring undocumented migration. What has occurred, however, is an increase in deaths at the border. *The Guardian* (US edition) article "US-Mexico Border Migrants Deaths Rose in 2017 Even as Crossing Fell, UN Says," from Agence France-Presse, reported that "last year 412 migrant deaths were recorded on either side of the border, up from 398 a year earlier, with 16 recorded so far in 2018." In February 2017 the cost of then-President Trump's border wall, estimated by him to be $12 billion and by a Senate Democratic report to be $70 billion, was estimated by Homeland Security to be $21.6 billion.

2 Consuelo Jimenez Underwood, "1995–1996 PowerPoint," notes to slide 26.

3 *Rebozos de la Frontera Dia/Noche* are in the collection of the Mexican Museum, San Francisco.

4 Jimenez Underwood, "Political Threads."

5 *Tortillas, Chiles and Other Border Things* was shown at Movimiento de Arte y Cultura Latino Americana/MACLA in San Jose, California, in 2006. *Tortilla Meets Tortilla Wall* was a 2005 performance at the US-Mexico border. Currently it is in the collection of the National Museum of Mexican Art, Chicago, Illinois.

6 The installation *Undocumented Tortilla Happening* was part of an exhibition I cocurated with Delilah Montoya, *Chicana Badgirls: Las Hociconas*, January 17–March 21, 2009, at the 516 Art Gallery in Albuquerque, New Mexico.

7 Scheid and Svenbro, *Craft of Zeus*.

8 Schaefer, *To Think with a Good Heart*; and *The Heart of the World: Elder Brother's Warning*, a 1990 BBC documentary directed by Alan Ereira at the invitation of the self-isolated Indigenous Kogi people of Columbia.

Chapter Six: Consuelo Jimenez Underwood

This essay was written for Consuelo Jimenez Underwood's solo exhibition *Welcome to Flower-Landia* in the fall of 2013. The exhibition was a culmination of a four-year collaboration with the artist to present a new body of work. Throughout those four years, we met monthly to discuss the work in progress and explore themes for the exhibition. I recently connected with Consuelo to discuss the exhibition and reflect on our time together. She mentioned that that time was a moment of great transition for her personally and professionally. She expressed that the exhibition gave her "permission" to do what she wanted, to work independently of the institution where she spent many years teaching. It was a moment of "busting through the borderline" that has since given her a new sense of freedom to create. The exhibition told that story. It exists as a personal narrative reflecting on her life from childhood along the border to adulthood within academia. The work exhibited represents the trajectory of her artistic practice through these momentous events in her life and her intimate relationship with hilo.

1 Biographical and other information on artworks comes from a series of interviews I conducted with the artist during a period of four years from 2009 to 2013.

2 The reference to Toltec understanding of consciousness is informed by the artist's interpretation and application of it in her practice.

3 Jimenez Underwood, interview with the author.

4 Jimenez Underwood created the dye by boiling yellow onion skins and salt for twelve hours.

5 Since the initial presentation of the five rebozos in her solo exhibition *Welcome to Flower-Landia* at the Triton Museum of Art, Underwood exclusively calls this work *Rebozos for Our Mothers*. Since the exhibition, the series now includes a sixth rebozo, which I also discuss (to respect the integrity and spirit in which this series has evolved).

6 Also known as Malinalli Tenépal and Doña Marina. Malintzin spoke many languages and gave birth to a son and daughter with Hernan Cortés.

7 See Alarcón, "Traduttora, Traditora"; Moraga, *Loving in the War Years*; Del Castillo, "Malintzin Tenépal."

8 Since this exhibition in 2013, Jimenez Underwood has woven six additional rebozos and many other works that have been shown in both national and international exhibitions.

Chapter Seven: Between the Lines

This essay was first published in 2017 as part of the exhibition catalog for *Mano-Made: New Expression in Craft by Latino Artists—Consuelo Jimenez Underwood*, which took place at the Craft in America Center in Los Angeles, California, from August 26, 2017, through January 20, 2018.

1 L. Pérez, *Chicana Art*, 163.

2 Gordon, *Textiles*, 279.

3 All quotes from Jimenez Underwood in this chapter are from interviews between Jimenez Underwood and the author, June 1, 2017, and September 22, 2017.

Chapter Eight: Flags, the Sacred, and a Different America

1 See Sandoval's *Methodology of the Oppressed* and "Re-entering Cyberspace," 75–93. Also useful is the concept of "artivism" that Sandoval and Latorre develop in "Chicano/a Artivism."

2 Ann Marie Leimer offered a comparative perspective of these works in her excellent talk "Quilting Knowledge, Weaving Justice: Sites of Struggle and Survival in the Works of Consuelo Jimenez Underwood" at the 2011 National Association for Chicana and Chicano Studies annual conference.

3 Some ideas from this chapter come from my book *Sacred Iconographies in Chicana Cultural Productions*.

4 See Spivak, "Can the Subaltern Speak?"

5 Cortez, "History/Whose-Story?," 51. See also chapter 3 in this volume.

6 "Frontera Flag #1, Revolution," Consuelo Jimenez Underwood website, accessed August

13, 2021, http://www.consuelojunderwood.com
/flags.html.

7 See Gloria Anzaldúa's interpretation of nepant-
 lism in "Nepantla, Creative Acts of Vision";
 "Nepantla, the Theory and Manifesto"; "Now
 Let Us Shift . . . the Path of Conocimiento . . .
 Inner Work, Public Acts"; *Borderlands/La Fron-
 tera* (1999), 99–113; and "Border Arte." Other
 useful explorations of the term are in León-
 Portilla, *Endangered Cultures*, 10–18; and Medina,
 "Nepantla Spirituality."

8 Artist's lecture, Kenyon College, March 21,
 2010.

9 Artist's lecture, Kenyon College, March 21,
 2010.

10 Consuelo Jimenez Underwood, personal com-
 munication with the author, March 15, 2011.

11 Sandoval, *Methodology of the Oppressed*, 43.

12 León, *La Llorona's Children*, 243.

13 U.S. Census Bureau, 2020 DEC Redistricting
 Data, Table ID: P2, https://data.census.gov
 /cedsci/table?q=Total%20Population&tid=
 DECENNIALPL2020.P2 (accessed on October
 7, 2021).

14 U.S. Census Bureau, 2020 DEC Redistricting
 Data, Table ID: P2, https://data.census.gov
 /cedsci/table?q=Total%20Population&tid=
 DECENNIALPL2020.P2 (accessed on October
 7, 2021).

15 León, *La Llorona's Children*, 262.

16 L. Pérez, "Rethinking Immigration with Art,"
 41.

17 Artist's lecture, Kenyon College, February 25,
 2014.

18 Consuelo Jimenez Underwood, personal com-
 munication with the author, March 21, 2010.

19 Mignolo, *Coloniality, Subaltern Knowledges*, 12.

20 Mignolo, *Coloniality, Subaltern Knowledges*, x.
 According to Mignolo, this gnosis is "conceived
 at the conflictive intersection of the knowl-
 edge produced from the perspective of modern
 colonialisms (rhetoric, philosophy, science) and
 knowledge produced from the perspective of
 the colonial modernities in Asia, Africa, and
 the Americas/Caribbean" (11).

21 Romo, "Weaving Politics," 28.

22 For a discussion of the spiritual, supernatu-
 ral symbolism of flowers in Nahua culture,

see Miguel León-Portilla's useful discussion of
Antonio Valeriano's 1556 manuscript account-
ing for the apparition of the Lady of Guada-
lupe. León-Portilla, *TonatzínGuadalupe*, 19–47.
Also see Román-Odio, "Queering the Sacred."

23 Anzaldúa, *Borderlands/La Frontera* (1999), 9.

24 Artist statement, *Consuelo Jimenez Underwood:
 Undocumented Borderlands* exhibition, California
 State University, Fresno, September 2011.

25 E. Pérez, *Decolonial Imaginary*.

26 Artist statement, *Consuelo Jimenez Underwood:
 Undocumented Borderlands* exhibition, California
 State University, Fresno, September 2011.

Chapter Nine: Garments for the Goddess of the Américas

1 Cortez, "History/Whose-Story?"

2 Cortez, "History/Whose-Story?," 36.

3 Cortez, "History/Whose-Story?," 42.

4 I provide the complete titles of the artworks
 at the first reference. Thereafter and when-
 ever possible, for ease of use, I abbreviate
 them to *Tepin*, *Chocoatl*, and *Nopal*. Addition-
 ally, curator Emily Zaiden states that wire
 has been "a signature element" in the artist's
 work since graduate school. See Zaiden,
 "Between the Lines," 22. This investigation
 treats *American Dress. Virgen de Tepin* in greater
 detail than *American Dress. Virgen de Chocoatl*
 because *Chocoatl* is held in a private collec-
 tion, is currently unavailable for viewing,
 and has received only minimal photographic
 documentation.

5 When referring to deities, I capitalize the pro-
 nouns used to describe them.

6 Consuelo Jimenez Underwood, telephone con-
 versation with the author, March 7, 2018.

7 Consuelo Jimenez Underwood, email corre-
 spondence with the author, June 12 and June 23,
 2018. The artist still has the green silk velvet
 she purchased during the late 1990s for the
 third work in the trio. At the time she was
 "thinking of playing more with the couch-
 ing structure of the dress, and other formal
 elements" in the final work, and had hoped to
 complete it sometime in the future. As I was
 writing this essay, the artist began work on
 and completed the third piece in the series and

has chosen to use a green *dupion* or *dupioni* silk (a shiny, heavily bodied fabric with horizontal slubs or raised areas of texture) in place of the original silk velvet because she found the velvet "too soft."

8 Jimenez Underwood, telephone conversation with the author, March 7, 2018. The 1995 exhibition *Fronteras de Anahuac* was shown in Madrid, Terrassa, Las Rozas, and Granada, Spain, and the artist traveled to each of these locations during that time. In 1993 she had traveled to San Ángel, D.F., México, for the exhibition *Fuerzas de la Tierra* at the Museo de San Carmen, where she observed "the great divide between Mexicans, Mexican-Americans, Euro-Mexicans and Hispanics!!" Consuelo Jimenez Underwood, email communication with the author, June 13, 2018.

9 Jimenez Underwood, telephone conversation with the author, March 7, 2018.

10 Jimenez Underwood, telephone conversation with the author, March 7, 2018.

11 Jimenez Underwood, telephone conversation with the author, March 7, 2018.

12 Jimenez Underwood, telephone conversation with the author, March 7, 2018. The concepts of fragment and fragmentation are significant when we consider that, in many cases, only remnants of precontact civilizations survive because of conquest and colonization and that identities become fragmented as a result of these processes.

13 All of the quotes in the paragraph to this point come from Jimenez Underwood, telephone conversation with the author, March 7, 2018.

14 This information is taken from Jimenez Underwood, "UNDOCUMENTED NOPAL.2525," unpublished artist statement, 2019.

15 Consuelo Jimenez Underwood, telephone conversation with the author, June 4, 2019.

16 Jimenez Underwood, telephone conversation with the author, June 4, 2019; Jimenez Underwood, "UNDOCUMENTED NOPAL.2525," unpublished artist statement, 2019.

17 Jimenez Underwood, telephone conversation with the author, March 7, 2018.

18 Blake, "Chicana Feminism," 83.

19 The mark C/S is known as a placa, a symbol or code used by artists to identify and protect their work from harm. It has various translations such as "whatever touches this returns to you," which serves as a warning to others to not damage the art or suffer the consequences, and has been popular with muralists. According to Rafaela G. Castro, "Placing a 'C/S' after one's name, especially after the name has been elaborately stylized on a wall, is meant to protect that name and by extension protect a part of that person also." Castro, "*Con Safos* (Don't Mess with This)," 62. Jimenez Underwood stated that she used C/S in "much of [her] early work" and that she was intrigued how if she divided her name, Consuelo, in half, it would "not only mean 'grounded' (with the ground-con suelo) but also belong in solidarity with my surrounding cohorts C/S." She also used the signature "ConSuelo" as another means to indicate and play with both C/S and her name. Consuelo Jimenez Underwood, email correspondence with the author, August 4, 2018.

20 The term *couching* refers to several embroidery techniques used to create texture, depth, and visual interest on a textile's surface. Typically, a length of thick thread (or several strands of thread) is placed on fabric and stitched at various intervals with a lighter weight thread, sometimes in a contrasting color. Couching is also a common method of attaching a length of beads to the surface of a garment. See Carroll, "Couching," 79, 85–90. Ruching and smocking are related methods that produce similar gathered results. The measurements of the barbed wire are approximate and vary slightly.

21 The buttons I refer to in *C. Jane Run* are found on a fragment of a pair of pants, silkscreened with the caution sign and integrated into the work. The information on the use of buttons in *Diaspora* came from a PowerPoint presentation analyzing the artist's art production during 2000–2004 provided by Laura E. Pérez and Alyssa Erickson.

22 Consuelo Jimenez Underwood, email correspondence with the author, June 12, 2018.

23 Consuelo Jimenez Underwood, email correspondence with the author, June 11, 2018. A running or straight stitch is the fundamental

hand-sewing stitch used principally for joining fabric together. In embroidery, its uses are multiple, including outlining and defining forms. See Carroll, "Straight Stitch," 24.

24 The artist used the X in *Sacred Jump* (1994) and several other works. For her explanation of the symbolic function of this image in *Tepin*, see Román-Odio, "Flags, the Sacred, and a Different America in Consuelo Jimenez Underwood's Fiber Art" in this volume.

25 Jimenez Underwood, email correspondence with the author, June 11, 2018.

26 Jimenez Underwood, email correspondence with the author, June 11, 2018.

27 Jimenez Underwood, email correspondence with the author, June 11, 2018.

28 Román-Odio, this volume.

29 The striped edging fabric on *Nopal* is quite similar to the beige-, brown-, and white-striped edging found on all four sides of *Virgen de los Caminos* (1994) (figure 15), although the stripes on *Nopal* are smaller in scale.

30 A seeding or speckling stitch takes its name from the tiny, somewhat haphazardly placed stitches that appear on the surface of the fabric being embroidered. See Gostelow, "Blackwork," 37.

31 Jimenez Underwood, telephone conversation with the author, June 4, 2019.

32 Jimenez Underwood, telephone conversation with the author, June 4, 2019.

33 It is important to note that cacao, or chocolate, was reserved for the nobility in precontact civilizations and that its form varied considerably from our contemporary versions. Chocoatl was combined with chili, had a thick consistency, and, among the Maya, was consumed from ceramic vessels glyphically marked for that purpose.

34 Jimenez Underwood, telephone conversation with the author, March 7, 2018.

35 Clara Román-Odio details Jimenez Underwood's intention in *Tepin* and places it squarely within current theoretical frameworks of the decolonial and postcolonial. See Román-Odio, this volume.

36 Jimenez Underwood, telephone conversation with the author, March 7, 2018.

37 In this instance, our planet can be understood as Mother Earth, as an above-human entity.

38 Román-Odio, this volume.

39 Laura E. Pérez has provided an in-depth analysis of Chicanx artists who have engaged with the dress form, such as Diane Gamboa, Ester Hernández, Yolanda López, and Amalia Mesa-Bains. Pérez frames her discussion of the works, largely produced during the 1980s and 1990s, with the understanding of body as social text and discusses how the body and the garments chosen to adorn it have a mutual relationship in "inscribing" cultural and racialized identities. See L. Pérez, "Body, Dress."

40 See Annie Lopez, "Artist Statement: An Altered Point of View." Cyanotype is an early and inexpensive photographic print process that uses only two chemical substances, does not require a camera or a darkroom, and results in a cobalt blue or cyan image produced by contact printing. For recent exhibitions of this work, see Burns and Wilson, *Cyanotypes;* and Sasse, *Dress Matters*. Also see de Borchgrave and Brown, *Papiers a la mode*; Stoeltie, Stoeltie, and de Borchgrave, *Paper Illusions*; and D'Alessandro and de Borchgrave, *Pulp Fashion*.

41 By "apply the lens of the spiritual" I mean bringing to bear knowledges, theories, and scholarly perspectives from the academic fields of history of religion and anthropology of religion, as well as the lived experiences of Native and Indigenous peoples and their bodies of knowledge, when considering works of visual art. Recent examples of the latter are Martinez-Cruz, *Women and Knowledge in Mesoamerica*; and P. Gonzales, *Red Medicine*, among others.

42 Here I am building on the work of Inga Clendinnen; see her "Ways to the Sacred." Jeanette Favrot Peterson compares Indigenous and Catholic practices of dressing sacred figures in "Creating the Virgin of Guadalupe," 582–83.

43 According to Buddhist belief, a bodhisattva is an enlightened being, one who has achieved Buddhahood but who has chosen to remain in the earthly realm to alleviate the suffering of others. In this essay, I use the Japanese term for this figure. Jizō originated in India with the Sanskrit name Ksitigarbha Bodhisattva

and soon gained popularity throughout the Buddhist world; therefore, the figure will have other names depending on the country of practice. For more information on bodhisattvas and Jizō, see Leighton, *Faces of Compassion*.

44 Leighton, *Faces of Compassion*, 212, 217.

45 Leighton, *Faces of Compassion*, 216.

46 Leighton, *Faces of Compassion*, 219–20.

47 The Indigenous worldviews reflected in Jimenez Underwood's art have been shaped by the Huichol (Wixárika) heritage of her father, Ismael Jimenez Aguirre (1923–2009) and influenced by the Yaqui (Yoeme) ceremonial practice of her husband, Marcos Underwood, and her extended family. Weaving and embroidery are two vital art and spiritual traditions from Wixárika culture infused with symbolic meanings that originate from the creation story where Our Great-Grandmother Takutsi made the world turn with Her spindle. Traditional Wixárika clothing is heavily embroidered using cross-stitch and bargello (long, straight stitches that create geometric patterns) techniques and often incorporates images of the deer-maize-peyote complex, which is central to Wixárika ideology. In "The Yaqui," Trudy Griffin-Pierce states that Yoeme "believe that they are entrusted with maintaining the well-being of the earth, including its animals, plants, and landscape" (206), a point of view that is clearly present in Jimenez Underwood's work. Native Yoeme spiritual beliefs and practices fused with Catholic ones in the seventeenth century, when Yoeme invited Jesuits into their communities during the Mission Period (1617–1767). One blending, important for this study, is that of the Catholic Virgin Mary and the Yoeme's female deity Our Mother, understood as Mother Earth who represents the "bounty of nature" and is "associated with trees, flowers, and the earth" (Griffin-Pierce, "The Yaqui," 223). For further information on the Wixárika, see Schaefer, *Huichol Women, Weavers, and Shamans*; Powell and Grady, *Huichol Art and Culture*; Schaefer and Furst, *People of the Peyote*; and Berrin, *Art of the Huichol Indians*. For further information on the Yoeme, see Griffin-Pierce, "The Yaqui";

Evers and Molina, *Yaqui Deer Songs Maso Bwikam*; and Spicer, *The Yaquis*.

48 This representation of the Christ Child originated in the Spanish city of Atocha and also has significant connection to Plateros, Zacatecas, México, and Chimayo. The stories surrounding this figure arose in the thirteenth century during an ongoing conflict between Muslims and Catholics on the Spanish Iberian Peninsula. Catholic prisoners held in Muslim prisons were allowed to receive care and sustenance from family members, but only children under the age of twelve were allowed, in E. Boyd's words, "to enter the prison on errands of mercy" ("El Santo Niño de Atocha," 91). According to this tradition, soon a young child dressed as a pilgrim began appearing at the prison at night with a basket of food and a gourd of water attached to a walking staff. The child's provisions never ran out, no matter how many prisoners were fed. For more information about El Santo Niño de Atocha and the shrine associated with him in New Mexico, see Griffith, "El Santo Niño de Atocha," 1; Boyd, "El Santo Niño de Atocha," 90–94; and Spanish Colonial Arts Society, *El Santuario de Chimayo*, 20–22.

49 For information about the figure and history of La Conquistadora and Her second representation in Santa Fe's Rosario Chapel, see Leimer, "La Conquistadora"; F. Chávez, *La Conquistadora*; Grimes, *Symbol and Conquest*. For scholarly treatment of the practices of clothing related to the Virgin of Alcala in Andalusia, Spain, see Whitehead, "Religious Objects and Performance." For those practices directly associated with La Conquistadora in Santa Fe, New Mexico, see Garza, "Fabric of Devotion."

50 Garza, "Fabric of Devotion," 10. Sacristanas typically serve a two-year term of office.

51 Garza, "Fabric of Devotion," 74.

52 Flores-Turney, "Dressing La Conquistadora with Care and Devotion," 31.

53 Garza, "Fabric of Devotion," 124.

54 Poet and novelist Ana Castillo uses the term "Goddess of the Americas" in a collection of writings that position the Virgen de Guadalupe as warrior, as sex goddess, as undocumented,

and as the Mexica Earth and Mother Goddess Tonantzin. I use the phrase in this study to indicate the artist's view of Coatlicue as the predecessor of Guadalupe. See Castillo, *Goddess of the Americas.*

55 I use the term *Mexica* to refer to one of the seven ethnic groups that began to inhabit the Central Valley of Mexico during the twelfth century. The Mexica arrived on the shores of Lake Texcoco in 1318 CE and founded their new capital, Tenochtitlan (the site of present-day México City), in 1325 CE. The term *Aztec* is often thought to have been first introduced by the German explorer and geographer Alexander von Humboldt in 1810, who used it to designate the members of the Triple Alliance, three city-states that formed the Mexica imperial ruling elite. Historian William Prescott later popularized the word in his *The History of the Conquest of Mexico*, originally published in 1843, where he conflated the terms *Aztec* and *Mexica* to indicate those peoples who spoke the Indigenous language Nahuatl. Other sources credit an earlier use of the term *Aztec* by Jesuit friar Francisco Javier Clavijero Echegarary in his 1780 *La Historia Antigua de México.* Still others argue that Fernando Alvarado Tezozómoc, the grandson of the next-to-last Mexica ruler, Motecuhzoma Xocoyotzin, provides one of the earliest uses of the term in his *Crónica mexicana*, published around 1598, sixty-seven years after contact. I use the word *Mexica* because this is the name the people called themselves. They are also known as the Nahua-Mexica or, more narrowly, the Colhua-Mexica.

56 Mary Ellen Miller and Karl Taube note the meaning as "Snakes-Her-Skirt," whereas Taube and Eduardo Matos Moctezuma mention the meaning "She of the Serpent Skirt." Miller and Taube, "Coatlicue," 64; Taube, "Aztec Mythology," 45; Matos Moctezuma, *Great Temple of the Aztecs*, 26.

57 Coupal, "Exhibiting Mexicanidad," 171.

58 See de León y Gama, *Descripción histórica y cronológica de las dos piedras que con ocasión del nuevo empedrado que se está formando en la plaza principal de México* (1792 and 1832).

59 Matos Moctezuma, *Great Temple of the Aztecs*, 25,

28; Navarrette, "Ruins of the State," 41; Matos Moctezuma, *Estudios mexicas*, 11–12.

60 Aguilar-Moreno, *Handbook to Life in the Aztec World*, 25.

61 Matos Moctezuma, *Great Temple of the Aztecs*, 24.

62 Locke, "Exhibitions and Collectors of Pre-Hispanic Mexican Artefacts in Britain," 83.

63 Matos Moctezuma and Solís Olguín, "Introduction," 20; regarding the *Ancient Mexico* exhibition, see also note 12 on page 88 of Matos Moctezuma and Solís Olguín, "Introduction." See also Locke, "Exhibitions and Collectors of Pre-Hispanic Mexican Artefacts in Britain," 83; Boone, "Templo Mayor Research, 1521–1978," 25; Contreras, "From La Malinche to Coatlicue," 117–18.

64 León-Portilla, *Bernardino de Sahagún.*

65 It would take Charles E. Dibble and Arthur J. O. Anderson thirty years to translate and annotate the *Florentine Codex* from Nahuatl and Spanish to English.

66 Manuel Aguilar-Moreno, *Handbook to Life in the Aztec World*, 26. For a more complete iteration of colonial accounts of the Mexica, see the chapter titled "Main Historical Primary Sources about the Aztec" in that volume.

67 Aguilar-Moreno, *Handbook to Life in the Aztec World*, 142. For an important essay on Coatepec, see Schele and Guernsey Kappelman, "What the Heck's Coatepec?"

68 Aguilar-Moreno, *Handbook to Life in the Aztec World*, 142. For narratives of Coatlicue, see Taube, "Aztec Mythology"; Coe and Koontz, *Mexico from the Olmecs to the Aztecs*, 216–21; Almere Read and González, "Coatlicue."

69 Almere Read and González, "Coatlicue," 150.

70 de Sahagún, *Florentine Codex*, volume 3, *The Origin of the Gods*, 2. It is productive to consider the cleaning act Coatlicue performs in a literal and a figurative sense. Literally She is physically removing debris from the temple, but if we think about the ritual termed *limpia*, or cleaning, enacted by contemporary healers (curanderas and curanderos), it provides a larger context for the story of Coatlicue in a figurative sense. For a recent text on Mesoamerican healers and healing practices from the viewpoint

of medical anthropology, see Huber and Sand-strom, *Mesoamerican Healers*. For an ethno-graphic account of cleaning rituals performed by Purépecha and Totonac peoples today, see Dow, "Central and North Mexican Shamans."

71 Mexica society was highly regulated and mili-tarized, with a profound moral code and strict parameters regarding sexual expression. Davíd Carrasco states, "A sexual transgression injured not just the person committing the immoral act but the parents, siblings, and friends of the trespasser as well. Sexual misconduct grew into a social contagion, a spiritual-psychological virus, a noxious force that grew and spread through the family, neighborhood, and friends." Carrasco, *The Aztecs*, 87.

72 de Sahagún, *Florentine Codex*, vol. 3, 2.

73 Miller and Taube state that Huitzilopochtli is "born at the moment of her death." Miller and Taube, "Coatlicue," 64. Huitzilopochtli, the god of the sun and of war, is variably known as Hummingbird of the South and Hummingbird on the Left and is pictured with a humming-bird helmet or headdress. He can also be under-stood as Blue Tezcatlipoca, one of the four sons of the ancestral couple Ometecuhtli and Omecihuatl, male and female aspects of the god of duality, Ometeotl. See Miller and Taube, "Ometeotl" and "Huitzilopochtli."

74 The term *xiuhcoatl* is also translated as "tur-quoise serpent," which references the color associated with Huitzilopochtli in his role as Blue Tezcatlipoca.

75 de Sahagún, *Florentine Codex*, vol. 3, 4.

76 Miller and Taube, "Coatlicue," 64.

77 Matos Moctezuma, *Great Temple of the Aztecs*, 26.

78 Aguilar-Moreno, *Handbook to Life in the Aztec World*, 190.

79 Cecelia F. Klein cites the earlier work of Justino Fernández, who establishes that "the snakes that form her missing limbs imply that she has also been dismembered." J. Fernández, "Coat-licue," 134. Klein, "A New Interpretation of the Aztec Statue Called Coatlicue," 231.

80 Aguilar-Moreno, *Handbook to Life in the Aztec World*, 190; and M. Miller, *The Art of Mesoamer-ica From Olmec to Aztec*, 255.

81 In Mesoamerican art, the maw is understood as a portal between worlds and is often associated with the mouths of caves.

82 Aguilar-Moreno, *Handbook to Life in the Aztec World*, 148.

83 Solís Olguín, "Art at the Time of the Aztecs," 60.

84 In the 1970s, Eduardo Matos Moctezuma led the archaeological excavations of the Templo Mayor for four years. He worked with a team of archaeologists, artists, anthropologists to uncover and document the findings, which ultimately were held in a museum dedicated solely to the Great Temple. See Matos Moc-tezuma and Solís Olguín, 2002, 243; Aguilar-Moreno, 2006, 191.

85 In 2007, Davíd Carrasco and Scott Sessions published an extensively researched text, titled *Cave, City, and Eagle's Nest: An Interpretive Journey through the Mapa de Cuauhtinchan No. 2*, that brought new insights to the stories of emergence of the Central Mexican Nahuatl-speaking groups from Chicomoztoc and the concept of Aztlan. Chicomoztoc has been previously understood as a seven-lobed cave from which the Mexica and others emerged, with the island of Aztlan understood as the homeland the Nahuatl-speaking peoples left to found their new capital city Tenochtitlan. See Carrasco and Sessions, *Cave, City, and Eagle's Nest*.

86 Klein, "A New Interpretation of the Aztec Statue Called Coatlicue," 233.

87 For a facsimile of this text, edited by Alec Christensen, see Foundation for the Advance-ment of Mesoamerican Studies (FAMSI), Foun-dation Research Department, "History of the Mexicans as Told by Their Paintings," accessed July 10, 2018, http://www.famsi.org/research/christensen/pinturas/index.html. Also see García Icazbalceta, ed., "*Historia de los mexicanos por sus pinturas*"; and Boone, "The Coatlicues at the Templo Mayor."

88 Taube, "Aztec Mythology."

89 Bierhorst, trans., *History and Mythology of the Aztecs*.

90 Klein, "A New Interpretation of the Aztec Statue Called Coatlicue," 233.

91 Klein, "A New Interpretation of the Aztec Statue Called Coatlicue," 244, 235.

92 Klein, "A New Interpretation of the Aztec Statue Called Coatlicue," 235.

93 Berdan and Rieff Anawalt, *The Essential Codex Mendoza*.

94 Coe and Coe, *The True History of Chocolate*.

95 Coe and Coe, *The True History of Chocolate*, 101. See the FAMSI website, where the *Codex Féjérváry-Mayer* is presented in facsimile at http://www.famsi.org/research/graz/fejervary_mayer/index.html.

96 Caso, *El Teocalli de la Guerra Sagrada*, 56–57, cited in Klein, "A New Interpretation of the Aztec Statue Called Coatlicue," 237.

97 Klein, "A New Interpretation of the Aztec Statue Called Coatlicue," 237, 239.

98 Jimenez Underwood understands Coatlicue within *Nopal* as "represent[ing] the world as we know it. All that can be thought, measured and remembered." Jimenez Underwood, telephone conversation with the author, June 4, 2019.

99 This essay benefited greatly from several engaged conversations with Laura E. Pérez during 2017 and 2018; it was Pérez who first articulated the idea of pain and pleasure associated with chili and chocolate depicted in these works.

Chapter Ten: Space, Place, and Belonging in *Borderlines*

I am grateful to Consuelo Jimenez Underwood for her art and her time. This essay is dedicated to her brilliance during these dark times. I also acknowledge the research assistance of Jeffrey O'Brien (University of Minnesota class of 2019) and the wisdom, feminist editorial praxis, and friendship of the anthology's editors.

1 Anzaldúa, *Borderlands/La Frontera* (1987).

2 Grandin, "Militarization of the Southern Border."

3 J. González, *Subject to Display*, 7.

4 Of the works in this ongoing series, I discuss eight. Missing from this analysis are the works produced after late 2017 and the first work, *Border X-ings* (2009), from the exhibition *Looking Back, Looking Ahead* at the Euphrat Museum of Art in Cupertino, California, which is a sculpture of wire.

5 E. Pérez, *Decolonial Imaginary*.

6 I follow the argument that settler colonialism is a "structure not an event." See Wolfe, *Settler Colonialism and the Transformation of Anthropology*, 2–3. Therefore, my use of *decolonial* recognizes the ways in which contemporary experience is deeply informed by coloniality, even after colonial regimes have ended. Thus, critical consciousness that resists, interrogates, and attempts to dismantle coloniality is also embedded in it. My goal here is to illuminate how the "decolonial imaginary" is visualized. E. Pérez, *Decolonial Imaginary*.

7 Broyles-González, "Indianizing Catholicism"; L. Pérez, *Chicana Art*.

8 Harley, "Maps, Knowledge, and Power"; Mignolo, "Putting the Americas on the Map"; Jacob, *Sovereign Map*.

9 Craib, *Cartographic Mexico*, 6. See also Padrón, "Mapping Plus Ultra," 39.

10 Warhus, *Another America*, 3.

11 Jacob, *Sovereign Map*, caption for figure 23, n.p.

12 Craib, *Cartographic Mexico*, 33.

13 Mignolo, "Putting the Americas on the Map," 222, 223; Harley and Woodward, "Concluding Remarks," 506–7.

14 Harvey, "Local and Regional Cartography in Medieval Europe," 473. Ptolemaic maps of the "known world" provided hegemonic and technical instructions for mapmaking, as evidenced by the toponym *terra incognita*, which was given to those places unknown or insignificant to Europeans.

15 Mirzoeff, *Right to Look*, 58. See also Harley, "Maps, Knowledge, and Power."

16 Harley, "Deconstructing the Map," n.p.

17 Harley and Woodward, "Concluding Remarks," 507. See also Harley, "Deconstructing the Map."

18 DiAngelo, "White Fragility," 54, 55.

19 Robin DiAngelo argues that these fears are part of the state of "white fragility," an insulated condition that allows whites to avoid challenging their racial privilege. DiAngelo, "White Fragility."

20 The US strategy of mitigating movement across the border includes the installation of high-powered illumination equipment, including spotlights, which supports twenty-four-hour surveillance at the border fence. Van Schoik, "Conservation Biology," 38. See also J. Smith, "Impact of the U.S.-Mexico Border Fence on Wetlands is Mixed."

21 Van Schoik, "Conservation Biology," 36.

22 Silko, *Almanac of the Dead*, quoted in Hartley, "Chican@ Indigeneity, the Nation-State, and Colonialist Identity Formations," 55.

23 The Treaty of Guadalupe Hidalgo ended the US-Mexican War (1846–48) and ceded nearly half of Mexico's territory to the United States. Through the Gadsden Purchase the United States acquired territory that included present-day southern Arizona and southwestern New Mexico, which allowed for a better route for the Southern Pacific line of the transcontinental railroad.

24 US Border Patrol states that between the fiscal years 1998 and 2013, 6,029 deceased migrants were found on the US side of the border with Mexico. The remains of at least 300 migrants have been recovered each year since 2000. See Brian and Laczko, *Fatal Journeys*, 54.

25 Tejada, *Celia Alvarez Muñoz*, 21.

26 Rowe, "Repairing Calif. Border Fence."

27 Rowe, "Repairing Calif. Border Fence." These costs have skyrocketed. The Trump administration began construction along 722 miles of the southern border, adding to the existing nearly 700 miles of barrier. The Washington Office of Latin America estimates that Trump's wall will cost $25 million per mile. Isacson, "23 Amazing Things You Can Do for the Cost of a Few Miles of Border Wall."

28 "Remarks by Secretary of Homeland Security Jeh Johnson."

29 Tamez, "Space, Position and Imperialism."

30 Tamez, "Space, Position and Imperialism," 112.

31 Tamez, "Space, Position and Imperialism," 113.

32 Tamez, "Space, Position and Imperialism," 115, 116.

33 Peluso, "Whose Woods Are These?," 384. Whereas Peluso discusses countermapping as a concrete and alternative documentation of space and people's relationship to the land, it is also a useful tool for exploring the art of Consuelo Jimenez Underwood.

34 Actor, director, and playwright Luis Valdez brought attention to this Maya principle in his 1973 poem, "Pensamiento Serpentino." The *Combined Dictionary—Concordance of the Yucatecan Mayan Languages* (1998) by David Bolles confirms this translation. For a comprehensive translation, see L. Pérez, "Enrique Dussel's *Etica de la liberación*, U. S. Women of Color Decolonizing Practices, and Coalitionary Practices amidst Difference," 124–25.

35 Kwon, "One Place after Another," 110, 92; J. González, *Subject to Display*, 13. For discussion of the site-sensitive work of Glenn Ligon, see Copeland, "Glenn Ligon and Other Runaway Subjects"; and for discussion of installations by Amalia Mesa-Bains, James Luna, Fred Wilson, and Renée Green, see J. González, *Subject to Display*.

36 Chela Sandoval defines "oppositional consciousness" as a critical awareness and strategy for action that intertwines ways of thinking to respond to inequality and injustice. See Sandoval, *Methodology of the Oppressed*. See also Davalos, "The Oppositional Consciousness of Yolanda M. López."

37 Unless otherwise noted, information about the artist's biography and her vision of her work comes from an interview of Consuelo Jimenez Underwood by the author on May 22, 2016 (hereafter cited as "interview of the artist, 2016"). Jimenez Underwood unknowingly paraphrased Harley's discussion of maps. See Harley, "Deconstructing the Map."

38 Interview of the artist, 2016.

39 Kwon, "One Place after Another."

40 Kwon, "One Place after Another," 96.

41 Unlike murals, the installations are intentionally ephemeral, but their impermanence is less significant in the claim that the installations exceed the definition of a mural. It is the three-dimensional aspect of the works that push beyond the mural.

42 Interview of the artist, 2016.

43 Avila, "The Folklore of the Freeway."

44 Artist statement, *Undocumented Border Flowers*,

Consuelo Jimenez Underwood website, http://www.consuelojunderwood.com/undocumented-border-flowers.html.

45 Castellanos, "Rewriting the Mexican Immigrant Narrative."

46 Rivera-Salgado, "From Hometown Clubs to Transnational Social Movement," 121.

47 Interview of the artist, 2016.

48 Interview of the artist, 2016. In this interview, Jimenez Underwood used the phrase "sacred and profane" to expose and interrogate the normative Eurocentric view that presumes a separation between the spiritual world and daily human experience. Certainly, she challenges this binary through the installations.

49 My analysis is based on the artist's poetic description of her work; artist statement, "Undocumented Border X-ings. Xewa (Flower) Time," Consuelo Jimenez Underwood website, http://www.consuelojunderwood.com/undocumented-border-x-ings-xewa-time.html.

50 Interview of the artist, 2016.

51 Castellanos, "Rewriting the Mexican Immigrant Narrative," 221.

52 Throughout her career, Consuelo Jimenez Underwood has played with phantasmagoria, using color saturation, such as black-on-black or white-on-white thread, to camouflage or hide figures, lines, and compositions. I posit that the ghostly qualities place her work in the spiritual and the cosmological realms, as noted by Laura E. Pérez. In this case, the installations echo her inflected notion of interconnectedness. The seen and unseen are simultaneously present. L. Pérez, *Chicana Art* and *Eros Ideologies*.

53 Castellanos, "Rewriting the Mexican Immigrant Narrative," 220.

54 Artist statement, "Undocumented Border X-ings. Xewa (Flower) Time."

55 Castellanos, "Rewriting the Mexican Immigrant Narrative."

56 Artist statement, "Undocumented Border X-ings. Xewa (Flower) Time."

57 I avoid a developmental analysis because I do not want to reinforce the current fascination with abstract art over political realism or the so-called universal idiom of abstraction. In the series the artist uses a variety of aesthetic

strategies. More importantly, her work does not chronologically allow for a simple interpretation. The work that is most realistic in style appears in the middle of the series, not at the beginning.

58 In *Mountain Mama Borderline Blues*, the artist relies on black for the first time in the series, a possible reference to Black Rock Desert, a landmark for the Paiute, an Indigenous people of the region, or the Sierra Nevada Range, as noted in a review by Josie Glassberg. Glassberg, "Mother Lands."

59 When she initiated the series, Jimenez Underwood learned from a newspaper article about the exact locations of the border fence in California, Arizona, and Texas. The series continues to reference that map. By 2014, Homeland Security boasted that it had constructed more than seven hundred miles of fence. See "Remarks by Secretary of Homeland Security Jeh Johnson."

60 Consuelo Jimenez Underwood, quoted in Rachel Waldron, "Undocumented Borderlands Featured in the Conley Art Gallery."

61 "Remarks by Secretary of Homeland Security Jeh Johnson."

62 "Remarks by Secretary of Homeland Security Jeh Johnson."

63 Interview of the artist, 2016.

64 Interview of the artist, 2016.

65 Interview of the artist, 2016.

66 Davalos, *Chicana/o Remix*.

67 L. Pérez, *Eros Ideologies*. For Pérez's discussion of this intellectual lineage of decolonial thought, see the preface (13–14 and 16). For a comprehensive account of the various intellectual lineages of decolonialization across the globe, see L. Pérez, "Enrique Dussel's *Etica de la liberación*."

68 E. Pérez, *Decolonial Imaginary*, xvi.

69 E. Pérez, *Decolonial Imaginary*, 6.

70 Lugones, "Heterosexualism and the Colonial/Modern Gender System," 191. See also Lugones, "Toward a Decolonial Feminism," 745.

71 Sandoval, "Dissident Globalizations, Emancipatory Methods, Social-Erotics," 25.

72 Peluso also argues that Indonesian counter-maps are "transformative." See Peluso, "Whose Woods Are These?," 400.

73 Lugones, "Toward a Decolonial Feminism," 754.

Chapter Eleven: Decolonizing Aesthetics in Mexican and Xicana Fiber Art

All Spanish-to-English translations are mine unless otherwise noted. The first epigraph translates to "Weavings are the books the colony was not able to burn." Sandra Cisneros (the second epigraph) is quoted in Shea, "Truth, Lies, and Memory," 35

1 Throughout this essay, I use *Chicana* or *Chicanx* as a general term to refer to people of Mexican Indigenous or mestizx descent, or both, who claim a politicized identity that traces its roots to the activism of the US Chicanx movement of the 1960s and '70s. I use *Chicana* to refer specifically to artists who identify as women and whom I understand as contributing to a genealogy of Chicana/Xicana feminist art and politics. When speaking broadly about Chicanx, I use *Chicanx* as a gender-inclusive, non–gender binary term. I adopt the terms *Xicana* or *Xicanx* to reflect artists' own terms of self-identification and to name artists and cultural texts that articulate an Indigenous identity and worldview. For instance, although she does not use the term to name herself, I use *Xicana* to signal Consuelo Jimenez Underwood's background as an Indigenous woman in diaspora and the Indigenous perspective that informs much of her artwork. For a definition of *Xicana* see Cherríe L. Moraga, "La Red Xicana Indígena."

2 Angelina Aspuac, a Maya-Kaqchikel weaver, activist, and lawyer who was legal coordinator for AFEDES, makes clear that the weavers' claims that their weavings are knowledge is a direct challenge to colonial dispossession. She asserts that "textiles are part of the territories. To protect water and land is to protect our textile art . . . they are our knowledge. Maya dispossession does not happen only through territory, it happens also through the dispossession of our ancestral knowledge." See Picq, "Maya Weavers Propose a Collective Intellectual Property Law."

3 *Abya Yala* is the term that the Indigenous Kuna or Guna peoples of Panama have for the Americas. Pan-Indigenous groups have taken up this

term as a decolonial gesture that refuses European namings, as have decolonial feminists in Abya Yala who foreground Indigenous concepts and languages. See Espinosa Miñoso, Gómez Correal, and Ochoa Muñoz, *Tejiendo de otro modo*.

4 *Craft in America*, "Threads" episode, directed by Carol Sauvion, Public Broadcasting System, aired May 11, 2012, on PBS, http://www.craftin america.org/episodes/threads/.

5 *Craft in America*, "Threads" episode, dir. Carol Sauvion.

6 John Hood, a graphic artist for Caltrans who is a Navajo and a Vietnam War veteran, is credited with developing this image as part of his duties. The freeway signs were first posted in 1990 in San Diego. See Berestein, "Highway Safety Sign Becomes Running Story on Immigration."

7 *Craft in America*, "Threads" episode, dir. Carol Sauvion.

8 The notion of a balanced duality is a central idea in Mesoamerican cosmovisions. Rather than understanding light/dark, life/death, masculine/feminine, and so on as binary opposing dualities, the Indigenous conception of duality is based on a principle of complementary opposition. It is not the either-or nor the binary duality of Western modernity that supports hierarchical thinking. See López Austin, *Cuerpo humano e ideología*, 59.

9 Women made most of this armor, like they made most cotton textiles, during the pre-contact period. Margaret A. Villanueva finds that "shortly after reaching central Mexico, the Spaniards discovered that the indigenous cotton armor, heavily quilted vests and long tunics, afforded more protection for warfare in the Americas than their own bulky armor." Villanueva, "From Calpixqui to Corregidor," 23.

10 According to Justyna Olko, in the *Anales de Cuauhtitlan* codex the metaphorical expression *in chimalli, in tlahuiztli* refers to the shields (chimalli) and feather-ornamented body suits (tlahuiztli) used by Nahua warriors as part of their war costumes. The phrase *in chimalli, in tlahuiztli* could also refer to an entire war outfit that included shields, bodysuits, feathered

insignia, and the protective tunics made of quilted cotton (ichcahuipilli) that warriors wore under their bodysuits. Olko, *Insignia of Rank in the Nahua World*, 109–11.

11 Anzaldúa, *Borderlands/La Frontera* (1987), 2–3.

12 Saldaña-Portillo, *Indian Given*. According to Saldaña-Portillo, the Spanish and British had differing modes of racializing Indigenous populations as part of their empire-building (and later nation-building) projects. *Racial geographies* is a term she uses to distinguish the different processes of racialization that Indigenous populations endured under Spanish and British colonialism, and later as part of US and Mexican nation building.

13 Parker and Pollock, *Old Mistresses*, 68.

14 Auther, "Classification and Its Consequences," 9.

15 Contemporary fashion designers who plagiarize Indigenous textile designs are numerous and span North to South America. Examples in Mexico include French designer Isabel Marant's appropriation of a traditional huipil from the Mixe community of Santa Maria Tlahuitoltepec in Oaxaca, and the Spanish fashion company Intropia who plagiarized a huipil from the Chinanteco community, also from Oaxaca. In both cases, weavers fought back by initiating lawsuits and demanding legal protection for their work. See Nayeli Roldán, "La falta de registro de derechos de autor de bordados indígenas permite que grandes marcas plagien sus diseños," *Animal Politico*, February 26, 2018, https://www.animalpolitico .com/2018/02/plagio-ropa-indigenas-marcas/.

16 I use the term *upper/middle class* broadly to indicate the culturally dominant classes (who are economically and socially privileged in relation to the poor or working classes). In the United States and Europe, it has been white, upper/middle-class men who have historically had the most access and representation within the modern art world and public museum—as artists, audience, or patrons. For a discussion of the norms established for subsequent art institutions by early public museums in Europe, see Paul, *The First Modern Museums of Art*.

17 L. Pérez, *Chicana Art*, 7. In *Chicana Art*, Pérez introduces a framework for understanding decolonizing aesthetics and spirituality in Chicana art. Echoing Pérez's critiques of Eurocentric definitions of art and the decolonizing role of artists, Walter Mignolo and the Decolonial AestheTics/AestheSis Working Group likewise argue that decolonial aesthetics "asks why Western aesthetic categories like 'beauty' or 'representation' have come to dominate all discussion of art and its value, and how those categories organize the way we think of ourselves and others . . . decolonial art (or literature, architecture, and so on) enacts these critiques . . . to expose the contradictions of coloniality. Its goal, then, is not to produce feelings of beauty or sublimity, but ones of sadness, indignation, repentance, hope, and determination to change things in the future." See Mignolo, "About: Decolonial AestheTics/AestheSis."

18 L. Pérez, *Chicana Art*, 15.

19 Chicana cultural theorists define "third space" as the space that exists within and between established borders, categories, and boundaries. Third space can refer to the undefined spaces that exist between bounded definitions and categories. In *The Decolonial Imaginary: Writing Chicanas into History* (1999), Emma Pérez refers to third space as the interstitial gaps that reveal what is unspoken, unheard, and unseen within dominant narratives of History. Pérez also uses the term *third space feminism* to talk about the ways women of color construct spaces of critical, oppositional consciousness that they must negotiate from within dominant structures. Here, I find another relevant application of the term *third space* to describe Jimenez Underwood's and Santos's art practice. As university-trained art practitioners, both artists are knowledgeable about dominant and nondominant formal and conceptual systems, allowing them to weave strands from multiple influences together into their own powerful, oppositional creations. For additional discussions of "third space," also referred to as the borderlands, see Anzaldúa, *Borderlands/La Frontera* (1987). Chela Sandoval likewise theorizes third space feminism in *Methodology of the Oppressed*.

20 According to Guisela Latorre, Border Art emerged in the 1980s, influenced by the work of Gloria Anzaldúa and the Border Arts Workshop. It is "defined by its subject matter and content, which often focuses on the social, political and cultural realities of life in the United States-Mexico region." Border artists deconstruct the border—they show its porosity and point to its colonial construction. Although Consuelo Jimenez Underwood does not consider herself a participant in the Border Art movement, her art has much thematic and political overlap, and it contributes to the dialogue that other Border artists have initiated. See Latorre, "Border Art."

21 Cortez, "History/Whose-Story?," 22.

22 The term *intersectionality* was coined by black feminist legal scholar Kimberlé Crenshaw in 1989, though it emerges from a much older political tradition of black feminist and woman of color thought that calls attention to the compounded forms of discrimination that women of color experience. An intersectional analysis recognizes that a singular lens (e.g., only race or only gender) is insufficient to address the experiences of women of color who face multiple oppressions. In their art, Consuelo Jimenez Underwood and Georgina Santos critique the impacts of racialized imperialism and capitalism along with racism and misogyny on Indigenous and mestiza women, which thus aligns them with woman of color feminist thought rather than with a mainstream feminism that focuses on sexism alone as the root of women's oppression.

23 Tracing the roots of decolonizing politics in woman of color feminism, Laura E. Pérez finds that "the feminist critiques of patriarchal racialized imperialism and capitalism are basic observations in Chicana and African American feminist thought dating at least to the late 1960s and throughout the 1970s. The imbricated, mutually constitutive and simultaneous functions of these oppressions and their root in the colonial encounter have been analyzed in essays originally published throughout the late 1960s and 1970s by Chicanas Anna Nieto Gomez and Elizabeth 'Betita' Martinez,

Audre Lorde, African American feminists of the Combahee River Collective (1977), Angela Davis and in the landmark anthology *This Bridge Called My Back: Writings by Radical Women of Color* (1981)." See L. Pérez, "Enrique Dussel's *Etica de la liberación*, U. S. Women of Color Decolonizing Practices, and Coalitionary Politics amidst Difference," 125.

24 See Auther, "Fiber Art and the Hierarchy of Art and Craft."

25 Parker and Pollock, "Crafty Women and the Hierarchy of the Arts," in *Old Mistresses*, 50–81; and Parker, *The Subversive Stitch*.

26 By *capitalism* I am referring to the economic system that today prevails in most of the world and that continues the methods of extraction and the exploitative relationships (between colonizer and colonized) that began during the era of colonialism. It is a neoliberal market system characterized by the privatization of land and resources, government deregulation, and a primary purpose of making profit through the extraction of land, resources, and labor without regard for the impact this extraction has on the land, ecosystems, or people.

27 E. Pérez, *Decolonial Imaginary*, xix.

28 E. Pérez, *Decolonial Imaginary*, 77.

29 See Cherríe L. Moraga, "La Red Xicana Indígena."

30 As quoted in De La Rosa, "Artists at the Border," 51.

31 Consuelo Jimenez Underwood refers to the hoops in her *Diaspora* installation as the space from which spirits move between celestial and material realms. The hoops symbolize a nonhierarchical and nondualistic Indigenous perspective that does not see the material and spiritual as separate. The hoops in *Diaspora* also invoke the idea of the sacred hoop. According to Paula Gunn Allen, the sacred hoop, or medicine wheel, is "the [Plains] Indian concept of a circular, dynamic universe in which all things are related and are of one family." The sacred hoop comes to represent the difference between an Indigenous and Euro-Christian worldview. Gunn Allen, *The Sacred Hoop*, 60.

32 MacLean, *The Shaman's Mirror*, 120.

33 Consuelo Jimenez Underwood, "Threads from

Borderlandia," artist's talk at the University of California, Los Angeles, November 6, 2014.

34 E. Pérez, *Decolonial Imaginary*, 77.

35 Román-Odio, "Undocumented Borderlands," 3.

36 L. Pérez, *Chicana Art*, 166.

37 Santos, "Entre tramas y urdimbres," 5.

38 Yarbro-Bejarano, "Diane Gamboa's Invasion of the Snatch," 63.

39 Santos, "Entre tramas y urdimbres," 5.

40 The 1997 massacre in Acteal was part of a terror campaign directed at Maya communities in Chiapas that was sanctioned by the Institutionalized Revolutionary Party (PRI) as part of their paramilitary strategy to defeat the Zapatista Army of National Liberation (EZLN). The EZLN is a political and military organization of mostly Indigenous Maya from Chiapas who declared war on the Mexican government and military on January 1, 1994. Their goal was to establish a new relationship between the government and Indigenous populations and to protest the poverty and exploitation that had resulted from more than five hundred years of colonization and neoliberal exploitation of their territories and bodies.

41 Heiskanen, "Ni Una Más, Not One More," 10.

42 Georgina Santos, interview with the author, Mexico City, July 2016.

43 "Day to day we encounter a system of signs, sayings, customs or traditions in which attitudes such as machismo or misogyny are rooted, and because they are already so naturalized they become invisible and we seldom notice their existence. It is for this reason that I utilized embossing as the technique for the piece that gives title to this exhibition. The imprints are so subtle that they are not easily perceived. It is necessary to approach and look carefully." Santos, quoted in "Bajo el rebozo, pieza de Georgina Santos," *El Sol de Toluca*, February 16, 2011, https://www.elsoldetoluca.com.mx.

44 Santos, interview with the author, 2016.

45 Zavala, *Becoming Modern, Becoming Tradition*, 146.

46 Gutiérrez y Muhs, "Rebozos, Our Cultural Blankets," 138.

47 "Virgen de los Caminos," Smithsonian American Art Museum website, accessed September 14, 2021, https://americanart.si.edu/artwork /virgen-de-los-caminos-35365.

48 "Virgen de los Caminos," Consuelo Jimenez Underwood website, accessed September 14, 2021, http://www.consuelojunderwood.com /virgen-de-los-caminos.html.

49 "Virgen de los Caminos," Consuelo Jimenez Underwood website, accessed September 14, 2021, http://www.consuelojunderwood.com /virgen-de-los-caminos.html.

50 Georgina Santos's methodology as an artist involved documenting popular remedies and knowledge from the women in Zóquite and returning it to the community in the form of artwork and a series of brochures that she disseminated at the exhibition she put together in Zóquite. With regard to chile, the women Santos talked to reported that, in the past, women who committed a transgression would be placed in a room full of burning chile smoke as punishment. Another woman commented that chile smoke had sometimes been used during childbirth to help the mother push the baby out. Santos, "Entre tramas y urdimbres," 21. The use of chile smoke as a form of punishment has ancient roots in Mexico. For documentation on the Nahua practice of burning chile to discipline children or to ward off enemies, see Berdan and Rieff Anawalt, *Essential Codex Mendoza*, 161.

51 "Of always waiting for the husband, the brother, the son who goes off to work. Of waiting for the crops, of waiting all that time, being in somewhat of a passive time, but at the same time not [passive], because you are also doing many other things." Santos, interview with the author, 2016.

52 See Ramos-Escandón, "La diferenciación de género en el trabajo textil mexicano en la época colonial"; and Villanueva, "From Calpixqui to Corregidor."

53 Abbott, "Opposing Corporate Theft of Mayan Textiles, Weavers Appeal to Guatemala's High Court." Maya weavers are demanding that the government and general public recognize their art and weavings as the collective intellectual and creative labor of Indigenous communities.

Chapter Twelve: Reading Our Mothers

1 I borrow the practice of placing parenthesis around the *b* from Adela C. Licona, who uses the practice "in order both to materialize a discursive (b)order and to visibly underscore the myriad ways (b)orders (much like dichotomies) have historically operated to artificially divide, order, and subordinate." Licona, "(B)orderlands' Rhetorics and Representations," 105. Because I believe that Licona's conceptualization of (b)order as rendered in this practice resonates with Jimenez Underwood's own, I use the term *(b)order* whenever the word appears (outside quotations and titles) throughout this essay.

2 The set of five *Rebozos for Our Mothers* were shown at the Nevada Museum of Art in 2015 as part of an exhibition entitled *Mothers—The Art of Seeing*.

3 Idaho State University Department of Art, "Works of Visiting Artist Consuelo Underwood."

4 Tlamatini (plural, *tlamatinime*) has been described and theorized by a number of scholars. I take the definition of the concept from Cherríe Moraga's theorization of the term in "Codex Xeri." Her work serves as a precursor to many feminist theorizations and investigations of the concept. For an insightful interpretation of Celia Herrera Rodríguez's art as an embodiment of tlamantini, see L. Pérez, "Spirit Glyphs." For another application of the concept to contemporary visual culture, see Lara, "Tonanlupanisma," 61–90.

5 The reclamation and integration of "tricultural heritage" is a nod to Gloria Anzaldúa, who posits in "Conciencia de la Mestiza" that the mestiza, "being tricultural, monolingual, bilingual, multilingual," is "torn between ways" and that the actualization of the new mestiza must be achieved "by developing a tolerance for contradictions, a tolerance for ambiguity" (179–81).

6 Román-Odio, *Sacred Iconographies*, 69.

7 In "Border Arte," Gloria Anzaldúa posits that "border artists cambian el punto de referencia. By disrupting the neat separations between cultures, they create a cultural mix, una mezcla in their artworks" (177). Jimenez Underwood is rooted in a mestiza experience, and as such she draws from and combines the cultural and spiritual practices and beliefs of the Yaqui and Huichol people as well as her European heritage. However, and as a reflection of her own plural cultural makeup, the artist is insistently syncretic in her work, honoring and invoking Amerindian cultural, linguistic, and spiritual practices and beliefs from across the American continents, and oft signaling in the process the (b)orderless fluidities and commonalities between and among them, and the resonances between Amerindian worldviews and belief systems and Indigenous cosmovisions from across the globe.

8 The term *nepantla* is a Nahuatl word that has generally been understood to connote an in-between space. It is sometimes translated as "in the middle." I borrow the terms *nepantla* and *nepantlera* from Gloria Anzaldúa, and in particular from the essay "Now Let Us Shift . . ." Anzaldúa affirms there that "through the in-between place of nepantla, you see through the fiction of the monoculture, the myth of superiority of the white races. And eventually you begin seeing through your ethnic culture's myth of the inferiority of mujeres. . . . In nepantla you sense more keenly the overlap between the material and spiritual worlds" (549). For an insightful in-depth discussion of nepantla as it applies to Chicana art, and specifically to Jimenez Underwood, see Román-Odio's essay "*Nepantlismo*, Chicana Approach to Colonial Ideology" in her *Sacred Iconographies*, 51–74.

9 Anzaldúa, "(Un)natural Bridges, (Un)safe Spaces," 1.

10 The assertion that Jimenez Underwood seeks to challenge the omission of La Virgen from the Catholic Holy Trinity is confirmed by the artist herself in her explanation of the *Father, Son and Holy Rebozo* (2017), which, as the artist explained in a 2018 lecture, replaces the undefined, ungendered Holy Ghost with the Holy Rebozo—which the artist has symbolically tied to Motherhood and to La Virgen in her *Rebozos for Our Mothers* series. Jimenez Underwood,

"Artist Talk: Consuelo J. Underwood" (lecture, 108 Contemporary, Tulsa, OK, June 2, 2018).

11 The term *Chicana* is used throughout the chapter in line with the terminology used in various references: Blake, *Chicana Sexuality and Gender*; Cortez, "History/Whose-Story?"; Elenes, "Nepantla, Spiritual Activism, New Tribalism"; Lara, "Goddess of the Americas"; L. Pérez, *Chicana Art*; Román-Odio, "Colonial Legacies."

12 Lara, "Tonanlupanisma," 64. See E. Pérez, *Decolonial Imaginary*, for an in-depth discussion of that concept.

13 Moraga, "Codex Xeri," 22. Jimenez Underwood does not refer to herself as a tlamatini, but she does embrace the term *Hag* in reference to herself. In fact, her grandchildren refer to the artist as "Hag" or "Haggie." Jimenez Underwood understands *Hag* to mean "wise female elder" and is intentional in calling out the simultaneous connotations of wisdom in women as associated with "ugliness" and duplicity. Jimenez Underwood, "ISU Cultural Events Committee Presents"; and Jimenez Underwood, conversations with the author, June 1–3, 2018.

14 I use the parentheses in "(re)present" because I intend here to connote the act of calling forth marginalized knowledge from the past—to present again, or re-present something that has been largely overlooked or ignored. I also mean to convey representation. The rebozos in this series are the artist's way of conveying or representing the sacred Mothers.

15 Jimenez Underwood, "ISU Cultural Events Committee Presents."

16 I use the term *herstories* as presented by Casey Miller and Kate Swift in *Words and Women* (1976). They offer that "when women in the movement use herstory, their purpose is to emphasize that women's lives, deeds, and participation in human affairs have been neglected or undervalued in standard histories" (135).

17 The rebozo has a complex and underexamined history replete with transcultural adaptations and resistance to encounter. For some sources and history, see Turok, "Some National Goods in 1871: The Rebozo"; De la Peña Virchez et al., "Exposición itinerante del rebozo." For a beautiful poetic/aesthetic reflection on and celebration of the rebozo, see Tafolla and Gárate García, *Rebozos*. For more on the geography of the rebozo, see Jenell Navarro's essay, this volume.

18 Jimenez Underwood, conversation with the author, May 31, 2018.

19 Jimenez Underwood implicitly refers to the Adelitas, female soldiers called *soldaderas* during the Mexican Revolution. They are the subject of song, text, and legend. Las Adelitas are often depicted wearing rebozos and carrying rifles.

20 Jimenez Underwood, "Artist Talk: Consuelo J. Underwood"; Jimenez Underwood, conversation with the author, June 2, 2018; Jimenez Underwood, "ISU Cultural Events Committee Presents."

21 I discuss the rebozos in chronological order of completion because Jimenez Underwood has stressed the importance of the order in which she conceived them.

22 Jimenez Underwood, conversation with the author, April 27, 2015.

23 Jimenez Underwood, "Artist Talk: Consuelo J. Underwood," 8.

24 See "Rebozos for Our Mothers," Consuelo Jimenez Underwood website, accessed July 22, 2019, http://www.consuelojunderwood.com /rebozos-for-our-mothers.html.

25 Although I do not question the validity of imagining the *Rebozos for Our Mothers* as a closed series, I assert nevertheless that the artist's creativity continues to be inspired by the initial creations, which generate new pieces such as *Mother Rain Rebozo* that dialogue patently with *Rebozos for Our Mothers*. Likewise, what I perceive to be the "offspring" rebozos, *Four Xewam* and *Inside the Rain Rebozo* (2017), may be the early manifestations of a separate series or may be envisioned in varying relationship to the *Rebozos for Our Mothers*.

26 Consuelo Jimenez Underwood, correspondence with the author, June 12, 2018.

27 Jimenez Underwood, correspondence with the author, June 12, 2018.

28 In the Huichol tradition, *Xewa(m)*, spelled with an *X*, means flower, specifically calabash flower. See Medina Miranda, "Las personalida-

des del maíz en la mitología wixarika o cómo las mazorcas de los ancestros se transformaron en peyotes." In Yaqui tradition, the same word is spelled with an *S*, *Sewa*, and also means flower, although it has a deep symbolic meaning that is sometimes translated as "all that is good and beautiful." It connotes youth and renewal, something that the artist frequently mentions. For a fuller description of the word's semantic potential, see Evers and Molina, *Yaqui Deer Songs Maso Bwikam*. According to Jimenez Underwood, the word was a source of dispute between her and her husband because he insisted the word was spelled with an *S* and she, with an *X*. Ultimately, the artist settled on the Huichol orthography for those works in which she highlights Xewa(m).

29 Chalmers, "Transformation of Academic Knowledges," 100.

30 Velina Underwood kindly made available to me an earlier prototype for *Mother Moon* on May 27, 2018. In that version, an attempt is made to represent phases of the moon on the garment. Jimenez Underwood was ultimately unsatisfied with that piece because it did not accomplish the airy softness she envisioned for *Mother Moon*.

31 Consuelo Jimenez Underwood, conversation with the author, June 1, 2018.

32 Anzaldúa, *Borderlands/La Frontera* (1987), 79.

33 Jimenez Underwood, correspondence with the author, June 12, 2018.

34 Jimenez Underwood, correspondence with the author, June 12, 2018.

35 L. Pérez, *Chicana Art*, 166.

36 Jimenez Underwood, correspondence with the author, June 12, 2018.

37 Jimenez Underwood, correspondence with the author, June 12, 2018.

38 "Rebozos for Our Mothers," Consuelo Jimenez Underwood website, http://www.consueloj underwood.com/rebozos-for-our-mothers.html. This has also been addressed and affirmed in various conversations and exchanges of correspondence between myself and Jimenez Underwood, the most recent on June 12, 2018.

39 Jimenez Underwood, correspondence with the author, June 12, 2018.

40 Jimenez Underwood, conversation with the author, April 27, 2015.

41 Carrasco, *Religions of Mesoamerica*, 162.

42 Carrasco and Sessions, *Cave, City, and Eagle's Nest*, 247.

43 Carrasco, *Religions of Mesoamerica*.

44 Martineau and Ritskes, "Fugitive Indigeneity," x.

45 Jimenez Underwood, conversation with the author, May 30, 2018.

46 Jimenez Underwood, "Artist Talk: Consuelo J. Underwood."

47 Carrasco, *Religions of Mesoamerica*, 183.

48 One of the (b)orders Jimenez Underwood perpetually challenges is that between cultures and spiritual belief systems. She invokes cultural symbols and spiritual beliefs across societies and continents and puts them in harmonious dialogue with each other. In the process, the origin of a particular element in her work is often blurred or complicated. Although the artist does not specify, the female serpent rain deity may evoke the aboriginal Australian Rainbow Serpent, which had many names and varying characteristics within aboriginal societies across time and geographic space. At the same time, the artist overtly links the practice of weaving in the piece to her Huichol heritage, and the rebozo itself is a garment through which she signifies and pays homage to women in a myriad of Native American cultures who made and used the rebozo. Jimenez Underwood approaches her art and her worldview from her own tricultural perspective, but part of that perspective is that her Huichol, Yaqui, and European heritages aren't a boundary of belonging but rather a place from which to begin to understand her connection to all other beings and societies.

49 Jimenez Underwood, "Artist Talk: Consuelo J. Underwood."

50 Consuelo Jimenez Underwood, conversation with the author, June 1, 2018.

51 Consuelo Jimenez Underwood, personal correspondence with the author, September 13, 2021.

52 Jimenez Underwood, personal correspondence with the artist, September 13, 2021.

53 To date, whether and when a rebozo in honor

of Mother Wind/Sky will be completed is a matter of speculation. Jimenez Underwood, conversation with the author, June 1, 2018; and Consuelo Jimenez Underwood (@cju.art .threads), "a new warp 4 the Wind," Instagram photo, October 22, 2021, https://www.instagram .com/p/B37MiMnpgjE/.

54 Jimenez Underwood, conversations with the author, April 27, 2015, and June 1, 2018.

Chapter Thirteen: Weaving Water

1 de Avila B, "Threads of Diversity," 87–90.

2 For example, Native people in the Southwest utilized blue or blue-green turquoise to make beads, coastal communities in locations such as Florida and California utilized shells for bead-work, and woodland peoples utilized porcupine quills to weave. See Shanks and Woo Shanks, *California Indian Baskets*; and McCallum, *The History of Beads*.

3 Epistemology is "the study or a theory of the nature and grounds of knowledge especially with reference to its limits and validity." "Epistemology," *Merriam-Webster Online*, accessed March 1, 2018, https://www.merriam-webster. com/dictionary/epistemology. I use the term *Indigenous epistemologies* to refer to the many forms of knowledge that reside with Indigenous peoples that most often cut against the grain of calculable Western forms of knowledge. For example, one form of Indigenous epistemology found in our woven arts is the belief/theory that our natural world is filled with sacred energy. Thus, woven motifs of flowers, plants, or animals are not simply reflections of what we see in the world; they are records of our sacred beliefs and knowledge about these plants or animals. Moreover, Indigenous epistemologies often integrate what we know and *feel* about our world. For more on Indigenous felt theory see Dian Million's chapter titled "Felt Theory" in her book *Therapeutic Nations*.

There is a rich body of work by Indigenous writers on the potency of storytelling. To learn more, please read Archibald, *Indigenous Story-work*; Christensen, Cox, and Szabo-Jones, *Activating the Heart*; King, *The Truth about Stories*; and Miranda, *Bad Indians*.

4 For example, aguayos or awayu is cloth used by Aymara and Quecha women in Bolivia, Chile, Colombia, Peru, and Ecuador. It is a large rect-angular cloth used to carry children or other items on the back. And, the huipil (from the Nahuatl word *huipilli*) is the woven garment worn by Indigenous women from many states in México and by the Maya in Guatemala. Although the huipil is not exactly a shawl, it does depend on the region for its design. It is generally two pieces of fabric sewn together, with an opening for the head. If the sides are sewn together it can be worn like a blouse. If the sides are unsewn, the garment can be worn over a blouse or another top. Some huipiles are very long and worn as a dress.

5 Carmen Tafolla writes: "El rebozo, the simple Mexican shawl, is that everyday item which we wrap around our lives like an emotion, an expression, an instrument. With it we carry our children or bury our dead. We cover our tears or dance out our joy. It is our hands, our face, a reflection of who we are." Tafolla and Gárate García, *Rebozos*, ix.

6 To read more about the complex and sophisti-cated spirit world of Mesoamerica, see Almere Read and Gonzalez, *Mesoamerican Mythology*. To learn more about the veneration of water gods, see de Orellana, "Worship of Water Gods in Mesoamerica."

7 I use the term *settler colonization* to reference a specific form of colonization wherein the colonizers came to stay, and the disruptions of Indigenous life and culture remain ongo-ing along with the continued dispossession of Indigenous peoples from our ancestral homelands. For a deeper reading on settler colonialism, please see Patrick Wolfe's article "Settler Colonialism and the Elimination of the Native," in which he describes settler colo-nialism as a structure that was implemented in the past and that continues today, rather than an event that happened in the past and has ended. Moreover, he explicates the logic of elimination (including the practice of geno-cide and extending that to the present-day disproportionate rates of Indigenous people killed by police in the United States and the

rates of sexual assault against Indigenous women), which is always attendant to settler colonialism to justify continued settler presence on Indigenous lands at the expense of Indigenous lives. Also see Dean Itsuji Saranillio's entry on "Settler Colonialism" in *Native Studies Keywords*, where he shows how settler colonialism becomes normalized occupation or normalized invasion.

8 The basic definition of *decolonization* is repatriation of life, land, and culture to Indigenous peoples. See Tuck and Yang, "Decolonization Is Not a Metaphor."

9 Manzanedo, "Afterword," 37.

10 Castelló Yturbide, "Geography of the Rebozo," 75–76.

11 One legendary weaver who does everything himself is Evaristo Borboa Casas. He was born in 1927 in Tenancingo in the state of México. Don Evaristo had very soft hands and once noted: "This job doesn't create calluses . . . my hands are softened by the thread that caresses them." Yanes, "Traditional Hands of Tenancingo," 77. Thus, whereas certainly a lot of difficult and highly skilled labor goes into the making of each rebozo, according to Don Evaristo there seems to be reciprocity in this labor. Namely, while he works so diligently for months to make a single rebozo, the threads of the garment also caress his hands, making them soft, unlike much of the physical work that men are expected to do with their hands. And even Don Evaristo, a master rebocero, is proud to have "soft hands," usually a description that men would deny in a heteropatriarchal state. He was awarded México's National Prize for Science and the Arts in 2005. At about eighty years old he said he would "meet death with threads in his hands" (de Orellana, "Wearing It Well," 74).

12 Her most recent work on the rebozo was published in *Artes de México*'s 2008 special issue on "*El Rebozo*," but she has been working on documenting the importance of the rebozo, along with others from *Artes de México*, since the early 1970s.

13 Castelló Yturbide, "Geography of the Rebozo," 75.

14 Castelló Yturbide, "Geography of the Rebozo," 75.

15 The genius of the backstrap loom design also displays an Indigenous worldview because it does not separate the body from art. In fact, the engineering of this loom shows that body, art, and culture were/are highly integrated.

16 Castelló Yturbide, "Geography of the Rebozo," 75–76.

17 Goeman, *Mark My Words*, 17.

18 Yanes, "Traditional Hands of Tenancingo," 77. To read more about the intricate connections between domestic space and colonization/imperialism, see Stoler, *Carnal Knowledge and Imperial Power*; and McClintock, *Imperial Leather*.

19 Yanes, "Scented Rebozo as Death Shroud," 80.

20 Yanes, "Scented Rebozo as Death Shroud," 81.

21 Yanes, "Scented Rebozo as Death Shroud," 81.

22 de Orellana, "Wearing It Well," 74.

23 Longeaux y Vásquez, "The Women of La Raza," 29.

24 Manzanedo, "Afterword," 39.

25 Manzanedo, "Afterword," 41.

26 Consuelo Jimenez Underwood, interview with the author, December 5, 2017.

27 Jimenez Underwood, interview with the author.

28 Jimenez Underwood, interview with the author.

29 Jimenez Underwood, interview with the author.

30 Jimenez Underwood, interview with the author.

31 Jimenez Underwood, interview with the author.

32 Jimenez Underwood, interview with the author.

33 Jimenez Underwood, interview with the author.

34 An artistic aesthetic attributed to Vincent van Gogh.

35 Jimenez Underwood, interview with the author.

36 Jimenez Underwood, interview with the author.

37 Jimenez Underwood, interview with the author.

38 Jimenez Underwood, interview with the author.

39 Lonetree, *Decolonizing Museums*, 39. For a more
in-depth discussion about the need to decol-
onize aesthetics and museums, see Lonetree,
Decolonizing Museums; and Martineau and
Ritskes, "Fugitive Indigeneity." Also, the Trans-
national Decolonial Institute (TDI+) defines
decolonial aesthetics as "ongoing artistic proj-
ects responding and delinking from the darker
side of imperial globalization. Decolonial aes-
thetics seeks to recognize and open options for
liberating the senses. This is the terrain where
artists around the world are contesting the
legacies of modernity and its re-incarnations
in postmodern and altermodern aesthetics."
Thus, colonial aesthetics or settler aesthet-
ics (a term I use) is what TDI+ critiques as an
"aspect of the colonial matrix of power, of the
imperial structure of control that began to be
put in place in the sixteenth century with the
emergence of the Atlantic commercial circuit
and the colonization of the New World, and
that was transformed and expanded through
the eighteenth and nineteenth centuries, and
up to this day." Thus, colonial/settler aesthetics
attempt to dominate the political, economic,
and knowledge bases of Indigenous life and art,
meaning they strategically seek control "over
our senses and perception." TDI+, "Decolonial
Aesthetics (1)."

40 Mignolo and Vázquez, "Decolonial AestheSis."

41 TDI+, "Decolonial Aesthetics (1)."

42 Jimenez Underwood, interview with the
author.

43 Jimenez Underwood, interview with the
author.

44 "Rebozos for Our Mothers," Consuelo Jimenez
Underwood website, http://www.consueloj
underwood.com/rebozos-for-our-mothers
.html. The other rebozos in this series and the
artist's statement can be viewed there as well.

45 Corporate giants such as Nestlé and Coca-
Cola have made large attempts to privatize
water and deny the human right to safe, clean
water. One recent attempt by Nestlé was in
2016, when they unsuccessfully attempted to
gain control of the Guaraní Aquifer in South

America. These attempts are ongoing. Another
attempt to water privatization was made by
Constellation Brands in 2018 in Mexicali; many
Indigenous protectors challenged this corpo-
ration, ultimately leading to a referendum in
2020 that voted down a Constellation Brands
brewery.

46 Consuelo Jimenez Underwood, personal com-
munication, December 1, 2017.

47 Other subtle water traditions are connected
to rebozos as well. For example, tradition-
ally, prior to the sale of rebozos in México,
they were pressed by a specialist. The pressing
machine, a tórcul, resembled a large paper
printing press and while there are not many left
who work in this hidden art of the rebozo, one
well-known presser today is Ramón Hernán-
dez Cervantes. Hernández Cervantes comes
from a family of rebozo pressers. He reports
that in the early days of pressing this intimate
garment, "you'd spray them with your mouth"
before pleating the garment in the press. This
meant the presser would fill their mouth with
water and spray or spit the water evenly over
the rebozo to help make it more eloquent and
smooth once pressed. This adds yet another
water element to the rebozo. Today, Hernán-
dez Cervantes wets his rebozos with a garden
sprinkler as a "job he performs with the same
affection as would any gardener who wants to
see his plants bloom." Olmos, "Hidden Arts of
the Rebozo," 87. Although Jimenez Under-
wood's rebozos were not pressed in this fashion,
the tradition of pressing rebozos before sending
them out into the world remains reliant on
water.

48 Jimenez Underwood, personal communication.

49 Jimenez Underwood, personal communication.

50 L. Pérez, "Writing with Crooked Lines," 23.

51 Jimenez Underwood, personal communication.

52 Jimenez Underwood, personal communication.

53 Jimenez Underwood, personal communication.

54 Typically, most Indigenous people believe
that we must live in balance with the earth.
For example, the earth provides us with food,
water, plants, fibers, and medicines. Therefore,
it is our duty to tend these plants, protect the

water, utilize the fibers with gratitude, and understand the natural medicines. In short, the earth will support our feet when we walk on it as long as we are taking care of her. For more on Indigenous understandings of ecosystems, Indigenous philosophies of balance, and Indigenous sustainability, see Nelson, *Original Instructions*.

55 For further reading on how capitalism and modernity have been anti-Indigenous structures, please see Alfred, *Peace, Power, Righteousness*, especially the chapters titled "Money" and "Modern Treaties: A Path to Assimilation?" For a discussion of racial capitalism, please see Allen, *Black Awakening in Capitalist America*.

56 I say this concept is universal in the real sense of universality, meaning that human beings cannot live without water because it constitutes and sustains our bodies. I am also cognizant of making universal claims that are not truly universal, such as "universal womanhood" or "universal Indigeneity." I do not mean to say that everyone universally values water as life, but factually in that life does not exist without water across the universe.

57 Alexander, *Pedagogies of Crossing*, 14.

58 Yreina Cervántez, interview with the author, September 25, 2017.

59 Cervántez, interview with the author.

60 Navarro, "The Promise of the Jaguar."

61 Cervántez, interview with the author.

62 Cervántez, interview with the author.

63 L. Pérez, "Writing on the Social Body," 51–52.

64 Cervántez, interview with the author. Cinnabar is the red mineral mercury sulfide. Olmecs understood it to have sacred energies related to magnetic fields.

65 To read more about Christi Belcourt please visit her website: "Bio – Short Version," Christi Belcourt website, 2021, http://christibelcourt.com/bio/.

66 I use the term *alter/Native* here to signal a departure from Western art and methodologies. Namely, I gesture toward Indigenous artists as visionaries, as cultural laborers who pull Indigenous futures into our present moment and provide us with alternative—or alter/Native—ways of being in relation with all living entities.

67 Martineau and Ritskes, "Fugitive Indigeneity," ii.

68 Martineau and Ritskes, "Fugitive Indigeneity," iii.

69 Miranda, *Bad Indians*, xiv.

70 The term *artivism* is being used more broadly now in order to signal a necessary relationship between art and activism and to underscore that many artists create art as a form of activism. For more in-depth discussion on this term, see Sandoval and Latorre, "Chicana/o Artivism."

Chapter Fourteen: Consuelo Jimenez Underwood

1 Consuelo Jimenez Underwood, interview with the author, November 2014.

2 Erica Diazoni, interview with the author, January 27, 2015. All subsequent quotes by Diazoni are also taken from this interview.

3 Victoria May, interview with the author, November 28, 2014. All subsequent quotes by Diazoni are also taken from this interview.

4 Wura-Natasha Ogunji, interview with the author, January 9, 2015. All subsequent quotes by Ogunji are also taken from this interview.

5 George Rivera, interview with the author, April 4, 2016. All subsequent quotes by Rivera are also taken from this interview.

6 Laura Ahola-Young, interview with the author, November 26, 2014. All subsequent quotes by Ahola-Young are also taken from this interview.

7 Jonathan Brilliant, interview with the author, January 15, 2015. Later quotes by Brilliant are also taken from this interview.

8 Robin Lasser, interview with the author, December 5, 2014. Later quotes by Lasser are taken from this interview.

9 "Tortilla Meets Tortilla Wall," Consuelo Jimenez Underwood website, accessed September 2021. http://www.consuelojunderwood.com/tortilla-meets-tortilla-wall.html.

10 Hedayat Munroe, interview with the author, December 2, 2014. All subsequent quotes by Munroe are also taken from this interview.

BIBLIOGRAPHY

Aaron, Jan, and Georgine Sachs Salom. *The Art of Mexican Cooking*. Garden City, NY: Doubleday, 1965.

Abbott, Jeff. "Opposing Corporate Theft of Mayan Textiles, Weavers Appeal to Guatemala's High Court." Truth-out.org, August 14, 2016. http://www.truth-out.org/news/item/37213-opposing-corporate-theft-of-mayan-textiles-weavers-appeal-to-guatemala-s-high-court.

Acuña, Rodolfo. *Occupied America: The Chicano's Struggle Toward Liberation*. San Francisco: Canfield Press, 1972.

Agence France-Presse in Geneva. "US-Mexico Border Migrants Deaths Rose in 2017 Even as Crossing Fell, UN Says." *The Guardian*, February 6, 2018. Accessed June 25, 2018. https://www.theguardian.com/us-news/2018/feb/06/us-mexico-border-migrant-deaths-rose-2017.

Aguilar-Moreno, Manuel. *Handbook to Life in the Aztec World*. New York: Oxford University Press, 2006.

Alarcón, Norma. "Traddutora, Traditora: A Paradigmatic Figure of Chicana Feminism." *Cultural Critique*, no. 13 (Autumn 1989): 57–87.

Albers, Anni. "Hand Weaving Today: Textile Work at Black Mountain College." *The Weaver* 6, no. 1 (January/February 1940): 3–7.

Albers, Anni. *On Designing* (1959). Middletown, CT: Wesleyan University Press, 1971.

Alexander, M. Jacqui. *Pedagogies of Crossing: Meditations on Feminism, Sexual Politics, Memory, and the Sacred*. Durham, NC: Duke University Press, 2006.

Alfred, Taiaiake. *Peace, Power, Righteousness: An Indigenous Manifesto*. 2nd ed. Oxford: Oxford University Press, 2009.

Allen, Robert L. *Black Awakening in Capitalist America*. Bensenville, IL: Lushena; 1990.

Almere Read, Kay, and Jason J. González. "Coatlicue." In *Mesoamerican Mythology: A Guide to the Gods, Heroes, Rituals, and Beliefs of Mexico and Central America*, 150–52. New York: Oxford University Press, 2000.

Almere Read, Kay, and Jason J. González. *Mesoamerican Mythology: A Guide to the Gods, Heroes, Rituals, and Beliefs of Mexico and Central America*. New York: Oxford University Press, 2000.

Alvarado Tezozómoc, Fernando, and Manuel Orozco y Berra. *Crónica mexicana*. México: Imprenta y lítografia de Ireneo Paz, 1878.

Anzaldúa, Gloria E. "Border Arte: *Nepantla*, el Lugar de la Frontera." In *La Frontera/The Border: Art about the Mexican/United States Border Experience*, 107–23. San Diego: Centro Cultural de La Raza/Museum of Contemporary Art, 1993.

Anzaldúa, Gloria E. "Border Arte: Nepantla, El Lugar de La Frontera." In *Light in the Dark/Luz en lo Oscuro: Rewriting Identity, Spirituality, Reality*, edited by AnaLouise Keating, 47–64. Durham, NC: Duke University Press, 2015.

Anzaldúa, Gloria E. *Borderlands/La Frontera: The New Mestiza*. San Francisco: Aunt Lute, 1987.

Anzaldúa, Gloria E. *Borderlands/La Frontera: The New Mestiza*. 2nd ed. San Francisco: Aunt Lute, 1999.

Anzaldúa, Gloria E. "La Conciencia de la Mestiza: Towards a New Consciousness." *Chicana Feminist Thought: The Basic Historical Writings*, edited by Alma M. García, 270–73. London: Routledge, 1997.

Anzaldúa, Gloria E. "Nepantla, Creative Acts of Vision." Collected Papers (1942–2004). Benson Library Collection, University of Texas at Austin.

Anzaldúa, Gloria E. "Nepantla, the Theory and Manifesto." Collected Papers (1942–2004). Benson Library Collection, University of Texas at Austin.

Anzaldúa, Gloria E. "Now Let Us Shift . . . the Path of Conocimiento . . . Inner Work, Public Acts."

In *This Bridge We Call Home: Radical Visions of Transformation*, edited by Gloria E. Anzaldúa and AnaLouise Keating, 540–78. New York: Routledge, 2002.

Anzaldúa, Gloria E. "(Un)natural Bridges, (Un)safe Spaces." In *This Bridge We Call Home: Radical Visions for Transformation*, edited by Gloria E. Anzaldúa and AnaLouise Keating, 1–5. New York: Routledge, 2002.

Anzaldúa, Gloria, and AnaLouise Keating, eds. *This Bridge We Call Home: Radical Visions for Transformation*. New York: Routledge, 2002.

Archibald, Jo-Ann. *Indigenous Storywork: Educating the Heart, Mind, Body, and Spirit*. Vancouver: University of British Columbia Press, 2008.

Ashcroft, Bill, Gareth Griffiths, and Helen Tiffin. *Post-Colonial Studies: The Key Concepts*. New York: Routledge, 2000.

Auther, Elissa. "Classification and Its Consequences: The Case of 'Fiber Art.'" *American Art* 16, no. 3 (2002): 2–9.

Auther, Elissa. "Fiber Art and the Hierarchy of Art and Craft." *Journal of Modern Craft* 1, no. 1 (2008): 13–34.

Auther, Elissa. *String, Felt, Thread: The Hierarchy of Art and Craft in American Art*. Minneapolis: University of Minnesota Press, 2010.

Avila, Eric R. "The Folklore of the Freeway: Space, Culture, and Identity in Postwar Los Angeles." *Aztlán: A Journal of Chicano Studies* 23, no. 1 (Spring 1998): 15–31.

Awalt, Barbe, and Paul Rhetts. *Our Saints Among Us/Nuestros Santos Entre Nosotros: 400 Years of New Mexican Devotional Art*. Albuquerque, NM: LPD Press, 1998.

"Bajo el rebozo, pieza de Georgina Santos." *El Sol de Toluca*, February 16, 2011. http://www.oem.com.mx/elsoldetoluca/notas/n1968135.htm.

Barad, Karen. *Meeting the Universe Halfway: Quantum Physics and the Entanglement of Matter and Meaning*. Durham, NC: Duke University Press, 2007.

Berdan, Frances F., and Patricia Rieff Anawalt. *The Essential Codex Mendoza*. Berkeley: University of California Press, 1996.

Berelowitz, JoAnne. "The Spaces of Home in Chicano and Latino Representations of the San Diego-Tijuana Borderlands (1968–2002)." In *Chicano and Chicana Art: A Critical Anthology*, edited by Jennifer A. González, C. Ondine Chavoya, Chon Noriega, and Terezita Romo, 351–73. Durham, NC: Duke University Press, 2019.

Berestein, Leslie. "Highway Safety Sign Becomes Running Story on Immigration." *San Diego Union-Tribune*, April 10, 2005.

Berrin, Kathleen, ed. *Art of the Huichol Indians*. San Francisco: Fine Arts Museums of San Francisco and Harry N. Abrams, 1978.

Bierhorst, John, translator. *History and Mythology of the Aztecs: Codex Chimalpopoca*. Tucson: University of Arizona Press, 1992.

Blake, Debra J. "Chicana Feminism: Spirituality, Sexuality, and Mexica Goddesses Re-membered." In *Chicana Sexuality and Gender: Cultural Refiguring in Literature, Oral History, and Art*, 70–101. Durham: Duke University Press, 2008.

Blake, Debra J. *Chicana Sexuality and Gender: Cultural Refiguring in Literature, Oral History, and Art*. Durham: Duke University Press, 2008.

Bolles, David. *Combined Dictionary–Concordance of the Yucatecan Mayan Language* (1998). Foundation for the Advancement of Mesoamerican Studies, 2001. http://www.famsi.org/reports/96072/index.html#guide.

Boone, Elizabeth Hill. "The Coatlicues at the Templo Mayor." *Ancient Mesoamerica* 10, no. 2 (Fall 1999): 189–206.

Boone, Elizabeth Hill. "Templo Mayor Research, 1521–1978." In *The Aztec Templo Mayor: A Symposium at Dumbarton Oaks, 8th and 9th October 1983*, 5–69. Washington, DC: Dumbarton Oaks Research Library and Collection, 1987.

Boris, Eileen. "'Dreams of Brotherhood and Beauty': The Social Ideas of the Arts and Crafts Movement." In *"The Art That Is Life": The Arts and Crafts Movement in America, 1875–1920*, by Wendy Kaplan, 208–22. Boston: Little, Brown, 1998.

Bourgeois, Louise. "The Fabric of Construction." *Craft Horizons* 29, no. 2 (March/April 1969): 31–35.

Boyd, E. "El Santo Niño de Atocha." In *Saints and Saint Makers of New Mexico*, revised edition, 90–94. Santa Fe, NM: Western Edge Press, 1998.

Bray, Hazel V. *The Tapestries of Trude Guermonprez*. Oakland, CA: Oakland Museum, 1982.

Brian, Tara, and Frank Laczko, eds. *Fatal Journeys: Tracking Lives Lost during Migration*. Geneva:

International Organization for Migration, 2014. https://publications.iom.int/books/fatal-journeys-tracking-lives-lost-during-migration.

Bristow, Maxine. "Continuity of Touch: Textiles as Silent Witness." In *The Textile Reader*, edited by Jessica Hemmings, 44–51. London: Berg Publishers, 2012.

Broyles-González, Yolanda. "Indianizing Catholicism: Chicana/India/Mexicana Indigenous Spiritual Practices in Our Image." In *Chicana Traditions: Continuity and Change*, edited by Norma E. Cantú and Olga Nájera-Ramírez, 117–32. Urbana: University of Illinois Press, 2002.

Burns, Nancy Kathryn, and Kristina Wilson. *Cyanotypes: Photography's Blue Period*. Worcester, MA: Worcester Art Museum, 2016.

Cajete, Gregory. *Native Science: Natural Laws of Interdependence*. Santa Fe, NM: Clear Light Publishers, 1999.

Carrasco, Davíd. *The Aztecs: A Very Short Introduction*. New York: Oxford University Press, 2012.

Carrasco, Davíd. *Religions of Mesoamerica*. Long Grove, IL: Waveland, 2014.

Carrasco, Davíd. *Religions of Mesoamerica: Cosmovision and Ceremonial Centers*. Religious Traditions of the World. San Francisco: Harper San Francisco, 1990.

Carrasco, Davíd, and Scott Sessions, eds. *Cave, City, and Eagle's Nest: An Interpretive Journey through the Mapa de Cuauhtinchan No. 2*. Albuquerque: University of New Mexico Press, 2007.

Carrasco, Davíd, and Scott Sessions. *Daily Life of the Aztecs*. 2nd ed. Santa Barbara, CA: ABC-CLIO, 2011.

Carroll, Amy, ed. "Couching." In *The Pattern Library: Embroidery*, 79, 85–90. New York: Ballantine Books, 1981.

Carroll, Amy, ed. "Straight Stitch." In *The Pattern Library: Embroidery*, 24. New York: Ballantine, 1981.

Caso, Alfonso. *El Teocalli de la Guerra Sagrada: Descripción y estudio del monolito encontrado en los cimientos del Palacio Nacional*. México, D.F.: Secretaría de Educación Pública, 1927.

Castellanos, M. Bianet. "Rewriting the Mexican Immigrant Narrative: Situating Indigeneity in Maya Women's Stories." *Latino Studies* 15, no. 2 (2017): 219–41.

Castelló Yturbide, Teresa. "A Geography of the Rebozo." *Artes de México*, no. 90 (2008): 75–77.

Castillo, Ana. *Goddess of the Americas: Writings on the Virgin of Guadalupe*. New York: Riverhead, 1997.

Castro, Rafaela G. "*Con Safos* (Don't Mess with This)." In *Chicano Folklore: A Guide to the Folktales, Traditions, Rituals and Religious Practices of Mexican-Americans*, 62–63. New York: Oxford University Press, 2001.

Chalmers, Jason. "The Transformation of Academic Knowledges: Understanding the Relationship between Decolonizing and Indigenous Research Methodologies." *Socialist Studies/Études Socialistes* 12, no. 1 (2017): 97–116.

Chávez, Fray Angélico. *La Conquistadora: The Autobiography of an Ancient Statue*. Revised edition. Santa Fe, NM: Sunstone, 1983.

Chávez, Patricio. "Through *The Border Door*." In *Born of Resistance: Cara a Cara Encounters with Chicana/o Visual Culture*, edited by Scott L. Baugh and Víctor A. Sorell, 94–100. Tucson: University of Arizona Press, 2015.

Chávez, Patricio, Madeleine Grynsztejn, and Kathryn Kanjo. *La Frontera/The Border: Art about the Mexico/United States Border Experience*. San Diego: Centro Cultural de la Raza, 1993.

Christensen, Julia, Christopher Cox, and Lisa Szabo-Jones. *Activating the Heart: Storytelling, Knowledge Sharing, and Relationship*. Waterloo, ON, Canada: Wilfrid Laurier University Press, 2018.

Clavijero Echegaray, Francisco Javier, and Mariano Cuevas. *La Historia Antigua de México*. México: Porrúa, 1964.

Clendinnen, Inga. "Ways to the Sacred: Reconstructing 'Religion' in Sixteenth Century Mexico." *History and Anthropology* 5, no. 1 (1990): 105–41.

"Codex Mendoza." Accessed September 21, 2021. https://codicemendoza.inah.gob.mx/inicio.php?lang=english.

Coe, Michael D., and Rex Koontz. *Mexico from the Olmecs to the Aztecs*. 6th ed. New York: Thames and Hudson, 2008.

Coe, Sophie D., and Michael D. Coe. *The True History of Chocolate*. 3rd ed. New York: Thames and Hudson, 2018.

Combahee River Collective. "A Black Feminist

Statement." In *This Bridge Called My Back: Writings by Radical Women of Color*, 2nd ed., edited by Cherríe Moraga and Gloria E. Anzaldúa, 210–18. New York: Kitchen Table, 1983. Essay first published in 1977.

Contreras, Sheila Marie. "From La Malinche to Coatlicue: Chicana Indigenist Feminism and Mythic Native Women." In *Blood Lines: Myth, Indigenism, and Chicana/o Literature*, 105–33. Austin: University of Texas Press, 2008.

Cooke, Rachel. "Anarchy & Beauty: William Morris and His Legacy, 1960–1960 Review—The Virtues of Simplicity." *The Guardian*, October 18, 2014. Accessed July 19, 2020. https://www.theguardian.com/artanddesign/2014/oct/19/anarchy-beauty-william-morris-legacy-review-virtue-of-simplicity.

Copeland, Huey. "Glenn Ligon and Other Runaway Subjects." *Representations* 113, no. 1 (Winter 2011): 73–110.

Cordry, Donald, and Dorothy Cordry. *Mexican Indian Costumes*. Austin: University of Texas Press, 1968.

Cortez, Constance. "History/Whose-Story? Postcoloniality and Contemporary Chicana Art." *Chicana/Latina Studies: The Journal of Mujeres Activas en Letras y Cambio Social* 6, no. 2 (2007): 22–54.

Cortez, Constance. "The New Aztlan: Nepantla (and Other Sites of Transmogrification)." In *The Road to Aztlan: Art from a Mythic Homeland*, edited by Virginia M. Fields and Victor Zamudio-Taylor, 358–73. Los Angeles: Los Angeles County Museum of Art, 2001.

Coupal, Melissa Biggs. "Exhibiting Mexicanidad: The National Museum of Anthropology and Mexico City in the Mexican Imaginary." PhD diss., University of Texas at Austin, 2011.

Coxon, Ann, ed. *Annie Albers*. London: Tate Modern, 2018.

Craib, Raymond B. *Cartographic Mexico: A History of State Fixations and Fugitive Landscapes*. Durham, NC: Duke University Press, 2004.

Cranbrook Academy of Art. *Hot House: Expanding the Field of Fiber at Cranbrook, 1970–2007*. Bloomfield Hills, MI: Cranbrook Art Museum, 2007.

Crenshaw, Kimberlé. "Mapping the Margins: Intersectionality, Identity Politics, and Violence against Women of Color." *Stanford Law Review* 43, no. 6 (July 1991): 1241–99.

D'Alessandro, Jill, and Isabelle de Borchgrave. *Pulp Fashion: The Art of Isabelle de Borchgrave*. San Francisco: Fine Arts Museums of San Francisco, 2011.

Davalos, Karen Mary. *Chicana/o Remix: Art and Errata since the Sixties*. New York: New York University Press, 2017.

Davalos, Karen Mary. "The Oppositional Consciousness of Yolanda M. López." *Aztlán: A Journal of Chicano Studies* 34, no. 2 (Fall 2009): 35–66.

de Avila B., Alejandro. "Threads of Diversity: Oaxacan Textiles in Context." *The Unbroken Thread: Conserving the Textile Traditions of Oaxaca*, edited by Kathryn Klein, 87–152. Los Angeles: Getty Conservation Institute, J. Paul Getty Trust, 1997.

de Borchgrave, Isabelle, and Rita Brown. *Papiers a la mode*. London: Bellew, 2000.

De la Peña Virchez, Rosa Guadalupe, Karla Josefina Nava Sánchez, Ingrid Jaqueline Juárez Castro, and Marisol Orozco Guerrero. "'Exposición itinerante del rebozo, como estrategia para la revalorización del patrimonio artesanal en el municipio de Tenancingo, Estado de México' [Exhibitions of the Rebozo as a Strategy for the Appreciation of the Handicraft Heritage in the Municipality of Tenancingo in the State of Mexico]." *Revista Digital de Gestión Cultural* 1, no. 2 (November 12, 2011): 48–69. http://observatoriocultural.udgvirtual.udg.mx/repositorio/handle/123456789/936.

De La Rosa, Vic. "Artists at the Border." *Fiberarts* 35, no. 1 (2008): 46–51.

Del Castillo, Adelaida R. "Malintzin Tenépal: A Preliminary Look into a New Perspective." In *Essays on La Mujer*, edited by Rosaura Sánchez and Rosa Martinez Cruz, 124–49. Los Angeles: UCLA Chicano Studies Center, 1977.

de León y Gama, Antonio. *Descripción histórica y cronológica de las dos piedras que con ocasión del nuevo empedrado que se está formando en la plaza principal de México, se hallaron en ella el año de 1790*. México: Impr. de Don F. de Zuñiga y Ontiveros, 1792.

de León y Gama, Antonio. *Descripción histórica y*

cronológica de las dos piedras que con ocasión del nuevo empedrado que se está formando en la plaza principal de México, se hallaron en ella el año de 1790, 2nd ed, edited by Carlos María de Bustamante. México: Impr. del ciudadano A. Valdés, 1832.

Delgadillo, Theresa. *Spiritual Mestizaje: Religion, Gender, Race, and Nation in Contemporary Chicana Narrative.* Durham, NC: Duke University Press, 2011.

de Orellana, Margarita. "Wearing It Well." *Artes de México*, no. 90 (2008): 74–75.

de Orellana, Margarita. "The Worship of Water Gods in Mesoamerica." *Artes de México*, no. 152 (1972): 70–74.

de Sahagún, Bernardino. *Florentine Codex: General History of the Things of New Spain.* Volume 3, *The Origin of the Gods.* 2nd ed. Revised and translated by Charles E. Dibble and Arthur J. O. Anderson. Salt Lake City: University of Utah Press, 1981.

DiAngelo, Robin. "White Fragility." *International Journal of Critical Pedagogy* 3, no. 3 (2011): 54–70.

Dow, James W. "Central and North Mexican Shamans." In *Mesoamerican Healers*, edited by Brad R. Huber and Alan R. Sandstrom, 66–94. Austin: University of Texas, 2001.

Elenes, Alejandra C. "Nepantla, Spiritual Activism, New Tribalism: Chicana Feminist Transformative Pedagogies and Social Justice Education." *Journal of Latino/Latin American Studies* 5, no. 3 (2013): 132–41.

Ereira, Alan, dir. *The Heart of the World: Elder Brother's Warning.* London: British Broadcasting Corporation, 1990. Film. VHS, 88 min.

Espinosa Miñoso, Yuderkys, Diana Gómez Correal, and Karina Ochoa Muñoz, eds. *Tejiendo de otro modo: feminismo, epistemología y apuestas descoloniales en Abya Yala.* Popayán, Colombia: Editorial Universidad del Cauca, 2014.

Evers, Larry, and Felipe Molina. *Yaqui Deer Songs Maso Bwikam: A Native American Poetry.* Tucson: Sun Tracks and University of Arizona Press, 1987.

Farrington, Lisa E. *Creating Their Own Image: The History of African American Women Artists.* Oxford: Oxford University Press, 2005.

Felbab-Brown, Vanda. "The Wall: The Real Costs of a Barrier Between the United States and Mexico." Brookings Institution, August 2017. Accessed June 25, 2018. https://www.brookings.edu/essay/the-wall-the-real-costs-of-a-barrier-between-the-united-states-and-mexico/.

Fernández, Justino. "Coatlicue: Estética del arte/indígena antiguo." In *Estética del arte mexicano/Coatlicue/El Retablo de los Reyes/el hombre*, 25–165. México City: Universidad Nacional Autónoma de México/Instituto de Investigaciones Estéticas, 1990.

Ferriss, Susan, and Ricardo Sandoval. *The Fight in the Fields: Cesar Chavez and the Farmworkers Movement.* San Diego, CA: Harcourt, 1997.

Flores-Turney, Camille. "Dressing *La Conquistadora* with Care and Devotion." *La Herencia del Norte* (Summer 1994): 31–33.

Furst, Peter T. *Visions of a Huichol Shaman.* Philadelphia: University of Pennsylvania Museum of Archaeology and Anthropology, 2003.

García Icazbalceta, Joaquin, ed. "*Historia de los mexicanos por sus pinturas.*" In *Nueva colección de documentos para la historia de México*, vol. 3, 228–63. México: Francisco Díaz de León, 1891.

Garza, Aimee Villarreal. "The Fabric of Devotion: Votive Vestments, Hidden Ministries, and the Making of Hispano Religious Traditions in Santa Fe, New Mexico." Master's thesis, University of Colorado, Boulder, 2007.

Glassberg, Josie. "Mother Lands: Consuelo Jimenez Underwood." *Reno News and Review*, March 5, 2015. https://www.newsreview.com/reno/mother-lands/content?oid=16453804.

Goeman, Mishuana. *Mark My Words: Native Women Mapping Our Nations.* Minneapolis: University of Minnesota Press, 2013.

Goldman, Shifra. "When the Earth(ly) Saints Come Marching In: The Life and Art of Santa Barraza." In *Santa Barraza, Artist of the Borderlands*, edited by María Herrera-Sobek, 51–68. College Station: Texas A&M University Press, 2001.

Gómez-Quiñonez, Juan. *Roots of Chicano Politics, 1600–1940.* Albuquerque: University of New Mexico Press, 1994.

Gonzales, Patrisia. *Red Medicine: Traditional Indigenous Rites of Birthing and Healing.* Tucson: University of Arizona Press, 2012.

González, Deena J. *Refusing the Favor: The Spanish-Mexican Women of Santa Fe, 1820–1880.* New York: Oxford University Press, 1999.

González, Jennifer A. *Subject to Display: Reframing Race in Contemporary Installation Art*. Cambridge, MA: MIT Press, 2008.

Gordon, Beverly. *Textiles: The Whole Story, Uses, Meanings, Significance*. New York: Thames and Hudson, 2011.

Gostelow, Mary. "Blackwork." In *Mary Gostelow's Embroidery Book*, 34–38. New York: E. P. Dutton, 1979.

Gouma-Peterson, Thalia. *Miriam Schapiro: Shaping the Fragments of Art and Life*. New York: Harry N. Abrams, 1999.

Grandin, Greg. "The Militarization of the Southern Border Is a Long-Standing American Tradition." North American Congress on Latin America (NACLA). January 17, 2019. Accessed September 10, 2021. https://nacla.org/blog/2019/01/17/militarization-southern-border-long-standing-american-tradition.

Griffin-Pierce, Trudy. "The Yaqui." In *Native Peoples of the Southwest*, 205–31. Albuquerque: University of New Mexico Press, 2000.

Griffith, Jim. "El Santo Niño de Atocha." In *Saints of the Southwest*, 1. Tucson, AZ: Rio Nuevo Publishers, 2000.

Grimes, Ronald L. *Symbol and Conquest: Public Ritual and Drama in Santa Fe, New Mexico*. Ithaca, NY: Cornell University Press, 1976.

Griswold del Castillo, Richard, Teresa McKenna, and Yvonne Yarbro-Bejarano, eds. *Chicano Art: Resistance and Affirmation, 1965–1985*. Los Angeles: Wight Art Gallery, University of California, Los Angeles, 1991. Exhibition catalog.

Gunn Allen, Paula. *The Sacred Hoop: Recovering the Feminine in American Indian Traditions*. Boston: Beacon, 1992.

Gustafson, Paula. *Salish Weaving*: Vancouver, BC, Canada: Douglas and McIntyre, 1980.

Gutiérrez y Muhs, Gabriella. "Rebozos, Our Cultural Blankets." *Voces: A Journal of Chicana/Latina Studies* 3, nos. 1–2 (Spring 2001): 134–49.

Hampton, Dave. *San Diego's Craft Revolution: From Post-War Modern to California Design*. San Diego: Mingei International Museum, 2011.

Harlan, Theresa, and Jolene Rickard. *Watchful Eyes: Native American Women Artists*. Phoenix. AZ: Heard Museum, 1994.

Harley, J. B. "Deconstructing the Map," *Passages*, no. 3 (1992): 10–13. Accessed September 10, 2021. http://hdl.handle.net/2027/spo.4761530.0003.008. Reprinted from *Cartographica* 26, no. 2 (Spring 1989): 1–20.

Harley, J. B. "Maps, Knowledge, and Power." In *The New Nature of Maps: Essays in the History of Cartography*, edited by Paul Laxton, 51–82. Baltimore: Johns Hopkins University Press, 2001.

Harley, J. B., and David Woodward. "Concluding Remarks." In *The History of Cartography*, vol. 1, edited by J. B. Harley and David Woodward, 502–9. Chicago: University of Chicago Press, 1987.

Hartley, George. "Chican@ Indigeneity, the Nation-State, and Colonialist Identity Formations." In *Comparative Indigeneities of the Américas: Towards a Hemispheric Approach*, edited by M. Bianet Castellanos, Lourdes Gutiérrez Nájera, and Arturo J. Aldama, 53–66. Tucson: University of Arizona Press, 2012.

Harvey, P. D. A. "Local and Regional Cartography in Medieval Europe." In *The History of Cartography*, vol. 1, edited by J. B. Harley and David Woodward, 464–501. Chicago: University of Chicago Press, 1987.

Hauseur, Krystal R. "The Crafted Abstraction of Ruth Asawa, Kay Sekimachi, and Toshiko Takaezu." In *American Women Artists 1935–1970: Gender, Culture and Politics*, edited by Helen Langa and Paula Wistozki, 145–64. London: Routledge, 2016.

Heiskanen, Benita. "Ni Una Más, Not One More: Activist-Artistic Responses to the Juárez Femicides." *JOMEC Journal: Journalism, Media, and Cultural Studies* 3 (2013): 1–21.

Held, Shirley E. *Weaving: A Handbook of the Fiber Arts*. 3rd ed. Belmont, CA: Wadsworth, 1999.

Heller, Barbara, Anthea Mallinson, Ruth Scheuing, eds. *Making a Place for Tapestry Symposium 1993*. Vancouver, BC, Canada: British Columbia Society of Tapestry Artists, Canadian Craft Museum, 1993.

Herrera Rodríguez, Celia. *Cositas Quebradas*. Performance in Medford, MA, 1999, and Santa Clara, California, 2000. Text of the performance made available by the artist.

Huber, Brad R., and Alan R. Sandstrom, eds.

Mesoamerican Healers. Austin: University of Texas, 2001.

Idaho State University Department of Art. "Works of Visiting Artist Consuelo Underwood to be Displayed at ISU in Pocatello." *The Jhub*, April 27, 2015. Accessed July 25, 2019. http://thejhub.com /works-of-visiting-artist-consuelo-underwood -to-be-displayed-at-isu-in-pocatello/.

Isacson, Adam. "22 Amazing Things You Can Do for the Cost of a Few Miles of Border Wall." *wola*, January 9, 2018. Accessed June 17, 2018. https://www.wola.org/analysis/23-amazing -things-can-cost-miles-border-wall/.

Jacob, Christian. *The Sovereign Map: Theoretical Approaches in Cartography throughout History*. Translated by Tom Conley, edited by Edward H. Dahl. Chicago: University of Chicago Press, 2006.

Jimenez Underwood, Consuelo. "Artist Talk: Consuelo J. Underwood." Lecture at 108 Contemporary, Tulsa, OK, June 2, 2018.

Jimenez Underwood, Consuelo. "Consuelo Jimenez Underwood." Artist website. Accessed September 13, 2021. http://www.consuelojunderwood .com/.

Jimenez Underwood, Consuelo. "ISU Cultural Events Committee Presents: Consuelo Jimenez Underwood." Lecture delivered at Idaho State University, Pocatello, April 27, 2015.

Jimenez Underwood, Consuelo. "Political Threads: A Personal History." Textile Arts Council lecture, De Young Museum, April 20, 2013. Recorded with permission by Laura E. Pérez.

Jimenez Underwood, Consuelo. "Rebozos de la Frontera: Día/Noche." Artist website. http:// www.consuelojunderwood.com/rebozos-de-la -frontera.html.

Jimenez Underwood, Consuelo. "Threads from Borderlandia." Artist talk presented at the University of California, Los Angeles, Chicano Resource Center, November 6, 2014.

Jimenez Underwood, Consuelo. "UNDOCUMENTED NOPAL.2525." Unpublished artist statement, 2019.

Jimenez Underwood, Consuelo (#cju.art.threads). "A new warp 4 the Wind." Instagram photo, October 22, 2019. https://www.instagram.com /p/B37MiMnpgjE/.

Kaplan, Wendy. "America: The Quest for Democratic Design." In *The Arts and Crafts Movement in Europe and America: Design for the Modern World*, by Wendy Kaplan, 246–82. London: Thames and Hudson, 2004.

Kaplan, Wendy. *"The Art That Is Life": The Arts and Crafts Movement in America, 1875–1920*. Boston: Little, Brown, 1998.

Kaplan, Wendy. "Introduction: 'Living in a Modern Way.'" In *California Design, 1930–1965: Living in a Modern Way*, edited by Wendy Kaplan, curated by Wendy Kaplan and Bobbye Tigerman, 27–60. Los Angeles: Los Angeles County Museum of Art, MIT Press, 2011.

King, Thomas. *The Truth about Stories: A Native Narrative*. Toronto: House of Anansi, 2003.

Klein, Cecelia F. "A New Interpretation of the Aztec Statue Called Coatlicue, 'Snakes Her Skirt,'" *Ethnohistory* 55, no. 2 (2008): 229–50.

Koplos, Janet, and Bruce Metcalf. *Makers: A History of American Studio Craft*. Chapel Hill: University of North Carolina Press, 2010.

Kracht, Benjamin R. "Kiowa Religion in Historical Perspective." In *Native American Spirituality: A Critical Reader*, edited by Lee Irwin, 236–55. Lincoln: University of Nebraska Press, 2000.

Kwon, Miwon. "One Place after Another: Notes on Site-Specificity." *October* 80 (1997): 85–110.

Langa, Helen, and Paula Wistozki, eds. *American Women Artists 1935–1970: Gender, Culture and Politics*. London: Routledge, 2016.

Lara, Irene. "Goddess of the Americas in the Decolonial Imaginary: Beyond the Virtuous Virgen/ Pagan Puta Dichotomy." *Feminist Studies* 34, nos. 1–2 (2008): 99–127.

Lara, Irene. "Tonanlupanisma: Re-Membering Tonantzin-Guadalupe in Chicana Visual Art." *Aztlán: A Journal of Chicano Studies* 33, no. 2 (2008): 61–90.

Latorre, Guisela. "Border Art." In *The Encyclopedia of Latinos and Latinas in the United States*, edited by Suzanne Oboler and Deena González, 209–13. Oxford: Oxford University Press, 2005.

Latorre, Guisela. "Public Interventions and Social Disruptions: David Avalos's *San Diego Donkey Cart* and Richard Lou's *The Border Door*." In *Born of Resistance: Cara a Cara Encounters with Chicana/o Visual Culture*, edited by Scott L.

Baugh and Víctor A. Sorell, 101–8. Tucson: University of Arizona Press, 2015.

Leighton, Taigen Daniel. *Faces of Compassion: Classic Bodhisattva Archetypes and Their Modern Expression—An Introduction to Mahayana Buddhism.* Revised edition. Boston: Wisdom Publications, 2012.

Leimer, Ann Marie. "Crossing the Border with *La Adelita*: Lucha-Adelucha as *Nepantlera* in Delilah Montoya's *Codex Delilah*." *Chicana/Latina Studies: The Journal of Mujeres Activas en Letras y Cambio Social* 5, no. 2 (2006): 12–59.

Leimer, Ann Marie. "Cruel Beauty, Precarious Breath: Visualizing the US-Mexico Border." In *Border Crossings: A Bedford Spotlight Reader*, edited by Catherine Cucinella, 222–33. Boston: Bedford/St. Martin's, 2016.

Leimer, Ann Marie. "Cruel Beauty, Precarious Breath: Visualizing the U.S.-Mexico Border." In *New Frontiers in Latin American Borderlands*, edited by Leslie G. Cecil, 73–84. Newcastle upon Tyne, UK: Cambridge Scholars, 2012.

Leimer, Ann Marie. "*La Conquistadora*: A Conquering Virgin Meets Her Match." In *Religion and the Arts* 18, nos. 1–2 (2014): 245–68.

Leimer, Ann Marie. "Quilting Knowledge, Weaving Justice: Sites of Struggle and Survival in the Works of Consuelo Jimenez Underwood." Talk presented at the National Association for Chicana and Chicano Studies Annual Conference, Pasadena, California, March 31, 2011.

Leimer, Ann Marie. "*Vidrio y hilo*: Two Stories of the Border." *Journal of Latino/Latin American Studies* 10, no. 1 (2019): 94–117.

León, Luis D. *La Llorona's Children: Religion, Life, and Death in the U.S.-Mexico Borderlands.* Berkeley: University of California Press, 2004.

León-Portilla, Miguel. *Bernardino de Sahagún: First Anthropologist.* Translated by Mauricio J. Mixco. Norman: University of Oklahoma Press, 2002.

León-Portilla, Miguel. *Endangered Cultures.* Dallas: Southern Methodist University Press, 1990.

León-Portilla, Miguel. *Tonatzin Guadalupe: Pensamiento náhuatl y mensaje cristiano en el "Nican mopohua."* México: Fondo de Cultural Económica, 2000.

Licona, Adela C. "(B)orderlands' Rhetorics and Representations: The Transformative Potential of Feminist Third-Space Scholarship and Zines." *NWSA Journal* 17, no. 2 (2005): 104–29.

Locke, Adrian. "Exhibitions and Collectors of Pre-Hispanic Mexican Artefacts in Britain." In *Aztecs*, edited by Eduardo Matos Moctezuma and Felipe Solís Olguín, 80–91. London: Royal Academy of Arts, 2002.

Lonetree, Amy. *Decolonizing Museums: Representing Native America in National and Tribal Museums.* Chapel Hill: University of North Carolina Press, 2012.

Longeaux y Vásquez, Enriqueta. "The Women of La Raza." *Chicana Feminist Thought: The Basic Historical Writings*, edited by Alma M. García, 29–31. London: Routledge, 1997.

Lopez, Annie. "Artist Statement: An Altered Point of View." *Chicana/Latina Studies* 16, no. 2 (Spring 2017): 12–20.

López Austin, Alfredo. "Aztec." In *The Oxford Encyclopedia of Mesoamerican Culture: The Civilizations of Mexico and Central America*, vol. 1, edited by Davíd Carrasco, 68–72. New York: Oxford University Press, 2000.

López Austin, Alfredo. *Cuerpo humano e ideología: las concepciones de los antiguos nahuas*, vol. 1. 3rd ed. México, D.F.: Universidad Nacional Autónoma de México, Instituto de Investigaciones Antropológicas, 2004.

Lou, Richard A. "The Border Door: Complicating a Binary Space." In *Born of Resistance: Cara a Cara Encounters with Chicana/o Visual Culture*, edited by Scott L. Baugh and Víctor A. Sorell, 83–93. Tucson: University of Arizona Press, 2015.

Lugones, María. "Heterosexualism and the Colonial/Modern Gender System." *Hypatia* 22, no. 1 (2007): 186–209.

Lugones, María. "Toward a Decolonial Feminism." *Hypatia* 25, no. 4 (2010): 742–59.

MacCarthy, Fiona. *Anarchy & Beauty: William Morris and His Legacy, 1860–1960.* London: National Portrait Gallery Publications, 2014.

Macias, Ysidro Ramon. *The Domingo Martinez Paredez Mayan Reader.* Self-published, Kindle Direct Publishing, 2017.

Maciel, Davíd, and María Herrea-Sobek, eds. *Culture across Borders: Mexican Immigration and Popular Culture.* Tucson: University of Arizona Press, 1998.

MacLean, Hope. *The Shaman's Mirror: Visionary Art of the Huichol.* Austin: University of Texas Press, 2012.

Making a Place for Tapestry Symposium. The British Columbia Society of Tapestry Artists and the Canadian Craft Museum, Vancouver, BC, Canada, September 17–19, 1993.

Malagamba-Ansótegui, Amelia. *Caras vemos, corazones no sabemos: Faces Seen, Hearts Unknown: The Human Landscape of Mexican Migration.* Notre Dame, IN: Snite Museum of Art, University of Notre Dame, 2006. Exhibition catalog.

Manzanedo, Hector García. "Afterword: The Rebozo as Cultural Icon." In *Rebozos,* by Carmen Tafolla and Catalina Gárate García, 37–41. San Antonio: Wings Press, 2012.

"Margarita Cabrera." In *Latinx: Artistas de Tejas.* Lubbock, TX: Louis Hopkins Underwood Center for the Arts, 2017. Exhibition catalog.

Martineau, Jarrett, and Eric Ritskes. "Fugitive Indigeneity: Reclaiming the Terrain of Decolonial Struggle through Indigenous Art." *Decolonization: Indigeneity, Education and Society* 3, no. 1 (2014): i–xii. Accessed July 22, 2018. https://jps.library.utoronto.ca/index.php/des/article/view/21320.

Martinez-Cruz, Paloma. *Women and Knowledge in Mesoamerica: From East L. A. to Anahuac.* Tucson: University of Arizona Press, 2001.

Matos Moctezuma, Eduardo. *Estudios mexicas.* Vol. 1, book 4, *Obras maestras del Templo Mayor.* México: El Colegio Nacional, 2005.

Matos Moctezuma, Eduardo. *Great Temple of the Aztecs: Treasures of Tenochtitlan.* Translated by Doris Heyden. London: Thames and Hudson, 1988.

Matos Moctezuma, Eduardo, and Felipe Solís Olguín. *Aztecs.* London: Royal Academy of Arts, 2002.

McCallum, Ray. "The History of Beads." *Saskatchewan Indian* 27, no. 2 (June 1997): 20–21, 26.

McClintock, Anne. *Imperial Leather: Race, Gender and Sexuality in the Colonial Context.* New York: Routledge, 1995.

Medina, Lara. "Nepantla Spirituality: Negotiation Multiple Religious Identities among U.S. Latina." In *Rethinking Latino(a) Religion and Identity,* edited by Miguel A. De la Torre and Gastón Espinosa. Cleveland, OH: Pilgrim Press, 2006: 248–66.

Medina Miranda, Héctor M. "Las personalidades del maíz en la mitología *wixarika* o cómo las mazorcas de los ancestros se transformaron en peyotes." *Revista de El Colegio de San Luis* 3, no. 5 (2013): 164–83.

Meier, Matt S., and Feliciano Ribera. *Mexican Americans/American Mexicans: From Conquistadors to Chicanos.* New York: Hill and Wang, 1993.

Mesa-Bains, Amalia. "A Chicana Aesthetic: Stitching Worlds Together." Unpublished manuscript, draft dated January 16, 2017. Microsoft Word file.

Mesa-Bains, Amalia. "A Tear in the Curtain: *Hilos y Cultura* in the Art of Consuelo Jimenez Underwood." In *Tortillas, Chiles and Other Border Things: New Work by Consuelo Jimenez Underwood,* n.p. San Jose, CA: MACLA, 2006.

Mignolo, Walter D. "About: Decolonial AestheTics/AestheSis." *Transnational Decolonial Institute,* December 9, 2013. https://transnationaldecolonialinstitute.wordpress.com/about-2/.

Mignolo, Walter D. *Coloniality, Subaltern Knowledges, and Border Thinking: Local Histories/Global Designs.* Princeton, NJ: Princeton University Press, 2000.

Mignolo, Walter D. *The Darker Side of Western Modernity: Global Futures, Decolonial Options.* Durham, NC: Duke University Press, 2011.

Mignolo, Walter D. *Local Histories/Global Designs. Coloniality, Subaltern Knowledges, and Border Thinking.* Princeton, NJ: Princeton University Press, 2000.

Mignolo, Walter D. "Putting the Americas on the Map: Cartography and the Colonization of Space." In *The Darker Side of the Renaissance,* 259–314. Ann Arbor: University of Michigan Press, 1995.

Mignolo, Walter D., and Rolando Vázquez. "Decolonial AestheSis: Colonial Wounds/Decolonial Healings." *SocialText: Periscope,* July 15, 2013. Accessed January 5, 2018. https://socialtextjournal.org/periscope_article/decolonial-aesthesis-colonial-woundsdecolonial-healings/.

Miller, Casey, and Kate Swift. *Words and Women.* Garden City, NY: Anchor Press/Doubleday, 1976.

Miller, Mary Ellen. *The Art of Mesoamerica From*

Olmec to Aztec. 6th ed. New York: Thames and Hudson, 2019.

Miller, Mary Ellen, and Karl Taube. "Coatlicue." In *An Illustrated Dictionary of the Gods and Symbols of Ancient Mexico and the Maya*, 64. New York: Thames and Hudson, 1997.

Miller, Mary Ellen, and Karl Taube. "Huitzilopochtli." In *An Illustrated Dictionary of the Gods and Symbols of Ancient Mexico and the Maya*, 93–96. New York: Thames and Hudson, 1997.

Miller, Mary Ellen, and Karl Taube. "Ometeotl." In *An Illustrated Dictionary of the Gods and Symbols of Ancient Mexico and the Maya*, 167–82. New York: Thames and Hudson, 1997.

Million, Dian. *Therapeutic Nations: Healing in an Age of Indigenous Human Rights.* Tucson: University of Arizona Press, 2013.

Miranda, Deborah A. *Bad Indians: A Tribal Memoir.* Berkeley, CA: Heyday, 2013.

Mirzoeff, Nicholas. *The Right to Look: A Counterhistory of Visuality.* Durham, NC: Duke University Press, 2011.

Mongabay. "Judge OKs Waiving Environmental Laws to Build U.S.-Mexico Borderwall." March 1, 2018. Accessed June 25, 2018. https://news .mongabay.com/2018/03/judge-oks-waiving -environmental-laws-to-build-u-s-mexico -border-wall/.

Monsiváis, Carlos. *Mexican Postcards.* Translated by John Kraniauskas. London: Verso, 1997.

Montoya, Delilah. *San Sebastiana: Angel de la Muerte.* Accessed August 4, 2004. http://www.uh.edu /-dmontoy2/. DVD made available by artist.

Moraga, Cherríe. "Codex Xeri: El Momento Histórico." In *The Chicano Codices: Encountering Art of the Americas*, by Patricia Draher, 20–22. San Francisco: Mexico Museum, 1992. Exhibition catalog.

Moraga, Cherríe L. "La Red Xicana Indígena," People, Places & Política. Accessed January 11, 2022. https://cherriemoraga.com/index.php /la-comunidad-y-politica/14-la-red.

Moraga, Cherríe. *Loving in the War Years.* 2nd ed. Boston: South End, 2000.

Moraga, Cherríe L., and Gloria E. Anzaldúa, eds. *This Bridge Called My Back: Writings by Radical Women of Color.* 3rd ed. Berkeley, CA: Third Woman Press, 2002.

Nathan, Harriet, Kay Sekimachi Stocksdale, and Signe Mayfield. *The Weaver's Weaver: Explorations in Multiple Layers and Three-Dimensional Fiber Art.* Fiber Arts Oral History Series. Berkeley: Regional Oral History Office, The Bancroft Library, University of California, 1996.

Navarrete, Frederico. "Ruins of the State." In *Indigenous Peoples and Archaeology in Latin America*, 39–53. London: Routledge, 2016.

Navarro, Jenell. "The Promise of the Jaguar: Indigeneity in Contemporary Chican@ Graphic Art." *rEvista: A Multi-media and Multi-genre e-Journal for Social Justice* 5, no. 2 (2017): 23–40.

Nelson, Melissa K., ed. *Original Instructions: Indigenous Teaching for a Sustainable Future.* Rochester, VT: Bear and Co., 2008.

Noriega, Chon. "Margarita Cabrera." In *Phantom Sightings: Art after the Chicano Movement*, 120–23. Los Angeles: Los Angeles County Museum of Art and the University of California Press, 2008. Exhibition catalog.

Olko, Justyna. *Insignia of Rank in the Nahua World: From the Fifteenth to the Seventeenth Century.* Boulder: University Press of Colorado, 2014.

Olmos, Gabriela. "The Hidden Arts of the Rebozo." *Artes de México*, no. 90 (2008): 87–88.

"Oral History Interview with Consuelo Jimenez Underwood, 2011 July 5–6." Archives of American Art, Smithsonian Institution. Accessed May 28, 2018. www.aaa.si.edu/collections/interviews /oral-history-interview-consuelo-jimenez -underwood-15964.

"Oral History Interview with Ferne Jacobs, 2005 August 30–31." Archives of American Art, Smithsonian Institution. Accessed June 15, 2018. https://www.aaa.si.edu/collections/interviews /oral-history-interview-ferne-jacobs-11804.

"Oral History Interview with Gerhardt Knodel, 2004 August 3." Archives of American Art, Smithsonian Institution. Accessed July 8, 2019. https://www.aaa.si.edu/collections/interviews /oral-history-interview-gerhardt-knodel-12740.

"Oral History Interview with Glen Kaufman, 2008 January 22–February 23." Archives of American Art, Smithsonian Institution. Accessed August 20, 2019. https://www.aaa .si.edu/collections/interviews/oral-history -interview-glen-kaufman-16155.

"Oral History Interview with Marianne Strengell, 1982 January 8–December 16." Archives of American Art, Smithsonian Institution. Accessed July 8, 2019. https://www.aaa.si.edu /collections/interviews/oral-history-interview -marianne-strengell-12411.

"Oral History Interview with Ted Hallman, 2006 May 23–2008 June 3." Archives of American Art, Smithsonian Institution. Accessed July 8, 2019. https://www.aaa.si.edu/collections/interviews /oral-history-interview-ted-hallman-15975.

Padrón, R. "Mapping Plus Ultra: Cartography, Space, and Hispanic Modernity." *Representations* 79, no. 1 (2002): 28–60.

Parker, Rozsika. *The Subversive Stitch: Embroidery and the Making of the Feminine.* London: I. B. Tauris, 2010.

Parker, Rozsika, and Griselda Pollock. *Old Mistresses: Women, Art, and Ideology.* London: I. B. Tauris, 2013.

Paul, Carole, ed. *The First Modern Museums of Art: The Birth of an Institution in 18th- and Early 19th-Century Europe.* Los Angeles: J. Paul Getty Museum, 2012.

Peluso, Nancy Lee. "Whose Woods Are These? Counter-mapping Forest Territories in Kalimantan, Indonesia." *Antipode* 27, no. 4 (1995): 383–406.

Pérez, Emma. *The Decolonial Imaginary: Writing Chicanas into History.* Bloomington: Indiana University Press, 1999.

Pérez, Laura E. "Body, Dress." In *Chicana Art: The Politics of Spiritual and Aesthetic Altarities,* 50–90. Durham, NC: Duke University Press, 2007.

Pérez, Laura E. *Chicana Art: The Politics of Spiritual and Aesthetic Altarities.* Durham, NC: Duke University Press, 2007.

Pérez, Laura E. "Enrique Dussel's *Etica de la liberación,* U. S. Women of Color Decolonizing Practices, and Coalitional Practices amidst Difference." *Qui Parle: Critical Humanities and Social Sciences* 18, no. 2 (2010): 121–46.

Pérez, Laura E. *Eros Ideologies: Writings on Art, Spirituality, and the Decolonial.* Durham, NC: Duke University Press, 2019.

Pérez, Laura E. "Rethinking Immigration with Art." *Tikkun* 28, no. 3 (2013): 38–41.

Pérez, Laura E. "Spirit Glyphs: Reimagining Art and Artist in the Work of Chicana Tlamatinime." *MFS Modern Fiction Studies* 44, no. 1 (1998): 36–76.

Pérez, Laura E. "Writing on the Social Body: Dresses and Body Ornamentation in Contemporary Chicana Art." In *Decolonial Voices: Chicana and Chicano Cultural Studies in the 21st Century,* edited by Arturo J. Aldama and Naomi H. Quiñonez, 30–63. Bloomington: Indiana University Press, 2002.

Pérez, Laura E. "Writing with Crooked Lines." In *Fleshing the Spirit: Spirituality and Activism in Chicana, Latina, and Indigenous Women's Lives,* edited by Elisa Facio and Irene Lara, 23–33. Tucson: University of Arizona Press, 2014.

Peterson, Jeanette Favrot. "Creating the Virgin of Guadalupe: The Cloth, the Artist, and Sources in Sixteenth-Century New Spain." *The Americas* 61, no. 4 (2005): 571–610.

Peterson, Jeanette Favrot. "The Virgin of Guadalupe: Symbol of Conquest or Liberation?" *Art Journal* 51, no. 4 (Winter 1992): 39–47.

Picq, Manuela. "Maya Weavers Propose a Collective Intellectual Property Law." Translated by Daniel Dayley. *Intercontinental Cry Magazine,* March 14, 2017. https://intercontinentalcry.org /maya-weavers-propose-collective-intellectual -property-law.

Powell, Melissa S., and C. Jill Grady, eds. *Huichol Art and Culture: Balancing the World.* Santa Fe: Museum of New Mexico Press, 2010.

Prescott, William Hickling, and C. Harvey Gardiner. *The History of the Conquest of Mexico.* Chicago: University of Chicago Press, 1966.

Public Radio International. "U.S. Border Fence Skirts Environmental Review." *Border Wall in the News* blog, August 12, 2013. http://borderwall inthenews.blogspot.com/.

Ramos, E. Carmen. "Margarita Cabrera." In *Our America: The Latino Presence in American Art,* 188–221. Washington, DC: Smithsonian American Art Museum, 2014. Exhibition catalog.

Ramos-Escandón, Carmen. "La diferenciación de género en el trabajo textil mexicano en la época colonial." *Boletín americanista* 50 (2000): 243–65.

"Remarks by Secretary of Homeland Security Jeh Johnson: 'Border Security in the 21st Century' – As Delivered." Homeland Security website.

Released October 9, 2014. https://www.dhs.gov/news/2014/10/09/remarks-secretary-homeland-security-jeh-johnson-border-security-21st-century.

Rivera-Salgado, Gaspar. "From Hometown Clubs to Transnational Social Movement: The Evolution of Oaxacan Migrant Associations in California." *Social Justice* 42, nos. 3–4 (2015): 118–36.

Rodríguez, Sylvia. *The Matachines Dance: Ritual Symbolism and Interethnic Relations in the Upper Río Grande Valley*. Albuquerque: University of New Mexico Press, 1996.

Roldán, Nayeli. "La falta de registro de derechos de autor de bordados indígenas permite que grandes marcas plagien sus diseños." *Animal Político*, February 26, 2018. https://www.animalpolitico.com/2018/02/plagio-ropa-indigenas-marcas/.

Román-Odio, Clara. "Colonial Legacies and the Politics of Weaving in Consuelo Jiménez Underwood's Fiber Art." Paper presented at "Textiles and Politics," the Textile Society of America's 13th Biennial Symposium, Washington, DC, September 18–21, 2012. American Tapestry Alliance website. Accessed December 18, 2012. https://americantapestryalliance.org/tapestry-education/educational-articles-on-tapestry-weaving/political-strings-tapestry-seen-and-unseen/colonial-legacies-and-the-politics-of-weaving-in-consuelo-jimenez-underwoods-fiber-art/.

Román-Odio, Clara. "Queering the Sacred: Love as Oppositional Consciousness in Alma López's Visual Art." In *Our Lady of Controversy: Alma López's Irreverent Apparition*, edited by Alicia Gaspar de Alba and Alma López, 120–47. Austin: University of Texas Press, 2011.

Román-Odio, Clara. *Sacred Iconographies in Chicana Cultural Productions*. New York: Palgrave MacMillan, 2013.

Román-Odio, Clara. "Undocumented Borderlands: Sites of Struggle and Spiritual Survival in Consuelo Jimenez Underwood's Visual Art." In *Consuelo Jimenez Underwood: Undocumented Borderlands*, leaflet for *Undocumented Borderlands* exhibition, 2–4. Fresno: California State University Fresno, Conley Art Gallery, 2011.

Román-Odio, Clara, and Marta Sierra. "Introduction: Transnational Borderlands in Women's Global Networks: The Marking of Cultural Resistance." *Transnational Borderlands in Women's Global Networks: The Making of Cultural Resistance*, edited by Clara Román-Odio and Marta Sierra, 3–19. London: Palgrave MacMillan, 2011.

Romo, Terezita. "Weaving Politics: The Art of Consuelo Jiménez-Underwood." *Surface Design Journal* 29, no. 1 (2004): 24–29.

Rowe, Peter. "Repairing Calif. Border Wall Is a Daily Endeavor for Officers." *San Diego Union-Tribune*, May 18, 2016. Police 1 by Lexipol. Accessed May 23, 2016. https://www.policeone.com/patrol-issues/articles/182562006-Repairing-Calif-border-wall-is-a-daily-endeavor-for-officers/.

Rowland, Ingrid, and Noah Charney. *The Collector of Lives: Giorgio Vasari and the Invention of Art*. New York: W. W. Norton, 2017.

Ruiz-Healy, Patricia. *Margarita Cabrera: Collaborative Work*. San Francisco: Blurb, 2018.

Saldaña-Portillo, María Josefina. *Indian Given: Racial Geographies across Mexico and the United States*. Durham, NC: Duke University Press, 2016.

Sandoval, Chela. "Dissident Globalizations, Emancipatory Methods, Social-Erotics." In *Queer Globalizations: Citizenship and the Afterlife of Colonialism*, edited by Arnaldo Cruz-Malavé and Martin F. Manalansan IV, 20–32. New York: New York University Press, 2002.

Sandoval, Chela. *Methodology of the Oppressed*. Minneapolis: University of Minnesota Press, 2000.

Sandoval, Chela. "Re-Entering CyberSpace: Sciences of Resistance." *Dispositio* 19, no. 46 (1994): 75–93.

Sandoval, Chela, and Guisela Latorre. "Chicano/a Artivism: Judy Baca's Digital Work with Youth of Color." In *Learning Race and Ethnicity*, edited by Anna Everett, 81–108. Cambridge, MA: MIT Press, 2008.

Santos, Georgina. "Entre tramas y urdimbres." Bachelor's thesis, Escuela Nacional de Pintura, Escultura y Grabado, 2010.

Saranillio, Dean Itsuji. "Settler Colonialism." In *Native Studies Keywords*, edited by Stephanie Nohelani Teves, Andrea Smith, and Michelle Raheja, 284–300. Tucson: University of Arizona Press, 2015.

Sasse, Julie. *Dress Matters: Clothing as Metaphor*. Tucson, AZ: Tucson Museum of Art and Historic Block, 2017.

Sauvion, Carol, dir. *Craft in America*. "Threads" episode. Aired May 11, 2012, on PBS. http://www.craftinamerica.org/episodes/threads/.

Schaefer, Stacy B. *Huichol Women, Weavers, and Shamans*. Albuquerque: University of New Mexico Press, 2015.

Schaefer, Stacy B. *To Think with a Good Heart: Wixárika Women, Weavers, and Shamans*. Salt Lake City: University of Utah Press, 2002.

Schaefer, Stacy B., and Peter T. Furst, eds. *People of the Peyote: Huichol Indian History, Religion and Survival*. Albuquerque: University of New Mexico Press, 1996.

Scheid, John, and Jesper Svenbro. *The Craft of Zeus: Myths of Weaving and Fabric*. Revealing Antiquities Series. Cambridge, MA: Harvard University Press, 2001.

Schele, Linda, and Julia Guernsey Kappelman. "What the Heck's Coatepec?" In *Landscape and Power in Ancient Mesoamerica*, edited by Rex Koontz, Kathryn Reese-Taylor, and Annabeth Headrick, 29–51. Boulder, CO: Westview, 2001.

Shanks, Ralph C., and Lisa Woo Shanks. *California Indian Baskets: San Diego to Santa Barbara and beyond to San Joaquin Valley, Mountains and Deserts*. Seattle: University of Washington Press, 2010.

Shea, Renee H. "Truth, Lies, and Memory: A Profile of Sandra Cisneros." *Poets and Writers Magazine*, September/October 2002, 31–36.

Slemon, Stephen. "The Scramble for Post-Colonialism." In *De-scribing Empire: Postcolonialism and Textuality*, edited by C. Tiffin and A. Lawson, 15–32. New York: Routledge, 1994.

Smith, Joshua Emerson. "Impact of the U.S.-Mexico Border Fence on Wetlands Is Mixed." *Los Angeles Times*, May 19, 2016. http://www.latimes.com/local/lanow/la-me-ln-border-fence-wetlands-20160519-snap-story.html.

Smith, T'ai. *Bauhaus Weaving Theory: From Feminine Craft to Mode of Design*. Minneapolis: University of Minnesota Press, 2014.

Solís Olguín, Felipe. "Art at the Time of the Aztecs." In *Aztecs*, 56–63. London: Royal Academy of Arts, 2002.

Sorell, Victor A. "Behold Their Natural Affinities: Revelations about the Confluence of Chicana Photography and Altarmaking." In *Imágenes e Historias/Images and Histories: Chicana Altar-Inspired Art*, edited by Constance Cortez, 21–28. Medford, MA: Tufts University Gallery and Santa Clara University, 1999.

"SPACE IN BETWEEN." Florezca: Creatively Changing the World. Accessed September 12, 2021. http://www.florezcacreativa.com/space.html.

Spanish Colonial Arts Society. *El Santuario de Chimayo*. Santa Fe, NM: Ancient City Press, 1956.

Spicer, Edward H. *The Yaquis: A Cultural History*. Tucson: University of Arizona Press, 1980.

Spilman, Karen. "Guide to the Records of *Fiberarts* Magazine." Colorado State University Archives and Special Collections, 2014. Accessed July 11, 2020. https://lib2.colostate.edu/archives/finding aids/manuscripts/mfam.html.

Spivak, Gayatri. "Can the Subaltern Speak?" In *Marxism and the Interpretation of Culture*, edited by Cary Nelson and Lawrence Grossberg, 271–313. Urbana: Illinois University Press, 1988.

Stoeltie, Barbara, René Stoeltie, and Isabelle de Borchgrave. *Paper Illusions: The Art of Isabelle de Borchgrave*. New York: Abrams, 2008.

Stoler, Ann Laura. *Carnal Knowledge and Imperial Power: Race and the Intimate Colonial Rule*. Berkeley: University of California Press, 2010.

Tafolla, Carmen, and Catalina Gárate García. *Rebozos*. San Antonio: Wings Press, 2012.

Tamez, Margo. "Space, Position and Imperialism in South Texas." *Chicana/Latina Studies* 7, no. 2 (Spring 2008): 112–21.

Taube, Karl. "Aztec Mythology." In *Aztec and Maya Myths*, 2nd ed., 31–50. Austin: University of Texas Press, 1995.

Tejada, Roberto. *Celia Alvarez Muñoz*. Los Angeles: UCLA Chicano Studies Research Center Press, 2009.

Transnational Decolonial Institute (TDI+). *Decolonial Aesthetics (I)*. 2011. Accessed January 5, 2018. https://transnationaldecolonialinstitute.wordpress.com/decolonial-aesthetics/.

Tuck, Eve, and K. Wayne Yang. "Decolonization Is Not a Metaphor." *Decolonization: Indigeneity, Education and Society* 1, no. 1 (2012): 1–40.

Turok, Marta. "Some National Goods in 1871: The

Rebozo." Presented at "Crosscurrents: Land, Labor, and the Port," Textile Society of America's 15th Biennial Symposium, Savannah, Georgia, October 19–23, 2016.

Valdez, Luis. *Pensamiento Serpentino: A Chicano Approach to the Theater of Reality*. n.p.: Cucaracha, 1973.

Van Schoik, Rick. "Conservation Biology in the U.S.-Mexican Border Region." *World Watch*, 17, no. 6 (2004): 36–39.

Vasari, Giorgio. *The Lives of the Artists*. Translated with an introduction and notes by Julia Conway Bondanella and Peter Bondanella. Oxford World's Classics. Oxford: Oxford University Press, 1991.

Venegas, Sybil. "Conditions for Producing Chicana Art." *ChismeArte* 1, no. 4 (1977): 2–4.

Villanueva, Margaret A. "From Calpixqui to Corregidor: Appropriation of Women's Cotton Textile Production in Early Colonial Mexico." *Latin American Perspectives* 12, no. 1 (1985): 17–40.

Waldron, Rachel. "Undocumented Borderlands Featured in the Conley Art Gallery." *The Collegian*, September 13, 2011. http://collegian.csufresno.edu/2011/09/13/undocumented-borderlands-featured-at-the-conley-art-gallery/#.Wyvw3fZFxEY.

Warhus, Mark. *Another America: Native American Maps and the History of Our Land*. New York: St. Martin's Press, 1997.

Weiner, Annette B., and Jane Schneider. *Cloth and the Human Experience*. Smithsonian Series in Ethnographic Inquiry. Washington, DC: Smithsonian, 1991.

Whitehead, Amy Renee. "Religious Objects and Performance: Testing the Role of Materiality." PhD diss., The Open University, Milton Keynes, UK, 2011.

Wingler, Hans M. *The Bauhaus: Weimar, Dessau, Berlin, Chicago*. Cambridge, MA: MIT Press, 1978.

Wolfe, Patrick. "Settler Colonialism and the Elimination of the Native." *Journal of Genocide Research* 8, no. 4 (2006): 387–409.

Wolfe, Patrick. *Settler Colonialism and the Transformation of Anthropology: The Politics and Poetics of an Ethnographic Event*. London: Cassell, 1999.

Yanes, Emma. "The Scented Rebozo as Death Shroud." *Artes de México*, no. 90 (2008): 80–82.

Yanes, Emma. "Traditional Hands of Tenancingo." *Artes de México*, no. 90 (2008): 77–80.

Yarbro-Bejarano, Yvonne. "Diane Gamboa's Invasion of the Snatch: The Politics and Aesthetics of Representing Gendered Violence." *Cultural Critique* 85 (2013): 61–83.

Ybarra-Frausto, Tomás. "Cultural Context." In *Ceremony of Memory: New Expressions in Spirituality Among Hispanic American Artists*, 9–13. Santa Fe, NM: Center for Contemporary Arts of Santa Fe, 1988. Exhibition catalog.

Ybarra-Frausto, Tomás. "Rasquachismo: A Chicano Sensibility." *Chicano Art: Resistance and Affirmation, 1965-1985*, edited by Richard Griswold del Castillo, Teresa McKenna, and Yvonne Yarbro-Bejarano, 155–62. Los Angeles: Wight Art Gallery and the University of California, Los Angeles, 1991.

Yorba, Jonathan. *Arte Latino: Treasures from the Smithsonian American Art Museum*. New York: Watson-Guptill Publications and Smithsonian American Art Museum, 2001. Exhibition catalog.

Young, William. *Quest for Harmony: Native American Spiritual Traditions*. New York: Seven Bridges Press, 2002.

Zaiden, Emily. "Between the Lines: Documenting Consuelo Jimenez Underwood's Fiber Pathways." In *Mano-Made: New Expressions in Craft by Latino Artists, Consuelo Jimenez Underwood*, 12–37. Los Angeles: Craft in America Center, 2017. Exhibition catalog.

Zamudio-Taylor, Victor. "Amalia Mesa-Bains." In *Ante América*, edited by Gerardo Mosquera, Carolina Ponce de León, and Rachel Weiss, 143–48. Santa Fe de Bogotá, Colombia: Banco de la República, 1992. Exhibition catalog.

Zamudio-Taylor, Victor. "Contemporary Commentary." In *Ceremony of Spirit: Nature and Memory in Contemporary Latino Art*, 14–18. San Francisco, CA: Modern Art Museum, 1993. Exhibition catalog.

Zavala, Adriana. *Becoming Modern, Becoming Tradition: Women, Gender, and Representation in Mexican Art*. University Park: Penn State University Press, 2010.

CONTRIBUTORS

CONSTANCE CORTEZ is a professor at the School of Art and Design at the University of Texas Rio Grande Valley (UTRGV), where she holds the Marialice Shary Shivers Chair in Fine Arts. She has published and taught in three fields: pre-Columbian and colonial arts of Mexico and contemporary Chicanx art. She also is a member of the editorial board for the *Art Bulletin*, a long-established periodical published by the College Art Association. Currently, she codirects Rhizomes: Mexican American Art Since 1848, a collaboration between UTRGV and the Department of Chicano and Latino Studies at the University of Minnesota. Rhizomes is an upcoming internet platform that will link and make accessible Chicano art from library archives and museums across the United States.

KAREN MARY DAVALOS is a professor in and chair (2018–21) of the Department of Chicano and Latino Studies at the University of Minnesota, Twin Cities. She has published widely on Chicana/o art, spirituality, and museums. Among her distinctions in the field, she is the only scholar to have written two books on Chicana/o museums: *Exhibiting Mestizaje: Mexican (American) Museums in the Diaspora* (2001) and *The Mexican Museum of San Francisco Papers, 1971–2006* (2010), which won the second-place International Latino Book Award for best reference book in English. Her research and teaching interests in Chicana feminist scholarship, spirituality, art, exhibition practices, and oral history are reflected in her book *Yolanda M. López* (2008), which received honorable mentions from the National Association of Chicana and Chicano Studies in 2010 and from the International Latino Book Awards (nonfiction, arts–books in English) in 2009. As lead coeditor of *Chicana/Latina Studies: The Journal of Mujeres Activas en Letras y Cambio Social* (2003–9), she revitalized the journal from its earlier incarnation, *Voces*, into the only interdisciplinary, flagship, peer-review journal of a Latin@/x studies organization. She served as president of the board of directors of Self Help Graphics & Art, the oldest Chicana/o-Latina/o arts organization in Southern California, between 2015 and 2018, during which the legacy arts organization acquired its building. Her latest book, *Chicana/o Remix: Art and Errata since the Sixties*, is informed by life history interviews with eighteen artists, a decade of ethnographic research in southern California, and archival research examining fifty years of Chican@/x art in Los Angeles since 1963. In 2012 she received the President's Award for Art and Activism from the Women's Caucus for Art. She is codirector of Rhizomes: Mexican American Art Since 1848, an ambitious initiative that will produce a coauthored, multi-

volume, full-color book; K-16 curriculum; and a shareable, searchable online digital platform linking art collections and related documentation from libraries, archives, and museums.

CARMEN FEBLES is an assistant professor of Spanish Language and Latin American literature and cultures with a specialization in eighteenth- and nineteenth-century Mexico and Cuba. Her work examines the formation, articulation, and representation of identities and cultural practices in the literary and cultural production of geographically and culturally dislocated people in and from Latin America. She is the author of several essays on Latinx identity formation and articulation, including "Exploring the Limits of Transculturation: Pérez Firmat's 'A Cuban in Mayberry'"; "Latinidad Ambulante: Collaborative Community Formation Week by Week"; and "Universalization and Imagined Community: Transbordering in Daniel Alarcón's Lost City Radio."

MARÍA ESTHER FERNÁNDEZ is the inaugural artistic director of the Cheech Marin Center for Chicano Art and Culture of the Riverside Art Museum, which is set to open in the spring of 2022. Formerly the chief curator and deputy director of the Triton Museum of Art in Santa Clara, California, Fernández has curated numerous group and solo exhibitions, including *Xicana: Spiritual Reflections/Reflexiones Espirituales* and *Consuelo Jimenez Underwood: Welcome to Flower-Landia*. In 2019 she cocurated *Xicanx Futurity* with Carlos Jackson and Dr. Susy Zepeda at the Jan Shrem and Maria Manetti Shrem Museum of Art at the University of California, Davis. Fernández is currently working on a major retrospective, *Amalia Mesa-Bains: Archaeology of Memory*, with Dr. Laura E. Pérez. She was the recipient of a Standing Committee on Education American Association of Museums' Multicultural Fellowship and a Smithsonian Latino Museum Studies Program Fellowship, and is a member of Silicon Valley's Multicultural Arts Leadership Initiative. In 2018, Fernández received a California Arts Council grant to advance her research on curatorial practices and their impact on representation and access for the Chicanx community in the contemporary art museum. She received her BA in Chicana/o and ethnic studies from the University of California, Berkeley, and her MA in visual and critical studies from California College of the Arts in San Francisco.

CHRISTINE LAFFER changed her focus to textiles while studying architecture at the University of Illinois, Chicago. After moving to California, she pursued the study of tapestry under Jean Pierre Larochette at the San Francisco Tapestry Workshop and then held an internship at the Manufacture Nationale des Gobelins in Paris (1985). After teaching and working on tapestry commissions, she completed her MFA degree in spatial arts at San José State University (1995). Laffer has developed a body of work in low-relief sculptural tapestry, written a number of articles, presented various lectures, and assisted Carole Greene with the book *Christine Laffer: Tapestry and Transformation*.

ANN MARIE LEIMER is a professor of art at the Juanita and Ralph Harvey School of Visual Arts at Midwestern State University (MSU Texas) in Wichita Falls, Texas. Leimer received her PhD and MA from the University of Texas, Austin. Her published work has appeared in the journals *Afterimage*, *Chicana/Latina Studies*, the *Journal of Latino-Latin American Studies*, and *Religion and the Arts*, and in the books *Beyond Heritage, Border Crossings, Chican@ Critical Perspectives and Praxis, New Frontiers in Latin American Borderlands, Tina Fuentes: Marcando el relámpago, LatinX: Artistas de Tejas, Voices in Concert: In the Spirit of Sor Juana Inés de la Cruz*, and *Los Maestros: Early Explorers of Chicano Identity*. She has curated several exhibitions of Chicanx art, including *¡Adelante Siempre! Recent Work by Southern California Chicana Photographers, Chicano Photographer: The 1970s from a Chicano's Perspective*, and *Globe, AZ: A Community at the Crossroads*. Leimer serves on the National Advisory Council of the initiative Rhizomes: Mexican Art Since 1848, inaugurated by Karen Mary Davalos and Constance Cortez in 2016, which will result in a shareable, searchable digital platform and a coauthored, multivolume book.

AMALIA MESA-BAINS is an internationally renowned artist, scholar, and curator. Throughout her career, Mesa-Bains has expanded understandings of Latina/o artists' references to spiritual practices and vernacular traditions through her altar installations, articles, and exhibitions. In 1992 she was awarded a MacArthur Foundation Distinguished Fellowship. Her work has been shown at institutions such as the Los Angeles County Museum of Art, the Whitney Museum of American Art at Philip Morris, and the New Museum, and at international venues in Mexico, Colombia, Venezuela, Ireland, Sweden, England, France, and Spain. In 2011 her work was featured as part of *NeoHooDoo: Art for a Forgotten Faith*, and in 2013 she recontextualized objects from the collections of the Fowler Museum at the University of California, Los Angeles, in *New World Wunderkammer*. As a cultural critic she has cowritten with bell hooks the book *Homegrown: Engaged Cultural Criticism*. She founded and directed the visual and public art department at California State University at Monterey Bay, where she is now a professor emerita. Mesa-Bains's community work includes positions on the board of trustees of the Mexican Museum in San Francisco and the advisory boards for the Galería de la Raza and the Social Public Resource Center in Los Angeles.

ROBERT MILNES holds a PhD in higher education administration from the University of Pittsburgh, an MFA in ceramics from the University of Washington, and a BA in philosophy and fine arts from Claremont McKenna College (1970). His artworks have been included in more than 180 exhibitions nationally, including 28 one- or two-person shows. His artworks are included in the collections of the Renwick Gallery (Smithsonian Institution), Seattle Arts Commission, Arizona State University Ceramic Research Center, San José Museum of Art, Louisiana State University Museum, Erie Art Museum, Edinboro University in Pennsylvania, and San José State Univer-

sity, and in private collections nationally. Milnes served as dean of the College of Visual Arts and Design at the University of North Texas from January 2006 until his retirement in August 2014, when he moved to Asheville, North Carolina, with his wife, Karen, reestablishing the Arbitrary Forms Studio there. A sculptor and ceramist, he served previously as the director of the School of Art and Design at San José State University in California, the director of the School of Art at Louisiana State University, and as chair of the Art Department at Edinboro University. He taught at the Penland School of Crafts in 1972 and 1979. Milnes is the past president of the National Council of Art Administrators and the National Association of Schools of Art and Design. He has served as a consultant or evaluator for more than sixty universities, colleges, and independent schools of art in the United States and abroad, and has served in Dallas on the board of directors of the Business Council for the Arts and as chair of the Community Advisory Board for KERA, the NPR station for North Texas. He was recently named a fellow and lifetime member of NASAD and recently served on the board of directors of the Center for Craft in Asheville, and as co-chair of the Blue Ridge Public Radio Community Forum and the Strategic Planning Committee for the station. He is a member of the Southern Highland Crafts Guild and is represented by the PDNB Gallery in Dallas, Texas.

JENELL NAVARRO is an associate professor of Ethnic Studies at California Polytechnic State University. Her research areas include Indigenous studies, hip-hop studies, and Indigenous feminisms. Her publications include "Solarize-ing Native Hip-Hop: Native Feminist Land Ethics and Cultural Resistance" (2014) in the *Decolonization: Indigeneity, Education and Society*; "WORD: Hip-Hop, Language, and Indigeneity in the Americas" (2016) in the *Journal of Critical Sociology*; and "Leading with Our Hearts: Anti-Violence Work, Community Action, and Beading as Colonial Resistance" (2018) in *Keetsahnak: Our Missing and Murdered Indigenous Sisters*. She is a cofounder of the Decolonial Dream Lab, is a beadwork artist, and lives on California's Central Coast in Chumash territories.

LAURA ELISA PÉREZ is a professor in the Department of Ethnic Studies and chair of the Latinx Research Center at the University of California, Berkeley. Pérez received her PhD from Harvard University and a BA/MA joint degree from The University of Chicago. Pérez curated UC Berkeley's first Latina/o Performance Art series; cocurated *Chicana Badgirls: Las Hociconas* in 2009 at 516 Arts Gallery in Albuquerque, New Mexico; and curated *Labor+a(r)t+orio: Bay Area Latina@ Arts Now* at the Richmond Arts Center, California in 2011. Pérez is the author of *Chicana Art: The Politics of Spiritual and Aesthetic Altarities* (Duke University Press, 2007), a work in which she theorized decolonial aesthetics and decolonial spiritualities at work in the art of feminist and queer visual and performance artists and writers. *Eros Ideologies: Writings on Art, Spirituality, and the Decolonial* (Duke University Press 2019) received a Book Award Honorable Mention from the

National Association of Chicana and Chicano Studies in 2020. She is currently working on a major retrospective, *Amalia Mesa-Bains: Archaeology of Memory*, with María Esther Fernández, which will open at the Berkeley Art Museum and Pacific Film Archive in the spring of 2023. Pérez serves on the National Advisory Council of the Rhizomes: Mexican American Art Since 1848 initiative.

MARCOS PIZARRO is the associate dean of the College of Education and a professor of Chicana and Chicano studies at San José State University. He coordinates MAESTRXS, a social justice teacher collective developing and implementing a transformative education model with Latinx communities. Pizarro also works with schools to develop and implement Latinx studies curricula to enhance Latinx student engagement, and he co-coordinates the Institute for Teachers of Color Committed to Racial Justice.

VERÓNICA "RONNIE" REYES is a Chicana feminist *marimacha* poet from East Los Angeles. Reyes is a proud alumnus of Garfield High (1987), California State University, Long Beach (BA, 1995), and the University of Texas at El Paso (MFA, 2000). Her poetry book *Chopper! Chopper! Poetry from Bordered Lives* (2013) was awarded Best Poetry in 2014 from the International Latino Book Awards and Golden Crown Literary Society Awards, and was a Lambda Literary Finalist. Reyes's poetry depicts the lives of her communities—Mexican Americans, brown queers, butches, immigrants—and contributes to the growing narrative of Chicana/o/x

literature. At UTEP, Verónica won AWP's 2000 Intro Journals Project Award. She is also a Macondo Writers' Workshop member. Reyes is a recipient of grants and fellowships from Astraea Lesbian Foundation, Vermont Studio Center, Virginia Center for the Creative Arts, Ragdale Foundation, and Montalvo Arts Center (Lucas Artist Fellowship). Her work has appeared in *ZYZZYVA*, *Calyx, Feminist Studies*, and *The Minnesota Review*. Verónica Reyes is a lecturer in the Department of English at California State University, Los Angeles.

CLARA ROMÁN-ODIO is a professor of Latin American literature and Latino/a studies with a specialty in cultural productions of the US-Mexico borderlands and feminisms of color. Author of *Sacred Iconographies in Chicana Cultural Productions* (2013) and co-editor of *Transnational Borderlands in Women's Global Networks* (2011) and "Global, Local Geographies: The (Dis)locations of Contemporary Feminisms" (2007), her scholarship examines the location of women in the present era of globalization, their making of cultural resistance, and the empowerment they seek in collective alliances. Her most recent scholarship includes public humanities exhibits entitled *Latinos in Rural America* and *Spiritism by Puerto Rican Women: From Remarkable Pioneers to Contemporary Heirs*.

CAROL SAUVION is the executive director of the Craft in America project, with the mission to promote and advance original handcrafted work through programs in all media. The cornerstone of their effort is *Craft in America*, the Peabody Award–winning doc-

umentary series celebrating American craft and the artists who bring it to life. Sauvion filmed with Consuelo Jimenez Underwood for the "Threads" episode of *Craft in America*. Craft is Sauvion's lifelong passion. For the past forty years she has been the director of Freehand, her Los Angeles gallery specializing in functional craft. Before her involvement in the gallery, she was a potter for ten years. She continues to make pots as an avocation.

CRISTINA SERNA is a binationally trained queer Xicana (Otomi Chichimeca) Indigenous scholar and researcher who performed her graduate studies in Mexico and the United States. She has a PhD in Chicana and Chicano studies from the University of California, Santa Barbara, with a specialization in Xicanx and Mexican art history through a feminist and queer lens. In addition to examining contemporary Mexican and Xicana Indigenous art, she has published on the networks and archives that connect queer Chicana/Latina feminist and Mexican/Latin American lesbian feminist artists and activists across borders. Serna has curated and cocurated exhibitions on Chicana and Mexican feminist and queer art in Mexico City, Santa Barbara, and Los Angeles. She is the author of several essays on Chicana and Mexicana transborder activism and art, including "Locating a Transborder Archive of Queer Chicana Feminist and Mexican Lesbian Feminist Art" (2017).

LUIS VALDEZ is regarded as one of the most important and influential American playwrights and filmmakers living today. Valdez

is the artistic director of the internationally renowned and Obie Award–winning theater company, El Teatro Campesino (The Farm Workers' Theater), which he founded in 1965—in the heat of the United Farm Workers (UFW) struggle and the Great Delano Grape Strike in California's Central Valley. It is the most important and longest running Chicano theater in the United States. His numerous feature film and television credits include, among others, the box-office hit film *La Bamba* starring Lou Diamond Phillips, *Cisco Kid* starring Jimmy Smits and Cheech Marin, and *Corridos: Tales of Passion and Revolution* starring Linda Ronstadt. Luis has never strayed far from his own farmworker roots. Valdez's hard work and long creative career have won him numerous awards, including multiple LA Drama Critic Awards, Dramalogue Awards, Bay Area Critics Awards, the prestigious George Peabody Award for excellence in television, the Presidential Medal of the Arts, the Governor's Award for the California Arts Council, and Mexico's prestigious Aguila Azteca Award, given to individuals whose work promotes cultural excellence and exchange between the United States and Mexico. In September 2016, he was awarded the National Medal of the Arts by President Obama at the White House. In May 2017, he was awarded San José State University's Tower Award, the university's highest award given to San José State exemplars. In addition to his numerous plays, Valdez has written various articles and books; his third anthology, *Mummified Deer and Other Plays*, was published in 2005. In July 2021, his book about theater

theory, *Theatre of the Sphere: The Vibrant Being*, was published.

Valdez has taught at the University of California, Berkeley, UC Santa Cruz, and Fresno State University and was one of the founding professors of California State University Monterey Bay. He is the recipient of honorary doctorates from, among others, the University of Rhode Island, the University of South Florida, Cal Arts, the University of Santa Clara, and San José State University, his alma mater. Valdez was inducted into the College of Fellows of the American Theatre at the Kennedy Center for the Performing Arts in Washington DC. In 2007 he was awarded a Rockefeller fellowship—one of fifty US artists so honored across the United States. The world premiere of his play, *Valley of the Heart*, opened to rave reviews and sold out audiences at the Mark Taper Forum/Center Theatre Group in Los Angeles in 2018. Valdez's play *Adios Mama Carlota* premiered at San Jose Stage Company in 2019. In 2021 he received a lifetime achievement award for directing at the Sedona International Film Festival.

EMILY ZAIDEN is the director and curator of the Craft in America Center in Los Angeles, where she has curated more than sixty exhibitions focused on contemporary craft, art, and design for the center and outside venues. Zaiden has published numerous exhibition catalogs and written articles and reviews for journals, including the *Archives of American Art Journal, American Tapestry Alliance, Metalsmith, Ornament,* and *Antiques*

and Fine Art. She has served as juror and guest curator for various organizations and exhibitions including Hawaii Craftsmen, the Los Angeles Department of Cultural Affairs, California Fibers, the Furniture Society of America, and the Smithsonian Craft Show. Zaiden has lectured on contemporary craft and American and international decorative arts topics at conferences and museums across the country, including the Los Angeles County Museum of Art, Craft Contemporary, and the Milwaukee Art Museum. After completing a BA from the University of California, Berkeley, in American studies and Italian, and an MA at the Winterthur Program in American Material Culture, Zaiden served as a research associate to the Decorative Arts department at the Los Angeles County Museum of Art. Before becoming Craft in America Center Director in 2010, she was a research editor for *Architectural Digest* and she consulted for private collections and institutions focusing on historic American and European decorative arts, material culture, architecture, and design.

X

Xewa Sisters (Jimenez Underwood), 84

Xicana art. *See* Chicana/o/x art

Xicana: Spiritual Reflections/Reflexiones Espirituales exhibition (2010), 5, 8, 16, 151

xiuhcoatl (or magic fire serpent), 135, 275n74. *See also* Mexica culture; myths

Xochil, 26, 97, 107

Xochiquetzal, 74, 138. *See also* Mexica culture; myths

Xochitlalpan (or the Flowering/Celestial Land), 120. *See also* Nahua culture; Nahuatl

xoxopaztle (or backstrap loom), 202. *See also* Nahua culture; Nahuatl

Y

Yanes, Emma, 204

Yapalliicue, 138. *See also* Mexica culture; myths

Yaqui culture: beliefs of, 64, 83, 184, 188, 194, 284n28; history of, 146; Jimenez Underwood's family and, 4, 14, 20, 83, 118, 184, 273n47. *See also* Indigenous cultures

Yarbro-Bejarano, Yvonne, 172

yauhtli, 204

Ybarra-Frausto, Tomás, 78

Yemayá, 61, 72. *See also* myths

Yoeme culture, 146. *See also* Indigenous cultures

Yolotlicue (or "Hearts-Her-Skirt"), 137. *See also* Coatlicue; Mexica culture; myths

yucca flower (New Mexico), 11, 64, 86, 94, 107, 151, 155, 188

Z

Zaiden, Emily, 16–17, 100–110

Zamudio-Taylor, Victor, 76

Zapatista uprising, 74, 214

Zapoteca culture, 203

Zavala, Adriana, 175

Zócalo (Mexico City), 133

Zóquite (Mexico), 177; women's lives in, 177–78